ISED

DAZED

DAZED

&Confused

andCONFUSED

DAZED
CONFUSED

Dazed

&Confused

DAZED
&CONFUSED

DAZED
&CONFU

DAZED

USED

DAZED

Dazed

&Confused

ZED

DAZED
&CONFU

ED
USED

DAZED
&CONFUSED

DAZED
&CONF

CONFUSED

and

DAZED

30 Years Confused:
The Covers That Launched a Movement

DAZED

30 Years Confused:
The Covers That Launched a Movement

RIZZOLI
NEW YORK

New York · Paris · London · Milan

When a cover line becomes a manifesto.

The ten commandments of *Dazed: 30 Years* make ten chapters, all taken from the magazine's most memorable cover lines.

Feel it!

I think the name *Dazed & Confused* says it all. We didn't have a plan. We didn't know what we were doing; the name was about admitting we didn't have answers, but we were open-minded, questioning. In a way, it gave us this freedom to feature anyone — and anything — we felt interested in, without boundaries. For the foreword of issue one, I wrote: 'This is Not a Magazine, this is not a conspiracy to force opinion into the minds of stylish young people... a synthetic leisure culture is developing...' I think what made *Dazed* amazing is the differing intentions between us all that collided into one creative expression.

From the very start, *Dazed* was a place for people to drop in and hang out. It was a 'living magazine': a network for friends, contemporaries, collaborators who put on events, helped each other's projects, staged exhibitions, fashion shows, shoots, parties, club nights, happenings, and also put out a magazine. It was a way of thinking and doing that was inspired by everything that was happening in the early-90s subculture and we just kept inviting more and more people into the party.

When we launched *Dazed*, Rankin and I never thought it was gonna last more than a couple of years, so every extra one has been a bonus! And to say what it has achieved is hard for me. I'm too close to really comprehend that. I think what's been a joy is that each generation has made it their own. And that over 30 years it has been a really beautiful and inspiring thing to have been witness to.

This book offers you a snapshot of the array of creative collaborators who have made *Dazed* so special, the images and covers they created and the stories that have defined it over the years. In many ways that same party we started all that time ago is still ongoing, and now, as it exists in your hands, it can also live in your imagination. Thank you for taking the time to explore the book, and if you're starting out on your own journey, then just do it; don't think about it, just get started. You don't need money, permission or to know anyone. We certainly didn't.

—Jefferson Hack

CONTENTS

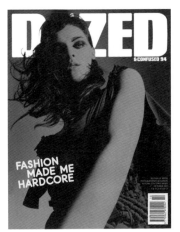

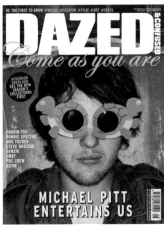

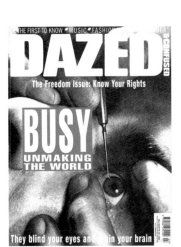

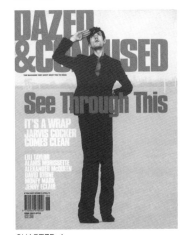

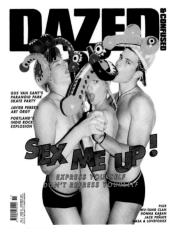

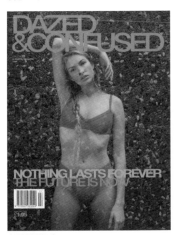

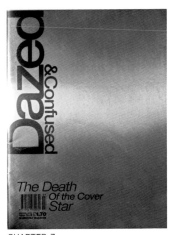

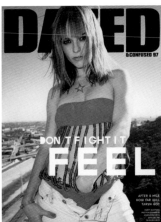

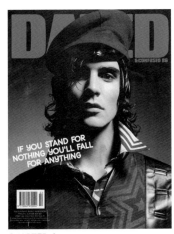

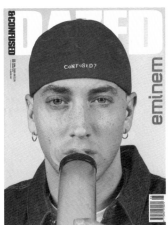

The Magazine That Became a Movement by Dean Mayo Davies

When a magazine begins life as a photocopy, you know it's being done for the right reason. A question of intention, when spirit is bigger than packaging, it arrives with all the potential of shaking things up.

While students at the London School of Printing, *Dazed* co-founders Jefferson Hack and Rankin made a zine, *Untitled*, square in format with no need for staples. (In some ways it was a giant flyer, a medium of recruitment. And it could blow any way the wind went.)

Still DIY, *Dazed* arrived in 1991. Audacious, with a dynamic subculture bent, it would go on to be published 12 times a year, made by emerging talents making it up as they were going along — as Jefferson says: 'I think what made *Dazed* amazing is the differing intentions between us all that collided into one magazine.' If *Dazed* was the definitive style magazine of the 90s, it is because it was born and raised in those years, with all the pure attitude of the era. As for the difference between a style magazine and a fashion magazine: one's about the culture of living, the other, skirt lengths.

Where other newsstand titles pursued a pop realm, *Dazed* magnified alternative voices like no other: a new generation out there and doing it, creating the climate of not just now, but the shape of tomorrow. To people beyond London, *Dazed* was truly seismic, like a bomb in WHSmith. The magazine was an education, and a corruptor — how many lives would it uproot, prompting moves to the capital, wanting to taste this world they'd been pressed against the glass of? The question has potential for its own feature.

The *Dazed* office, at 112–116 Old Street, was part myth (because if you knew anything about it it's likely you weren't there). Partying through launches, exhibitions and, more than sometimes, just because, it soldiered through comedowns and hangovers to produce a cultural artefact, something readers could line up on shelves the world over, 12 times per year. It was *Dazed* that presaged publishing's broader movement to east London, because rent was cheap and that's where those making it lived. Unlike now, the area was bereft: you couldn't get ramen or sushi for lunch. It was a pasty from the garage, or nothing.

This context is not pre-internet, since dial-up modems began trickling into our homes en masse around 1998 (take this from experience). It is, however, pre-internet publishing as we're familiar with, when magazines treated their websites as holding pages. When *Dazed Digital* launched in 2006, it arrived as the first of its kind, not an afterthought but as its own entity, with its own editorial team and content. What's more, it was free, harnessing the democracy inherent to the internet.

When *Dazed* magazine was reconfigured as a bimonthly in 2015, focusing on tactile experience with elevated paper stock and beautiful design, it would begin its lean into how we know it today. And let it be said: being immaculately dressed allows you to work a whole other level of storytelling and influence.

'As a magazine, *Dazed* has always had a rare ability to shapeshift and react to the cultural and political landscape of the times we live in,' declares Isabella Burley, editor-in-chief from 2015's redesign to 2021. 'We've never been scared to hand over the pages of the magazine to someone else for their big ideas — and I think that's something we're pushing now more than ever. Thirty years on, the magazine

is as open and fluid as it ever was. As an editor, that makes things really exciting.'

Through its documentation, guest voices, projects, featured talents and fashion, when *Dazed* commissions something, it's multifaceted, like a diamond — the light bounces off in many ways. Moving readers and fuelling movements full stop.

This is a magazine that has never shied away from activism. Chelsea Manning, the American whistleblower who shook WikiLeaks with the biggest exposé of classified military documents in US history, prominently covered the Spring 2019 issue with bright red lips and Gucci bouclé. During her seven-year incarceration from 2010, she endured treatment deemed by the United Nations as 'cruel, inhuman and degrading'. Since her release from military prison in 2017 (she was again imprisoned for contempt in 2019, after the issue's release), she has found herself not just in this new era of activism, but in her personal life and transition.

For America's teen anti-gun activists, featuring members from the LGBTQ, Black Lives Matter, and student movements, orange is their official protest colour. They were photographed by Ryan McGinley for Summer 2018, and Adam Eli wrote: 'Orange is a colour that says to other hunters, "I'm human, please don't shoot."'

'I have been advocating against senseless gun violence and I believe my generation will get things done,' said 11-year-old Christopher Underwood. 'I've seen young people like me from all across the 50 states standing up and saying "no more".'

'No one should have to plead for their life; this is a demand,' declared 18-year-old Christian Carter. 'We have to have these conversations. This is not a taboo topic.'

For the 'Age of Craziness' issue, June 2011, Ai Weiwei covered the magazine's global activism special. Photographed by Gao Yuan, the artist's portrait was taken following surgery for a cerebral haemorrhage, four weeks after being severely beaten by Chinese police for trying to attend the trial of activist Tan Zuoren. At the time of going to press, Weiwei's whereabouts, following his detention, were unknown. Alongside a previously unpublished interview, leading curators and artists discussed the voice that wouldn't be silenced.

April 27, 2004: *Dazed* was in the South African capital of Pretoria and saw thousands crowd the city to celebrate both President Thabo Mbeki's second inauguration and the country's first decade of democracy. Speaking to people on the ground about their hopes and fears, it was thanks to post-apartheid President Nelson Mandela that South Africa was free to flourish in the areas *Dazed* cherishes: music, film, art, and fashion. The issue featured kwaito superstar Zola, jazz pioneer Hugh Masekela, jailed people's poet Mzwakhe Mbuli and hero of the apartheid era Desmond Tutu, yet this optimism was contrasted by recognising the country's escalating Aids crisis. Photographed by Rankin, the issue's cover story was made with young people living with HIV in Johannesburg.

More than platforming voices, the magazine has routinely reconfigured itself as a journal for entire perspectives, the most panoramic kind of storytelling.

'We are not really trying to start new conversations, but there are conversations happening all over that we are a part of,' said Kwamé

Sorrell from BlackMass Publishing of their contribution to the Autumn 2020 issue. 'I think we are making a place for these kinds of exchanges to continue and grow. It's not just this insular, homogenous thing — it's expanding.' BlackMass' art project featured in 'Read Up Act Up', an issue in which conversation replaced the cover star. In solidarity with the Black Lives Matter movement, each section had its own guest editor: Black Lives Matter's international ambassador Janaya Future Khan; rapper and abolitionist on behalf of the incarcerated, Noname; and designers Samuel Ross, Grace Wales Bonner and Shayne Oliver, who are so much more than ready-to-wear that clothing is a punctuation in their research.

Along with repeat collaborators Björk, Vivienne Westwood and Lee Alexander McQueen, the guest edit is an important strand in *Dazed*'s history.

Björk, who has had more *Dazed* covers than anyone else, guest-edited the 200th issue, August 2011. And starred in Spring 2015, Autumn 2017 and Winter 2019, rounding out the decade. Westwood appeared across four covers shot by Harley Weir for Spring 2018, three of them featuring her own handwritten cover lines: 'Make History!', 'Protest!' and 'Resist!'

Throughout the 2010s, *Dazed* had its fashion moments: images, bigger than clothes, which became everlasting.

For Spring/Summer 2019, British-Nigerian designer Mowalola joined iconic model Debra Shaw in conversation, interviewed by Dominic Cadogan, the day after she'd been shot by Campbell Addy and styled by fashion editor Emma Wyman in her collection. With over 20 years in the industry, Shaw is a recognisable Thierry Mugler face, and stuck her tongue out while wearing a crucifix-adorned gothic mask at Alexander McQueen's AW96 show, *Dante*.

After setting a new benchmark for Black LGBTQ portrayals on screen, Ashton Sanders was styled by creative director Robbie Spencer and photographed by Sean and Seng on the beach for the Spring 2017 issue, wearing Craig Green and Wales Bonner. While the magazine was on shelves, *Moonlight*, Barry Jenkins' coming-of-age drama that Sanders lit up with his performance, became the first film with an all-Black cast, as well as the first LGBTQ film, to win Best Picture at the Oscars.

Young Thug, also styled by Robbie Spencer and photographed by Harley Weir in the Autumn 2015 issue, wore a sheer Molly Goddard dress, careless of the fact it was from a womenswear collection. The image presaged the musician's Alessandro Trincone-created get-up for his *Jeffery* record sleeve. During the shoot in Atlanta, Thug's sister and day-to-day manager, Amina, demanded he, 'TAKE THE TUTU OFF, NOW!' It was too late: Thug had happily posed for the shot.

Back in the 00s, Hedi Slimane photographed a British Youth portfolio for the January 2009 issue, gathered from various nightlife locations around London. Renowned for his street-casting approach, the project happened in the period after his hugely influential stint at Dior Homme and before he would arrive, for the second time, at Saint Laurent. Styled by Nicola Formichetti, the iconic portraits story ran over 34 pages and two covers — one featuring the debut of 17-year-old Louis Simonon, son of Clash bassist Paul. The clothes were almost exclusively vintage — because that's how this generation expressed themselves.

Matt Irwin, Walter Van Beirendonck and Formichetti would combine, for November 2007's 'Sex Me Up!' cover, a foursome of models Anna, Luke, Florian and Eddie. Naked aside from pow-wow headwear by Stephen Jones for Walter, and more headpieces by Gary Card, it captured a particular *Dazed* energy. The story also epitomised the magazine's love of sculptural and showpiece fashion.

But the magazine has never just featured the collections. It's been present at the first stages of creation.

Since the 90s, *Dazed*'s fashion editors have styled new talent's shows and lookbooks, and consulted and made connections with other visual talents to bring visions to life. A designer's message pales into a void without the photography that depicts their world, and *Dazed* has continuously supported emerging talent by running their campaigns in print — something that was previously the mark of only the biggest houses. These personal and extracurricular fashion relationships continue to feed not only into the magazine but beyond. When you believe in someone, it's unconditional.

Then there are those designer relationships so close to the magazine, they're part of *Dazed*'s social fabric.

An archive search for Gareth Pugh brings more than 200 results. His first cover, featuring early ball silhouettes, was April 2004, photographed by Laurie Bartley and styled by Formichetti. The tagline? 'Performance!' Pugh's October 2008 cover featured an epic collaboration with Nick Knight, styled by *Dazed*'s Katie Shillingford, who has worked with Pugh for over a decade, from London squats to the V&A. The feature presaged Pugh's first Paris show: *oh la la!*

Designers were asked to make custom looks for Beyoncé for July 2011. The likes of Riccardo Tisci (at Givenchy), Tom Ford, and Marc Jacobs (at Louis Vuitton) obliged. Pugh made a metallic snood and leggings, and like four of the designers, asked the diva a question: 'You were born four days after me, which means you're a Virgo. What Virgo characteristics do you have?' The same month, Shillingford got married in a bespoke Pugh wedding dress of dove-grey slashed chiffon.

Pugh talked about his dad's love of Sunderland FC for the Spring/Summer 2015 issue. He used the club's chant on the soundtrack to his AW15 show: its striped kit is uncannily like the 2004 cover look.

Lee Alexander McQueen and *Dazed* were inextricable: super-stylist Katy England met McQueen at a trimmings shop in Soho in 1994, and worked as his studio's creative director for over ten years, across everything from research and casting to styling and fittings. (The first show she styled was SS95, *The Birds*; she worked with the designer until 2007.)

During the late 90s, England's collaboration with McQueen was so intensive that she'd work on *Dazed* at night. (And when she was *Dazed*'s fashion director, McQueen spent time on the masthead as fashion editor-at-large.) McQueen guest-edited September 1998's 'Fashion-Able?' issue, featuring arguably the magazine's most iconic cover: Paralympian Aimee Mullins, photographed by Nick Knight. The shoot went on to inform McQueen's next runway show, *No.13*, for which Mullins walked in legs carved from elm.

During Isabella Burley's time as editor-in-chief, she sought to showcase cult and influential artists in the magazine, whether giving pages to their lesser-known projects, commissioning new work or highlighting an important show.

Byron Newman sent a CD to the office with unseen images from *The Ultimate Angels*, his documentary about transgender communities in 1980s Paris. And for Autumn/Winter 2015's issue, Adrienne Salinger submitted never-before-seen images from her *Teenagers in their Bedrooms* series. The project was in a box in her attic: it was the first time in over 20 years she'd looked through the images.

Liz Johnson Artur, who spent 30 years photographing the African diaspora, was featured at the time of her acclaimed South London Gallery exhibition. And in *Dazed*'s Autumn/Winter 2020 issue, Zanele Muholi, interviewed by Jess Cole, discussed their Tate Modern exhibition and published unseen images from their *Brave Beauties* series.

It was back in July 2006 that Barbara Kruger made the case for *Dazed* as a gallery-in-print. Realising the cover of 'The Freedom Issue', her signature graphic language declared: 'BUSY UNMAKING THE WORLD' / 'They blind your eyes and drain your brain'.

Then there is simply the power of capturing the mood. The Spring 2020 issue of *Dazed* was one of the first magazines to acknowledge the Covid-19 pandemic, and was, for the first time, offered as a free download while we were in lockdown. Commissioned before the coronavirus hit and sent to print remotely from the team's beds, living rooms and sofas, the 'alone together' content captured the mood of our experience as it was playing out. Featuring cover star Billie Eilish (photographed by Harmony Korine, styled by fashion director Emma Wyman) and 100 Gecs, there was a focus on talents who are somewhat enigmatic but who live freely online in their own realms. It was the internet that would be our lifeline through isolation, ending in video-call fatigue.

This unprecedented event of our lifetime didn't discriminate, meaning brands had to adapt. While models shot themselves for campaigns, SS21 fashion weeks were seen, by and large, on a laptop. An extraordinary period for image-making — and for planning future issues of *Dazed*, with the newly appointed editor-in-chief Ib Kamara and executive editorial director Lynette Nylander.

1.
Fashion Made
Me Hardcore

Go harder than anyone else,
dare to dream extreme
008–051

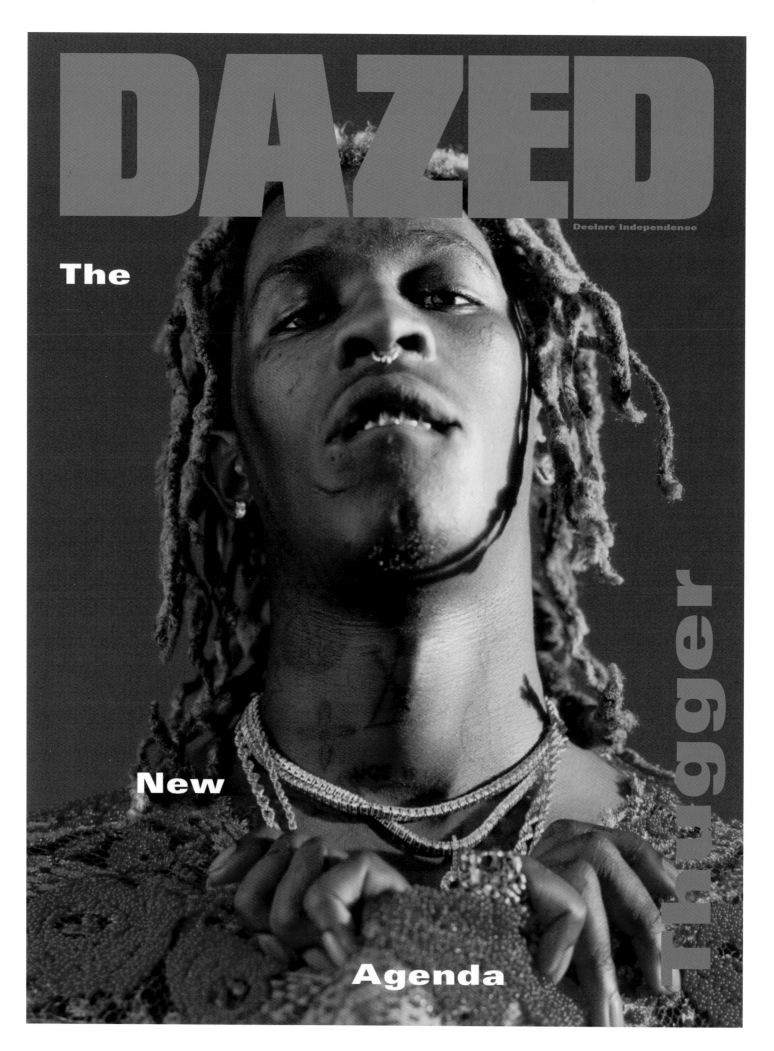

DAZED

Declare Independence

The

New

Agenda

thugger

Young Thug
by Jon Caramanica

In March of 2014, a photo began to circulate online of Young Thug wearing a leopard-print, little girl's dress, much to the consternation of, well, people who specialise in consternation. Hip-hop has long been saddled with anxieties about gender, sexuality, and the limits of acceptable personal expression. Thug's casual meta-machismo was so disruptive, so sudden, and so unexpected that for some, it was tantamount to a full-scale short-circuiting of genre norms.

The photo might have been punted as a curiosity if Thug weren't one of hip-hop's most promising talents at the time, who would release two of the genre's biggest and most flammable singles of that year: 'Stoner' and 'Danny Glover' (later renamed '2 Bitches'). Here was a rising star beholden to none of the usual rules, and a provocateur whose many tweaks — sonic, sartorial, conceptual and so on — seemed designed to underscore just how staid and conservative hip-hop, long the outlaw genre, had become.

By the time he appeared on the cover of *Dazed*'s Autumn 2015 issue under the coverline 'The New Agenda', Young Thug was the quixotic king of hip-hop's emergent — and soon to be dominant — psychedelic wing. In the images, shot by Harley Weir and styled by Robbie Spencer, the then 23-year-old leans into the androgyne — a Gucci pussy-bow top (two years before Harry Styles did it in *Rolling Stone*), a sheer plastic Walter Van Beirendonck sheath top that reads, 'WARNING: EXPLICIT BEAUTY'. Most striking is Thug in the Molly Goddard dress: sheer up top, over bare skin, and a full tulle skirt on bottom.

Shot in and around his home in Atlanta, the photos blend cosiness and regality, hauteur and warmth. In one picture, Thug is in the bathtub, covered in gold chains and bubbles (perhaps a nod to David LaChapelle's notorious Tupac photos). In another, a silk leopard-print robe by Ed Marler slips off his shoulder as he reclines atop a red Mercedes, an image that's both a come-on and a taunt.

Here was the new king, nothing like the old ones. Thug released his earliest mixtapes during the peak Drake era, a time that was musically progressive, but also exceedingly legible. He replaced this with rapping that dissembled, that was quarter-baked, flambéed, narcotised, minced, mulched and dipped in both sweetener and embalming fluid.

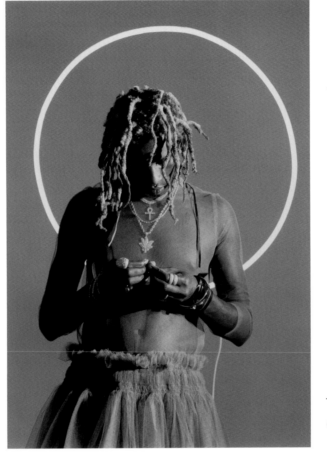

What was once rapping was now something wholly other. Everything bled together. His vocal choices were novel and curious: strained, ecstatic yelping; trombone-slide slithering between syllables; deconstructed rhyme patterns; multiple colliding and competing melodies. Structurally, he reduced the unit of innovation from the verse to the line to the rhyme to the word to the syllable to the post-syllabic sound. His best songs had the feeling of experiments; his car crashes were as fascinating as his ballets.

As rowdy and unfiltered as Thug's music was, his public persona was more so — the chaos that he projected to the world was merely the tip of a very, very deep iceberg. He gave famously inscrutable interviews. He appeared to be beholden to no schedule. He had a smattering of breakthrough hits, but they didn't define or limit him. Like his idol Lil Wayne, he recorded extensively and released music at a prodigious clip. He was growing extremely popular online, so it didn't much matter whether he fit into the conventional patterns of a radio-era rap star. Thug's success at first felt like that of an outlier, but soon became a beacon: he presaged a coming wave of younger stars who displayed next to no interest in the conventions of centrist hip-hop stardom that had been concretising for, at that point, more than two decades.

And even as he became extraordinarily popular, he remained interested in testing boundaries — throughout his rise, he casually referred to his male friends as 'lover,' 'bae' or 'hubby,' once again triggering predictable shock. In 2016, he chose to wear a Japanese-inspired dress by the Italian designer Alessandro Trincone — which he likened to a *Mortal Kombat* character — for the cover of his mixtape *Jeffery*, hitting a pose both fluid and angular.

Similarly, there's a dreamy tenderness to Weir's images, but just beneath the soft-focus surface is a backbone of steel. This is who he is — take it or leave it.

In a hilarious moment from the accompanying feature to the *Dazed* cover, Thug's manager exasperatedly demands he take off the Goddard dress, as if imagining the dominoes that inevitably would fall. But the photo had already been taken. In it, he looks unflustered, almost bored.

PATRIK SANDBERG, US Editor-at-Large: I think the Young Thug cover is probably my favourite experience. Going to Atlanta with Jamie and Harley and Robbie, getting to drive around neighbourhoods where Young Thug grew up and meet his mom, his nieces, and his whole extended family... To spend several days with him for the story felt like a big luxury. Most celebrities don't give you that much access and such a rich experience when writing a magazine profile these days. It was unforgettable. After we did the bubble bath setup I remember Harley turning to me and saying, 'I think we created something really iconic today.' I think she was right.

JAMIE REID, Art Director: Harley and I were obsessed with Young Thug. It was my first *Dazed* cover after joining as art director and we flew out to Atlanta to shoot him. After a day on location, we went back to his house to finish the shoot and had an idea of taking a picture of him in his bathtub. I had the honour of running his bubble bath, but ran it too hot. To this day I still remember the look on his face when he got in; it totally scalded him!

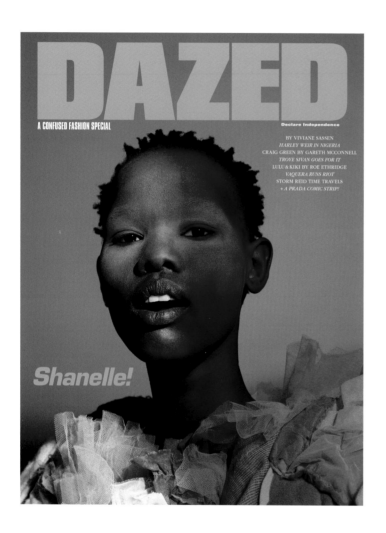

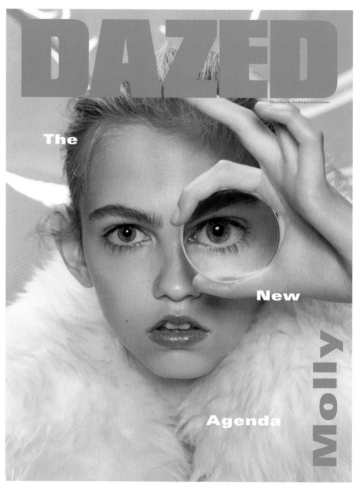

ISSUE 55, VOL. IV, SPRING 2018 **SHANELLE**
PHOTOGRAPHY **VIVIANE SASSEN**
STYLING **ROBBIE SPENCER**

ISSUE 40, VOL. IV, AUTUMN 2015 **MOLLY BAIR**
PHOTOGRAPHY **ROE ETHRIDGE**
STYLING **ROBBIE SPENCER**

012 FASHION MADE ME HARDCORE

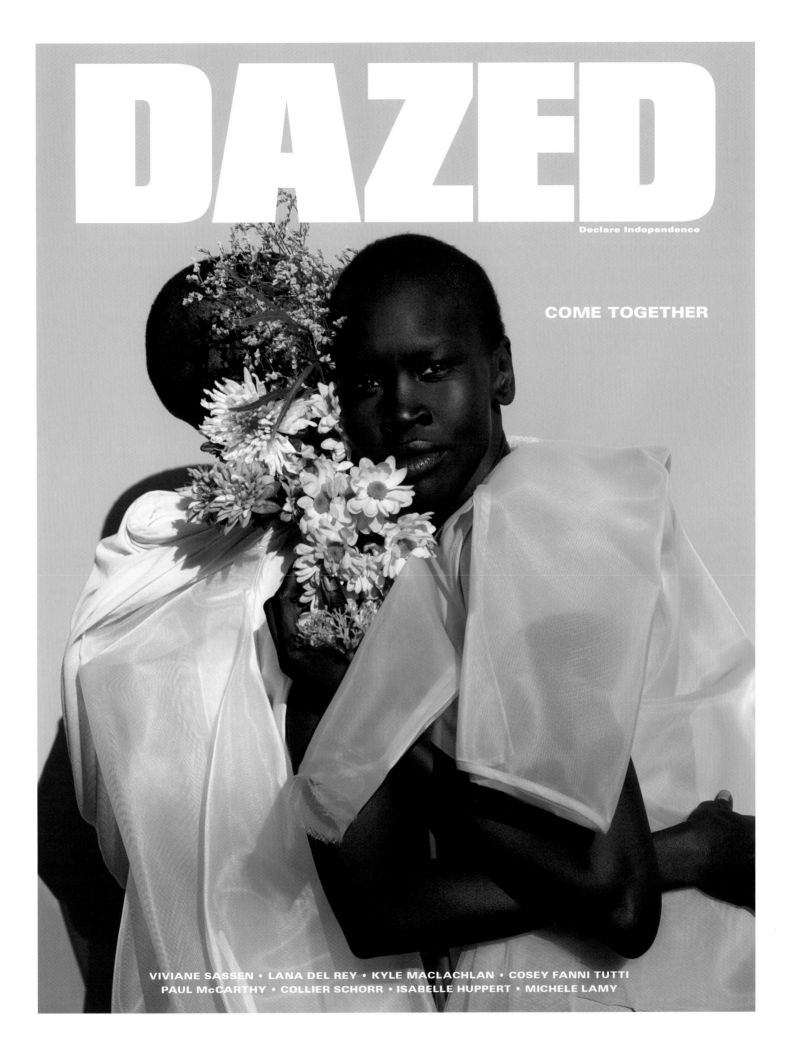

DAZED

Declare Independence

COME TOGETHER

VIVIANE SASSEN • LANA DEL REY • KYLE MACLACHLAN • COSEY FANNI TUTTI
PAUL McCARTHY • COLLIER SCHORR • ISABELLE HUPPERT • MICHELE LAMY

ISSUE 50, VOL. IV, S/S 2017 **ALEK WEK & GRACE BOL** PHOTOGRAPHY **VIVIANE SASSEN** STYLING **ROBBIE SPENCER**

FASHION MADE ME HARDCORE

Iris Apfel on being a 91-year-old Comme des Garçons cover girl

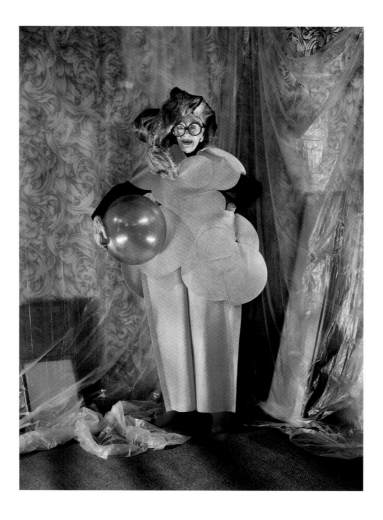

I'd never been to a shoot like that, and I'd never experienced those kinds of clothes. It was all quite exciting and very, very different. I came for hair and make-up, but then they pulled my hair back and they brought out all these strange sort of... wig-hats, whatever they were supposed to be. That was unusual, and then the clothes were really quite strange. They were very attractive but they were all made of construction material. And you could hardly navigate; it was very difficult to walk. Sitting was an agony! I mean, they weighed a ton. I'd never had to have anybody almost drag me to the camera before — it was very hard work. It was all sort of surreal... I still don't understand what it was all about. But it turned out to be a smash, and just sort of went viral, you know? Everybody called me and it was a big sensation. I only had one negative response — some very elegant, super-elegant, couturier thought that I'd made a fool of myself and said I should be very careful, otherwise, I'd ruin my career. He had no sense of humour, obviously.

I'm not an empty-headed fashionista. I knew of Rei (Kawakubo) before and I always admired her clothes, but they were always very strange.

I remember the first time I saw one of her outfits, I was very taken with it. I didn't have time to try it on so I bought it and took it home, and when I got it home, I couldn't figure out how to get into it!

I think fashion is pop art. It's really a mirror of what is going on in the world — a mirror of the economic, the social, the cultural conditions under which we live. (The pandemic has) been devastating to the fashion world. Everybody in the fashion business is tearing their hair out because there are no sales — (sweatpants) are the only type of clothing that's selling. I've been completely confined in my apartment in Florida because, as you know, I'm 99. I don't go perusing around — I've only been out for doctor's appointments about half a dozen times in the last year. At home I have a million different robes, so I change my robes constantly. I feel I might as well be comfortable. Jewellery is one thing I still wear — I wear it with my robes. I feel naked if I'm not wearing jewellery. It makes me feel happy. And we need to do everything we can these days to keep ourselves in a good frame of mind. AS TOLD TO **EMMA HOPE ALLWOOD**

ISSUE 15, VOL. III, NOV 2012 **IRIS APFEL** PHOTOGRAPHY **JEFF BARK** STYLING **ROBBIE SPENCER**

FASHION MADE ME HARDCORE

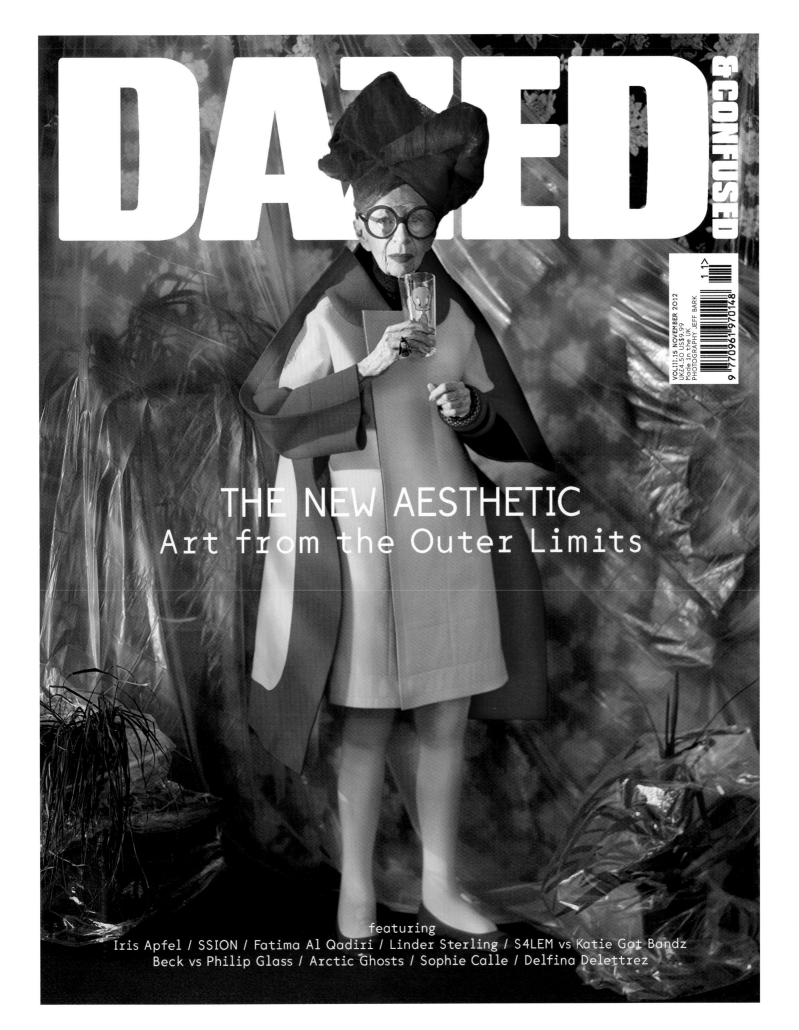

DAZED

&CONFUSED

VOL.III.15 NOVEMBER 2012
UK£4.50 US$9.99
Made in the UK
PHOTOGRAPHY JEFF BARK

11>

THE NEW AESTHETIC
Art from the Outer Limits

featuring
Iris Apfel / SSION / Fatima Al Qadiri / Linder Sterling / S4LEM vs Katie Got Bandz
Beck vs Philip Glass / Arctic Ghosts / Sophie Calle / Delfina Delettrez

NOAH SHELLEY, Casting Director: It took a while to reach out and discuss Iris Apfel's involvement regarding the 2012 cover we did with her. While she was a known character in NYC, she wasn't in the public eye the way she is now, and hadn't really done anything like this yet. I think she didn't have a cell phone, and in the end she invited me for tea even. So my craziest story from my years at *Dazed* is being invited to tea.

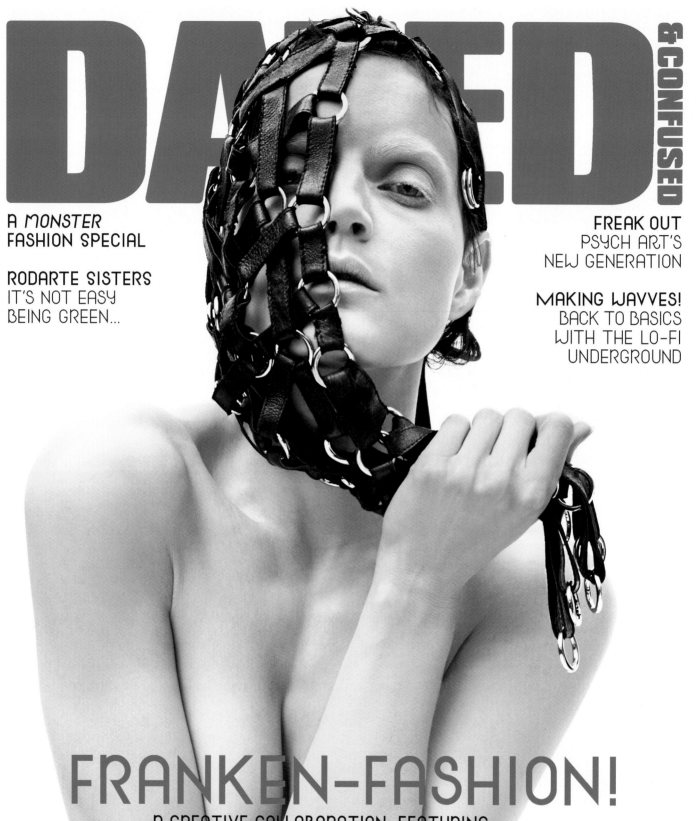

DATED & CONFUSED

A *MONSTER*
FASHION SPECIAL

RODARTE SISTERS
IT'S NOT EASY
BEING GREEN...

FREAK OUT
PSYCH ART'S
NEW GENERATION

MAKING WAVVES!
BACK TO BASICS
WITH THE LO-FI
UNDERGROUND

ISSUE 78, VOL. II, OCT 2009 **FRANKEN-FASHION** PHOTOGRAPHY **DANIEL JACKSON** STYLING **KAREN LANGLEY**

FRANKEN-FASHION!

A CREATIVE COLLABORATION, FEATURING...

JC DE CASTELBAJAC ALEXANDER MCQUEEN PLUS!
ROBERTO CAVALLI GARETH PUGH REBECCA HALL
HUSSEIN CHALAYAN RICCARDO TISCI TIM & ERIC
MARTIN MARGIELA ...AND MANY MORE 60S DEATH CULTS

VOL.2 ISSUE #78 OCTOBER 2009 UK £3.95 US $9.95 MADE IN THE UK

KAREN LANGLEY, Fashion Director: This 'Make Me a Monster' story with Guinevere van Seenus was so special. We invited 13 different designers — including Margiela, Alexander Wang and Riccardo Tisci — to make a custom mask for the shoot. I was a relatively young stylist, so that just shows you what is possible with *Dazed*. How as a magazine it takes risks, and how that inspires the establishment to take risks too. Alexander McQueen made a really dark and fun one, Walter Van Beirendonck created a glass mask, and Gareth Pugh's leather one became the cover. Guinevere made everything look so cool!

FASHION MADE ME HARDCORE

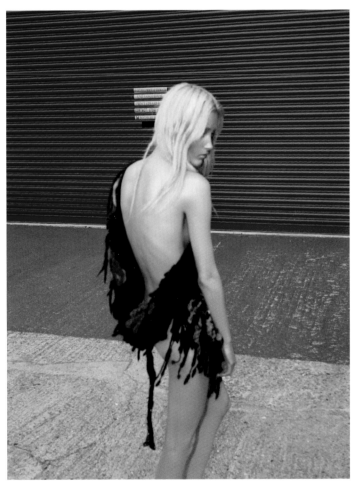

ISSUE 78, VOL. II, OCT 2009 **RODARTE** PHOTOGRAPHY **VIVIANE SASSEN** STYLING **KATIE SHILLINGFORD**

FASHION MADE ME HARDCORE

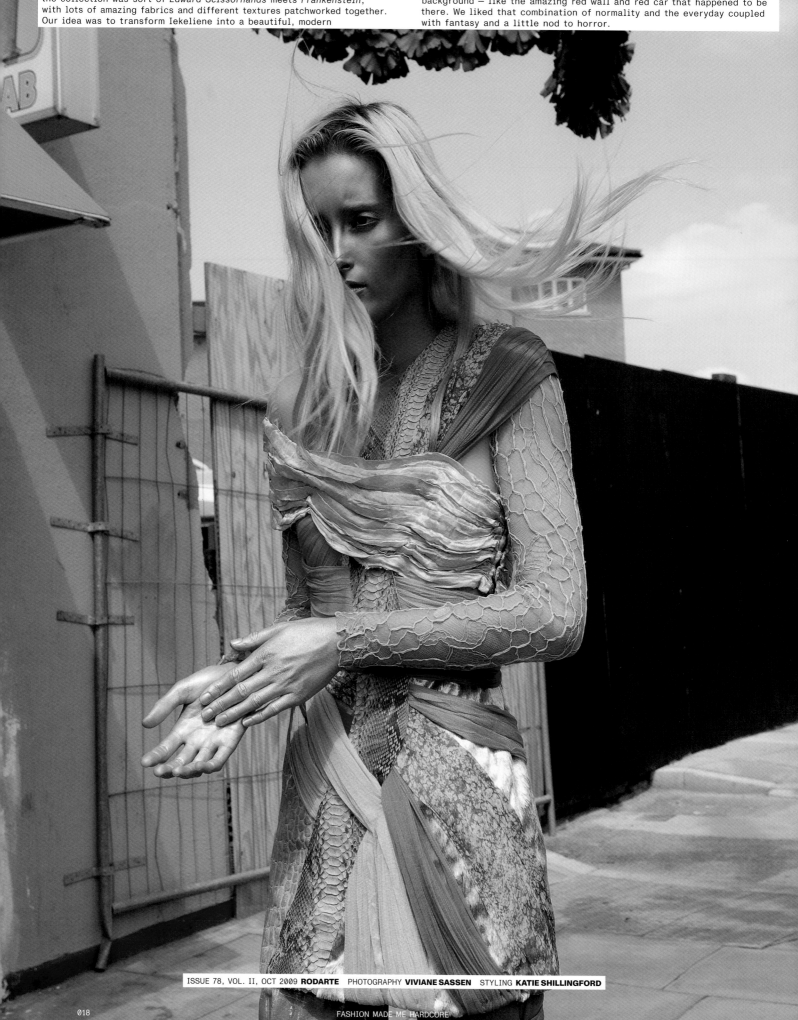

KATIE SHILLINGFORD, Fashion Director, *AnOther*: This was the first time I worked with Viviane Sassen and we were shooting a story to go with an interview with sisters Laura and Kate Mulleavy of Rodarte about their spooky AW09 collection. The designers were inspired by horror films and the collection was sort of *Edward Scissorhands* meets *Frankenstein*, with lots of amazing fabrics and different textures patchworked together. Our idea was to transform Iekeliene into a beautiful, modern Frankenstein. That's why Hiromi painted her green — a pearlescent green, which looked so beautiful, especially in the London summer sunshine! We shot it around Hackney Wick, which was pretty abandoned at that time. Viviane has this very special way of finding the perfect background — like the amazing red wall and red car that happened to be there. We liked that combination of normality and the everyday coupled with fantasy and a little nod to horror.

ISSUE 78, VOL. II, OCT 2009 **RODARTE** PHOTOGRAPHY **VIVIANE SASSEN** STYLING **KATIE SHILLINGFORD**

DAZED: What would your epitaph be?

ALEXANDRA: Ooh, *killer* question... It'd be on a fang-shaped piece of marble and carved into it in neon would be, 'I'm having the best time.'

Having the best time for Alexandra Bone, 2011's wildest model, right now involves bopping into a Dazed × Rodarte shoot a mere two hours late ('Alexandra is never on time for anything, not even her own birth,' quips her mother) kneeling on the street in a sick latex halter top ('I'm a witch and a dominatrix! I'm every boy's dream!'), and smoking enough Marlboro Lights to give the Hulk a heart attack. It also involves releasing an ultra-limited VHS (!) tape with dark-hearted witch house trio Salem called *Alexandra's Guide to Graveyards*, getting gifted 'insane' boots by Margiela, blasting 'What's a Girl to Do?' by Cristina on a smashed-up iPad, and, yes, being Wicked Witch green, which has led to her casting spells on the catwalk from Milan and New York, while sending goose bumps through the fashion world faster than me roar,' she yells between shots, cracking up in 'I am monster, hear me roar,' she yells between shots, cracking up in a shaggy grey jumper. Even when it felt like a semi-tragic predicament, I knew I didn't superpower. Even when she dubs 'the depressed Sasquatch'. 'I mean, it's a Cristina purrs, 'My sheets are *stained* / So is my brain / What's a *girl to do?*' wanna be like the other girls, I knew I was fucking magic.' From the iPad, and Alexandra grins when Kate and Laura Mulleavy (aka the Sisters Rodarte) It all began when she scouted her in an LA bowling alley. 'I was obliterating a plate of curly fries and thinking about my death: classic "me time",' shrugs Alexandra. The union of Kate, Laura and Alexandra is a marriage made in heaven and hell. She's the perfect fit for their woozy, supernatural vibe: slender enough to have stepped out of an Edward Gorey illustration combined with blonde tresses and bone structure weirdly suggestive of a past life as a 70s singer-songwriter with a penchant for tarot: Rodarte to the, uh, bone. Alexandra mock-pukes at the West Coast — 'I'm from Jersey! I was conceived at (notoriously dangerous NJ

WHAT'S IT LIKE BEING AN INTERNATIONAL SUPERSTAR SUPERMODEL WHO ALSO HAPPENS TO BE BRIGHT GREEN? TIME-TRAVELLING TO THE 2009 SET OF THE *FRANKEN-FASHION* ISSUE OF *DAZED*, WRITER CHARLIE FOX FINDS OUT.

amusement attraction) — but still as hot for hardcore prankster owl to PE, which, fixing Dazed into a descendent of 'Halloween is next week, she loves Kate and Laura and she adores their garms. 'It's *luxury goth!*' she yells, as somebody who discovered in the middle of an MDMA binge. Narnia, all the clothes are super-romantic but also, 'I mean, if you're a girl, getting dressed up as, like, this trippy you're a girl, getting dressed up to scare dudes makes you...' fairy-tale countess. Not that I need to dress up for that myself, but...' feel so powerful. Not that I need to dress up to scare dudes makes you...'

Being scary and being powerful have always gone hand in sly green for Alexandra. (BTW her glitter-encrusted black claws are looking 'very eagle' today.) Asked for a quote under her yearbook picture, she growled. 'Grr!' she repeats, leaping at Dazed like a fun-loving werewolf. 'Was I high? Def.' (She's the Saint of Misfit Girls everywhere, whose dalliance with 'a hot boy from the zoo' once led to her bringing a barn castle whose points out, wasn't *explicitly* against the rules. Even if she wasn't always, a descendent of Frankenstein's monster and having this disease, obviously. Kids at school yelled, have to worry about today. Indeed, the WTF experience of going from stoned suburban outcast to hotter-than-a-mushroom- Alexandra as it would be for someone 'normal'. 'I'm used to people staring at me because I'm a weirdo. At least nobody yells anything when I'm walking in Hood By Air, dressed up like a demonic cyberpunk or whatever.

Liberated from the true horror of having 'a boring body', Alexandra is, as per her epitaph, having more fun than a carload of sugar-crazed clowns. Re the question of what kind of friend she is, she claims, 'most likely to send you a picture of a stuffed animal in a dumpster at 4am and also to randomly set off fireworks. Relax, nobody was ever seriously injured.' The shoot concludes, the sun takes a dive, and she sparks yet another cigarette and cracks open a Guinness. Ask her what she's gonna do if she ends up rich and famous beyond her wildest dreams, and she's got no time for slobbering over the dumb luxuries that regular folk might crave. She just grins again, eyes like evil diamonds: 'Probably get a dog,' she says, 'and I'd name him Smoke...'

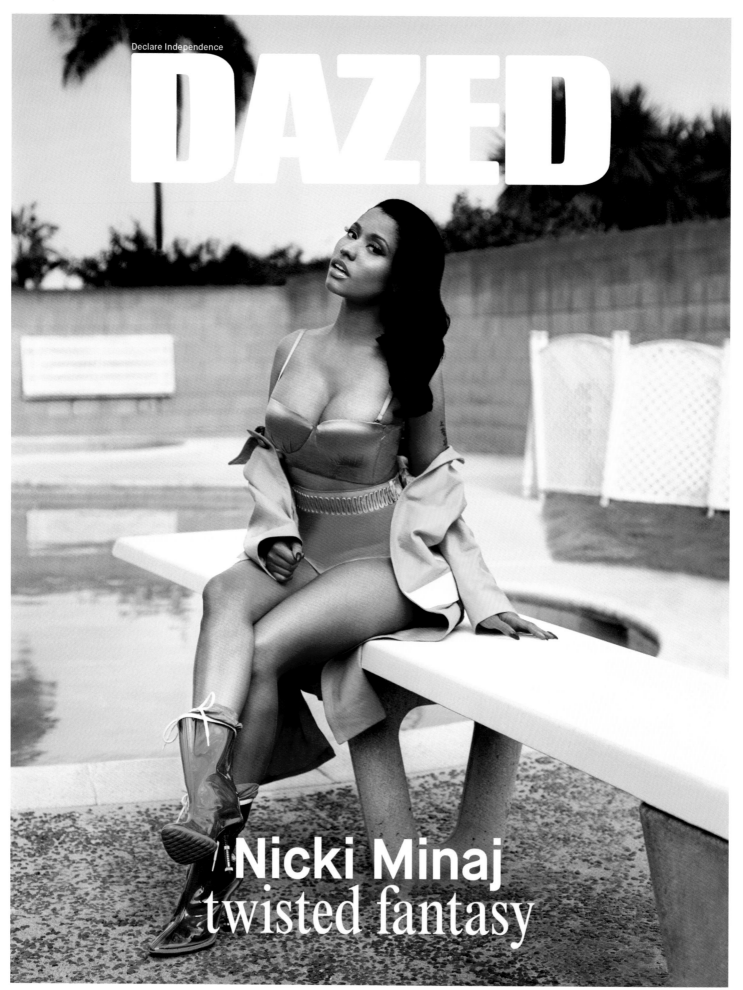

Declare Independence

DAZED

ISSUE 35, VOL. IV, A/W 2014 **NICKI MINAJ** PHOTOGRAPHY **JEFF BARK** STYLING **ROBBIE SPENCER**

Nicki Minaj
twisted fantasy

JULIA HACKEL, Photographic Director: I still have flashbacks of prepping Nicki Minaj's infamously hefty rider from my sofa on a Saturday in Hackney, most notably trying to track down Febreze "Hawaiian Aloha" candles and all the various brands of hot sauce in NY — Instacart was a saviour!

FASHION MADE ME HARDCORE

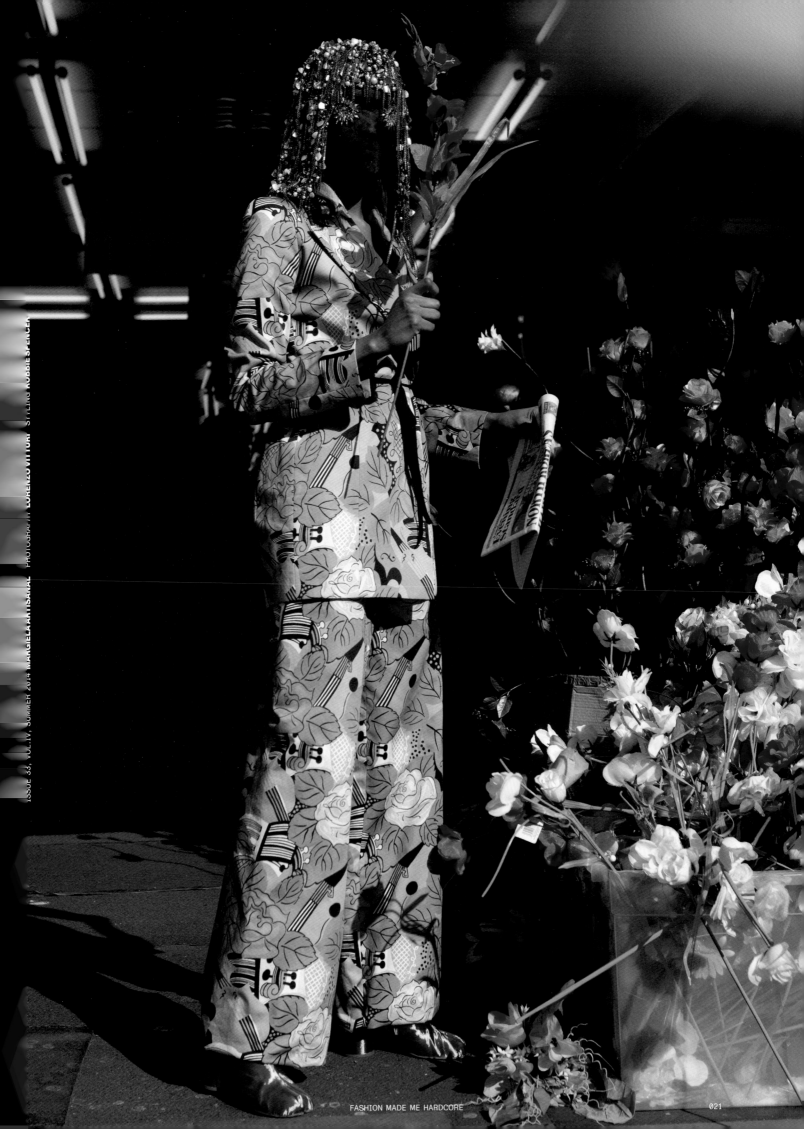

ISSUE 33, VOL.IV, SUMMER 2014 MARGIELA ARTISANAL PHOTOGRAPHY LORENZO VITTORI STYLING ROBBIE SPENCER

FASHION MADE ME HARDCORE

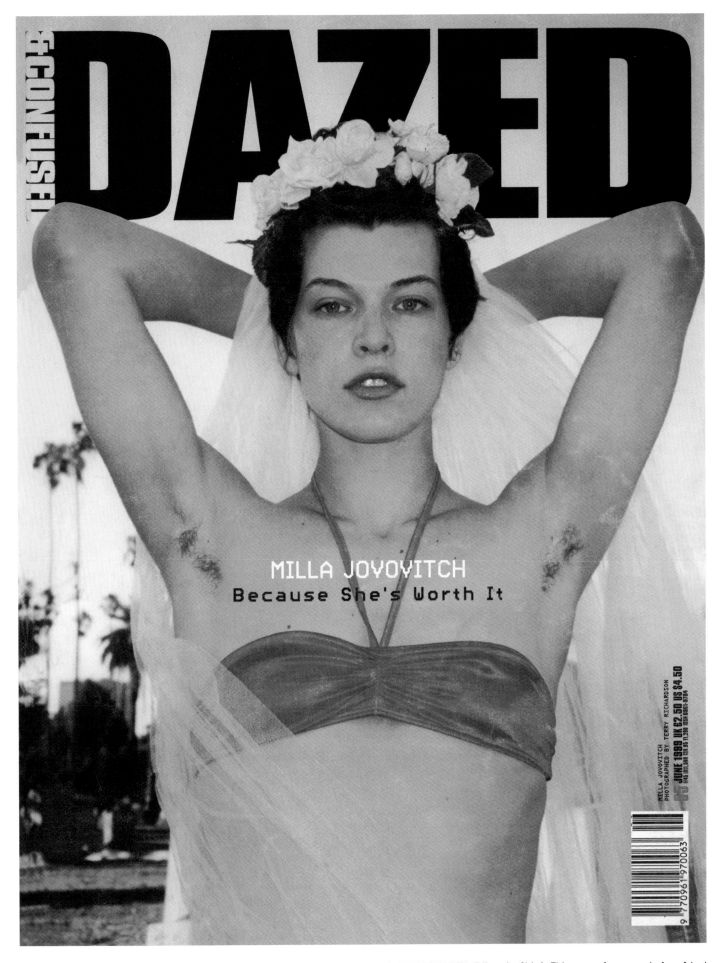

ISSUE 55, VOL. I, JUN 1999 **MILLA JOVOVICH** PHOTOGRAPHY **TERRY RICHARDSON** STYLING **NANCY STEINER**

DAZED & CONFUSED

MILLA JOVOVITCH
Because She's Worth It

EMMA WYMAN, Fashion Director: I used to go to Barnes & Noble every Sunday in Los Angeles when I was in high school, to sit and look through magazines for hours. I very clearly remember seeing the 1999 Milla Jovovich cover. I think I was 12 and I forced my mom to buy it for me. I was obsessed with *The Fifth Element*, that shoot papered my walls and remained there through high school. I often reference that shoot now. Brianna Capozzi and I shot Helena Howard as a bride, as an homage to the Milla cover.

RODERICK STANLEY, Editor-in-Chief: This was a few years before I had any involvement with the mag, but it sticks out in my memory with its style and attitude, and is just so of its time. Plus her name is spelled incorrectly, which makes it pretty much the perfect *Dazed* cover!

Alexander McQueen
by Charlie Fox

'I don't think like the average person on the street,' Lee Alexander McQueen, aged 27, is telling David Bowie over the phone in a conversation published by *Dazed & Confused* in 1996. Bowie has plenty of proof: shocked tabloid accounts of the young designer's *Highland Rape* collection; his noted fascination with the mysterious zone between the spine and arse where a satanic tail could swish. But the self-proclaimed 'ooligan' prodigy from Stratford will provide tons more before his heartbreaking death. There will be waifs covered in flowers at *Sarabande*, and lunatic asylum ghosts stalking around a padded cell for *Voss*. There will be sea monsters, robots, rave aliens, angels and devils. It will be beautiful.

'I think quite perversely', he tells Bowie, 'in my own mind...'

Yes, you dark wizard, I know.

I mean, I also know the delicious cautionary fairy tale of it all — McQueen's brain-melting success, galaxies of cocaine, flame-eyed vampires, silk flowing in slo-mo like spilt blood — and I could bust out the commemorative Moët and say melancholy RIP stuff, but his work feels too rich and wild and alive. Not that it isn't haunted a lot of the time — the clowns in his shoot for *Dazed*'s June 2001 issue are as gloomed-out as Joaquin Phoenix's Joker, morbidly depressed jesters in black metal corpse paint. But it doesn't seem like the creation of a tragic and intensely tormented ghost. Intoxicatingly strange sensuality and monsters galore: it's magical.

Being a kid with a weird body and a horror obsession who previously liked to wander around my house in Dracula drag, I found McQueen's world was simultaneously bewitching and trippily familiar. Halloween anarchy! Hot mutant bodies run amok! Freaky phantasmagorical worlds weaved out of a romantic interpretation of horror and realised on the lavish scale of Disneyland attractions, like Tim Burton gone demonic. The deformed was gorgeous and the gorgeous was deformed. Hell, yes. His enchanted garms were Halloween costumes on drugs. They transmogrify you from a vulnerable person to a scary and powerful creature. They reveal the rage and fear and perversity going on inside. I was extremely into it.

My McQueen crush kicked in during my teens, when my body was seriously giving me the creeps. The reigning babes were Marissa from *The OC* and Paris Hilton, sun-kissed princesses for the boom years protected by multi-million-dollar force fields. Meanwhile, I was discovering a more extreme breed of beauty, frequently caught snogging the trashy and grotesque, and my heart was getting high. There was Chloë as a bleached-blonde minx in *Gummo*, and Matthew Barney as a devilish and dashing satyr in *The Cremaster Cycle*, and the Aphex babes in the video for 'Windowlicker'. All of them slunk (not so coincidentally) through the pages of *Dazed*, which I knew was a glamorous rabbit hole to all kinds of darkly fantastical and sexy stuff. And McQueen was the king.

He created a bunch of luxuriously strange and amazing bangers for the magazine. Take his fetish funhouse extravaganza shot by photographer Norbert Schoerner for the September 2001 issue. Dogs, spurting fluids, rotten fruit; a cute shot of a nude model's derriere facing off against a donkey's sleek rump, like they're rival players in a *Mortal Kombat* game, ready to be spanked. But greatest of all is his legendary 'Fashion-Able?' cover story from September 1998 (shot by Nick Knight), which celebrates models with extreme physical idiosyncrasies such as Paralympian and double amputee Aimee Mullins, looking killer in McQueen couture.

Beyond fashion's wonderland of strung-out androgynes with cheekbones so sharp they should be illegal, there's a whole other world of bodies that stays hidden because they don't conform to the boring tyranny of the beautiful established long ago. 'Fashion-Able?' is a ravishing fuck-you to everything that suckered everyone into believing normality was the same thing as perfection. What Grinch-hearted and flesh-phobic creep decided that only one brand of body could be adored?

For McQueen, the stars of 'Fashion-Able?' are the same as heroes in classical mythology, whose godly powers are only intensified by their physical singularity. (Remember the snakes in Medusa's hair?) Part woman, part tree on prosthetic legs carved from elm, Mullins is the closest anybody has come to a nymph since Hercules, a sublime creature escaped into the regular world. I remember wandering around his *Savage Beauty* show at the V&A and kind of weeping, even as the devils inside me swooned. It was bewildering to think that whoever was responsible for so many luscious worlds could do something as boring as die.

Yeah, he's gone now but his legacy will never rot. All the *Dazed* shoots are at its heart since they were how McQueen reached a big audience in the pre-Instagram world of yore. He's a corruptor of youth in the best way, by that I mean, like, a supernatural entity which tells you *something else* exists outside what your parents and school would like you to know. That means everything when you're a confused and lonely kid whose future is a black hole. You can set the game on fire, puke in the faces of all the bullies, have wicked fun. Stay loyal to the weird chimeras that live in your head. Whatever horrors or joys are eating you up, they can be transformed (all of them!) into a feast.

DAZED

SEPTEMBER 2001 UK£2.99 US $8.25
FF42 LR14,500 C$8.50 ¥1,600 ISSN 0961-9704
YANNIS AND ABDULAI KAMARA
PHOTOGRAPHED BY SCHOERNER

ALEXANDER MCQUEEN
& SCHOERNER
BLOW YOUR MIND

09>

ISSUE 81, VOL. I, SEP 2001 **ALEXANDER MCQUEEN & SCHOERNER** PHOTOGRAPHY **NORBERT SCHOERNER**

FASHION MADE ME HARDCORE

025

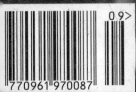

770961 970087

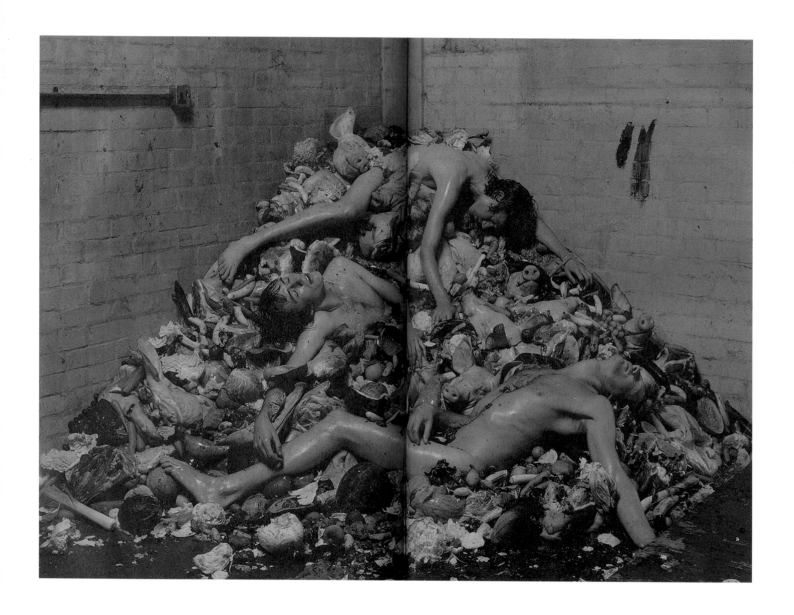

NORBERT SCHOERNER, Photographer: The story was never a literal interpretation of (Pier Paolo Pasolini's notorious last film) Salò, though it explored some of the plot's touchstones, such as sex and death. We shot it in this enormous derelict factory in east London. There were no storyboards, just a loose concept — Lee would always encourage that freedom to create and was happy to go where the process took him. I feel this is the most powerful image from the story. We approached it as a still-life because of the naturalistic quality of all the food. It has a biblical dimension and a sort of medieval texture. The placid expressions on the models' faces became especially memorable — I think we both knew we were skirting the edges of taste. As we started draping the three of them on this huge mound of pigs' heads and rotting food to look as though they were dead, suddenly the atmosphere became very intense. It was a warm day so the smell was really pungent, too. I remember Lee running around smashing watermelons on set to add to the pile. He was always so hands-on with each composition.

ISSUE 81, VOL. I, SEP 2001 **SALÒ** PHOTOGRAPHY **NORBERT SCHOERNER** STYLING **KATY ENGLAND**

FASHION MADE ME HARDCORE

VAL GARLAND, Make-up Artist: This collection was an exploration of the sinister side of childhood, and Lee took his inspiration from the 80s US slasher film *Child's Play*. We created this extreme beauty look that turned runway models into macabre clowns. Nobody but Lee would have dared to do this. I felt like we were part of history in the making. We needed girls with simple features and strong bone structure that could be used as a blank canvas. Acrylic make-up wasn't available back then, so I used thick theatre paints and blanked out the face, then drew black graphic patterns around the eyes, nose and mouth. I remember Lee examining the models and saying, 'Let's push it further!' He never wanted to play it safe. There was an enormous amount of energy backstage at the show that day, as there always was when Lee was around. We all wanted to go that extra mile for him. The stark, shadowy lighting made the hair and make-up seem so much more intense. I think that's caught on camera here — these images really capture the darkness of McQueen.

ISSUE 78, VOL. I, JUN 2001 **CLOWNS** PHOTOGRAPHY **MARTINA HOOGLAND IVANOW** STYLING **KATY ENGLAND**

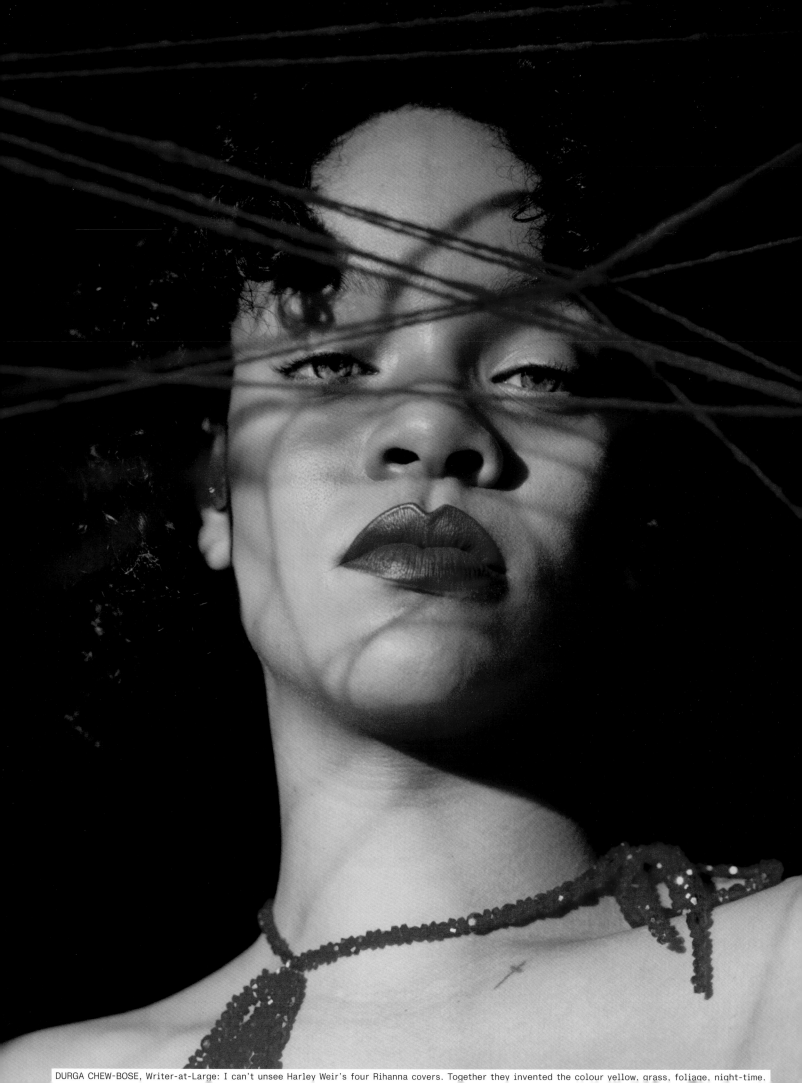

DURGA CHEW-BOSE, Writer-at-Large: I can't unsee Harley Weir's four Rihanna covers. Together they invented the colour yellow, grass, foliage, night-time.

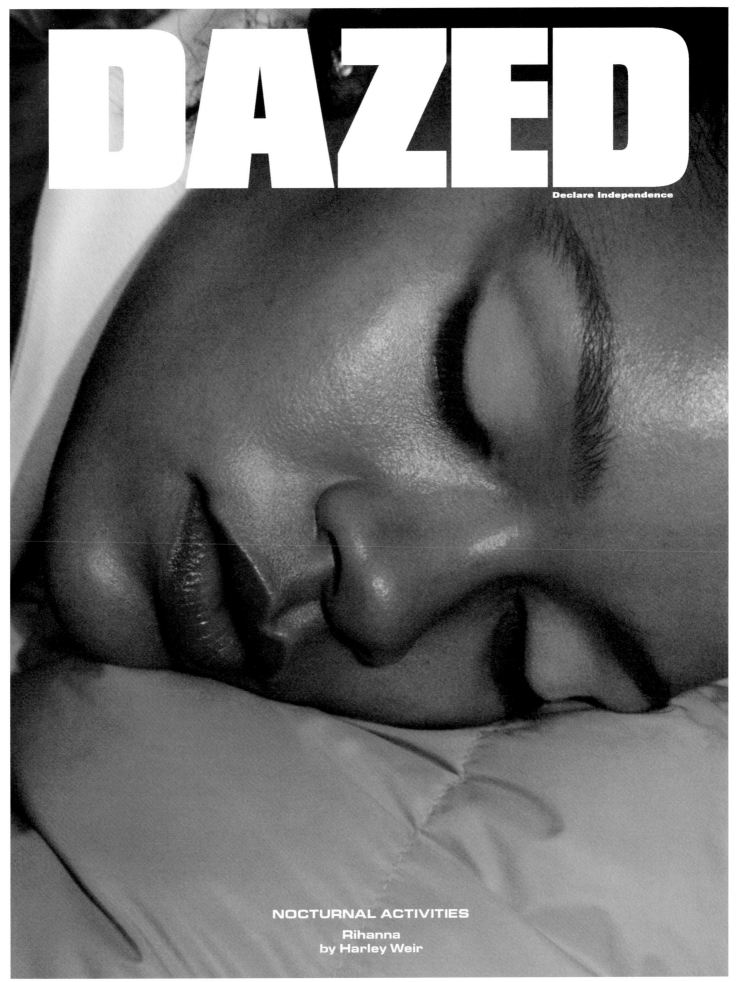

DAZED

Declare Independence

ISSUE 54, VOL. IV, WINTER 2017 **RIHANNA** PHOTOGRAPHY **HARLEY WEIR** STYLING **ROBBIE SPENCER**

NOCTURNAL ACTIVITIES
Rihanna
by Harley Weir

ROBBIE SPENCER, Fashion and Creative Director: My craziest memory of *Dazed* is getting caught in a studio-cum-makeshift hot box and shooting until 4am with Rihanna and Harley Weir. During my tenure as creative director, it was always a combination of excitement and being on the verge of a panic attack pulling together numerous big celebrity cover stories and being on set. Putting myself in these insane situations with big celebrities and big personalities so frequently.

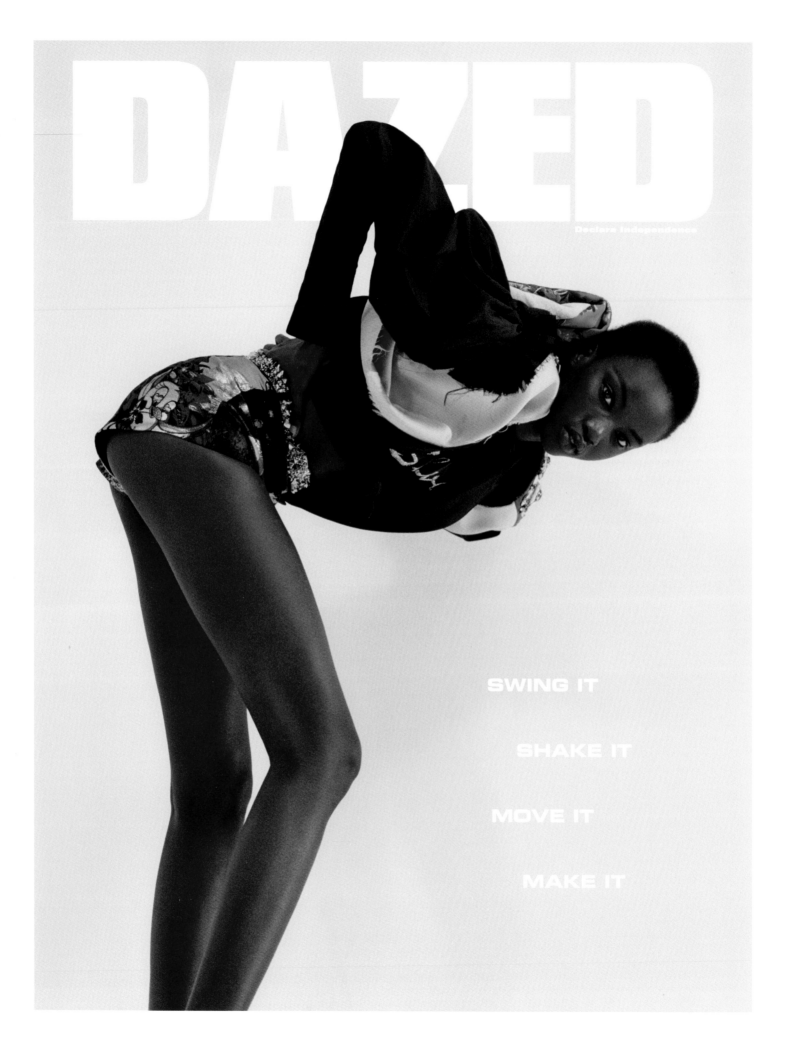

DAZED

Declare Independence

SWING IT

SHAKE IT

MOVE IT

MAKE IT

ISSUE 56, VOL. IV, S/S 2018 **ANOK YAI** PHOTOGRAPHY **BRIANNA CAPOZZI** STYLING **EMMA WYMAN**

FASHION MADE ME HARDCORE

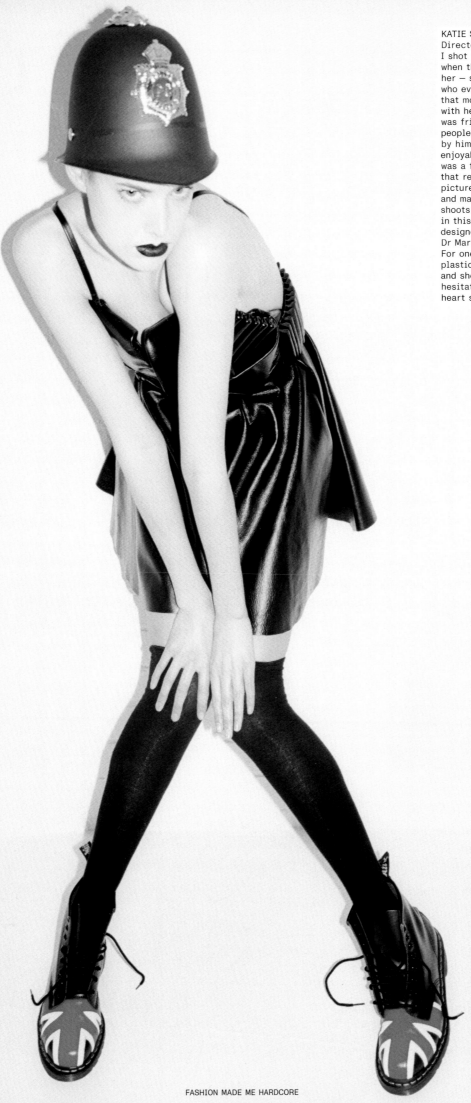

ISSUE 50, VOL. II, JUN 2007 **AGYNESS DEYN** PHOTOGRAPHY **MATT IRWIN** STYLING **KATIE SHILLINGFORD**

KATIE SHILLINGFORD, Fashion Director, *AnOther*: Matt Irwin and I shot this Agyness Deyn story when there was a huge buzz about her — she was the fun, fab model who everyone wanted to shoot at that moment. Matt was friends with her of course, because he was friends with all the fabulous people. They wanted to be shot by him because it was such an enjoyable experience — there was a freedom and joyful energy that really shone through in his pictures. He was such a special and magnetic person — those shoots were the best. The fashion in this story was also all London designers, hence the Union Jack, Dr Martens and police helmet. For one look I had brought these plastic Halloween fingernails and she put them on without any hesitation and started making heart shapes!

FASHION MADE ME HARDCORE

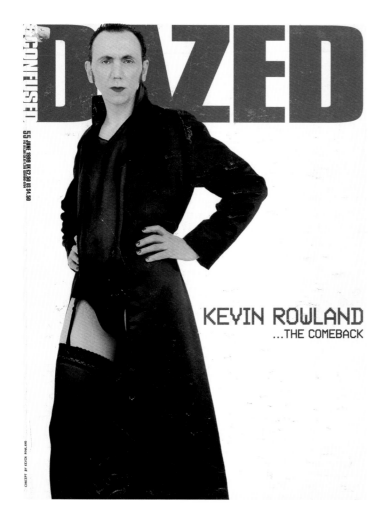

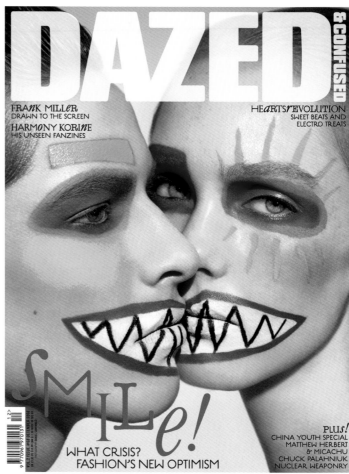

KEVIN ROWLAND
...THE COMEBACK

ISSUE 55, VOL. I, JUN 1999 **KEVIN ROWLAND**
PHOTOGRAPHY **RANKIN**

ISSUE 68, VOL. II, DEC 2008 **SMILE!**
PHOTOGRAPHY **DANIEL SANNWALD**
STYLING **KATIE SHILLINGFORD**

032 FASHION MADE ME HARDCORE

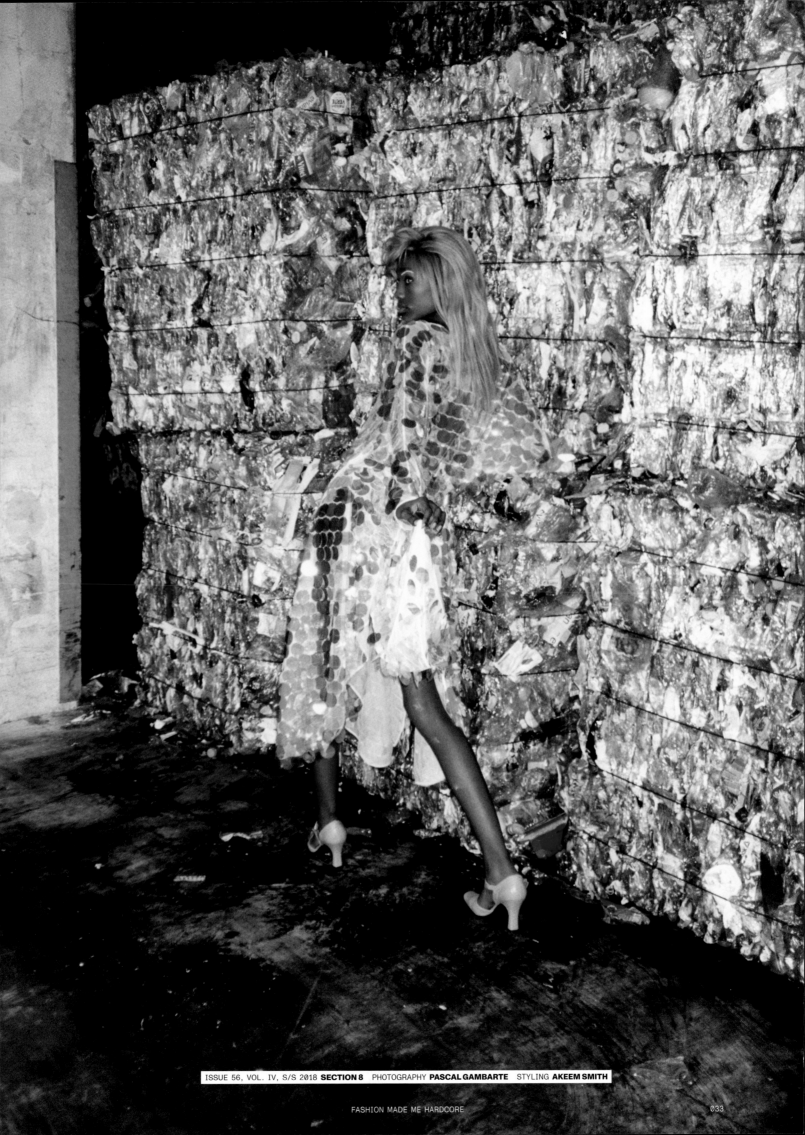

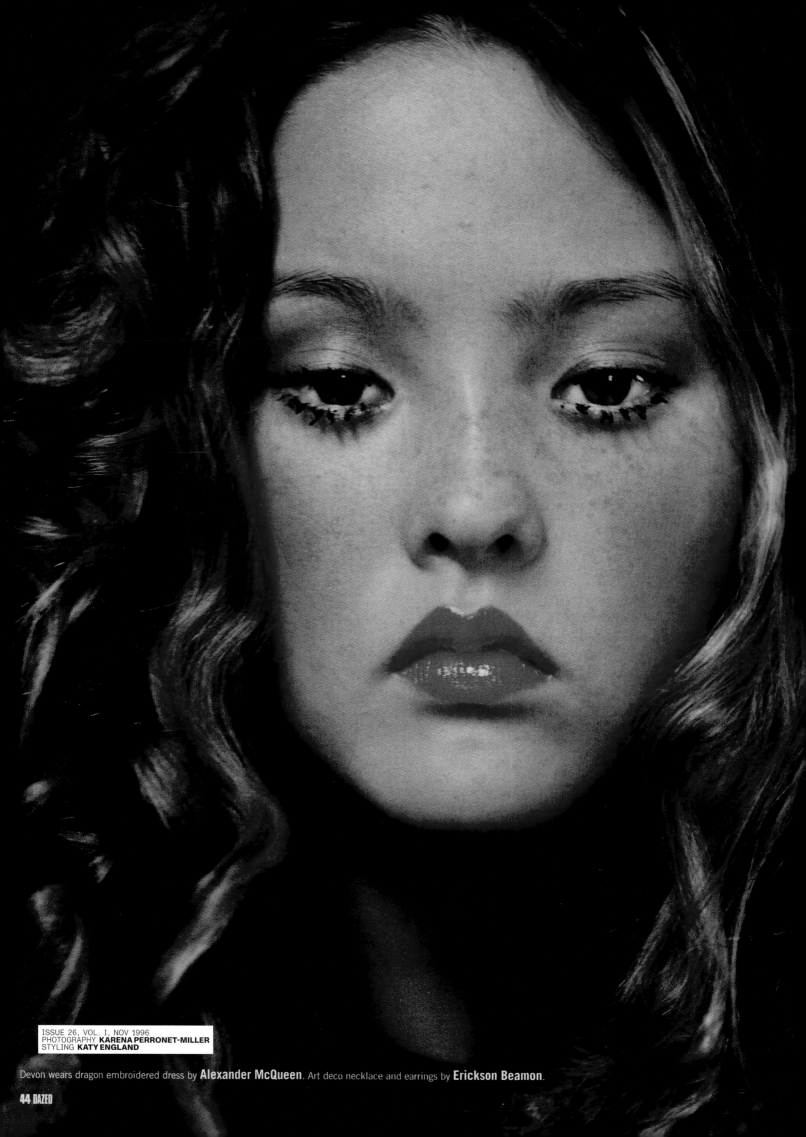

ISSUE 26, VOL. I, NOV 1996
PHOTOGRAPHY **KARENA PERRONET-MILLER**
STYLING **KATY ENGLAND**

Devon wears dragon embroidered dress by **Alexander McQueen**. Art deco necklace and earrings by **Erickson Beamon**.

FASHION: TURN TO THE LEFT.
FASHION: TURN TO THE RIGHT.

BRITISH DESIGNER OF THE YEAR **ALEXANDER MCQUEEN** IN CONVERSATION WITH **DAVID BOWIE**.

This conversation took place on the phone, as is always the case with my conversations with Alex. We have worked together for over a year on various projects and never once met. It's a beautiful Sunday afternoon and he is in the verdant green hills of Gloucestershire visiting at the house of his friend, Isabella Blow. Ring ring. Ring ring. Ring ring.

David Bowie: **Are you gay and do you take drugs?** (*laughter*)
Alexander McQueen: Yes, to both of them. (*more laughter*)
DB: **So what are your drugs of choice?**
AM: A man called Charlie!
DB: **Do you find that it affects the way you approach your designing?**
AM: Yeah, it makes it more erratic. That's why you get my head blown up shot. (*In reference to a Nick Knight photograph at the Florence Biennale.*)
DB: **Well I once asked you to make me a specific jacket in a certain colour and you sent me something entirely different in a tapestry fabric, quite beautiful I might add, but how would you cope in the more corporate world?**
AM: I wouldn't be in a corporate world.
DB: **Even if you're going to be working for a rather large fashion house like Givenchy?**
AM: Yeah.
DB: **So how are you going to work in these circumstances? Do you feel as though you're going to have rules and parameters placed on you, or what?**
AM: Well, yeah, but you know I can only do it the way I do it. That's why they chose me and if they can't accept that, they'll have to get someone else. They're going to have no choice at the end of the day because I work to my own laws and requirements, not anyone else's. I sound a bit like yourself!
DB: **Unlike most designers, your sense of wear seems to derive from forms other than fashion history. You take or steal quite arbitrarily from, say the neo Catholic macabre photographs of Joel Peter Witkin, to rave culture. Do you think fashion is art?**
AM: No I don't. But, I like to break down barriers. It's not a specific way of thinking, it's just what's in my mind at the time. It could be anything - it could be a man walking down the street or a nuclear bomb going off - it could be anything that triggers some sort of emotion in my mind. I mean, I see everything in a world of art in one way or another. How people do things. The way people kiss.
DB: **Who or what are your present influences?**
AM: Let me think. I don't know. I think that's a really hard question because in one way, one side of me is kind of really sombre and the other side of my brain is very erratic and it's always this fight against the other and I choose so many different things. This is why my shows always throw people completely: one minute I see a lovely chiffon dress and the next minute I see a girl in this cage that makes her walk like a puppet and, you know, they can't understand where it's coming from because there are so many sides of me in conflict. But influences are really from my own imagination and not many come from direct sources. They usually come from a lone force of say, the way I want to perform sex or the way I want people to perform sex or the way I want to see people act, or what would happen if a person was like that. You know what I mean? It's not from direct sources. It's just sort of from a big subconscious or the perverse. I don't think like the average person on the street. I think quite perversely sometimes in my own mind.
DB: **Yeah, I would say, from just looking at the way you work, that sexuality plays a very important part in the way that you design.**
AM: Well, because I think it's the worst mental attitude. Sexuality in a person

confines you to such a small space and, anyway, it's such a scary process trying to define one's sexuality. Finding which way you sway or what shocks you in other people and who accepts you at the end of the day when you're looking for love. You have to go through these corridors and it can be kind of mind-blowing sometimes.

DB: **There's something a lot more pagan about your work compared, say, to Gaultier. Your things work at a more organic level.**

AM: Possibly. I gather some influence from the Marquis de Sade because I actually think of him as a great philosopher and a man of his time, where people found him just a pervert. (*laughs*) I find him sort of influential in the way he provokes people's thoughts. It kind of scares me. That's the way I think but, at the end of the day, that's the way my entity has grown and, all in all, in my life, it's the way I am.

DB: **Do you think of clothes themselves as being a way of torturing society?**

AM: I don't put such an importance on clothes, anyway. I mean at the end of the day they are, after all, just clothes and I can't cure the world of illness with clothes. I just try to make the person that's wearing them feel more confident in themselves because I am so unconfident. I'm really insecure in a lot of ways and I suppose my confidence comes out in the clothes I design anyway. I'm very insecure as a person.

DB: **Aren't we all? Could you design a car?**

AM: Could I? It would be as flat as an envelope if I designed a car.

DB: **Could you design a house?**

AM: Yes, very easily, very easily.

DB: **Do you paint or sculpt?**

AM: No. I buy sculptures. I don't do it, I buy it. I buy lots of sculptures.

DB: **Do you ever work in the visual arts?**

AM: No, but I just did a show the other day. I don't know if you heard, but we did this show, it was on water and we did this kind of cocoon for this girl made of steel rods and it was in the form of a three dimensional star and it was covered in this glass fabric so you could see through it and this girl was inside it, but we had all these butterflies flying around her inside it. So she was picking them out of the air and they were landing on her hand. It was just about the girl's own environment. So I was thinking about the new millennium in the future thinking you would carry around with you your home like a snail would. She was walking along in the water with a massive star covered in glass and the butterflies and death-faced moths were flying around her and landing on her hand and she was looking at them. It was really beautiful. It threw a lot of people completely sideways.

DB: **It's interesting how what you're talking about, is somewhere between theatre and installation.**

AM: Well, I hate the theatre, I hate it. I used to work in the theatre. I used to make costumes for them and films, and it's one thing I've always detested - the theatre. I hate going to the theatre, it bores me shitless.

DB: **Well, I'm not talking about a play.**

AM: I know, but I just wanted to tell you that anyway! (*laughs*)

DB: **All right, change the word to ritual.**

AM: Yeah, that's better. I like ritual... (laughs)

DB: **Armani says, 'Fashion is dead'.**

AM: Oh, so is he... I mean, God...

DB: **Now you sound like Versace...**

AM: He's close to dead. I mean, no one wants to wear a floppy suit in a nice wool - the man was a bloody window dresser. What does he know?

DB: **Do you think that what he's really saying is that maybe...**

AM: He's lost it...

DB: **He might still be making an observation in as much as the boundaries are coming down....**

AM: Yeah.

DB: **The way fashion is presented these days is a quantum leap from how it was presented say, five to ten years ago. It's become almost a new form, hasn't it?**

AM: Yeah, but you know you can't depend on fashion designers to predict the future of society, you know, at the end of the day they're only clothes and that never strays from my mind for one minute.

DB: **Is the British renaissance a reality or a hype do you think? The world is being told that it's so. Through all strata of British life and from fashion to visual arts, music, obviously, architecture, I mean there's not one aspect of culture where Brits haven't got some pretty fair leaders, English designers in**

French houses, you know what I mean? It's like we're pervading the whole zeitgeist at the moment.

AM: Being British yourself, I think you understand that Britain always led the way in every field possible in the world from art to pop music. Even from the days of Henry VIII. It's a nation where people come and gloat at what we have as a valuable heritage, be it some good, some bad, but there's no place like it on earth.

DB: **But why is it we can't follow through once we've initially created something? We're far better innovators than we are manufacturers.**

AM: Yeah, exactly. But I think that's a good thing. I don't think that's a bad thing. It makes you holy, it makes you quite respectable about what you do and the actual moneymaking part of it is for the greedy.

DB: **So you're not greedy, Alex?**

AM: I'm afraid I'm not. Money's never been a big object. Well, I mean I like to live comfortably, but I've been asked by this French fashion house how would I put on a show and I said, well, the sort of money these people buy these clothes for in this day and age, you don't want to flaunt your wealth in front of the average Joe Public because it's bad taste and with all the troubles in the world today, it's not a good thing to do anyway. I'm sure these people that have this sort of money don't feel like showing their face on camera, so I said it would be more of a personal show and people with this sort of money who do appreciate good art and good quality clothes and have these one-off pieces made just respect the ideal, not the actual chucking money around. They can do that anywhere.

DB: **So when you are affluent, which I'm afraid is probably on the cards for you, how are you going to deal with that?**

AM: I'd like to buy Le Corbusier's house in France... (*sniggers*)

DB: **Here's a nice thing. What was the first thing you designed ever? Like when you were little or a kid or something?**

AM: Oh. I can't think that far back, but for my own professional career, it was the bumsters. The ones that Gail, your bass player, wears.

DB: **Was there a point when you were sort of playing around with stuff, and when you used to dress up and go to clubs when you were a kid, and all that, where you would do original things?**

AM: Actually, yeah. I would wear my sister's clothes and people wouldn't recognise it because I'd wear them in a male way. I did go round my street once in my sister's bra when I was about 12 years old and the neighbours thought I was a freaky kid, got dirty looks and all that... and you're talking about Stepney here.

DB: **My father used to work in Stepney.**

AM: Yeah?

DB: **What age were you when you left home?**

AM: 19.

DB: **Did it give you an incredible feeling of freedom? Or did you suddenly feel even more vulnerable?**

AM: I felt really vulnerable actually. Because I was the youngest and I was always mollycoddled by my mother, so that's why I turned out to be a fag, probably. (*laughter*)

DB: (*laughing*) **Was it a clear choice?**

AM: I fancied boys when I went to Pontins at three years old!

DB: **Did you ever go on holiday to Butlins or Bognor Regis or Great Yarmouth?**

AM: No, I went to Pontins in Cambersands.

DB: **Cambersands?! I used to go there too!**

AM: Oh my God!

DB: **They had a trailer park with caravans...**

AM: Exactly.

DB: **...and next door to us we had a, at the time, very well known comedian, Arthur Hanes, who was sort of like a bit of a wide boy; that was his bit on stage, you know, and I used to go over and try and get his autograph. I went three mornings running and he told me to fuck off every day. (*laughing*) That was my first time I met a celebrity and I was so let down. I felt if that's what it's all about... they're just real people.**

AM: Two memories on Pontins - one, was coming round the corner and seeing my two sisters getting off with two men. (*laughter*) I thought they were getting raped and I went screaming back to my Mum and I wound up getting beat up by my two sisters! The other one was turning up in Pontins when we first got there and looking out the cab window 'cos my family was, like, full of cabbies; it was like a gypsy caravan-load to go to these places, and I looked out the

window when I got there and there were these two men with these scary masked faces on and I shit myself there and then in the cab! I literally just shit my pants! (*laughter*)

DB: **Which comes to... who is the shittiest designer?**

AM: Oh my God...

DB: **Who is the worst designer?**

AM: In my eyes?

DB: **Yeah, in your eyes.**

AM: Oh God, I'm open for libel here now, David...

DB: **Do you think there's more than one?**

AM: I think you've got to blame the public that buy the clothes of these people, not the designers themselves because it turns out they haven't got much idea about, you know, design itself. It's the people that buy the stuff. My favourite designer, though, is Rei Kawakubo. She's the only one I buy, the only clothes I buy ever for myself as a designer are Comme des Garçons. I spent about a thousand pounds last year (I shouldn't say that) on Comme des Garçons menswear...

DB: **I've never paid, Alex!** (*laughs*) **Until...**

AM: Until you met me! (*more laughter*)

DB: **Until I met you! Yes, but I knew that you needed it!**

AM: I did at the time! But I tell you what I did do when you paid me, I paid the people that actually made the coat!

DB: **No, listen, you were so kind about the couple of things that I didn't need that you actually gave me. I thought that was very sweet of you. You work very well in a collaborative way as well. I thought the stuff...**

AM: I still haven't bloody met you yet! (*laughs*)

DB: **I know, I think it's quite extraordinary that we've done so well with the stage things that we put together. Do you enjoy collaboration?**

AM: I do, but the one thing you have to do when you collaborate is actually respect the people that you work with: and people have phoned me up and asked me to collaborate with them before and I've usually turned them down.

DB: **Do your clients really know what they want and what is right for them, or do you usually have to dress them from the floor up?**

AM: It can work either way and I don't resent either because, at the end of the day, I'm the clothes designer and they are the public. If you want a house built you're not expected to build it yourself.

DB: **Here's a fan question. Who would you like to dress more than anyone else in the world and why?**

AM: There's no-one I'd like to dress more than anyone else in the world, I'm afraid. I can't think of anyone who deserves such a privilege! (*laughs*)

DB: **The sub-headline there!** (*laughs*)

AM: Oh my God no, 'cos I'm an atheist and an anti-royalist, so why would I put anyone on a pedestal?

DB: **Well it does draw one's attention back to your clothes and what you do is actually more important than anything else.**

AM: Well, I think it would limit your lifestyle somewhat if you said your music is just for that person down the road.

DB: **You just sort of hope there's someone out there that might like what you do.**

AM: And there's always someone, I mean the world is such a big place.

DB: **Yeah. Prodigy or Oasis?**

AM: Prodigy. I think they're brilliant.

DB: **Well, you haven't answered this one. I have to drag you out on this one. Armani or Versace?** (*laughs*)

AM: Marks and Spencer. I'm sorry. I don't see the relevance of the two of them put together. Actually, they should have amalgamated and sort of formed one company out of both. If you can imagine the rhinestones on one of them deconstructed suits...

DB: **What do you eat?**

AM: What do I eat?

DB: **Yeah.**

AM: Well, I've just had a guinea fowl today... it was quite an occasion to come here... It's such a lovely place and I love to come here. Bryan Ferry comes here a lot. It's an amazing place and it was built in the Arts and Crafts Movement by Isabella's husband's grandfather. It's on a hill in Gloucestershire and it overlooks Wales and everything. And my bedroom is decorated with Burne-Jones' Primavera tapestry - I always come here to get away.

DB: **So this is your sanctuary is it?**

AM: Yes, it is. Very much so.

DB: **Did you ever have an affair with anyone famous?**

AM: Not famous, but from a very rich family. Very rich Parisian family.

DB: **Did you find it an easy relationship, or was it filled with conflicts?**

AM: No, it: he was the most wonderful person I have ever met and I was completely honest with him. Never hushed my background or where I came from, and this was when I was only 19 or 20, I went out with him and I said to him whatever we do, we do it Dutch and he didn't understand what I said. He thought it was a form of sexual technique! Going Dutch!! (*laughs*) I said i means paying for each of us separately. He thought it that was great, but he gave the best blow job ever! (*laughter*)

DB: **How royal! Was it old money or was it industrial wealth?**

AM: Long time industrial aristocratic wealth.

DB: **Do you go abroad very much? I mean just for yourself, not for work?**

AM: No, not really.

DB: **So you really are happy in your home grown environment?**

AM: I like London, but I love Scotland! I'd never been to Aberdeen before and went to see Murray's friends in Aberdeen for the first time and it was unrea because I stepped off the plane and I just felt like I belonged there. It's very rare that I do that because I have been to most places in the world, like mos capital cities in Japan and America, and you feel very hostile when you step of the plane in these places. I stepped off the plane in Aberdeen and I felt like I've lived there all my life. And it's a really weird sensation. I like more of the Highlands. My family originated from Skye.

DB: **Are you a good friend, a stand up guy, or a flake?**

AM: I'm afraid I have very few friends and I think that all of the friends I have I can depend on and they can depend on me. I don't have hangers-on, and I'm very aggressive to people that if I read through 'em in a second, they've usually found the wrong person to deal with. So if you have got me as a friend, you've got me for life. And I'd do anything for them, but I don't really have associates that use me or abuse me, unless I ask them to! (*laughs*)

DB: **Are you excited about taking over at Givenchy?**

AM: I am and I'm not. To me, I'm sort of saving a sinking ship and not because of John Galliano, but because of the house. It doesn't really seem to know where it's going at the moment and, at the end of the day, they've got t depend on great clothes, not the great name.

DB: **Have you already formulated a kind of direction you want to take them?**

AM: Yeah, I have.

DB: **Is it exciting?**

AM: Yeah it is, because the philosophy is mainly based on someone I reall respected in fashion. There's a certain way fashion should go for a house o that stature, not McQueen bumsters, I'm afraid.

DB: **My last question. Will you have time to be making my clothes for nex year's tour?** (*laughs*)

AM: Yeah, I will. We should get together. I mean, I want to see you this time. (*laughs*

DB: **We could put this on the record right now... are you going to make it over here for the VH-1 Fashion Awards? I can't remember.**

AM: When is it?

DB: **October 24th or something...**

AM: My fashion show is on the 22nd.

DB: **So you're probably not going to make it. 'Cos you know I am wearing the Union jacket on that. Because millions of people deserve to see it.**

AM: You've got to say, 'This is by McQueen'! (*laughs*)

DB: **Gail will be wearing all her clobber as well.**

AM: Oh, she's fab!

DB: **Oh, she wears it so well.**

AM: I'd love to do your tour clothes for you again.

DB: **Oh, well that's great. I can't wait to be properly fitted up this time!**

AM: Yeah, definitely. But I've got to see you. I don't want wrist measurements over the phone, 'cos I'm sure you lie about your waist measurements as well (*laughs*)

DB: **No, not at all...**

AM: 'cos you know some people lie about their length! (*laughs*)

DB: **I just said I'd never lie about the inside leg measurement.**

AM: What side do you dress David, left or right? (*laughs*)

DB: **Both!**

AM: Yeah, right.

DB: **No. Yes. Well, maybe.**

THINK QUITE PERVERSELY SOMETIMES IN MY OWN MIND'

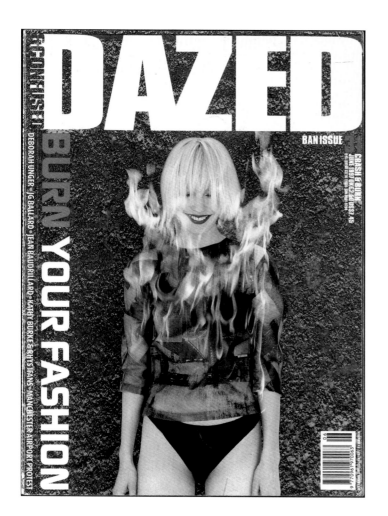

ISSUE 31, VOL. I, JUN 1997 **BURN YOUR FASHION**
PHOTOGRAPHY **RANKIN**
STYLING **MIRANDA ROBSON**

ISSUE 83, VOL. II, MAR 2010 **MIA WASIKOWSKA**
PHOTOGRAPHY **LAURENCE PASSERA**
STYLING **KATIE SHILLINGFORD**

FASHION MADE ME HARDCORE

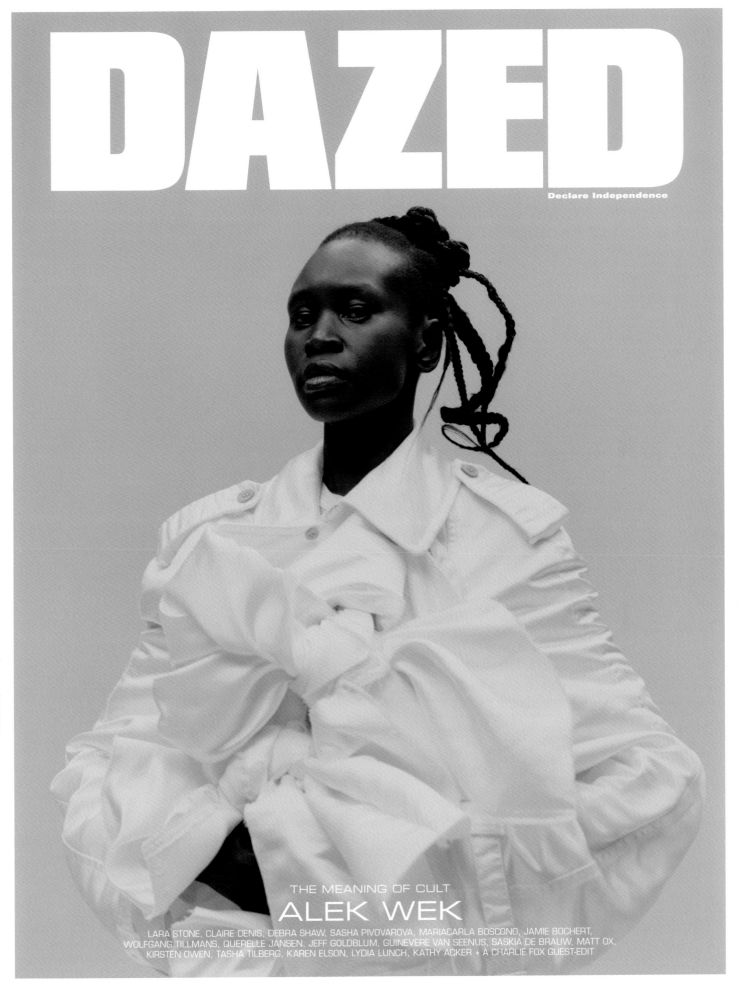

ISSUE 62, VOL. IV, S/S 2019 **ALEK WEK** PHOTOGRAPHY **TYLER MITCHELL** STYLING **ROBBIE SPENCER**

DAZED

Declare Independence

THE MEANING OF CULT
ALEK WEK

LARA STONE, CLAIRE DENIS, DEBRA SHAW, SASHA PIVOVAROVA, MARIACARLA BOSCONO, JAMIE BOCHERT,
WOLFGANG TILLMANS, QUERELLE JANSEN, JEFF GOLDBLUM, GUINEVERE VAN SEENUS, SASKIA DE BRAUW, MATT OX,
KIRSTEN OWEN, TASHA TILBERG, KAREN ELSON, LYDIA LUNCH, KATHY ACKER + A CHARLIE FOX GUEST-EDIT

TYLER MITCHELL, Photographer: Alek is amazing. Such a warm spirit and a complete icon and legend. I remember the Comme des Garçons show blowing me away. I remember the clothes were about Rei Kawakubo's relationship to her own body and the bodies of other women — how bodies grow, change and decay over time. The show was so personal and powerful in that way. I only hoped to echo and reflect that sentiment with the images. The chains and flowers felt both heavy and optimistic at the same time. Alek was having fun swinging and dangling the chains around as we were shooting. It was a blast.

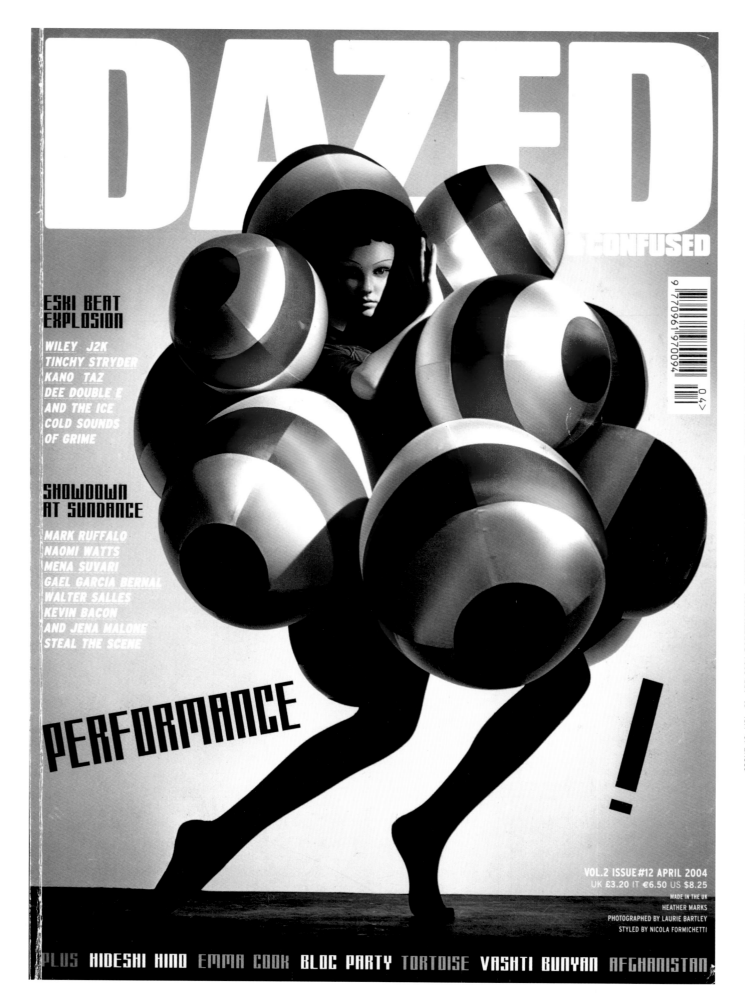

ISSUE 12, VOL. II, APR 2004 **GARETH PUGH** PHOTOGRAPHY **LAURIE BARTLEY** STYLING **NICOLA FORMICHETTI**

DAZED

CONFUSED

ESKI BEAT EXPLOSION

WILEY J2K
TINCHY STRYDER
KANO TAZ
DEE DOUBLE E
AND THE ICE
COLD SOUNDS
OF GRIME

SHOWDOWN AT SUNDANCE

MARK RUFFALO
NAOMI WATTS
MENA SUVARI
GAEL GARCIA BERNAL
WALTER SALLES
KEVIN BACON
AND JENA MALONE
STEAL THE SCENE

PERFORMANCE

!

VOL.2 ISSUE#12 APRIL 2004
UK £3.20 IT €6.50 US $8.25

MADE IN THE UK
HEATHER MARKS
PHOTOGRAPHED BY LAURIE BARTLEY
STYLED BY NICOLA FORMICHETTI

PLUS HIDESHI HINO EMMA COOK BLOC PARTY TORTOISE VASHTI BUNYAN AFGHANISTAN

KATIE SHILLINGFORD, Fashion Director, *AnOther*: I actually wore this balloon look to a *Dazed* Christmas party in a tiny pub! The theme being *Dazed* covers. I think I had to deflate after about an hour because I kept knocking people out… Looking back, this cover feels so special because it was the turn of events that led me to working at *Dazed*. It was shot before I worked with Nicola, but when I lived with Gareth it was a really exciting time for us because we had just graduated. We were kind of figuring everything out while simultaneously doing our best to have a pretty wild time! If Nicola hadn't met Gareth on that shoot then I don't think I would have come to work at *Dazed*, so it was meant to be…

FASHION MADE ME HARDCORE

The Making of the Balloon Cover
by Gareth Pugh

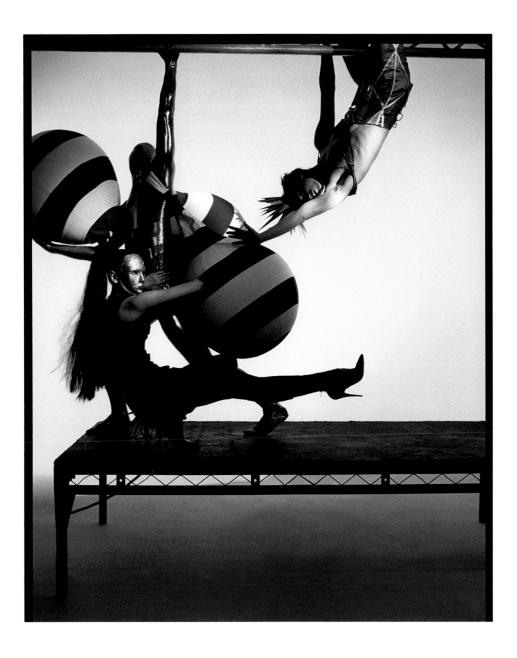

The shoot was at a photography studio just off Old Kent Road in Peckham, and at the time I lived in Camberwell (with Katie Shillingford), so off I went on the day with all my bits and bobs. I spent the whole day on set blowing up balloons with this incredible gymnast guy. Nicola (Formichetti) had called in all this amazing stuff — (like) the incredible (AW03) Dior Couture that Erin O'Connor wore when she was dressed as kind of the strange Nefertiti character. So it was kind of amazing to be there surrounded by all this stuff.

At the end of the shoot Nicola told me, 'Oh, it's either going to be between a Galliano look, with a model kind of behind a big balloon, or it's going to be your red and white striped balloons that are going to be on the cover.' Obviously he had to have these things signed off, and I wasn't an advertiser. So it wasn't until it actually came out and I went to the *Dazed* offices on Old Street to pick up a copy that I found out I was on the cover, which was a pretty surreal experience and quite a big moment, I guess. Looking back, I probably didn't really appreciate how important it was, but it was actually the thing that meant I was able to get in front of Michèle (Lamy) and Rick (Owens) for the first time, because I'd been emailing them for months, trying to get some sort of contact to do an internship with them. After that issue of *Dazed* came out, I actually emailed them again — quite cuntily, I should say — and was like, 'If you want to see recent examples of my work, here I am on the cover of *Dazed*.' Anyway, it worked, because soon after that I got a first-class British Airways ticket to go and meet them! AS TOLD TO **EMMA DAVIDSON**

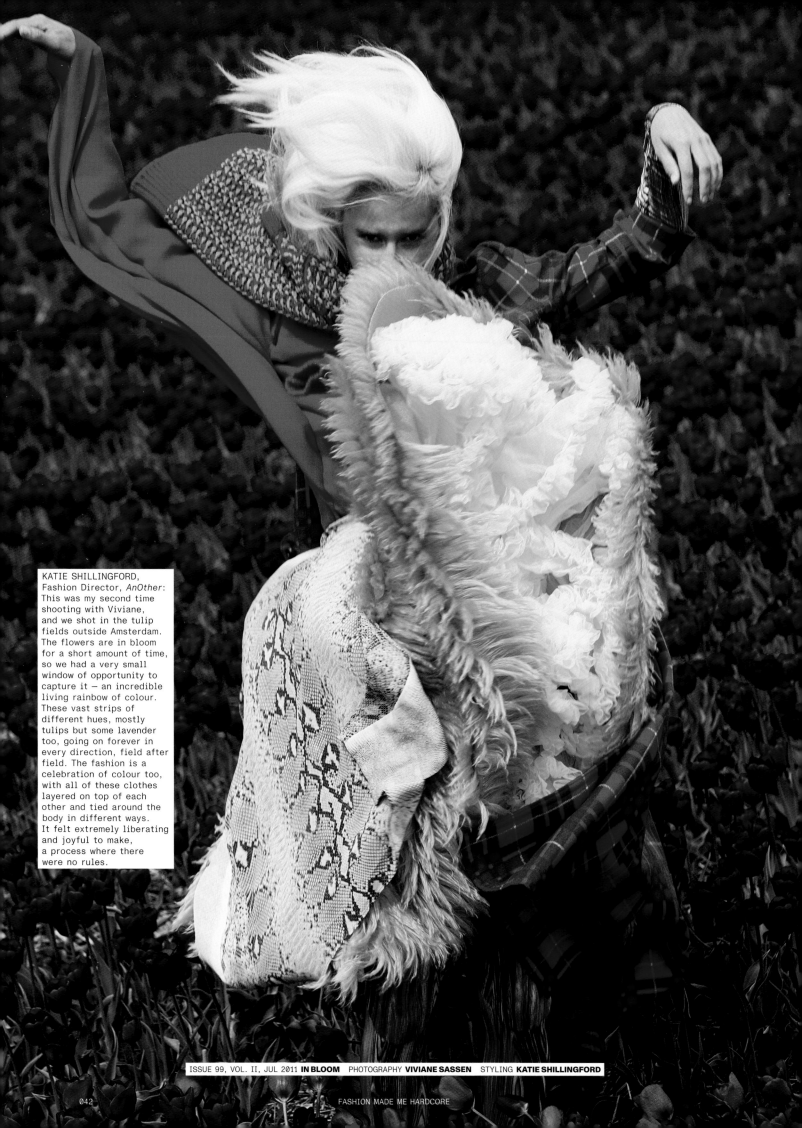

KATIE SHILLINGFORD,
Fashion Director, *AnOther*:
This was my second time
shooting with Viviane,
and we shot in the tulip
fields outside Amsterdam.
The flowers are in bloom
for a short amount of time,
so we had a very small
window of opportunity to
capture it — an incredible
living rainbow of colour.
These vast strips of
different hues, mostly
tulips but some lavender too,
going on forever in
every direction, field after
field. The fashion is a
celebration of colour too,
with all of these clothes
layered on top of each
other and tied around the
body in different ways.
It felt extremely liberating
and joyful to make,
a process where there
were no rules.

ISSUE 99, VOL. II, JUL 2011 **IN BLOOM** PHOTOGRAPHY **VIVIANE SASSEN** STYLING **KATIE SHILLINGFORD**

FASHION MADE ME HARDCORE

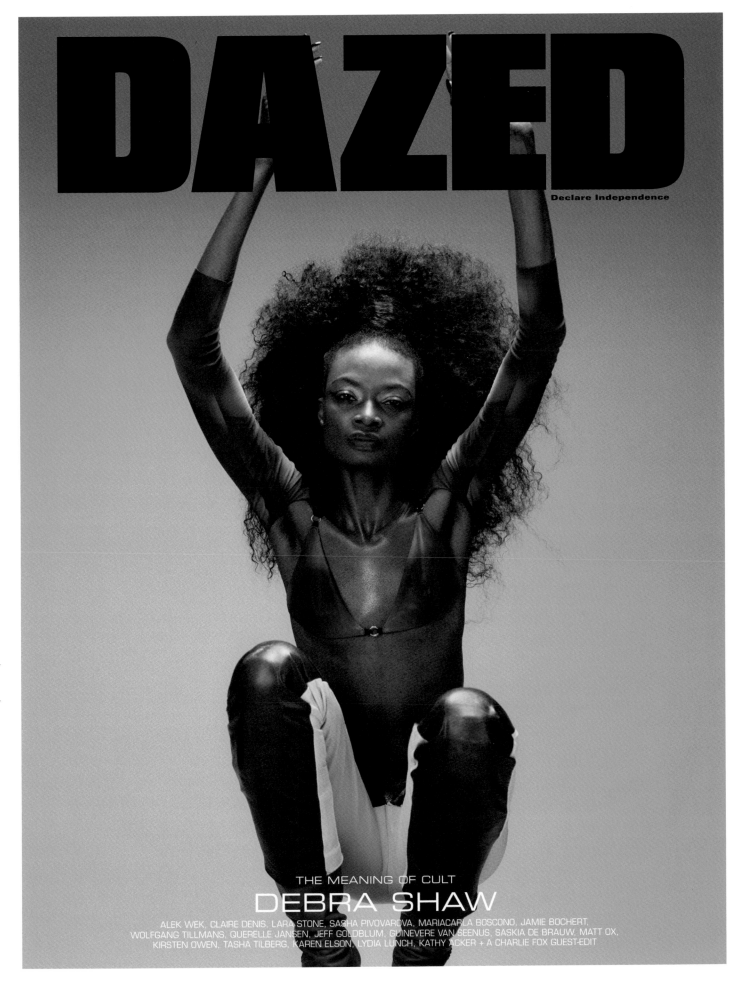

ISSUE 62, VOL. IV, S/S 2019 **DEBRA SHAW** PHOTOGRAPHY **CAMPBELL ADDY** STYLING **EMMA WYMAN**

THE MEANING OF CULT
DEBRA SHAW

ALEK WEK, CLAIRE DENIS, LARA STONE, SASHA PIVOVAROVA, MARIACARLA BOSCONO, JAMIE BOCHERT, WOLFGANG TILLMANS, QUERELLE JANSEN, JEFF GOLDBLUM, GUINEVERE VAN SEENUS, SASKIA DE BRAUW, MATT OX, KIRSTEN OWEN, TASHA TILBERG, KAREN ELSON, LYDIA LUNCH, KATHY ACKER + A CHARLIE FOX GUEST-EDIT

DOMINIC CADOGAN, Assistant Editor, *Dazed Beauty*: My interview with Debra Shaw and Mowalola Ogunlesi was a whirlwind trip to Paris and back in a single day. When I arrived at the hotel where the interview was scheduled to take place, I was rudely turned away, causing me to frantically try and find somewhere else in an unfamiliar city. Debra arrived looking cool, beautiful and sophisticated, and managed to secure us a private area in the hotel away from everybody else. The interview itself was so affirming, bringing together two incredible women of colour, and the fact that it later became a cover was the cherry on top of the whole thing. It will remain one of my proudest achievements for the rest of my life!

Hood By Air
by Arca

I remember we were feeling it so much! It was Akeem (Smith), Richard Burbridge and Inge Grognard, and we were laughing so hard on set. (At the time) we didn't know one image was gonna end up as the cover, so that was a very welcome surprise! Inge brought this viscous material, like a translucent goo, to dribble out of my mouth with the mouthpieces on and we were just screaming at how it dripped all over the set. Screaming!

My ongoing collaboration with Shayne is one I feel so lucky to have. I don't know if I've ever had more fun in the studio than with Shayne and Ian Isiah. Honestly, ask Shayne, any single fucking time that bitch and I speak it's guaranteed belly laughter, full spectrum magic with the sense of humour. That's family. I feel like we've grown so much since (this time), and at the same time I feel that exact same love and energy from when we were all waiting for a moment to shine, working so hard and following a vision, collaborating together. Wench forever!

I am so grateful for this *Dazed* moment. I feel honoured I got to walk the HBA runway — that collection is so insanely beautiful. On top of it all, I'm happy to see these images because I find them beautiful.

'We thought we knew each other, now we definitely do!' Voyage to page 103 to find out which musician said this about Arca after a wild summer in Ibiza.

FASHION MADE ME HARDCORE

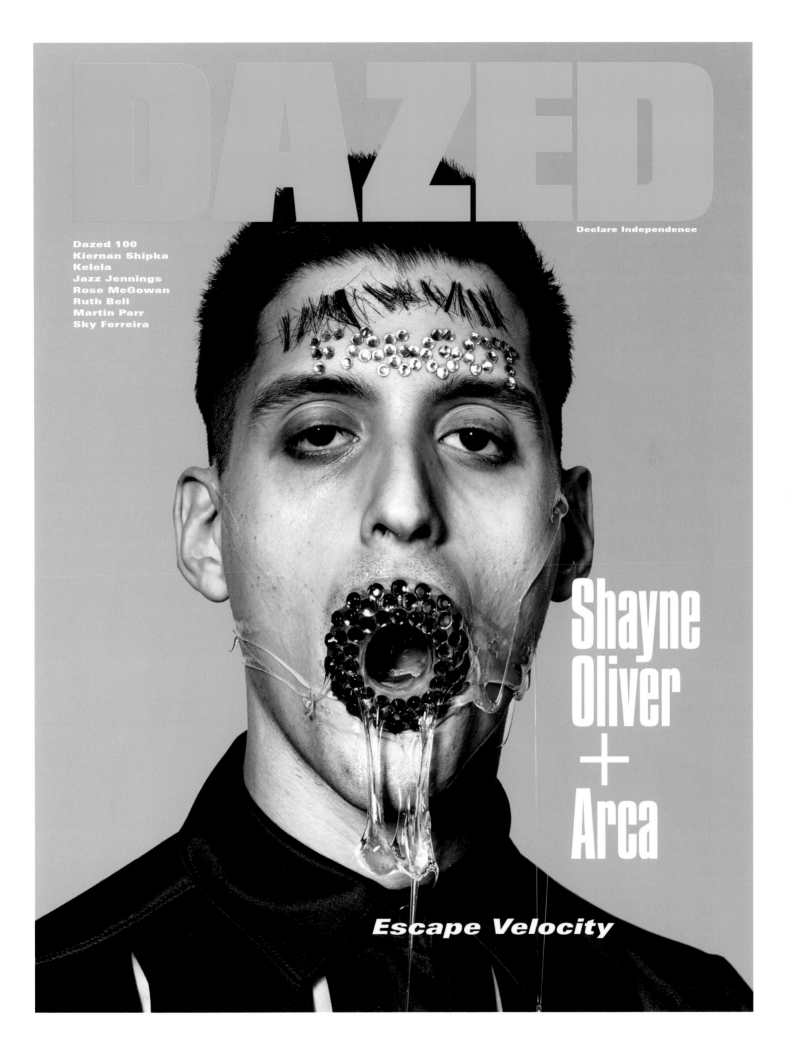

DAZED

Declare Independence

Dazed 100
Kiernan Shipka
Kelela
Jazz Jennings
Rose McGowan
Ruth Bell
Martin Parr
Sky Ferreira

Shayne Oliver + Arca

Escape Velocity

ISSUE 43, VOL. IV, SPRING 2016 **SHAYNE OLIVER + ARCA** PHOTOGRAPHY **RICHARD BURBRIDGE** STYLING **AKEEM SMITH**

GRINDCORE, DEATH METAL, BLACK METAL, THRASH METAL, ATMOSPHERIC DOOM METAL. DYING FETUS SWEATS, CORPSE PAINT, CHAIN MAIL... NEW JERSEY'S METAL MELTDOWN IS WHERE THE UNDERBELLY OF AMERICA'S FORGOTTEN ROCK FANS GO TO MOSH, GRIND, PULL AND PUKE TO THE KIND OF METAL MADNESS THAT WOULD SEND KORN FANS RUNNING HOME TO MUMMY. WELCOME TO THE LAST BASTION OF THE REAL HARDCORE UNDERGROUND...

DEAD CAN DANCE

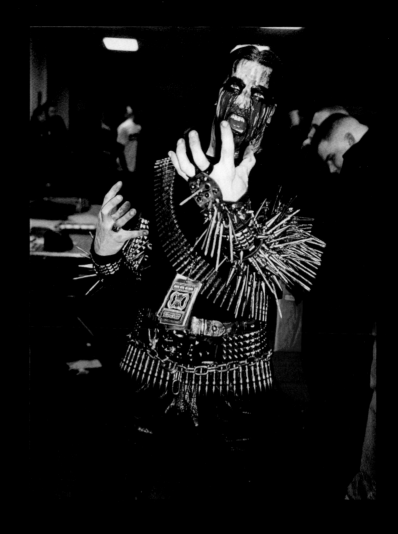

It's the sea of black T-shirts you notice above all else. Jesus Was a Cunt. I Am Dead, Angel Of Disease, Hate My Lord, The Killith Fair. Huddled packs of white, working-class male beer-guzzlers in size XXL long-sleeve metal tees mill around in pick-up trucks and Dodge Chargers in the parking lot outside the March Metal Meltdown in the industrial wasteland of Pennsauken, New Jersey, featuring Anal Blast, Skinless, Mortician, Corpse Vomit, Vomit Snack, Hate Eternal, Vital Remains, '80s thrash veterans Testament, Finland black metal gods Impaled Nazarene, Swedish black/thrash hybrid Witchery, Norse Viking metal legends Immortal... the list is staggering, over a hundred bands from the darkest corners of America and Europe on four stages for two days of extreme sonic dissonance, fists raised in the sign of the beast, and enough headbanging to rattle a nation. If you've never heard of these bands, you probably weren't meant to. And if you brought earplugs along, you're a total pussy. The South Jersey Expo Center is a sprawling convention hall sandwiched between a sex club catering to swingers and a 12-screen multiplex showing Scream 3. Across the street sits a motel renting rooms by the hour for $25. Name talent has been put up here for the weekend. Pennsauken's bleak commercial thoroughfare stretches into the distance, grotty motels and fast food restaurants,

abandoned strip malls, grimy auto repair shops, tired old titty bars. Ridiculed for years as the place where heavy metal never died, New Jersey rocks as hard and fast as it always did. Only metal has slipped defiantly underground - speedier, witchier, filthier and more sacrilegious - counting fewer adherents than in its '80s heyday. America's mainstream rock press won't go near it, nor will Beavis and Butthead or Wayne and Garth. Pennsauken's not even on

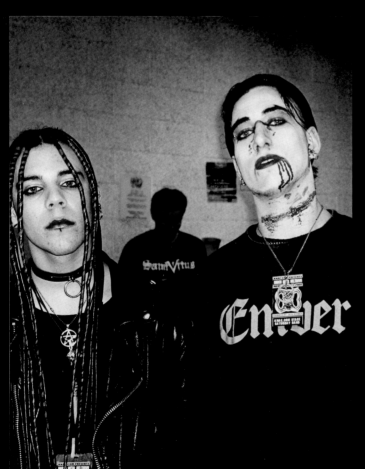

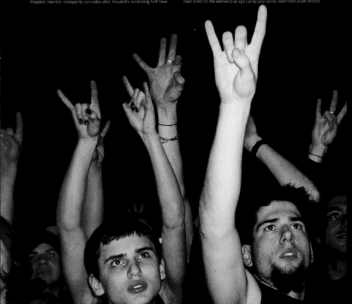

most mad maps. You have to know how to get there.

America's extreme metal underground thrives on the margins of the music business, forsaking major label representation and radio play in favour of a grass-roots, word-of-mouth network of mail-order record companies, websites, specialist record shops, fanzines and the rag-tag live festivals which provide networking opportunities for unsigned bands as well as a chance to see revered European talent like Immortal, Impaled Nazarene and Witchery perform rare, one-off American gigs. Flown over by festival promoters at costs in the range of $5000 per band, booking European names means higher attendance but lower profits. Lesser-known performers don't earn a penny. Greedier promoters often charge high fees to unknown talent for the privilege of opening for a Cannibal Corpse or a Morbid Angel, two of America's more successful death metal draws.

"Record sales and popularity determine which bands get paid," according to March Metal Meltdown promoter Jack Koshick, who stages four festivals each year, including the Milwaukee Metalfest, America's largest underground metal festival, attracting thousands of spectators each July. "Unsigned bands from across the country can get on stage by helping us to sell tickets."

San Francisco's Impaled are a lesser-known young grindcore band playing for free at the Meltdown. They've flown over from the West Coast at their own expense to play a Saturday slot at 11.40am, watched by fewer than two dozen people. "We don't have to pay to play, that's a big bonus," one Impaled member sheepishly concedes after Impaled's lumbering half-hour

set. "Necropolis Records paid for our singer's plane ticket out of future royalties - which we'll probably never earn anyway," he laughs. Impaled's debut album, The Dead Shall Dead Remain, includes a cover photo of a toilet overflowing with bloody faeces and eviscerated organs and features an opening number entitled "Faeces Of Death", sung in bleeding throat vocal grunts with lyrics that go Your evacuated torso is stuffed/With soiled toilet tissue balled into clumps/Diarrhea is imbued with a smile/With my conspicude concoction your body I defile/Inundated arteries now humble festering excreta, immersed/Your body is awash in disease/When I'm alone in the morgue I do as I please. This is perhaps the most compelling example of why underground metal won't ever go Top Of The Pops.

Pennsauken's festival will go on to attract 3,600 fans and performers of death metal, black metal, thrash metal, atmospheric doom metal and grindcore during its nerve-shattering two days. In a surreal feat of booking, skinhead stalwarts The Business wind up on Friday night's bill so there's a smattering of crisply-attired skins in the hall sticking out like sore thumbs alongside the more amply tressed death metal kids in their rumpled cargo pants and Anal Blast T-shirts. Merchandise booths flog everything from Cradle Of Filth panties to vintage Slayer badges to triple extra-large black hoodie-style sweatshirts - a lot of death metal fans are overweight - displaying barely legible band names - Incantation, Viral Load, Dying Fetus, Angel Corpse, all scrawled in a Viking-inspired type. Professional wrestlers and porn stars have been hired for the weekend as eye candy and comic relief from death metal's

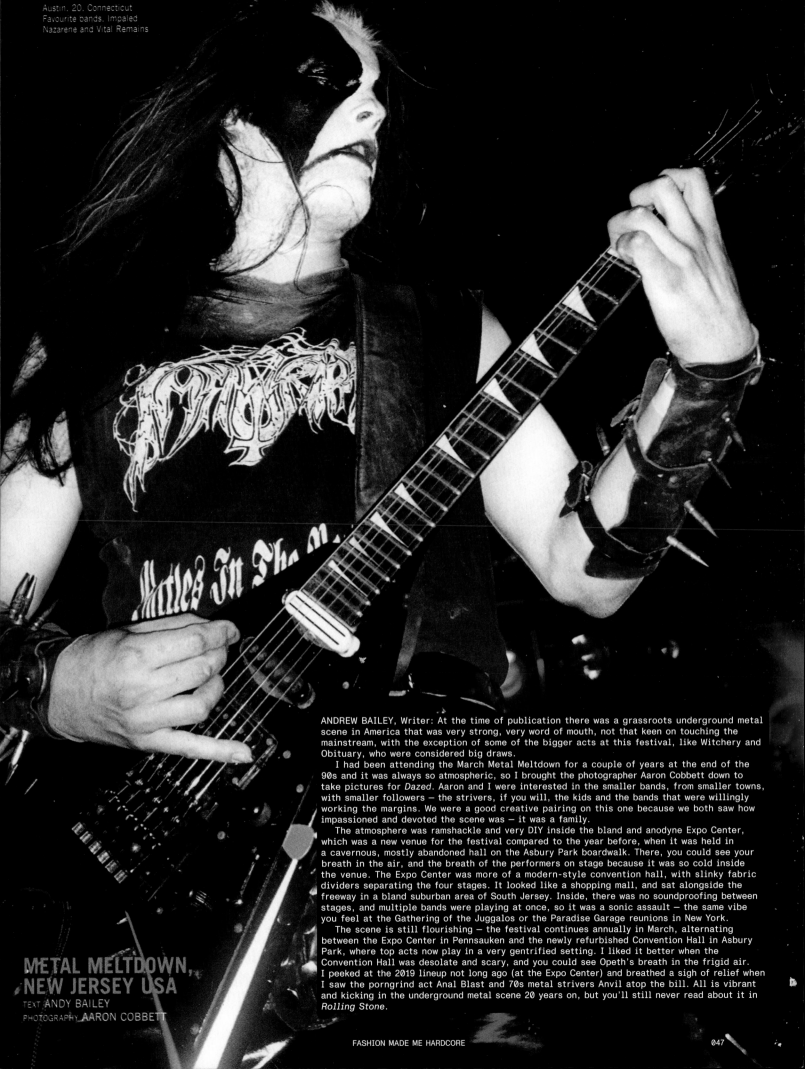

Austin. 20. Connecticut
Favourite bands. Impaled
Nazarene and Vital Remains

ANDREW BAILEY, Writer: At the time of publication there was a grassroots underground metal scene in America that was very strong, very word of mouth, not that keen on touching the mainstream, with the exception of some of the bigger acts at this festival, like Witchery and Obituary, who were considered big draws.

I had been attending the March Metal Meltdown for a couple of years at the end of the 90s and it was always so atmospheric, so I brought the photographer Aaron Cobbett down to take pictures for *Dazed*. Aaron and I were interested in the smaller bands, from smaller towns, with smaller followers — the strivers, if you will, the kids and the bands that were willingly working the margins. We were a good creative pairing on this one because we both saw how impassioned and devoted the scene was — it was a family.

The atmosphere was ramshackle and very DIY inside the bland and anodyne Expo Center, which was a new venue for the festival compared to the year before, when it was held in a cavernous, mostly abandoned hall on the Asbury Park boardwalk. There, you could see your breath in the air, and the breath of the performers on stage because it was so cold inside the venue. The Expo Center was more of a modern-style convention hall, with slinky fabric dividers separating the four stages. It looked like a shopping mall, and sat alongside the freeway in a bland suburban area of South Jersey. Inside, there was no soundproofing between stages, and multiple bands were playing at once, so it was a sonic assault — the same vibe you feel at the Gathering of the Juggalos or the Paradise Garage reunions in New York.

The scene is still flourishing — the festival continues annually in March, alternating between the Expo Center in Pennsauken and the newly refurbished Convention Hall in Asbury Park, where top acts now play in a very gentrified setting. I liked it better when the Convention Hall was desolate and scary, and you could see Opeth's breath in the frigid air. I peeked at the 2019 lineup not long ago (at the Expo Center) and breathed a sigh of relief when I saw the porngrind act Anal Blast and 70s metal strivers Anvil atop the bill. All is vibrant and kicking in the underground metal scene 20 years on, but you'll still never read about it in *Rolling Stone*.

METAL MELTDOWN,
NEW JERSEY USA
TEXT ANDY BAILEY
PHOTOGRAPHY AARON COBBETT

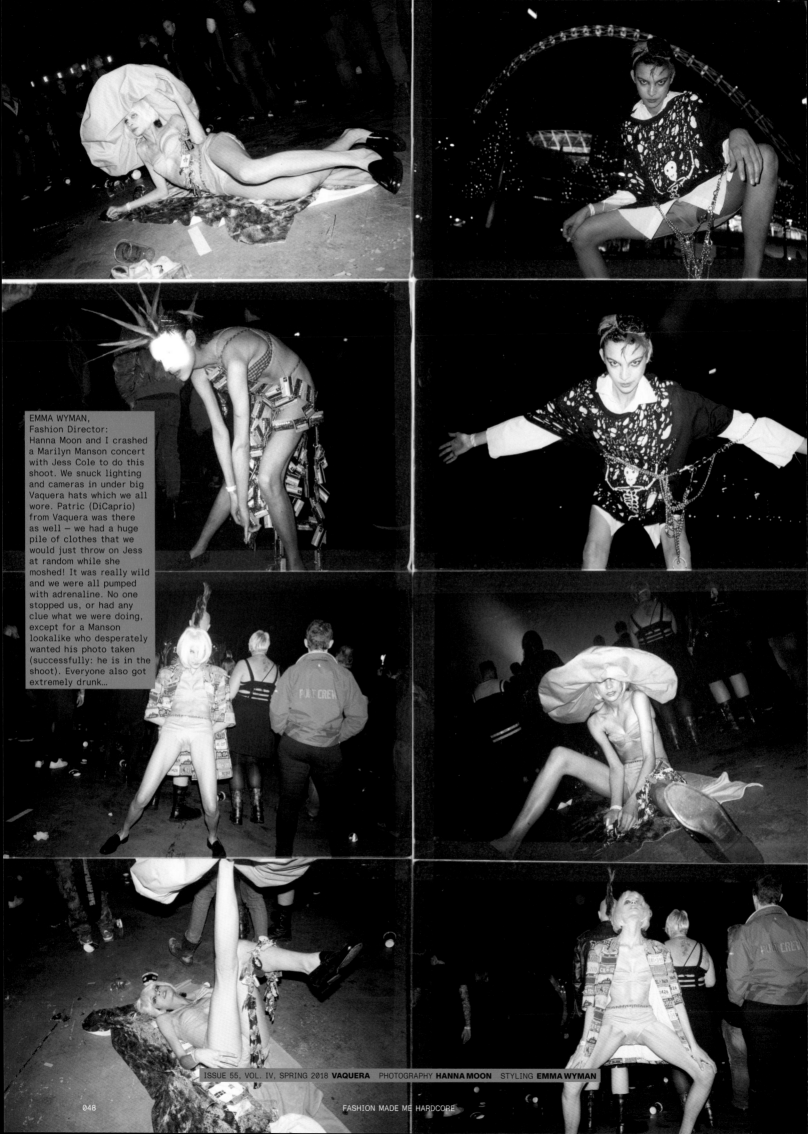

EMMA WYMAN,
Fashion Director:
Hanna Moon and I crashed
a Marilyn Manson concert
with Jess Cole to do this
shoot. We snuck lighting
and cameras in under big
Vaquera hats which we all
wore. Patric (DiCaprio)
from Vaquera was there
as well — we had a huge
pile of clothes that we
would just throw on Jess
at random while she
moshed! It was really wild
and we were all pumped
with adrenaline. No one
stopped us, or had any
clue what we were doing,
except for a Manson
lookalike who desperately
wanted his photo taken
(successfully: he is in the
shoot). Everyone also got
extremely drunk…

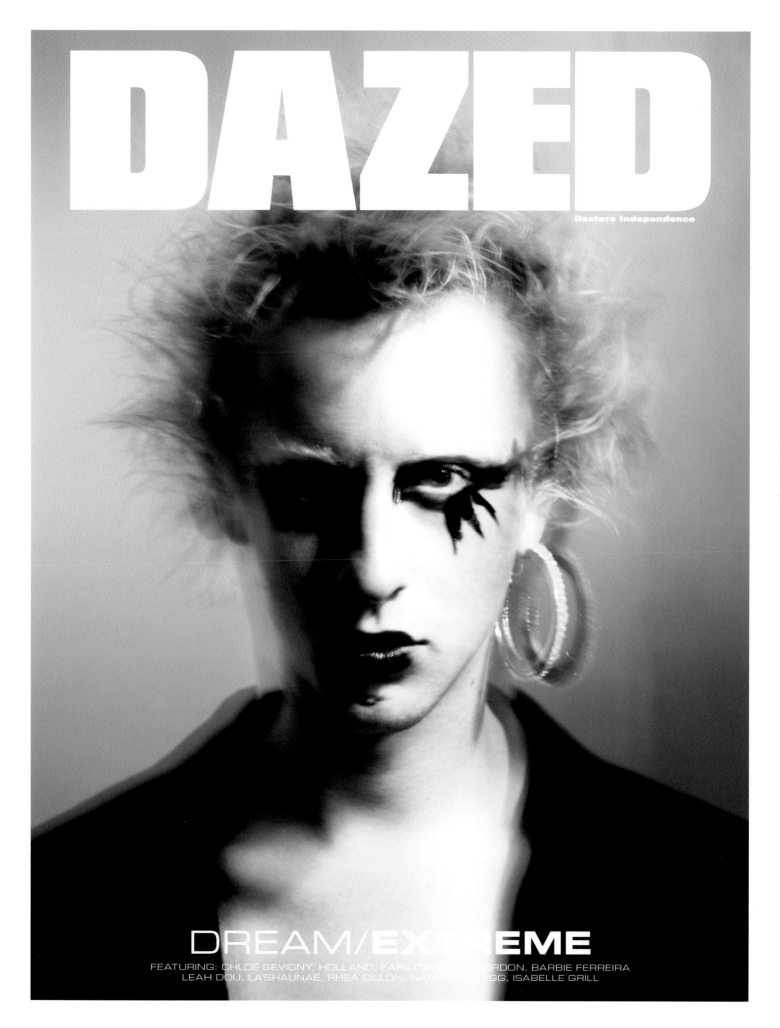

DAZED

Declare Independence

DREAM/EXTREME

FEATURING: CHLOÉ SEVIGNY, HOLLAND, EARL CAVE, KIM GORDON, BARBIE FERREIRA
LEAH DOU, LA'SHAUNAE, RHEA DILLON, NATASHA BRAGG, ISABELLE GRILL

ISSUE 65, VOL. IV, A/W 2019 **COMME DES GARÇONS** PHOTOGRAPHY **PAOLO ROVERSI** STYLING **ROBBIE SPENCER**

FASHION MADE ME HARDCORE

ISSUE 35, VOL. I, MAR 2006 **GILLIAN WEARING** PHOTOGRAPHY **WILLIAM SELDEN** STYLING **CATHY EDWARDS**

SUSANNAH FRANKEL, Editor-in-Chief, *AnOther*:
Working with Cathy Edwards was the most
immense privilege — she was so talented, clever,
kind and funny. I will always miss her.

KAREN LANGLEY, Fashion Director: I would not
be working in fashion today if it weren't for
Cathy. She showed me a part of the fashion
industry where actually you don't have to be an
asshole, you can be a great human being and
still be a badass in the industry. She was also
so loyal to her aesthetic. That's the goal, really,
isn't it? To put your stamp on something that
is so fluid and have such a strong identity.

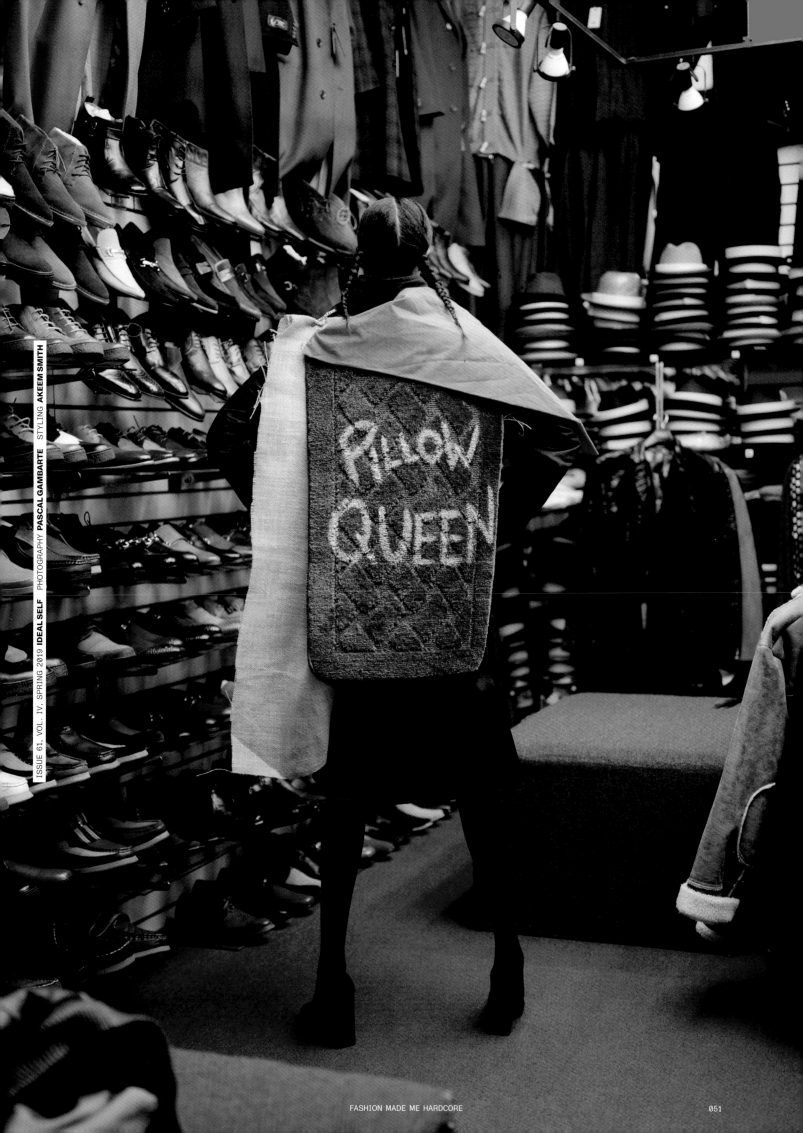

ISSUE 61, VOL. IV, SPRING 2019 **IDEAL SELF** PHOTOGRAPHY **PASCAL GAMBARTE** STYLING **AKEEM SMITH**

FASHION MADE ME HARDCORE

Come as you are

SHARIN FOO
RONNIE SPECTOR
MOE TUCKER
STEVE BUSCEMI
DANZIG
SWAY
PDC CREW

2.
Come As You Are

Totally uncompromising
and unguarded
052–081

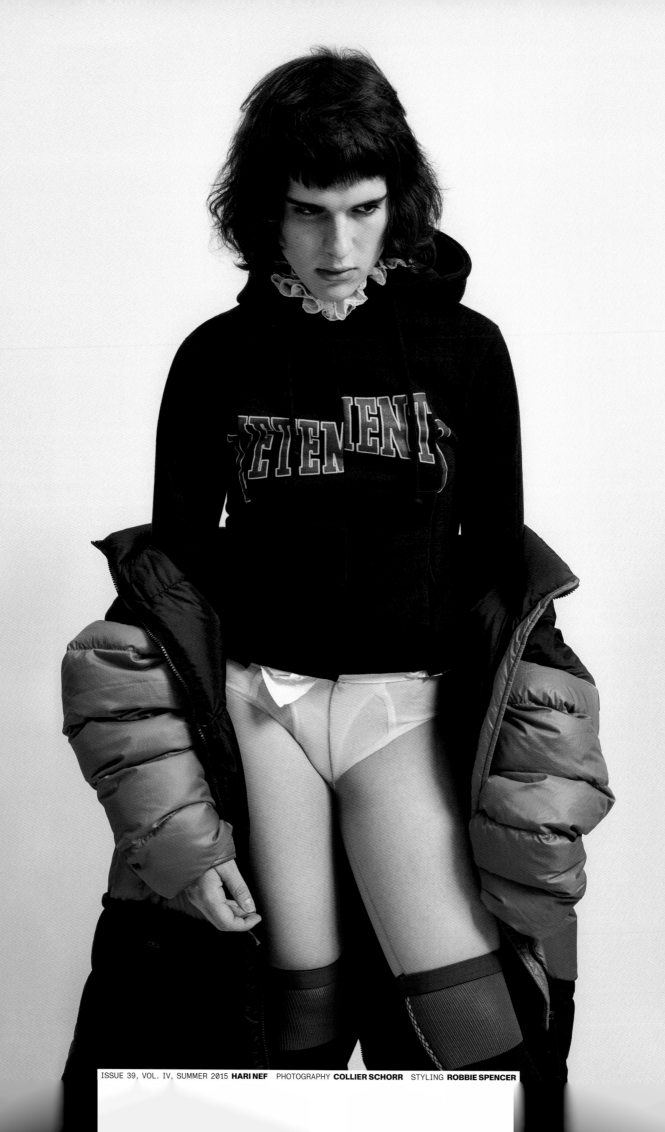

ISSUE 39, VOL. IV, SUMMER 2015 **HARI NEF** PHOTOGRAPHY **COLLIER SCHORR** STYLING **ROBBIE SPENCER**

Rowan Blanchard in conversation with Hari Nef

The best friends and long-time Dazed family members on navigating magazines and the internet in the 2010s.

ROWAN BLANCHARD: I miss you.

HARI NEF: Miss you more! Were you ever a *Dazed* subscriber when you were younger?

RB: I didn't have a subscription but Chris (Horan) gave me all of his old magazines. You are the queen of magazine subscription and collection.

HN: Yeah, I was a *Dazed* subscriber from a very young age. I subscribed to it all through high school. *Dazed* was how I found out who Courtney Love was because they had that Courtney Love cover (in 2010) — it was a big access point for me to find out more about people like Tilda Swinton, Crystal Castles, Kristen McMenamy...

RB: The legends.

HN: Legends only! It felt like my guide to something I knew I was going to need guidance for, but knew that I would have to move to New York for that guidebook to even apply. I studied *Dazed* not knowing what I was studying for, but knowing that it was going to pay off somehow — because this was before Instagram and before Twitter and even before I'd got on Tumblr. (It was) the way to find out about what was new and fab, or people who had always been fab, who are still fab. The shift online was, I think, exciting because I felt like I could participate and engage and that's what I did when I won the readers' choice *Dazed 100*. The first one.

RB: Yeah, that's iconic, honestly.

HN: I wanted to win it so badly, I (literally) logged onto the voting portal from every computer in the Columbia library and voted for myself.

RB: Yes, my Libra sis! (*laughs*) I would have done the same.

HN: I was at Art Basel in those final days of voting and it was me and FKA twigs fighting for that top spot and I remember locking eyes with her across a club.

RB: What was that like?

HN: She's so cool, because I bet she didn't even know that she was up for a readers' choice. But I had so much more to prove at that point than FKA twigs. I locked eyes with her and I just gave her this respectful nod and she gave me a respectful nod. She probably didn't even know who I was, but in my mind (she did).

RB: Smile and nod. Nodding works no matter what.

HN: I do think that *Dazed* gave us a platform in a major way. It picked up on not just what we were doing but what we were saying. And I think that when you and I started to appear in *Dazed* regularly we had a point of view about the intersection of celebrity and social change, (this) intersection of art-making and social change — you know, responsibilities connected to a platform — and I think both of us have had our views about that evolve since then.

RB: It can be hard to find your place again when your views evolve. When I was in *Dazed* back in 2016 I was really excited at that point

to be embraced as anything other than a Disney star. It felt really affirming for me and it made me feel taken more seriously. I felt like I had something to say at that point. I was processing in real time and out loud, my proximity to that sort of aware-celebrity-meets-online-activism. And then I guess that moment changed when I realised, I don't want to speak on things I don't want to speak on. It's also been kind of shocking to do this all so young and have a lot of public reference (to) things I said when I was 14.

HN: I believe what they called me in *Dazed* was the trans fashion muse of my generation. They also called me the Chloë Sevigny of the Tumblr era.

RB: I remember that. That's really it, that's the quote.

HN: You know what, I still cuddle up with that little quote at night. I'm really proud of the fact that I was in *Dazed* talking about being trans, and you should be proud about the fact that you were 16 years old in these magazines talking the talk — because that stuff boomeranged right back to us, and gave us all these complicated feelings about big voice, young age, what do I want to say. We had to deal with the trauma of being trapped in things that we said years ago, but let's think about the young people who found us, let's think about the people that we reached. I do think representation comforts and I do think representation makes people feel less alone, (even) soundbites that we would find cringe in 2020. When Sam Levinson put that poster of me on the wall of Jules' bedroom on *Euphoria* I was thinking in my head it should have been a tear-out from *Dazed* because that's where she would have found me. Those pictures that Collier took of me, it feels like a much earlier stage in my transition, and Collier was really playing at my androgyny. And I can't even feel that thing that trans girls feel when they look back at old pictures because I was giving what I was giving, and Collier brought that out of me. And I can't feel ashamed about that because if I weren't me I'd be like, cool. Being seen and being perceived is tricky and slippery. *Dazed* walks a tricky tightrope of being a force for visibility — and I think *Dazed*, just like all of us, is trying to figure out how to do right by that mission. But I think that what they have done from the get-go is just listen to the people that they choose to represent. Which is the youth.

RB: The youth. I'm grateful you have a decade on me, I would hate if we were the same age — I need somebody to look up to!

HN: I mean, we were both coming into our respective womanhood on a similar timeframe, so as much as I feel older than you, I also feel close to you in another timeline. Not as much as I feel older than you though. You can't keep bringing those Gen Zs over to my apartment, ashing off on the couch, drinking wine... Oh, baby, I miss you.

RB: I miss you too. *Dazed*, give us the covers!

HN: Give us covers for no reason.

RB: Don't play.

HN: *Dazed*, we're doing your Rizzoli book. Throw these sexy brunette Libras a bone and put us on the cover. Come on now.

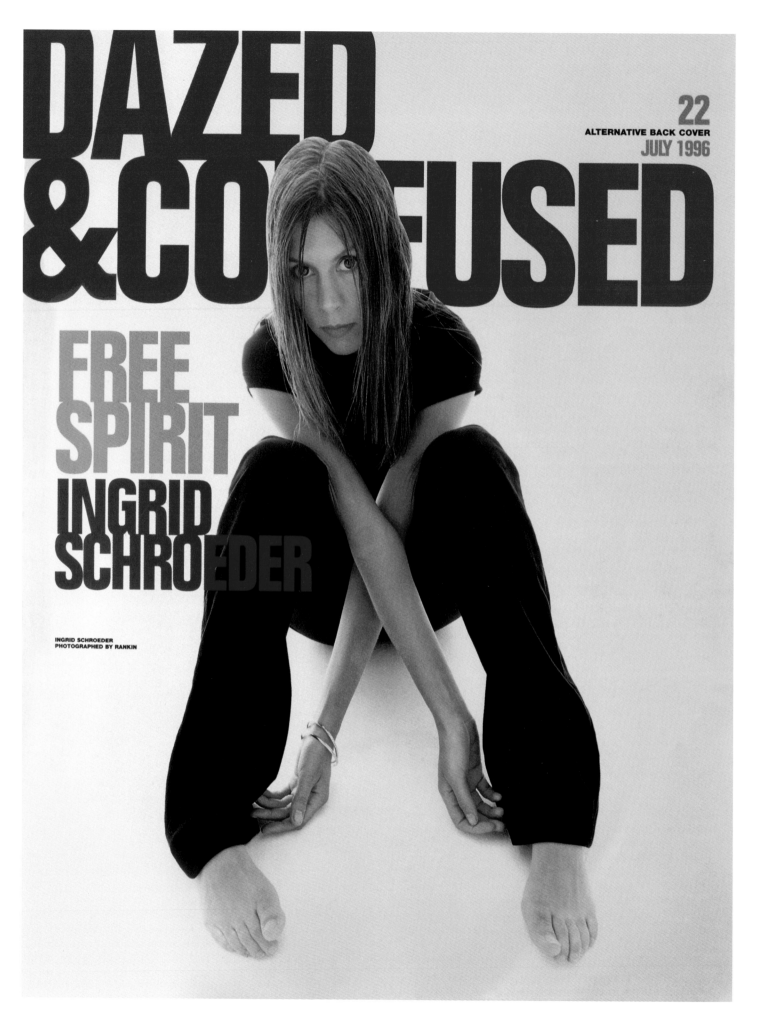

DAZED &CONFUSED

FREE SPIRIT
INGRID SCHROEDER

INGRID SCHROEDER
PHOTOGRAPHED BY RANKIN

ISSUE 22, VOL. I, JUL 1996 **INGRID SCHROEDER** PHOTOGRAPHY **RANKIN** STYLING **KATIE GRAND**

COME AS YOU ARE

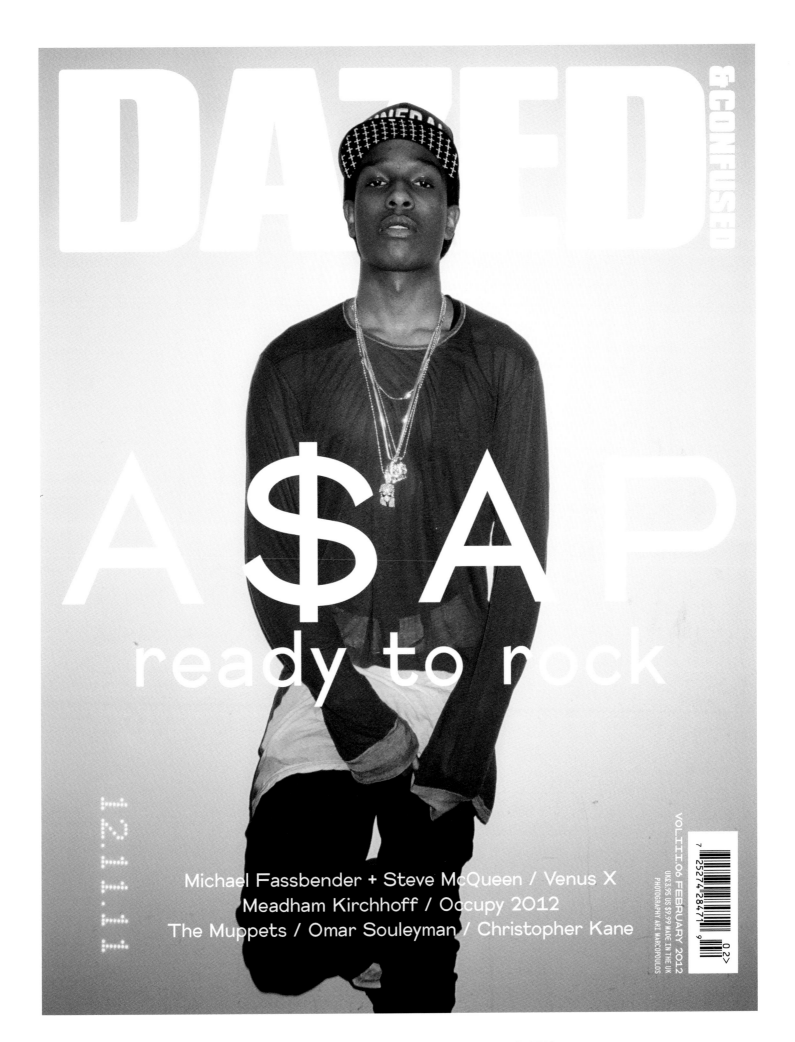

DAZED & CONFUSED

A$AP
ready to rock

Michael Fassbender + Steve McQueen / Venus X
Meadham Kirchhoff / Occupy 2012
The Muppets / Omar Souleyman / Christopher Kane

VOL.III.06 FEBRUARY 2012
UK£3.95 US $9.99 MADE IN THE UK
PHOTOGRAPHY ARI MARCOPOULOS

ISSUE 6, VOL. III, FEB 2012 **A$AP ROCKY** PHOTOGRAPHY **ARI MARCOPOULOS**

COME AS YOU ARE

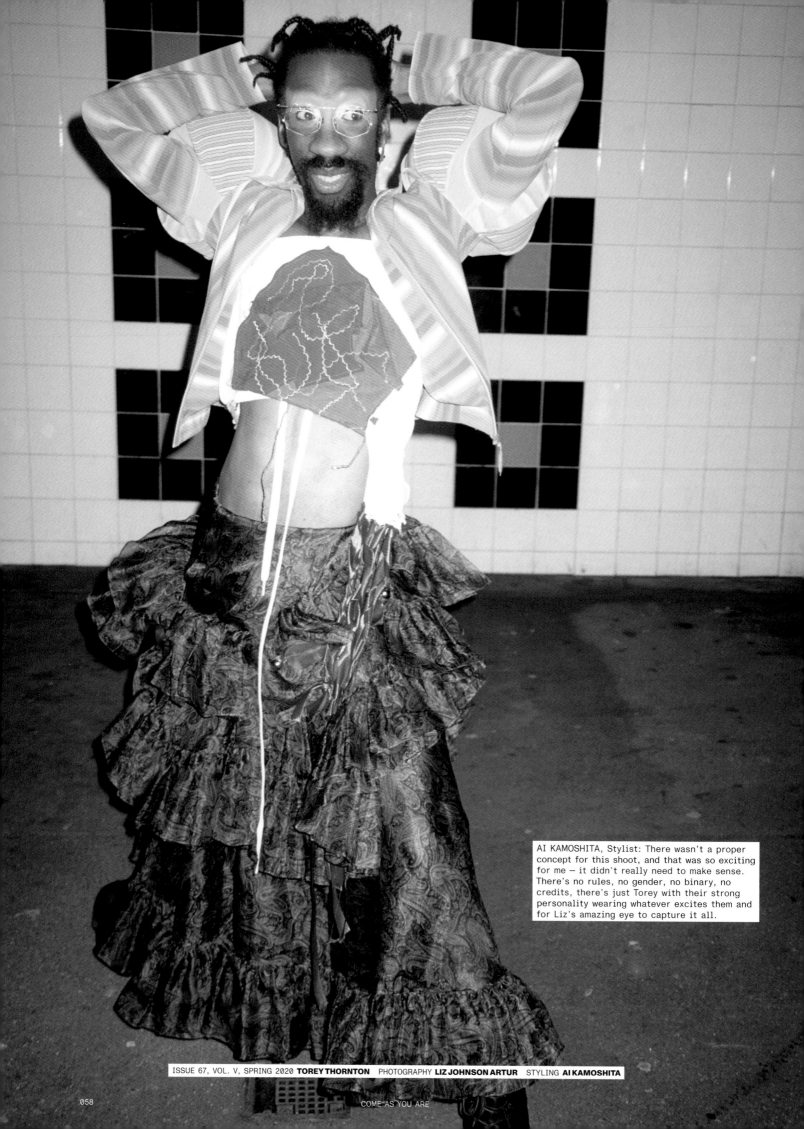

AI KAMOSHITA, Stylist: There wasn't a proper concept for this shoot, and that was so exciting for me — it didn't really need to make sense. There's no rules, no gender, no binary, no credits, there's just Torey with their strong personality wearing whatever excites them and for Liz's amazing eye to capture it all.

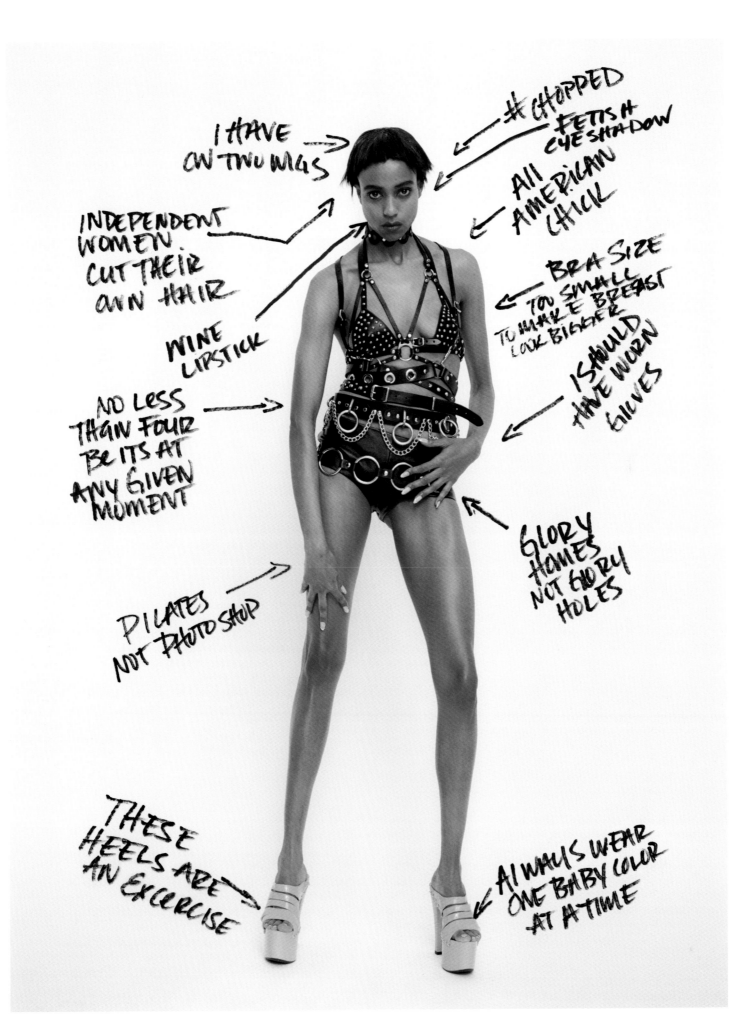

ISSUE 61, VOL. IV, SPRING 2019 **IDEAL SELF** PHOTOGRAPHY **PASCAL GAMBARTE** STYLING **AKEEM SMITH**

Katie Grand in conversation with Jeanie Annan-Lewin

Something like a rollercoaster: the magazine's very first fashion director on leading her one-woman fashion department in the early Dazeds.

KATIE GRAND: It's so funny looking back at this picture, because no one cared about it at the time. It was only recently when Marc Jacobs referenced it for Heaven (their new clothing line) that it re-emerged. Actually, Nellee Hooper, who I didn't even know, asked me out on a date having seen that picture. I thought that was weird.

JEANIE ANNAN-LEWIN: Oh God, essentially this is like, I don't know, it's pre-Tinder!

KG: Yeah, fuck yeah.

JAL: But nobody cared.

KG: Nobody cared, definitely no one cared at the time and I think it was when I was still dating Rankin, so it was kind of like, it was just fun — whatever.

JAL: What's your earliest memory of *Dazed* as a magazine?

KG: It was just something that this group of friends did. I knew Rankin from going out. My friends were all being photographed by him and he was putting on exhibitions, so we'd go to the private views. I lived in Brixton at the time, and one Sunday we were all hanging out and Rankin said, 'Do you want to come over to the office and fold the magazine?' At the time it was just off Kings Road and it's when they used to do big fold-out issues. So, me and my friend Christine Kellogg drove there in my Ford Fiesta, and just sat and folded the magazine all afternoon. There were these other kids there called Keld van Schreven and Mark — what was Mark's last name again? (Westall) — they had a magazine called *GSpot* and shared the same office, so we were all there on a Sunday afternoon, probably drinking vodka and folding magazines. I don't remember Jefferson being there but I do remember Keld being there. Think I went home with Keld. (*laughter*)

JAL: Then you were like, I'm done folding magazines, what next?

KG: One day, Rankin phoned on my landline and said, 'What are you doing? Do you want to come over to LCP and help out with the student union magazine that I'm working on?' So I just started going in every day, and then kept going in every day. I don't think they really wanted a fashion department. Both of them had issues with how to tackle fashion — as most people do — and I think that was, in some ways, their viewpoint. It's what made them different from *i-D* and *The Face* — it was culture and style culture, over fashion. But that just made it quite hard for everyone in the fashion department... or the fashion department as it later became. But then as time went on, we kind of got together the knowledge and the language that the fashion department had to work with the advertising department and if the two worked together you could make money.

JAL: And you could pay someone else to fold the magazines. Looking back, what is your favourite *Dazed* cover?

KG: In retrospect, the most clever cover was the mirror board one that they did in 1993 with the cover line 'The Death of the Cover Star'. It cost a fortune, but it was way, way ahead of its time because people have used mirror boards since. I also love issue six, it was an art cover with a mask. If you look at it now it could be published tomorrow and people would think it's Richard Quinn or someone like that. I didn't work on either, but I do remember them... The thing was, you could never propose something straightforward for a *Dazed* cover, and I think that definitely came from Rankin. It had to have a concept, it had to have a meaning, it had to have an ironic title. If you thought of the title first you could always get something past them, whereas if you said, 'Oh I really want to shoot with Juergen Teller,' Jefferson would turn round and say, 'Why?' Maybe it put them in good stead for later, but it was very much that

thinking of, why should we be part of the establishment? Whereas I was in fashion because I liked the idea of working with David Sims or a famous photographer. It got to a point where everyone was quite interested in *us*, but we never asked anyone to work for us because everyone at the magazine was so down on it — to the point of it being stifling by the time I left... I think I left and Dave Sims shot the cover.

JAL: And the craziest shoot you worked on?

KG: When I was there, there was nothing very crazy in front of the camera, it was all behind the camera. That was where the craziness was because we were so young and daft. The night before we were due to shoot Kylie I got on the phone at 2:30 in the morning and told Jefferson that I wasn't going. Also, I remember the time we shot Robbie Williams and everyone was so excited that, literally, the whole of the fashion department came in (wearing) bra tops and low-rise cargo pants. Then Robbie turned up, ordered curry, and literally all the fashion assistants disappeared and decided to clear up the fashion cupboard that day because they weren't interested in him after all.

JAL: That's not boyfriend material.

KG: Or that every Friday we'd have to clear out the fashion cupboard because it would be turned into a bar. Or if we had hangovers we would get into bed with Matt Roach in the basement because that was a good idea... Or that I would go next door and buy fried breakfast for him and sit under a *Star Wars* duvet. The shoots weren't crazy, but the process was just extremely funny in retrospect.

JAL: It sounds chaotic, but in the best way.

KG: Yes, and I think it was highly emotional.

JAL: What's your fondest memory of this period?

KG: I suppose I'm very nostalgic. It's the joy of it that no one had any experience from anywhere else. There wasn't a single person in that set-up (who knew what they were doing) — until later when Katy England came in — who could say, yeah, this is how you do it. So that's probably my fondest memory — the naivety and also the camaraderie of when you're all experiencing something for the first time. And also, (how) I don't remember any of us taking it very seriously.

JAL: That's quite refreshing. I guess you can't really roll like that now because people know how things work. Even if you've just come into the industry, you've got some sort of an idea because we're fed so much information of how a magazine operates, and that's quite sad. I quite like the idea of experiencing something like a rollercoaster.

KG: It was. It's weird to think that none of us had any experience in finance, didn't use printers, just producing all of that content and the back end with zero experience. In retrospect, I kind of look at it and just think... I don't know how we did it with five people! I mean, it was literally Rankin, Jefferson, Ian Taylor, Matt Roach, me and there was a girl who did production who is really nice who was the sane one. We had a sane person.

JAL: There was one.

KG: And then later Susanne, Rankin's sister. Literally everyone was straight out of college, and I say it all the time, Rankin doesn't get enough credit for the fact that he was a sheer bulldozer with such arrogant ambition that this would work.

JAL: Which is kind of what you need, just blind faith.

KG: It was, definitely. You know, there was never any question of anything not working. It was literally Rankin sat in the student union and he said we can be the next *i-D* — and then we were.

JAL: It's kind of amazing.

KG: I'm glad I was there for that moment, sat on the floor with Matt Roach and Phil Poynter and Rankin, (and) he'd go 'OK, we'll be *i-D*,' and then here we are, 30 years later.

OPPOSITE PAGE: You might recognise this two-headed teddy from another iconic *Dazed* shoot from the same year — to see which Icelandic pop star is clutching the teddy, go to page 222.

COME AS YOU ARE

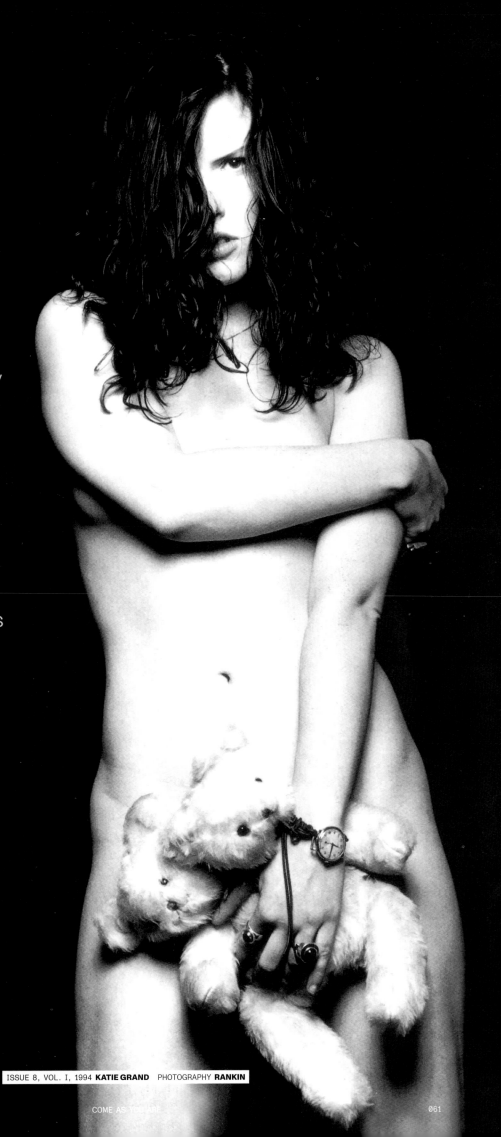

Opposite Page

JUDY BLAME

Contributing fashion editor i-D magazine.
Freelance stylist and designer.

Grooming **Liz Daxtaeur** at Marina Jones.

"These are my three favourite designers and my three favourite pieces of the moment by Philip Treacy, Helmut Lang and Azzedine Alaia. So that no one else can have them they are going up in flames with me. I might as well die as a fashion queen."

KATIE GRAND

Fashion editor Dazed & Confused magazine.
Hair and make up **Hina Dohi**.

"We're born naked and clothes are just something that happens to us while we're growing up. It would be nice to leave in the same state I started."

ISSUE 8, VOL. I, 1994 **KATIE GRAND** PHOTOGRAPHY **RANKIN**

KATY ENGLAND, Fashion Director: I wanted these beautiful women
to look strong and highly stylish. I wanted them to be proud
to show they had survived, to show their battle scars.

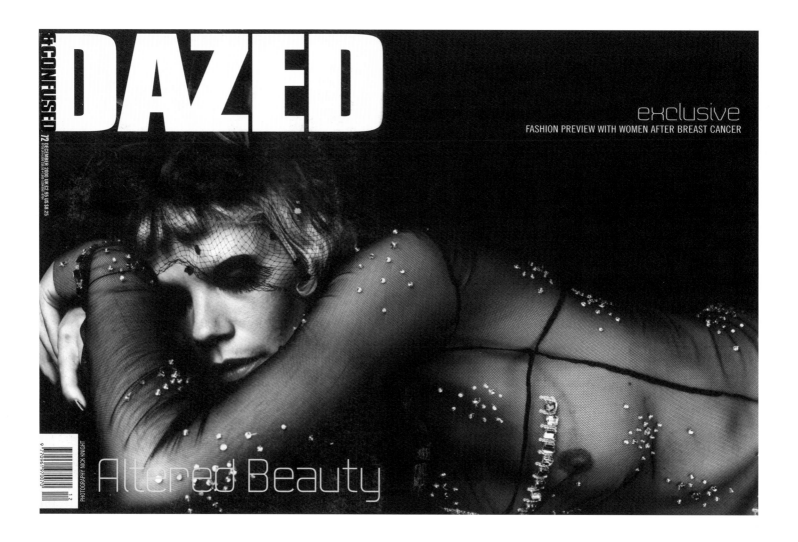

DAZED
&CONFUSED
72 DECEMBER 2000 UK £2.95 US $8.25

exclusive
FASHION PREVIEW WITH WOMEN AFTER BREAST CANCER

PHOTOGRAPHY NICK KNIGHT

Altered Beauty

NICK KNIGHT, Photographer: Katy is one of the best stylists I've ever
worked with. She is inventive, passionate, smart and funny and has such
a sense of elegance, refinement and counter-culture. If I ever find myself
on a job with Katy, it's always a joy. She was close to Lee's heart, too.
She has a tenacity for getting the best possible image without being
bullish or boorish. She will encourage you to keep on pushing to get an
image because she loves it and understands it.

Katy had a sister who died tragically of breast cancer. Without being
too personal, my wife had a moment; they did an investigation and it
was nothing, which is great, but Katy sadly lost her sister. We started
talking about it. Why is it this dreadful disease not only robs us of
our physical health and our life but also robs us of our sexuality and
our fantasy?

I looked at images of women who had breast cancer in some form and
we found all the images were totally desexualised. I think sex is an
enormous part of people's lives and fantasy is an enormous part of sex.
All of the images I saw were medical images taken of what women had

suffered at the hands of a surgeon, and they were all so condescendingly
sensitive and tasteful. They had removed every idea of fantasy from
these women.

I wanted to do a series of pictures. I spoke to all the women
involved, told them exactly what we were doing, and then pushed it to
the lengths that I could. I didn't want to make the pictures vulgar but
I wanted to make the pictures sexual in some way. Sex and death are very
closely related. Lee McQueen is a testament to that. The pictures had
to deal with the sexuality and sexualisation of death. Life becomes more
vital or more poignant, more heightened. You feel more alive.

I'm not trying to be macabre but it is part of what shapes us. You
don't have happiness without sadness; you don't have life without death.
To some degree we all use those emotions and boundaries to push
against, to experiment, to play. We tried in an elegant way to show women
who still had the ability, if they chose, to look at death in a different
way. It was a very heartfelt series of pictures with the idea that you
shouldn't let cancer rob you of your sexuality and your fantasy.

ISSUE 72, VOL. I, DEC 2000 **ALTERED BEAUTY** PHOTOGRAPHY **NICK KNIGHT** STYLING **KATY ENGLAND**

COME AS YOU ARE

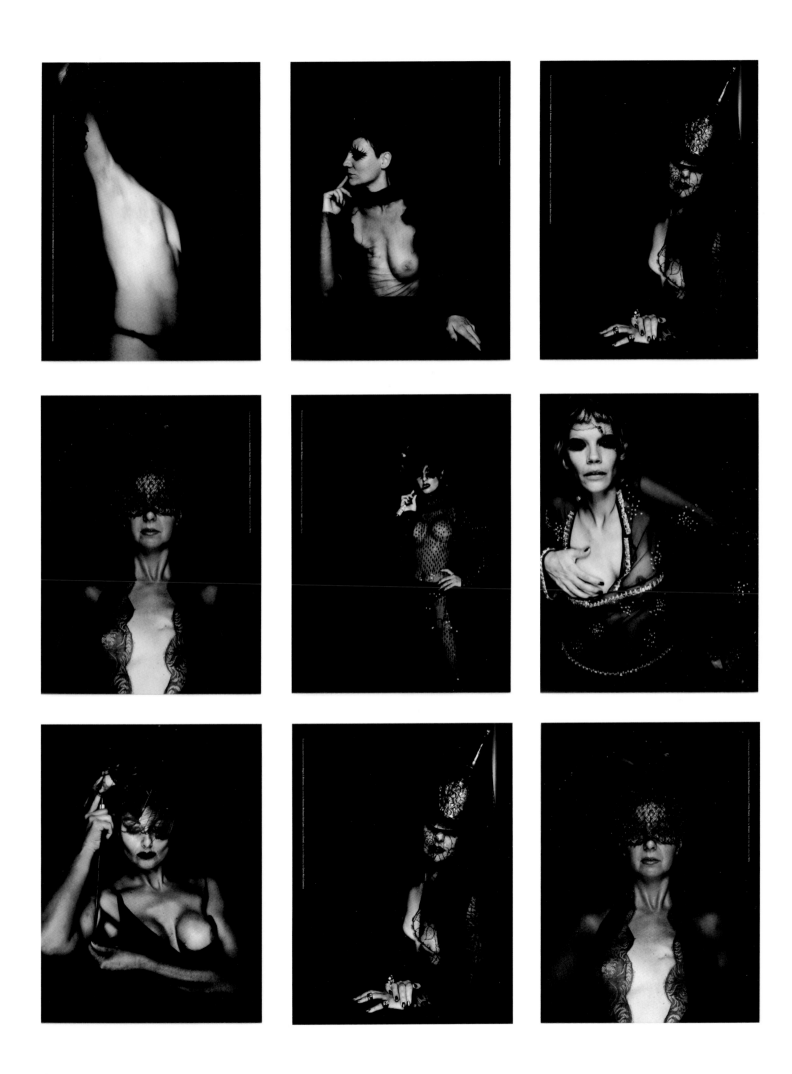

Having shot the artwork for one of this artist's albums, who did Nick Knight say this about in 2016? 'I think the most important thing he taught us is about people's sexuality, that we are sexual beings, we are not heterosexual, homosexual, bisexual.' Turn to page 111 to find out.

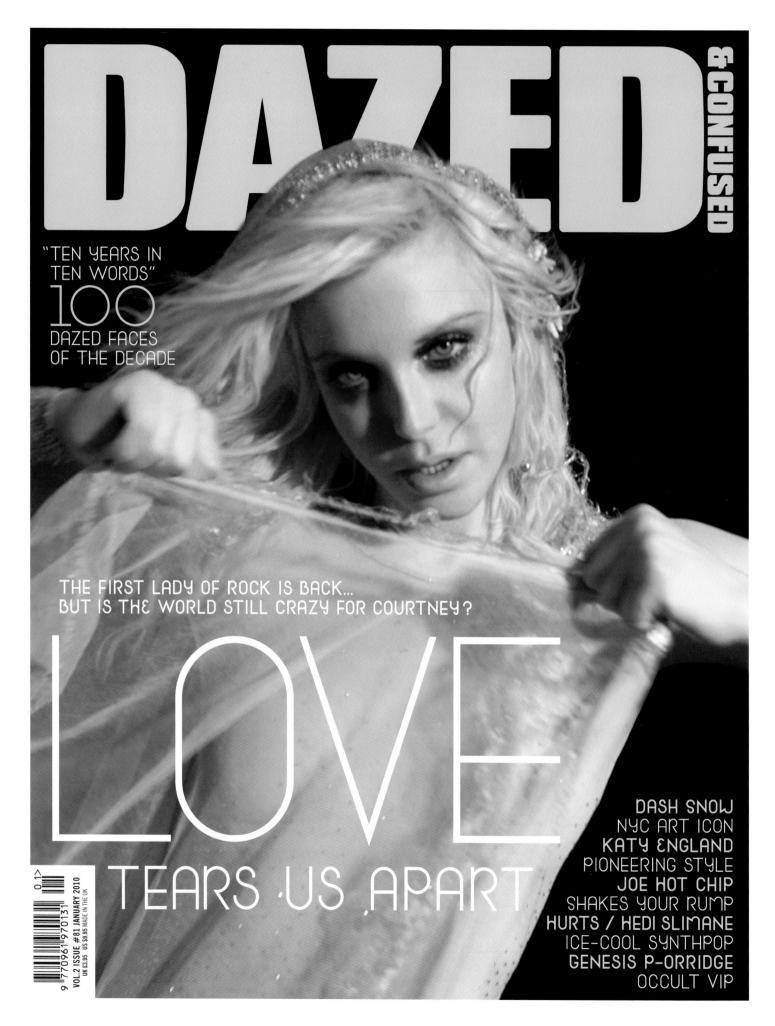

DAZED

&CONFUSED

"TEN YEARS IN
TEN WORDS"

100

DAZED FACES
OF THE DECADE

THE FIRST LADY OF ROCK IS BACK...
BUT IS THE WORLD STILL CRAZY FOR COURTNEY?

LOVE

TEARS US APART

DASH SNOW
NYC ART ICON
KATY ENGLAND
PIONEERING STYLE
JOE HOT CHIP
SHAKES YOUR RUMP
HURTS / HEDI SLIMANE
ICE-COOL SYNTHPOP
GENESIS P-ORRIDGE
OCCULT VIP

VOL.2 ISSUE #81 JANUARY 2010
UK £3.95 US $9.95 MADE IN THE UK

ISSUE 81, VOL. II, JAN 2010 **COURTNEY LOVE** PHOTOGRAPHY **YELENA YEMCHUK** STYLING **KAREN LANGLEY**

COME AS YOU ARE

Courtney Love on the *Dazed* Cover That Stopped Her Feeling Confused

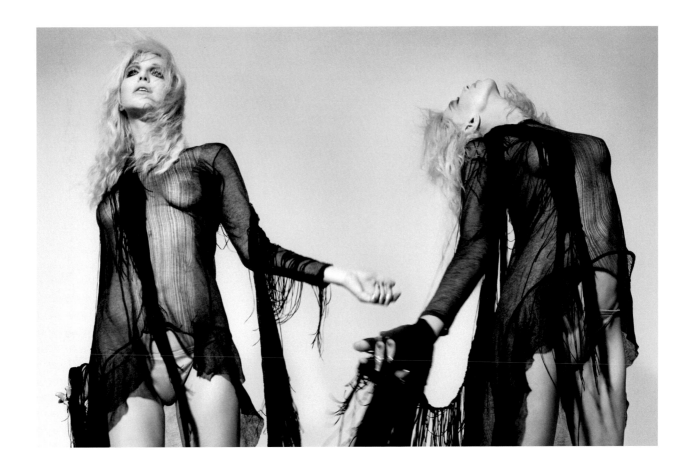

At the time of this *Dazed* cover I'd been living in the Mercer (hotel) for about a year, but right before the shoot my band, Frances, and I moved into this loft — where the photos were taken. It belonged to Justin Portman and Natalia Vodianova when they were married and it was huge. I remember it had this enormous river that ran through the centre of it, and at one point I fell in because I wasn't thinking. I'm not kidding, it was like this full-on creek in the middle of this apartment in Tribeca. Cool-looking, but truly strange.

I'd known Yelena (Yemchuk) for a very long time — I first met her as a very young woman when she was dating Billy Corgan and I'd watched her establish herself as an amazing photographer who'd worked really, really hard to get to where she was. Because I'd dated Billy myself at one point, our shared emotional past of dealing with this genius but complicated man added an interesting under-current. And I knew I wouldn't look bad with Yelena, because she has this incredible signature style — her photos are so surrealistic and pretty.

(When the shoot took place) I was going through a very strange fashion moment in my life. I'd discovered Etsy, which I started called Regretsy because I was dressing crazy — like *What Ever Happened to Baby Jane?* style, but way beyond. I was 46 and I was wearing red eyeshadow and these tutus from designers who weren't designers at all.

Right before the *Dazed* cover, we were moving into the loft and I was getting some clothes together to bring with me. So I was collecting them from the storage space under the Mercer, which was literally full of all my stuff, and Mr Lagerfeld was downstairs in the lobby. He asked me why I was wearing a tutu, and I replied... 'Well, I wanna be wearing a tutu.' And he said, 'You'll never get laid looking like that in a tutu at your age' — Karl Lagerfeld, in front of all of his people! I felt crushed, but I told him, 'Oh you just don't understand!'

Before the shoot I was like, 'I'm wearing my own stuff, I have my own style, this tutu's *in*,' but actually I heeded Mr Lagerfeld's advice. It was a transitional moment for me, stylistically. I remember Karen Langley brought some great pieces, and I had some Galliano bias-cut dresses, which I collect, and this leather Margiela — like *Margiela* Margiela — gown. I don't know where that is now; maybe I gave it to someone. (Looking back at the cover now) I'm glad I wasn't wearing a full tutu look. I wouldn't wanna be remembered for that moment. I think they're beautiful photographs that Yelena should be very proud of. And I look cool, so that makes me happy. AS TOLD TO **EMMA DAVIDSON**

ROBBIE SPENCER, Fashion and Creative Director: This was a personal highlight; it was something myself and Ben Toms both felt very strongly about — celebrating such an inspirational person and putting her on the cover.

DAZED

Declare Independence

CHELSEA WERNER
Kindred Spirit

THE FAMILY TIES ISSUE: SAOIRSE RONAN & LAURA DERN, BJÖRK, NATHAN WESTLING, ATLANTICS
DANIEL JOHNSTON, FREDRIK TJÆRANDSEN, ED ATKINS, HAUS OF US, NOAH JUPE

Chelsea Werner has broken boundaries as both an athlete and model; an achievement shared by Paralympian and McQueen model Aimee Mullins. Go to page 230 for more Aimee.

BEN TOMS, Photographer: Of all the shoots I've done for *Dazed* over the past 15 years, this was my favourite. I first spotted Chelsea on Instagram, where she posts videos of her gymnastics routines, so when the opportunity for the *Dazed* shoot came up I was excited to work with her. Chelsea is a world champion, Special Olympian and acclaimed athlete, and was an incredible subject to photograph. We shot in a gymnasium in the Bronx, where she performed her routines all day. Within the fashion industry it's no secret that there is a lack of diversity, in all its forms in front of the camera and behind it, and that includes the representation of people with disabilities. Diversity has become an increasingly important issue, but disabilities are often not on the radar. To be inclusive and represent the population, more than 15 per cent of which is disabled, it's important to attempt to play a small part in this.

COME AS YOU ARE

THORA SIEMSEN, Writer-at-Large: I grew up in the arid sprawl of Phoenix, Arizona and lived in chain bookstores as a delinquent teen. The newsstands taught me about fashion you couldn't buy at the mall. Kate Moss was the model and *Dazed* was the magazine.

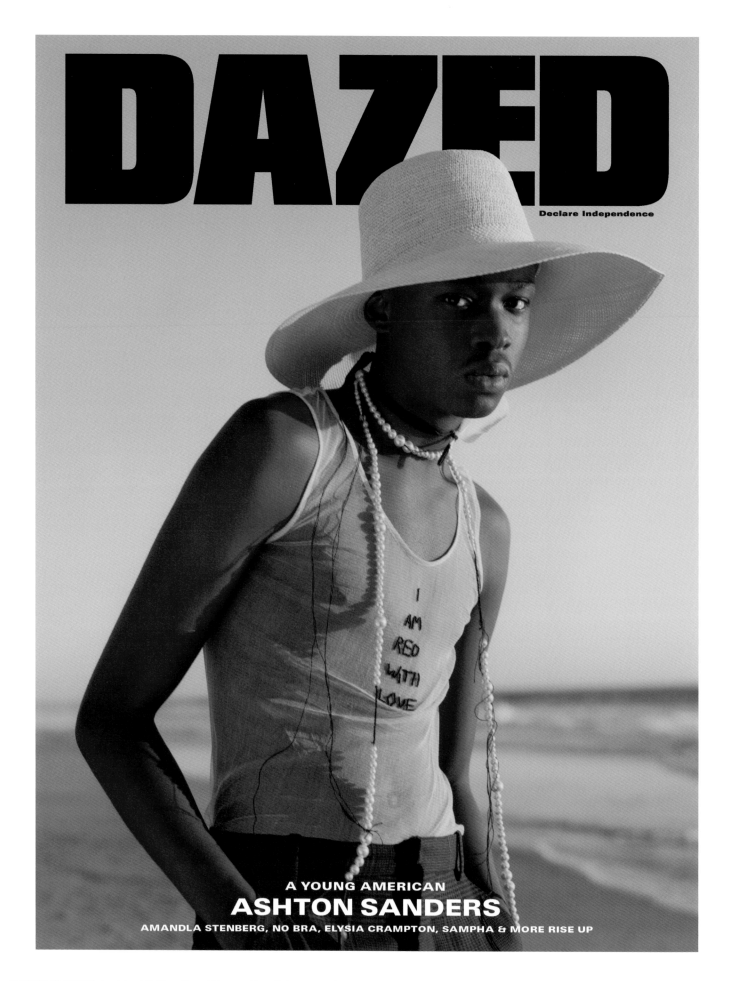

DAZED

Declare Independence

ISSUE 49, VOL. IV, SPRING 2017 **ASHTON SANDERS** PHOTOGRAPHY **SEAN AND SENG** STYLING **ROBBIE SPENCER**

A YOUNG AMERICAN
ASHTON SANDERS
AMANDLA STENBERG, NO BRA, ELYSIA CRAMPTON, SAMPHA & MORE RISE UP

DOMINIC CADOGAN, Assistant Editor, *Dazed Beauty*: *Moonlight* was such a ground-breaking film in so many ways — rightfully winning a bevy of accolades — but what stuck with me after leaving the cinema the first time I watched it was a feeling of being seen in a way that no other film had made me feel before. I remember asking my white friends if that was how they always felt watching coming-of-age movies, but I don't think the sentiment is the same when you always see yourself on the screen.

Seeing myself represented — particularly through Sanders' portrayal of teen Chiron — was (and still is) so affirming and this will forever be one of my favourite *Dazed* covers because of that; I even mentioned it in the interview for my first role at *Dazed*. It's quiet in both its portrayal of Blackness and femininity, not making a big deal about either, but capturing them candidly and beautifully. It's the nuance that Ashton brought to the role, showing the complexities of Black masculinity. If I were to be photographed, it's how I'd dream of being portrayed.

ISSUE 67, VOL. V, SPRING 2020 **MARIEKE LUCAS RIJNEVELD** PHOTOGRAPHY **VALERIA HERKLOTZ** STYLING **BIANCA RAGGI**

COME AS YOU ARE

Black lace top by **Betsy Johnson**.
Black top by **Fab 208** (77E. 7th St, NYC). Skirt from **Blackout II**. Animal belt by **Hellfire**. Shoes by **Candies**.

CHLOË SEVIGNY

Interview **Jefferson Hack**
Photography **Rankin**
Styling **Jennifer Elster**
Hair **Linda Daniele** for **Louise Vicari**
Make-up **Christine Hoffman** at **Kramer and Kramer**

Chloë is the girl of the moment. She is the unaffected actress who puts in an amazingly affective performance in *Kids*. She is the girl who, styled like a northern slag, is crouched in a pissing position, replacing Drew Barrymore for fashion company *Miu Miu*. She is the girl of the moment because the moment needs her more than she needs the attention. In a world obsessed by the fake plastic tits of Hollywood babes in fake plastic films, Chloe and *Kids* couldn't have come at a better time.

The Making of the Chloë Sevigny *Kids* Cover
by Jennifer Elster

Zebra printed dress by **Versus** by **Versace**. Cork heeled shoes from **Blackout II**.

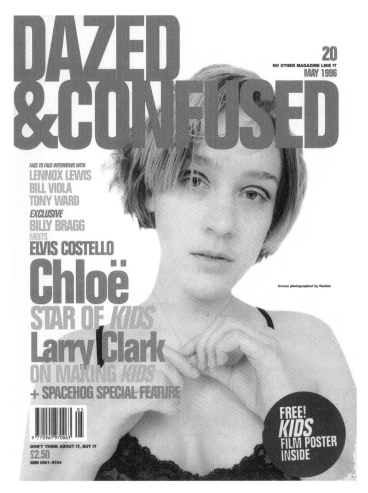

Chloë Sevigny was already en route to becoming a fashion icon at that moment in time. *Kids* had (made) a significant cultural impression. I grew up in a very dangerous New York City and had seen and been through a lot, so it was a different experience for me. Chloë had such great style and was a boundary breaker in all the different mediums she participated in.

Many of the shoots I did were how I dressed growing up. During that time I would even use my childhood neighbourhood as the location for several shoots I worked on. I was an off-to-the-side American and I think the style here exhibits that. Not being a part — wilfully. Rejecting fashion, with great taste, and at the same time being very much a part of what was happening in fashion. A (certain sense of) knowing. Chloë pulled off the style perfectly. Most could not.

Mostly I remember Chloë's laugh. She had this funny laugh, kind of snorkely in an endearing way that would make you laugh too. She was in an erratic mood the night of the shoot. Later I ran into her and she told me her father had just passed away, which explained everything. I was sorry that I didn't know at the time. My father passed when I was young too, so I understood the deep pain she must have been feeling.

Looking at this cover story now, I feel proud. I've done many different expressions of art throughout my life and I love to look back and feel something was perfect and I wouldn't have done it any other way. Linda Danielle and Christine Hoffman (who were also my friends) did an excellent job with the make-up and hair, and of course Rankin captured it with such punk style. The moment lives on.

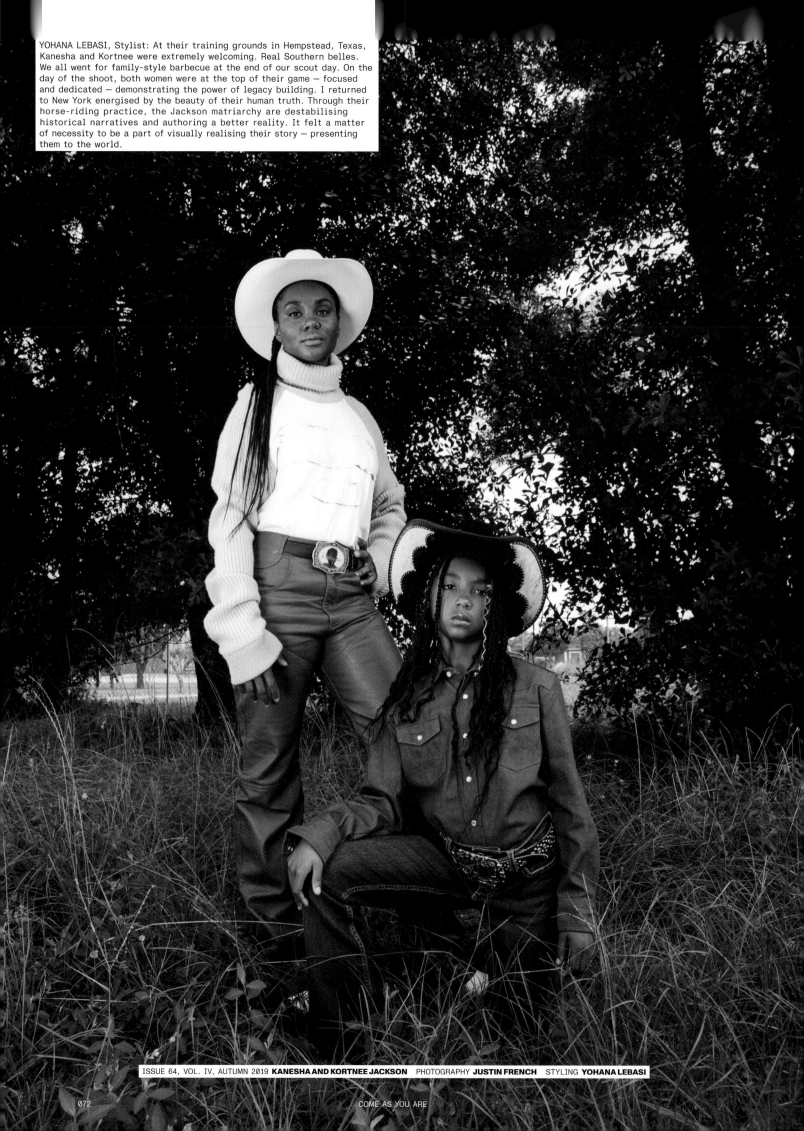

YOHANA LEBASI, Stylist: At their training grounds in Hempstead, Texas, Kanesha and Kortnee were extremely welcoming. Real Southern belles. We all went for family-style barbecue at the end of our scout day. On the day of the shoot, both women were at the top of their game — focused and dedicated — demonstrating the power of legacy building. I returned to New York energised by the beauty of their human truth. Through their horse-riding practice, the Jackson matriarchy are destabilising historical narratives and authoring a better reality. It felt a matter of necessity to be a part of visually realising their story — presenting them to the world.

PHOTOGRAPHY BY AMANDA MARSALIS

BE THE FIRST TO KNOW #MUSIC #FASHION #FILM #ART #IDEAS

DAZED &CONFUSED

JULIETTE LEWIS LEADS THE CHARGE

#INSIDE
GRIME GIRLS
KORAN ACADEMY
LORDS OF DOGTOWN
GOGOL BORDELLO
MATTHEW BARNEY
& BJÖRK

VOL.2 ISSUE #29 SEPTEMBER 2005. MADE IN THE UK
UK £3.40 IT €6.50 US $9.99 CAN $9.99

ISSUE 29, VOL. II, SPRING 2020 **JULIETTE LEWIS** PHOTOGRAPHY **AMANDA MARSALIS**

ISSUE 45, VOL. I, AUG 1998 **PJ HARVEY** PHOTOGRAPHY **RANKIN**

COME AS YOU ARE

PJ Harvey
by Claire Marie Healy

'She is a medieval sorceress who is conjuring music out of spells. She is both a conjurer of storms and a prisoner of love'.

The especially iconic thing about PJ Harvey's 1998 *Dazed* cover, I think, is that the musician has nothing to do but stand there. Three albums behind her and on the brink of arguably her most career-defining, she's a queen ascendant; for Rankin's camera, she need only stand still and stare it down. She doesn't even need to smile (that really would have been a 'world exclusive'). Because even in her absolute stillness, stormy obsessions swirl around Harvey. Like that of Dorian Berger, the creator of an unofficial PJ Harvey fan page on the internet whose confession of love opens the inside feature by Bidisha, the then-teenage, mono-monikered author. Maybe it's like the rivers she's always singing about: the way desire swirls and ebbs around Harvey, the feeling there could be anything going on underneath that watery surface. Best to just let her wild current drag you.

My relationship with PJ Harvey's music is well encapsulated by the title of the album this cover story was secured to promote: *Is This Desire?* Harvey's songs are either paeans to desire, or searing indictments of it; she's either jubilant, proud, snarling, frustrated, vengeful or really in lo-o-o-o-oove. She's never entirely happy, because she recognises that all happiness has its time limit (about 3 minutes 24 seconds). Depending on the track, she sounds like several different women, or the same woman experiencing flashbacks of different kinds of fights with herself. Even now, I can't decide if it's better to listen to the album on a blustery lockdown depression walk (*'Listen to the wind blow...'*) or head up, stalking city pavements, musing on past lovers while swinging an undersized handbag (*'Till the light shines on me... I damn to hell every second you breathe'*). In the *Dazed* interview with Bidisha, Harvey says she feels 'governed by nature', but to me it feels more like she commands it, flying above it all. Other pop singers who straddle the mainstream like to package feminine desire: they tell us, here is my desire, look at it and listen to it and buy it. It's the question mark that tells us what Polly Jean instead innately recognises: desire's ambivalence.

This *Dazed* cover, which was unstyled, directly communes with *Is This Desire?* not just in terms of timing but in atmosphere. Here, at a moment where she admits to feeling more herself than ever before, Harvey dons the same lips t-shirt that she wears on the album art, a mouth that can't speak but which says a lot. It's the kind of girlish-boyish mix that always feels powerfully direct, like the way Kim Gordon wears t-shirts. The tee works because it tells us, the audience, that Harvey has set aside the overblown make-up and skintight

hyperfemininity of her previous album cycle, wrapped it into a single image and literally put it on a plain white top. 'I always felt ugly,' reads the inside feature pull quote emblazoned in hot pink. 'I spent a lot of the time feeling like the back of a bus.' Prettiest mess you've ever seen, as Polly Jean sings five words into this, her fourth album.

Along with this new stripped-backness, this indelible cover also marks a moment in time when the musician had come out of the shadowy woods. Looking back at the cover story now, it's clear that Harvey feels at peace, and hence her most powerful, at this juncture. She makes fun of herself in the interview, saying it sounds like she's been reborn; Nick Cave isn't mentioned, but *Is This Desire?* was the album she spent a year writing after that breakup. She was drowning, and now she isn't: perhaps there's no better reason to be on the cover of a magazine. When PJ Harvey says she's 'more of me than I've ever been' in August 1998, she speaks as a woman who has reached the point where she is no longer lonely when she is alone — and what could be more powerful than that?

(Writing this, I realise that at the time of this cover, Harvey was two months shy of 29, just like me. Maybe that's why I relate to it more strongly the older I get, because I had to get through all the heartbreak first too.)

It may surprise the reader to know that I also have a space reserved in my heart for PJ Harvey's other *Dazed* cover moment, one of the multiple covers marking the 20th anniversary in 2011. For the cover concept, different figures, from Chloë Sevigny and Jarvis Cocker to Tilda Swinton, were shot, each choosing someone else to appear on their back cover — for many, a collaborator, friend or someone they felt would have a similar future impact on culture as themselves. Harvey chose a pre-*The Crown*, pre-fame Claire Foy, an actress who she had never met and simply thought was pretty good on telly the other evening. Foy, meanwhile, is confused, and evidently has never listened to Harvey, but is happy to be included (you can still watch the whole thing, incredibly, on *Dazed*'s YouTube). Here, Harvey partakes fully, all while sending up the whole thing, honestly responding to the brief, but probably not in the way the *Dazed* team had envisioned at the time. It's worth a mention as an exquisite example of Harvey's wicked witch-ness, the particular way she has always frustrated the expectations laid on her. You could say it lives in my head rent-free.

We have a tradition at *Dazed*, when it's someone's birthday, of making a magazine birthday card with the birthday girl or boy's head subbed in for the cover star. For one of mine — my 25th, I think — the beyond-obvious choice was PJ HARVEY, 1998. She Rocks.

DAZED &CONFUSED

22
NO OTHER MAGAZINE LIKE IT
JULY 1996

NENEH *EXCLUSIVE* FIRST INTERVIEW IN OVER THREE YEARS

STEVE McMANAMAN / INGRID SCHROEDER / DENNIS PENNIS IN CANNES / ICE-T MEETS GEORGE CLINTON / MALCOLM McLAREN REEF / LONGPIGS / MARC QUINN SPECIAL ARTIST'S PROJECT

CHERRY ON A SUNDAY PHOTOGRAPHED BY RANKIN

£2.50
ISSN 0961-9704

9 770961 970063 07

The 'Buffalo Stance' legend once stayed at Dame Vivienne Westwood's Ladbroke Grove flat. For more Viv, turn to page 87 or page 229.

ISSUE 22, VOL. I, JUL 1996 **NENEH CHERRY** PHOTOGRAPHY **RANKIN** STYLING **KATIE GRAND**

COME AS YOU ARE

DAZED
&CONFUSED

ISSUE 9
1994

NO TURNING BACK

FREE!
MISSION IMPOSSIBLE
20 PAGE SUPPLEMENT
SPONSORED BY SONY MINIDISC

9 770961 970056

03

£3

ISSN 0961-9704

ISSUE 9, VOL. I, 1994 **NO TURNING BACK** PHOTOGRAPHY **RANKIN** STYLING **KATIE GRAND**

KATY ENGLAND, Fashion Director: Originally, when the *Dazed & Confused* offices were in Soho, on Brewer Street, Corinne Day lived on the floor above, so there was this link between her and the magazine that was formed at the very beginning. By this time though, the offices had moved to Old Street, and this shoot actually took place in my old flat, above a post office, which was practically opposite and owned by the same landlord. Old Street was completely different back then; it was this new, totally undeveloped area and we all thought it was super cool to live in these big warehouses and do them up ourselves.

I was really excited to work with Corinne; she's obviously pretty legendary. The time when I started being really aware of fashion growing up, and being really excited about it, was when she was creating great work, and (so were) Juergen Teller, David Sims, Glen Luchford. It was

the very early 1990s, and I saw her work in *i-D* and *The Face* and was really inspired by it — her pictures were always on my moodboards, so to work with her was like a dream. It was a really big thing for me.

We worked with Alister Mackie on the shoot — Alister had a series of boys, I had a series of girls. The idea came from the Andy Warhol screen tests; we used them as an inspiration because we wanted it to look like it had been filmed. I think the pictures were stills, and then they were treated afterwards to look like they were on TV — the whole point was for it to look filmic. I know Corinne picked most of the girls; she was very, very particular about models. It is quite timeless, I think because it was never a fashion-based idea, it was all about treating them as people, and girls. We just wanted it to feel like they were talking to the camera.

ISSUE 61, VOL. I, DEC/JAN 2000 **SCREENTEST #1: GIRLS ON FILM** PHOTOGRAPHY **CORINNE DAY** STYLING **KATY ENGLAND**

COME AS YOU ARE

Bloody nickers 1995

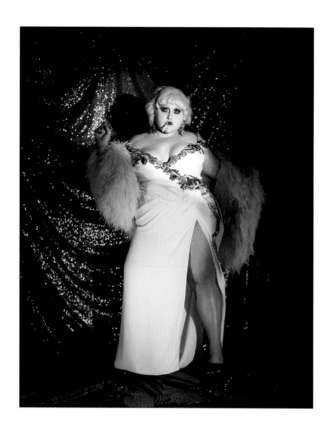

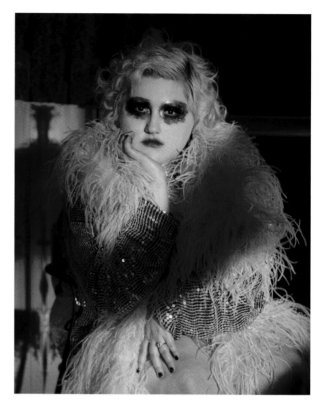

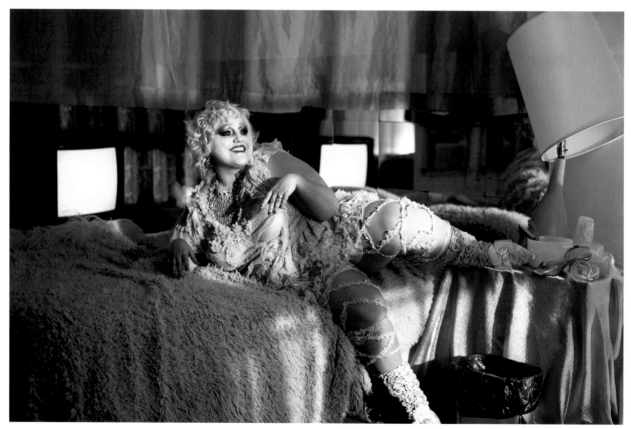

ELIZABETH FRASER-BELL, Senior Fashion Editor: Beth was so incredible to work with! I don't think I've ever laughed so much and felt so inspired when working with a celebrity. From the word go she was swearing and telling hilarious anecdotes whilst stripping off naked to excitedly try on all of the clothes. After seeing Beth walk the SS16 Marc Jacobs show in her custom white high-slit dress and feather boa, we wanted to expand on that kind of eccentric Hollywood siren character but take it further into fucked-up Mae West territory. It was so fun to work with a bunch of new designers at the time and create one-off custom looks especially for her. Molly Goddard made this beautiful black tulle dress (which Beth kept), Claire Barrow made this incredible illustrated silk top and leather shorts ensemble (I still have it in my archive) and Ryan Lo made such a cute ruffle and transparent set with matching tights and socks.

ISSUE 42, VOL. IV, WINTER 2015 **BETH DITTO** PHOTOGRAPHY **JEFF BARK** STYLING **ELIZABETH FRASER-BELL**

COME AS YOU ARE

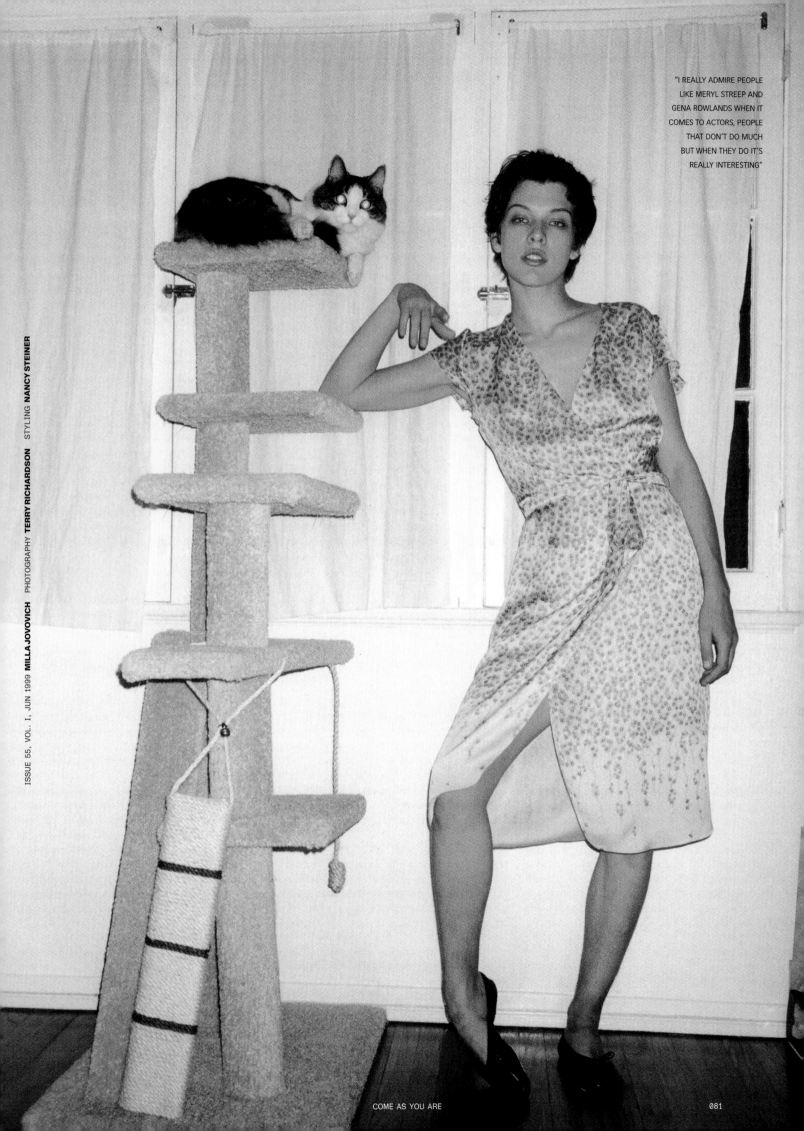

ISSUE 55, VOL. I, JUN 1999 **MILLA JOVOVICH** PHOTOGRAPHY **TERRY RICHARDSON** STYLING **NANCY STEINER**

"I REALLY ADMIRE PEOPLE
LIKE MERYL STREEP AND
GENA ROWLANDS WHEN IT
COMES TO ACTORS, PEOPLE
THAT DON'T DO MUCH
BUT WHEN THEY DO IT'S
REALLY INTERESTING"

COME AS YOU ARE

BUSY
UNMAKING
THE WORLD

3.
Busy Unmaking
the World

The line between politics, provocation and pop

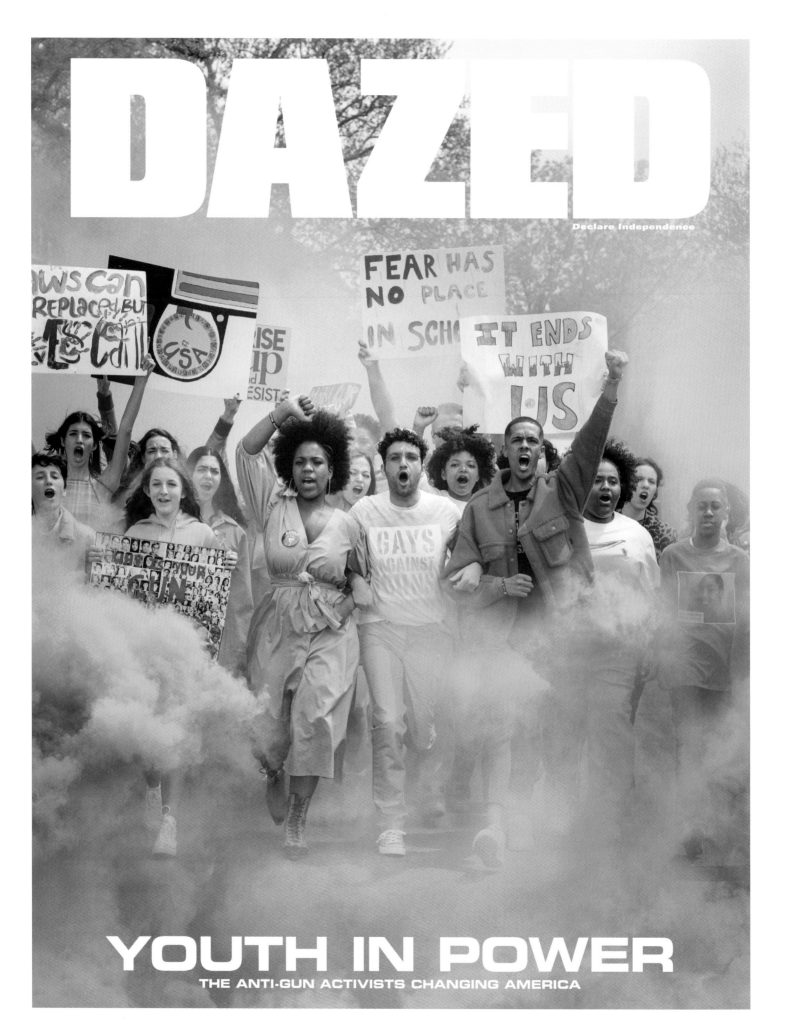

DAZED

Declare Independence

FEAR HAS NO PLACE IN SCHOOL

IT ENDS WITH US

GAYS AGAINST

YOUTH IN POWER
THE ANTI-GUN ACTIVISTS CHANGING AMERICA

ISSUE 57, VOL. IV, SUMMER 2018 **YOUTH IN POWER** PHOTOGRAPHY **RYAN MCGINLEY** STYLING **EMMA WYMAN**

BUSY UNMAKING THE WORLD

Ryan McGinley in conversation with Adam Eli

In the wake of tragic shootings across America in the 2010s, writer, organiser and campaigner Adam Eli teamed up with photographer Ryan McGinley to unite the brave young gun control activists fighting for permanent change.

The Wear Orange Campaign was started in 2013 by a group of students following the tragic death of their friend Hadiya Pendleton, a 15-year-old Black girl who was fatally shot while playing in the park. Since the inauguration of National Gun Violence Day on June 2, 2015 — on what would have been Hadiya's 18th birthday — the colour orange has become synonymous with gun safety reform. Orange is a colour that says to other hunters, 'I'm human, please don't shoot.' It was also Hadiya's favorite colour. For anti-gun violence activists, wearing orange is an act of solidarity with the victims of firearms and a demand for action from local and federal representatives.

ADAM ELI: What do you remember most from that day of the shoot? Because we shot all of this in a day.

RYAN MCGINLEY: Well, I remember coming to set and being completely mind-blown by how many pieces of orange clothing there were. I was overwhelmed and astonished. It's interesting as a photographer when you put somebody next to a certain colour — it really has an effect on their glow. So having these orange backdrops and orange photography paper and orange clothing, it basically just served as a giant sun. It was amazing watching the people we were photographing filter in, because it was a lot of high school kids with their parents. A lot of them also brought friends who wanted to see what a fashion shoot looked like. And I think it was the first time for me that I realised it was OK to have fashion and activism meet, because a lot of the time that can feel challenging. How can you talk about something so serious and match it with something that is clothing or luxury? I was worried about that. When you look at any kind of activism, the issues that people are talking about are so strong and so serious — you're talking about death and about guns and violence and the language around it can feel different than the language when you talk about fashion. But the power of fashion and imagery is undeniably so strong. When I was in high school, I was part of Peta and I was part of Amnesty International. I was young and I didn't have the (opportunity) to speak about a lot of the issues being discussed. Initially I joined those groups because the cool, punk, fashionable kids that listened to the music that I listened to were in them. So I came into those groups visually, by fashion. People who were into them wore Dr Martens. People who were into them wore vintage army clothes. Boys wore mascara.

AE: Yes, absolutely. And this is true historically as well. Activism groups and activists have always used fashion and visuals to impart their message. Think about Act Up, the anti-war movement of the 1960s, the Black Panthers, or AOC wearing white, hoops and red lipstick to her swearing-in at congress, (or) even the red MAGA hat. This cover story was, from where I am standing, a success and that was, in part, because the visuals were so strong and eye catching.

RM: Yes, it got much attention and the people that were involved in it were so excited. The kids were *so* excited to be photographed and to be photographed not only taking their message but being paid attention to in an artistic way. What were your recollections of the day?

AE: I have a lot of the same recollections from that day. I remember coming in and the stylist Emma Wyman had racks and racks of orange clothes and there was a sea of orange shoes, which I also thought was so crazy. I was shocked. I also remember that we did some photos outside which ended up being on the cover. While we were outside shooting I remember at a certain point it sounded like a gun went off. Either it was a car backfiring or a gun went off somewhere. All at once the huge group of the kids ducked and reacted to it really quickly and really intensely. That made total and complete sense because some of them are survivors of gun violence. All of them go to school every day wondering if today is going to be the day a school shooter takes one of their lives. It was just like this vivid and visceral reminder of how real what we were really doing was. Something else that is so important to me about this is that Brandon Wolf was able to be in the shoot. I was standing right next to him. Brandon is so incredible, he is a Pulse (nightclub) survivor and an extraordinary activist. I firmly believe that one day he will be an elected public official. I texted Brandon and said, 'Brandon, is there any chance that you're in New York?' He lives in Orlando, and he said, 'I'm literally in New York for like 36 hours to present at the Glaad awards,' and I'm like, 'No. Fucking. Way! That is crazy!' And so I was like, 'OK well meet me outside your hotel at like 9am and I'm gonna come and pick you up.' I got to introduce you to Brandon, which was really beautiful, and to have him there was so incredibly powerful.

RM: So how did it feel to be at a newsstand and see yourself on the cover of a magazine for the first time?

AE: It was extraordinary. It was really cool — and I'm not just saying this — to have it be *Dazed*, because *Dazed* was the first place ever to feature my work. Claire (Marie Healy) was the first person ever to reach out to me and talk to me about my activism because she saw something that I'd tweeted. It was for a portfolio of activists a while back, when Trump was elected. So it came full circle for me. To do it with two people who I really, really admire and really impacted my life — you and Brandon — was amazing.

RM: Have you worn pleather pants since that moment?

AE: I will say that the stylist — shout out Emma — let me keep them and they no longer fit.

RM: (*Laughs*) Maybe one day you'll be able to pass them onto someone. Did you have any experiences where somebody reached out to you and said, 'Oh my God, I saw you on the cover of a magazine'?

AE: Something that was really powerful was that almost across the board all of the various gun violence groups shared this cover and shared this press within the gun safety community. This was such a moment. So many gun violence groups shared this story. The story, I hope and believe, became something bigger.

ISSUE 61, VOL. IV, SPRING 2019 **ARIEL NICHOLSON & HUNTER SCHAFER** PHOTOGRAPHY **MARIO SORRENTI** STYLING **ROBBIE SPENCER**

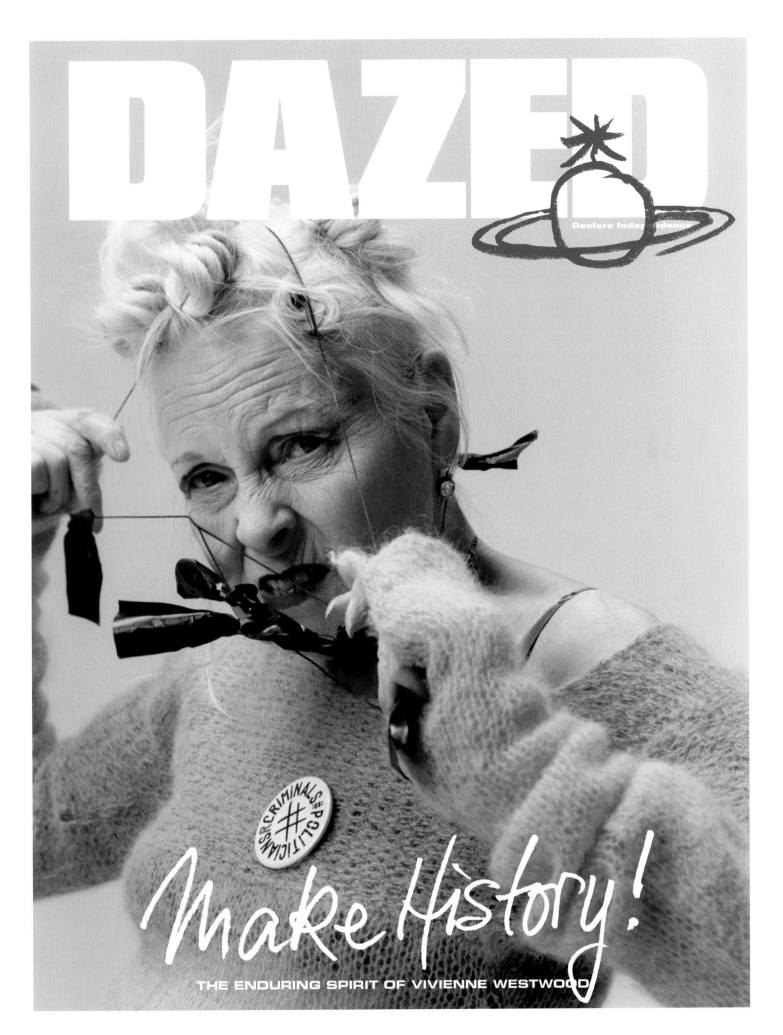

DAZED

Declare Independence

#POLITICIANSRCRIMINALS#

Make History!

THE ENDURING SPIRIT OF VIVIENNE WESTWOOD

ISSUE 57, VOL. IV, SUMMER 2018 **VIVIENNE WESTWOOD** PHOTOGRAPHY **HARLEY WEIR** STYLING **ROBBIE SPENCER**

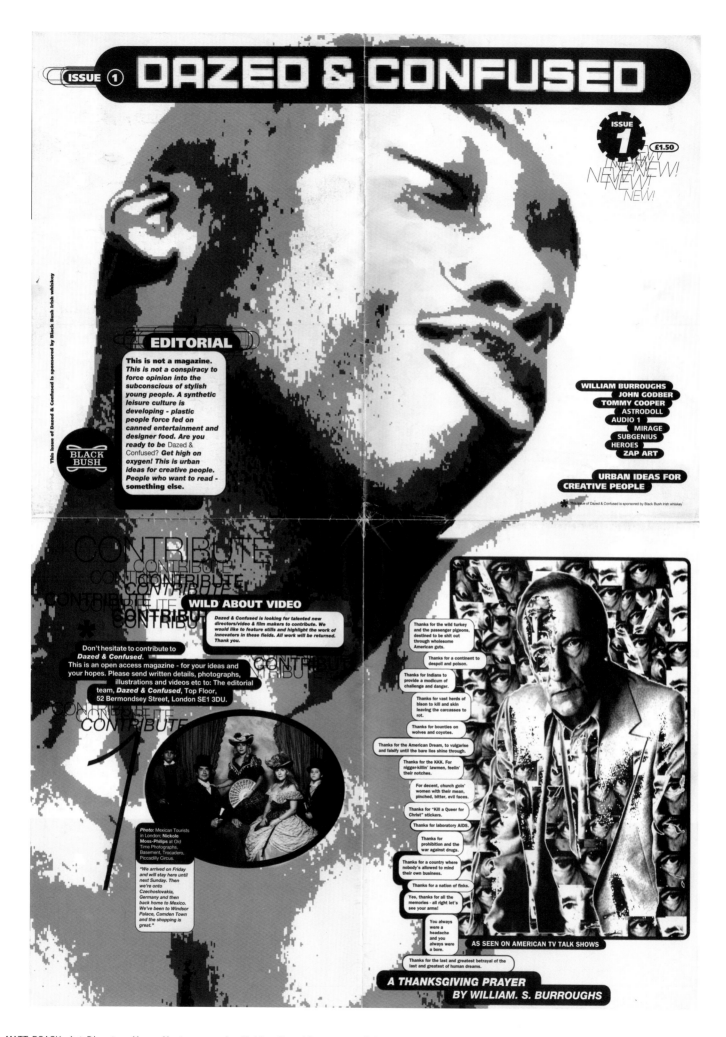

MATT ROACH, Art Director: My earliest memory is sticking *Dazed* issue one stickers all over the Tube… And stealing all the computer equipment from the LCP Student Union on a Friday night by making a human chain over three floors and then staying up all weekend working with Ian (Taylor — the original art director) to finish the issue. And then returning all the computers unnoticed (hopefully!) first thing on Monday morning…

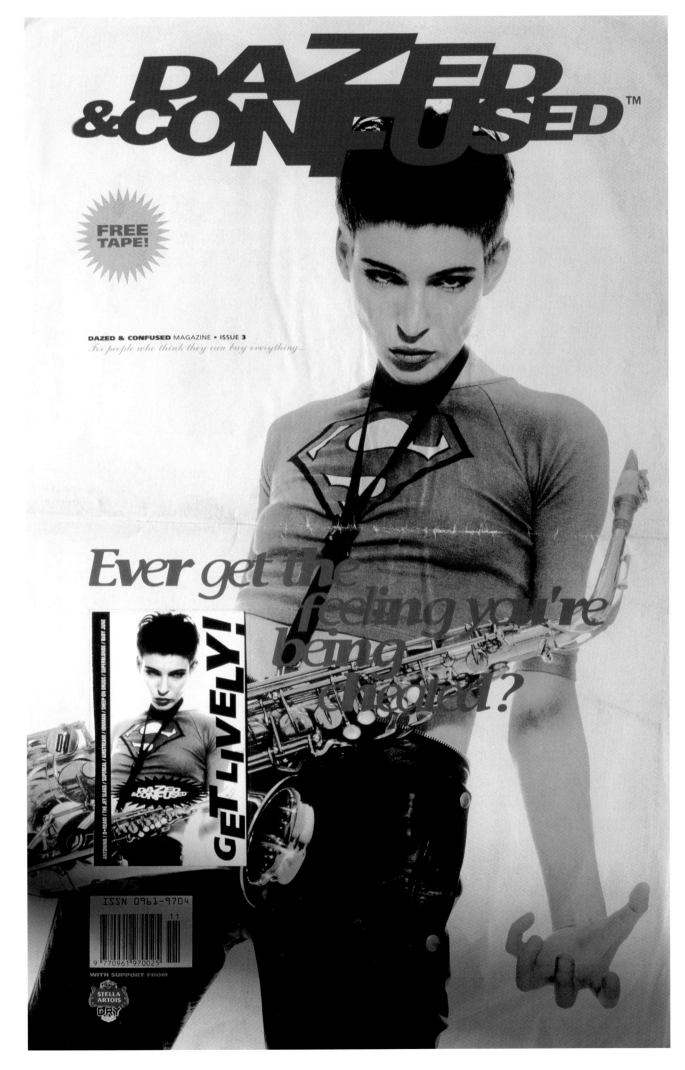

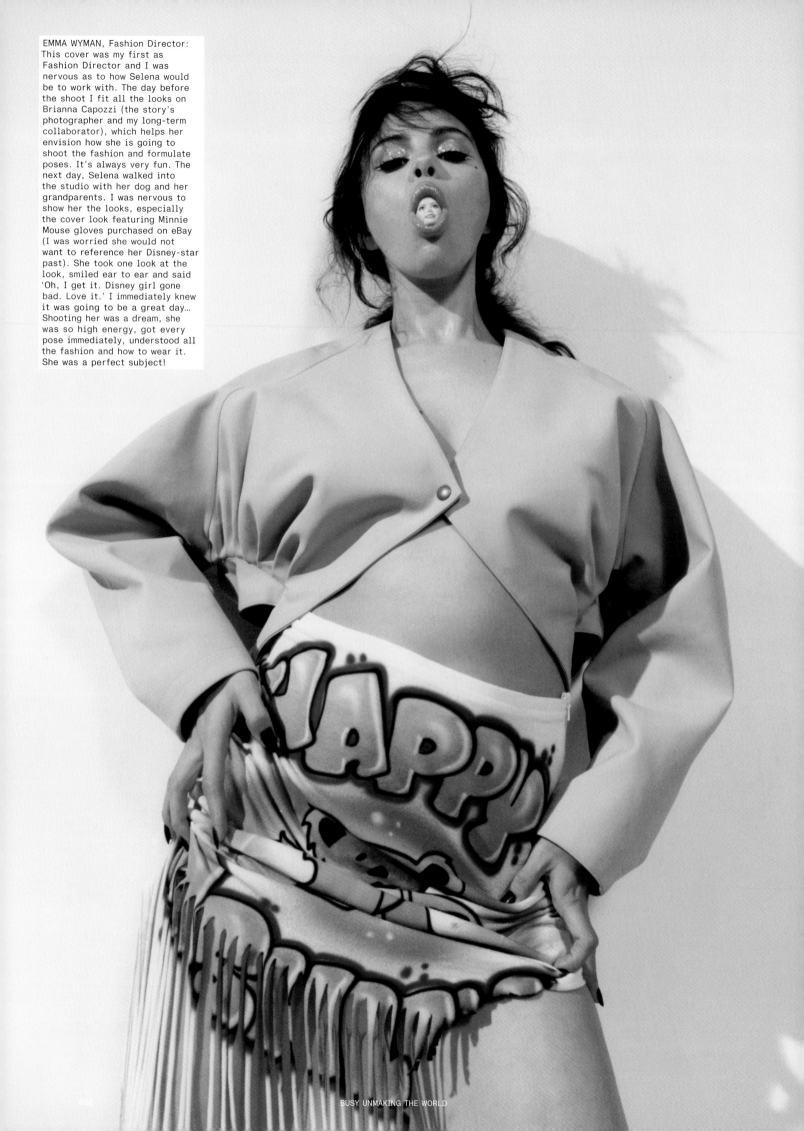

EMMA WYMAN, Fashion Director: This cover was my first as Fashion Director and I was nervous as to how Selena would be to work with. The day before the shoot I fit all the looks on Brianna Capozzi (the story's photographer and my long-term collaborator), which helps her envision how she is going to shoot the fashion and formulate poses. It's always very fun. The next day, Selena walked into the studio with her dog and her grandparents. I was nervous to show her the looks, especially the cover look featuring Minnie Mouse gloves purchased on eBay (I was worried she would not want to reference her Disney-star past). She took one look at the look, smiled ear to ear and said 'Oh, I get it. Disney girl gone bad. Love it.' I immediately knew it was going to be a great day... Shooting her was a dream, she was so high energy, got every pose immediately, understood all the fashion and how to wear it. She was a perfect subject!

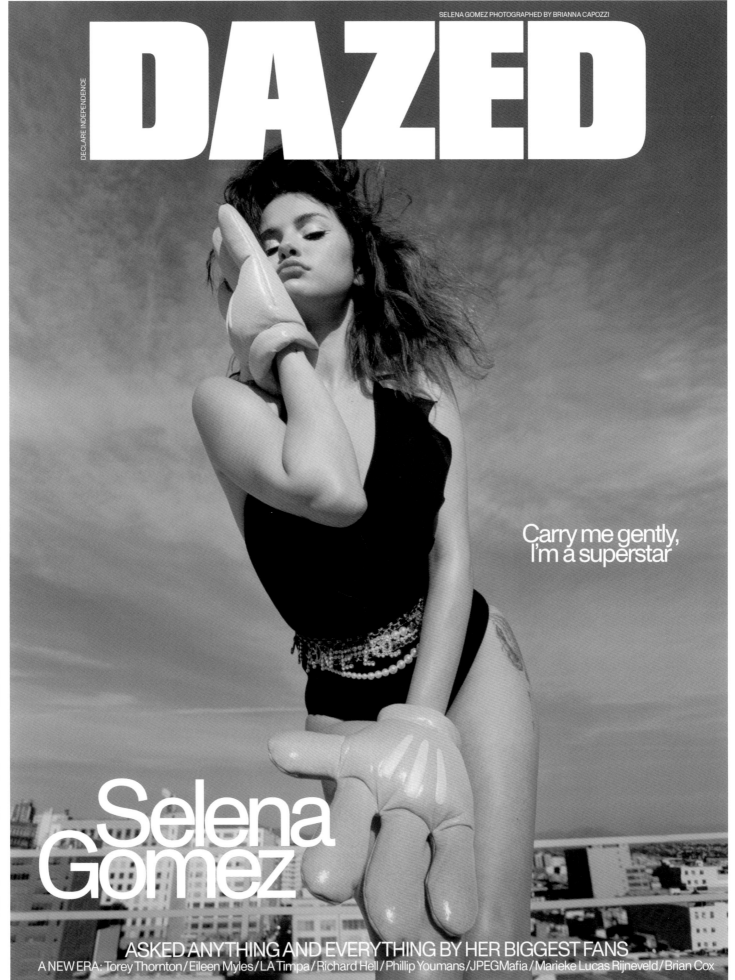

SELENA GOMEZ PHOTOGRAPHED BY BRIANNA CAPOZZI

DECLARE INDEPENDENCE

DAZED

Carry me gently,
I'm a superstar

The 2010s were a good time for zombies, weren't they? Selena starred in Jim Jarmusch's zomedy *The Dead Don't Die* with, honestly, everyone: Bill Murray, Adam Driver, Tilda Swinton, Iggy Pop and Chloë Sevigny. Go to page 194 for more Iggy, pages 196 and 221 for more Tilda, and pages 70 and 198 for more Chloë.

Selena Gomez

ASKED ANYTHING AND EVERYTHING BY HER BIGGEST FANS

A NEW ERA: Torey Thornton / Eileen Myles / LA Timpa / Richard Hell / Phillip Youmans / JPEGMafia / Marieke Lucas Rijneveld / Brian Cox

ISSUE 67, VOL. V, SPRING 2020 **SELENA GOMEZ** PHOTOGRAPHY **BRIANNA CAPOZZI** STYLING **EMMA WYMAN**

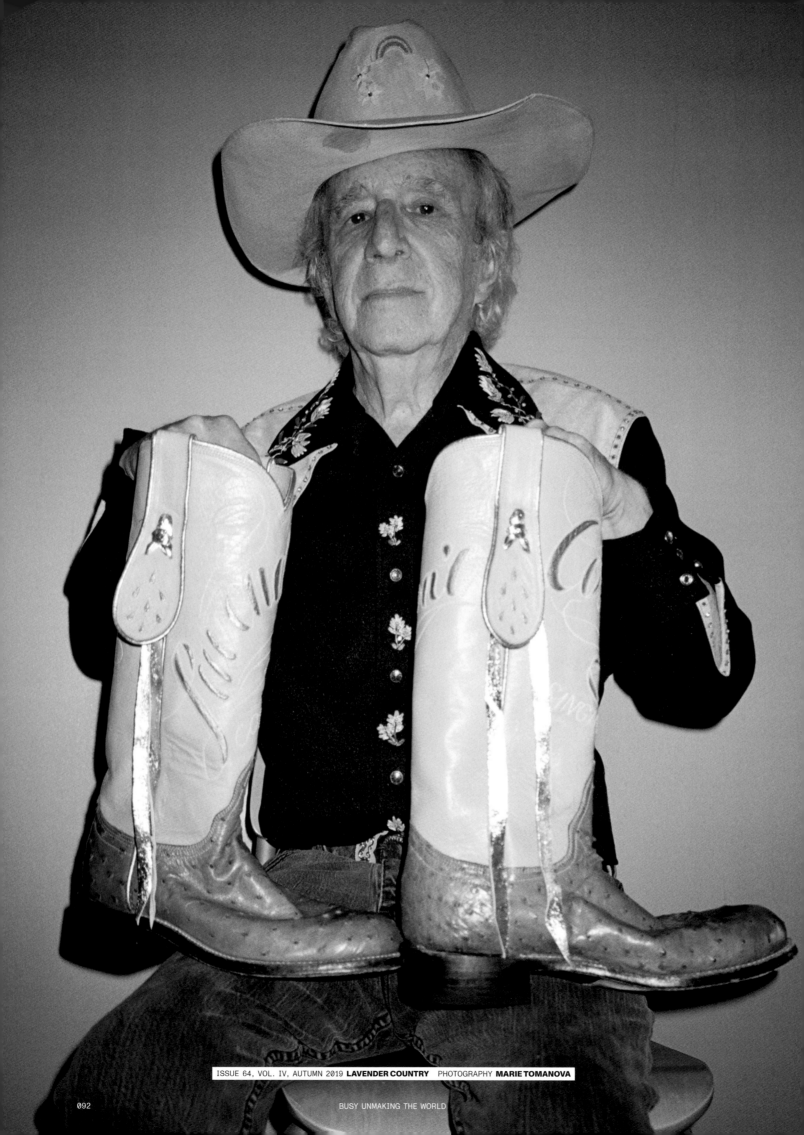

DAZED

DECLARE INDEPENDENCE

ISSUE 70, VOL. V, A/W 2020 **PA SALIEU** PHOTOGRAPHY **GABRIEL MOSES** STYLING **RAPHAEL HIRSCH**

Pa Salieu

prophecies

RAPHAEL HIRSCH, Fashion Editor: The Shaun Leane moment with Pa was inspired by the Deana Lawson image of two guys on a brown leather couch with one holding a remote control and the other with a gold mouth piece. I was speaking to the amazing man who manages The Arc, an archive place I usually go to for shoots, and I showed him the references of what we were doing, and on seeing the Deana Lawson image he mentioned that it reminded him of the Shaun Leane Jaw Bone, and I had been trying to find something in the same world. We spoke to the Shaun Leane team and luckily the Jaw Bone was available from his archive and Pa was open to wearing it. Pa had been shot in the head earlier in the year so the metal Jaw Bone served as a metaphor for a strengthening of self after that experience. It felt apt.

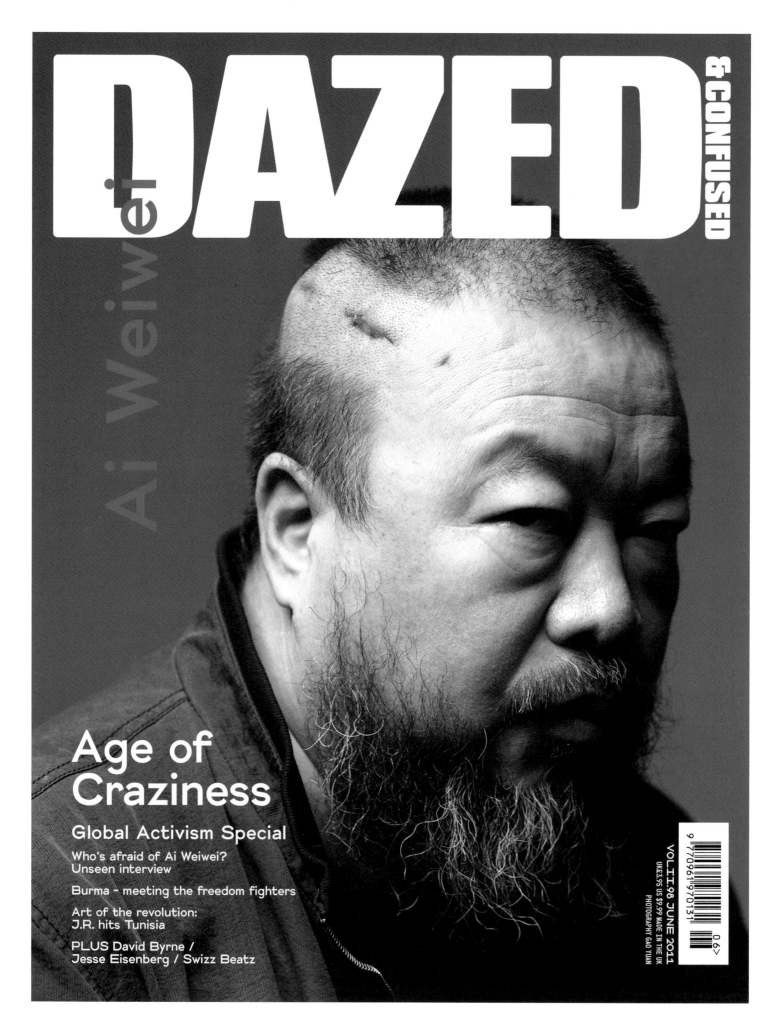

ISSUE 98, VOL. II, JUN 2011 **AI WEIWEI** PHOTOGRAPHY **GAO YUAN**

BUSY UNMAKING THE WORLD

The Making of the Ai Weiwei Cover
by Roderick Stanley

It was a few days after we had confirmed Ai Weiwei for the cover feature that he disappeared. When the magazine was published, Ai's whereabouts were still unknown.

For two weeks, the Chinese government offered no word on his location, only stating he had been arrested for 'economic crimes'. About 50 police officers had also surrounded Ai's studio, searching it and taking away laptops and hard drives, while a number of people connected with Ai, including staff members, had also disappeared.

It was 2011, and we had all been working on the special activism Summer issue. It had been a tumultuous few years following on from the 2008 financial crisis — Occupy, Arab Spring, UK student protests — and we wanted to highlight the individuals and movements around the world fighting for a better future.

Our writer William Oliver was set to talk to Ai about his upcoming solo exhibitions at the Lisson Gallery, and at Somerset House (*Circle of Animals / Zodiac Heads*), when, a few days later, we received news that Ai had been detained and that the interview was cancelled. As a magazine, we decided to press ahead with a cover story without either an interview or a shoot, as we felt it was important to support Ai and stand up for freedom of expression. The gallery was supportive and supplied us with an image that we used on the cover — a portrait of Ai, by Gao Yuan, with part of his head shaved (taken the preceding year following emergency brain surgery to treat a haemorrhage from a beating by Chinese police).

The cover Christopher Simmonds (*Dazed*'s creative director) designed with the image was the subject of much internal argument, and a pitched battle ensued between different camps about whether it was an appropriate image for a 'fashion magazine', and whether it would 'scare away' readers and advertisers. Eventually, the arguments went above my head and reached Jefferson's inbox. He came to sit at my desk and asked to see the mocked-up cover. I took a deep breath, then made an impassioned case for why we should run it. He agreed and the cover ran.

Ai's profile as an artist had grown hugely in the UK since the preceding year's *Sunflower Seeds* installation at the Tate Modern, and his work as an activist holding the Chinese state to account for its human rights abuses was well known. At the start of Ai's career, he created a provocative photo series of himself dropping and smashing a 2,000-year-old Han dynasty urn. He also launched an independent investigation into the 2008 Sichuan earthquake, which claimed 60,000 lives — many of them children in poorly built schools, a fact the government tried to keep quiet.

Ai's blog collected and publicised the names of 5,000 child victims to a growing audience before it was shut down by the government. He continued his campaign via social media, and in 2009 commemorated the lost children by covering the facade of Munich's Haus der Kunst with 9,000 backpacks for a piece called *Remembering* — a powerful statement against Chinese state censorship.

After the issue launched, *Dazed* joined the campaign to free Ai, urging readers to write letters to the Chinese ambassador, while William spoke to leading figures in the art world about his disappearance for the feature. Here we are, ten years later.

We were right. It is the Age of Craziness.

DAZED

Declare Independence

'I noticed her immediately from across the room. She was wearing a long black coat, heavy black boots and had short, spiky blue hair. She looked pretty punk for a 12-year-old.' Turn to page 161 to find out who Amandla said this about.

A YOUNG AMERICAN
AMANDLA STENBERG
ASHTON SANDERS, NO BRA, ELYSIA CRAMPTON, SAMPHA & MORE RISE UP

ISSUE 49, VOL. IV, SPRING 2017 **AMANDLA STENBERG** PHOTOGRAPHY **BEN TOMS** STYLING **ROBBIE SPENCER**

BUSY UNMAKING THE WORLD

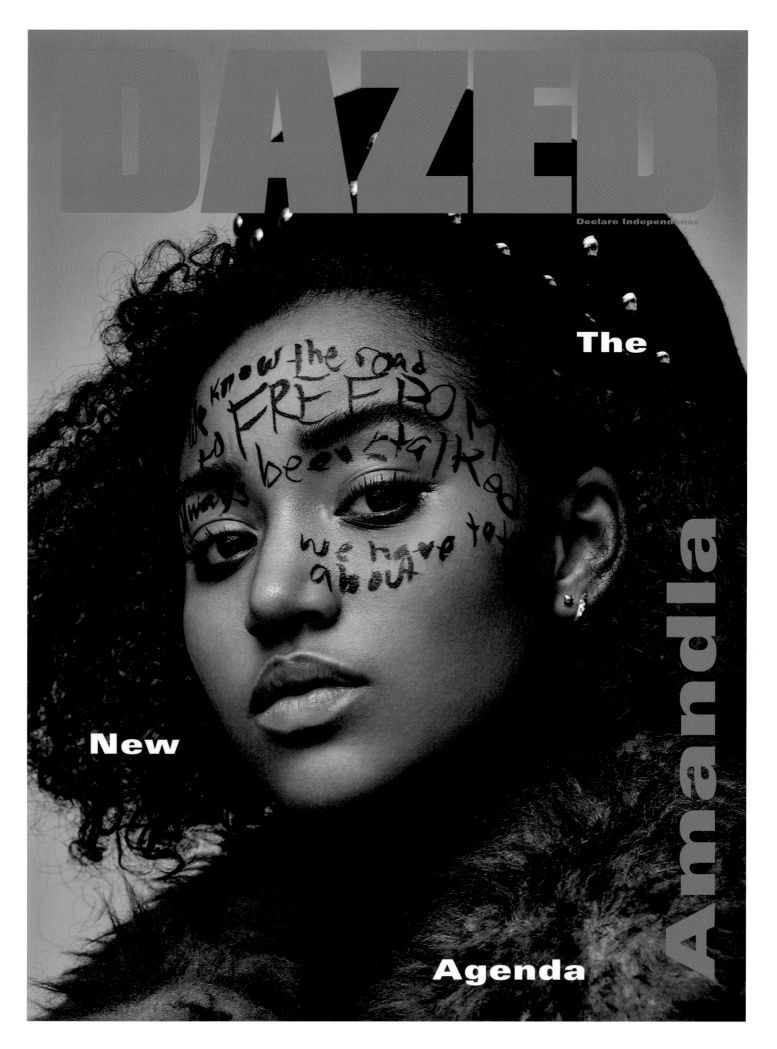

THE FIRST TO KNOW #MUSIC#FASHION

DAZED

& CONFUSED

The Freedom Issue: Know Your Rights

BUSY
UNMAKING
THE WORLD

They blind your eyes and drain your brain

VOL.2 ISSUE#39 JULY 2006
UK £3.40 IT €6.95 US $8.99 CAN $9.99. MADE IN THE UK
COVER BY BARBARA KRUGER

ISSUE 39, VOL. II, JUL 2006 **BUSY UNMAKING THE WORLD** ARTWORK **BARBARA KRUGER**

In 2006, *Dazed* asked Barbara Kruger to create an original artwork for the cover of the 'Freedom Issue', a special edition that explored social, political and personal oppression in the 21st century. Commissioned by Mark Sanders, the magazine's former long-standing arts editor, the resulting cover image was an act of subversion disguised as advertising—the monochrome image of a needle pointed precariously over a human eye.

Barbara Kruger: I try to make work about how we are to one another: our adoration, contempt, desire, disgust, hopes and fears. The work is seldom 'event' based, but rather, tries to engage the gathering of moments that record the actions, liberations, subjugations, caresses and punishments that construct the everyday and collect themselves into commentaries that are sometimes called histories.

Mark Sanders: The contribution by Barbara Kruger for the *Dazed* 'Freedom Issue' in 2006 was an amazing coup for the magazine. I had left the *Dazed* family by then, but as the past arts editor for the magazine throughout the 90s I knew Barbara well, as she had completed a full eight-page artists project for me for issue 21 of *Dazed* back in June 1996. For the 'Freedom Issue', I invited Barbara to take the whole cover of the magazine and intervene with total freedom. With what the Situationist International might refer to as an act of detournement, she stamped the cover with an image of an eye being forced open and a surgical implement hovering above the pupil and then added the strapline 'Busy Unmaking the World', followed by 'They blind your eyes and drain your brain'. Not content with just one artist taking over the cover of *Dazed*, I also invited Damien Hirst, who supplied an image of a naked male torso with a bullet wound. Both covers were intended to be an act of subversion from within, meaning that, as a magazine, *Dazed* had the self-honesty to understand its role within the media landscape and then turn that on its head by creating a platform for freedom of expression by two of the leading artists of the day. Not a profile piece but a real statement of intent, a proactive act of engagement with its audience and beyond.

AHMAD SWAID, Head of Content: When I was growing up in places like Beirut, Aleppo and Sierra Leone, magazines were my portal to accessing the culture of what seemed like a distant fantasy world. It was my last year of high school and I had come to London for the summer and I came across an issue of *Dazed* on a newsstand. It must have been the Barbara Kruger issue. It was so bold and looked so different to everything else that was on the rack, it spoke to me. I didn't know what it was but I knew that it was something very important that I had to have.

DAZED&C

23

NO OTHER MAGAZINE LIKE IT
ISSUE23 AUGUST96 €2.50
ISSN 0961-9704

THE ALL-GIRL CLUB THE FEMA

LEFT TO RIGHT: MARTINA (TRICKY), LOU (LAMB)

COOL, CREDIBLE & COLLECTED HERE:

SPECIAL FASHION ISSUE

BJÖRK INTERVIEWS AVANT-GARDE COMPOSER KARLHEINZ STOCKHAUSEN

BEASTIE BOYS: FREE TIBET VIDEO DIARY

+ SPECIAL ARTIST'S PROJECT BY HELEN CHADWICK

THE ALL-GIRL CLUB PHOTOGRAPHED BY RANKIN

9 770961 970063

ISSUE 23, VOL. I, AUG 1996 **THE ALL-GIRL CLUB** PHOTOGRAPHY **RANKIN** STYLING **KATIE GRAND**

BUSY UNMAKING THE WORLD

ONFUSED

VOICES IN DANCE MUSIC SPEAK OUT

DEDER, RUTH-ANN (OLIVE), ROBA (ATTICA BLUES), RÓISÍN (MOLOKO), SKYE (MORCHEEBA), LESLEY (RUBY), BETH ORTON, KELLI (FAKED PHILS), ANDREA PARKER, NICOLETTE

RANKIN, Co-founder and Publisher: This is one of my favourite covers. We were a bit obsessed by *Vanity Fair* and their fold-out covers. At the time I was working (with) a few different female vocalists who were fronting up bands. I suddenly looked around and thought that's so exciting, why don't we do a big thing on it and sell it to Levi's and get them to pay for us to do it?! I don't really want to say it but we kind of invented advertorials…

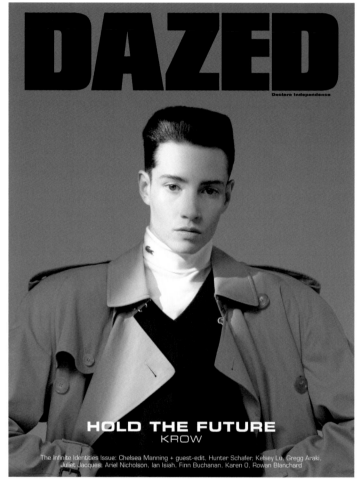

ISSUE 61, VOL. IV, SPRING 2019 **FINN BUCHANAN**
PHOTOGRAPHY **SHARNA OSBORNE**
STYLING **HALEY WOLLENS**

ISSUE 61, VOL. IV, SPRING 2019 **KROW**
PHOTOGRAPHY **SEAN AND SENG**
STYLING **ROBBIE SPENCER**

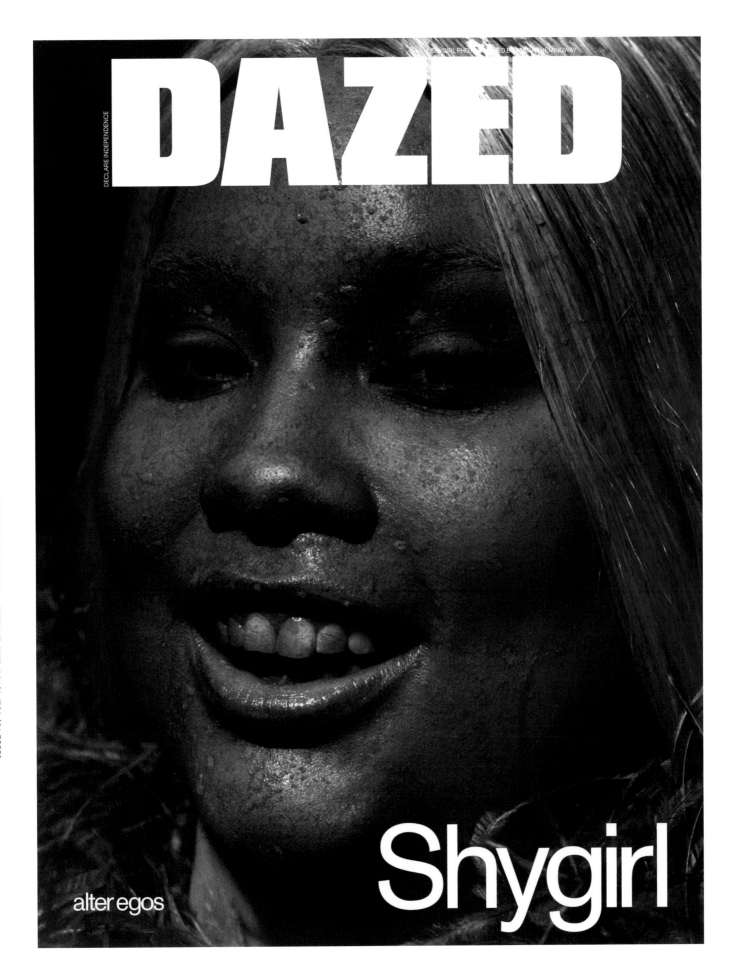

DAZED

DECLARE INDEPENDENCE

STYLING **NELL KALONJI** PHOTOGRAPHY **JORDAN HEMINGWAY** **SHYGIRL** ISSUE 70, VOL. V, A/W 2020

alter egos

Shygirl

NELL KALONJI, Senior Fashion Editor-at-Large, *AnOther*: This was one of my favourites. Watching Shy transform with every look was captivating. It was an amazing collaboration between everyone on set and I think that shows in the images. We had fun… a lot of fun showing the many faces of Shygirl.

ANNA CAFOLLA, Editor, *Dazed Digital*: My first cover story for *Dazed*! It was a joy to speak to an artist who has such an incisive point of view, who isn't afraid to make people uncomfortable. Her concepts are so elastic, but she is so in control of the universe she's creating for herself and a host of collaborators that I think will define the future of music. It's an interview that somehow encompasses clubbing, sci-fi fantasy epic *Dune* and Jane Austen, and our shared love of long acrylic nails. I think she represents the real spirit of *Dazed*. The cover and shoot, lensed by Jordan Hemingway, is so powerful and hot!

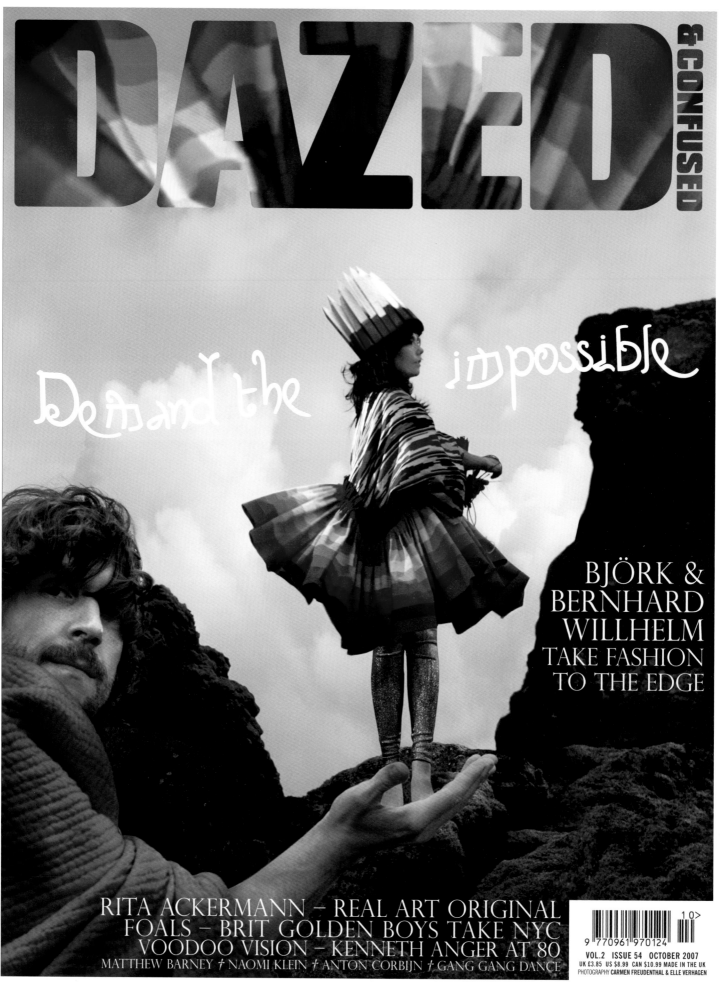

DAZED &CONFUSED

Demand the impossible

BJÖRK &
BERNHARD
WILLHELM
TAKE FASHION
TO THE EDGE

RITA ACKERMANN – REAL ART ORIGINAL
FOALS – BRIT GOLDEN BOYS TAKE NYC
VOODOO VISION – KENNETH ANGER AT 80
MATTHEW BARNEY † NAOMI KLEIN † ANTON CORBIJN † GANG GANG DANCE

10>
9 770961 970124

VOL.2 ISSUE 54 OCTOBER 2007
UK £3.85 US $8.99 CAN $10.99 MADE IN THE UK
PHOTOGRAPHY CARMEN FREUDENTHAL & ELLE VERHAGEN

Which model said that Björk makes her feel like a swan in her February 2019 cover story? Float to page 86 to find out.

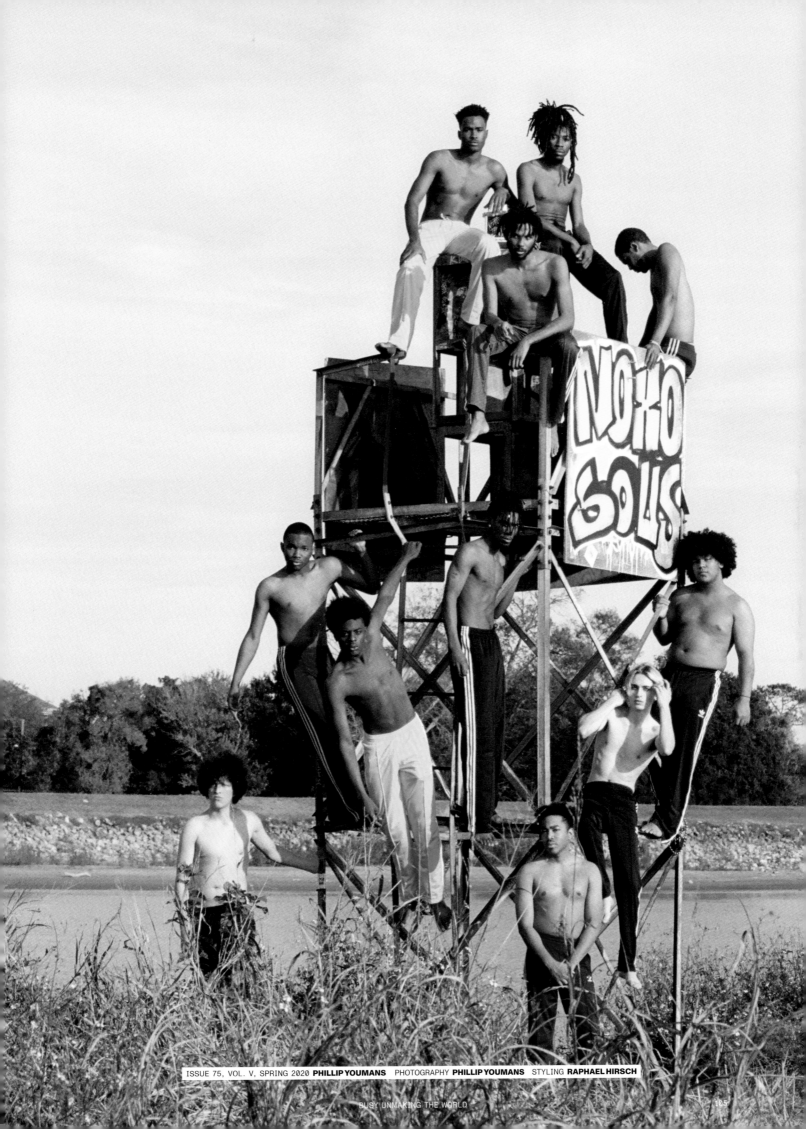

ISSUE 75, VOL. V, SPRING 2020 **PHILLIP YOUMANS** PHOTOGRAPHY **PHILLIP YOUMANS** STYLING **RAPHAEL HIRSCH**

BUSY UNMAKING THE WORLD

D/\ZED

&CONFUSED

WORLDWIDE SPECIAL
GLOBAL FASHION

DISCO HEROES
HERCULES &
LOVE AFFAIR

BLOOD BROTHERS
PAUL DANO & PAUL
THOMAS ANDERSON

ZOMBIE ROCKERS
KAREN O & TINY
MASTERS OF TODAY

SPRING COLLECTIONS
PART TWO

PLUS

MGMT
MICHAEL PITT
BLACK KIDS
PATTI SMITH
LYKKE LI
JEAN-PAUL
GAULTIER

AROUND
THE
WORLD
LOVEFOXXX AND
CSS IN BRAZIL

VOL.2 ISSUE #59 MARCH 2008
UK £3.85 US $10.99 CAN $11.99 MADE IN THE UK
PHOTO MATT IRWIN STYLING KAREN LANGLEY

ISSUE 59, VOL. II, MAR 2008 **LOVEFOXXX** PHOTOGRAPHY **MATT IRWIN** STYLING **KAREN LANGLEY**

BUSY UNMAKING THE WORLD

DAZED

Declare Independence

ISSUE 66, VOL. IV, WINTER 2019 **NATHAN WESTLING** PHOTOGRAPHY **ROE ETHRIDGE** STYLING **ROBBIE SPENCER**

NATHAN WESTLING
Kindred Spirit

THE FAMILY TIES ISSUE: SAOIRSE RONAN & LAURA DERN, BJÖRK, CHELSEA WERNER, ATLANTICS
DANIEL JOHNSTON, FREDRIK TJÆRANDSEN, ED ATKINS, HAUS OF US, NOAH JUPE

AMY ROSE SPIEGEL, Writer-at-Large: For the last *Dazed* cover I wrote, I talked to a young skater and model, Nathan Westling, who I believe was only inclined to open up to me because I had a black eye that took up half of my face.

IF YOU CAN'T AFFORD IT, STEAL IT.

06

9 770961 970056

ISSN 0961-9704

£2.50

4.
If You Can't Afford It, Steal It

The paradigm-shifting figures who ripped up the rule book

Dazed was myself and Jefferson's idea (when) we met at college. I was trying to find an editor, a writer actually, (so) I put a notice up asking if anybody wanted to work on a college magazine. He was the only person who turned up for the meeting! He was really interested in crystals and jazz — I immediately liked him. We weren't interested in fashion at all, really, we were both interested in art, and music. We were very interested in Andy Warhol's *Interview* magazine; in a way we were kind of influenced by punk even though we weren't punks. We wanted to create a piece of art, really. That's the thing — if you think about the philosophy behind it, it's about creating culture, it's not about reflecting culture and I think that very much came from the punk scene of just doing it yourself.

We literally grew up in public. A lot of people that came through our offices, our teams, saw these two kids — because we were kids, making this thing — and they thought, 'Fucking hell, if they can do it we can do it.' We just happened to be doing that at the same time as Brit pop, and the YBA movement was happening, and they all had this similar attitude. Which was, 'Why can't we just do this ourselves?' And I think that that still pervades the magazine when I look at it — I'm always impressed how that philosophy is still there. One of the other things that is really interesting about (me and Jefferson) is (that) we're kind of yin and yang: we had the same intent but we were very opposite. And what was really interesting was that we both knew that we would only have a certain amount of time to do it, and then we would have to hand it over to younger people. When we started it we said that — we said we're not going to hang onto this, we're going to pass it down through time and hopefully it will have an existence of its own.

We wanted to be a platform before there was such a thing as a platform. Now people talk about platforms and verticals but that's what we wanted, we wanted to be a platform with these verticals that were all coming from the same ideology but were very different — and that's why we were always looking for people to collaborate with. Katie (Grand) will always say my problem is I always want to have an idea, I never wanted to show the clothes, but that was the point of it. For me, it was like what's the point of doing it unless it's *more than a magazine*?

Rankin

AS TOLD TO **CLAIRE MARIE HEALY**

IF YOU CAN'T AFFORD IT, STEAL IT

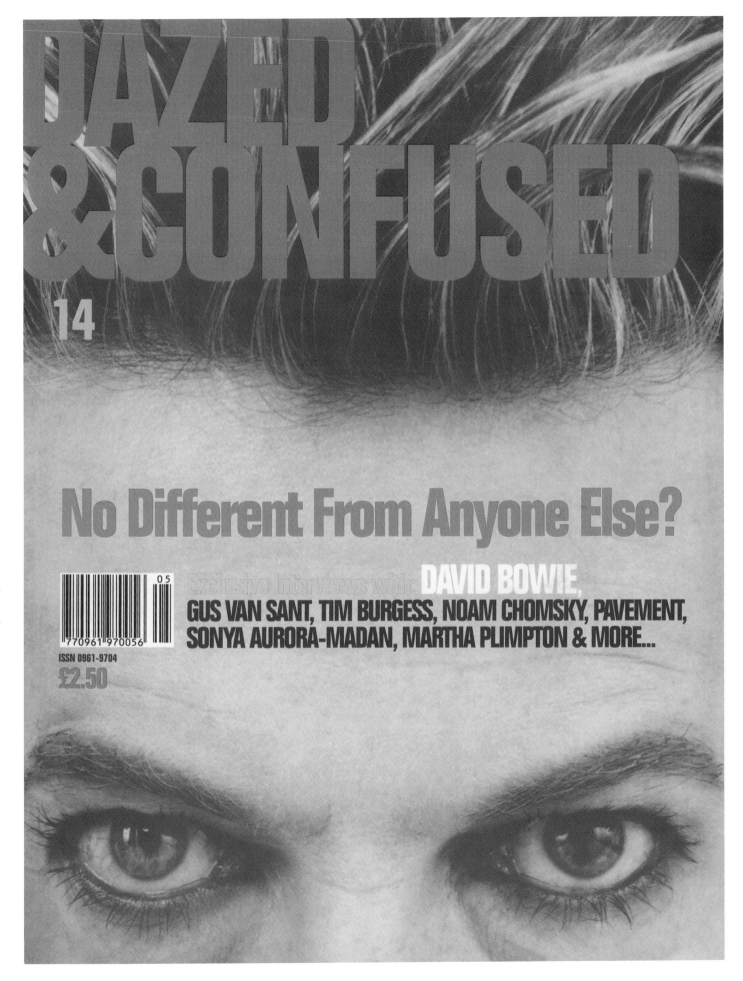

ISSUE 14, VOL. I, 1995 **DAVID BOWIE** PHOTOGRAPHY **RANKIN**

DAZED &CONFUSED

14

No Different From Anyone Else?

Exclusive interviews with **DAVID BOWIE,**
GUS VAN SANT, TIM BURGESS, NOAM CHOMSKY, PAVEMENT,
SONYA AURORA-MADAN, MARTHA PLIMPTON & MORE...

ISSN 0961-9704
£2.50

JEFFERSON HACK, Co-founder and Publisher: David Bowie with Rankin in LA was the craziest cover I ever worked on, more because of how young we were and how mega the situation was. David Bowie had asked his record company to track us down because he liked the magazine — this was after we had only about ten issues out! He wanted us to fly to LA to shoot and interview him. I felt like I was tripping. Rankin had never shot in a studio before. Neither of us had ever been to LA, let alone interviewed or photographed anyone of the level of David Bowie. I remember the record company put me up at the legendary Sunset Marquis hotel and I had no credit card or money of any kind for the incidentals so the hotel management took everything out of the room, including the telephone... David Bowie told me the filthiest joke any rock star has told me and I printed it.

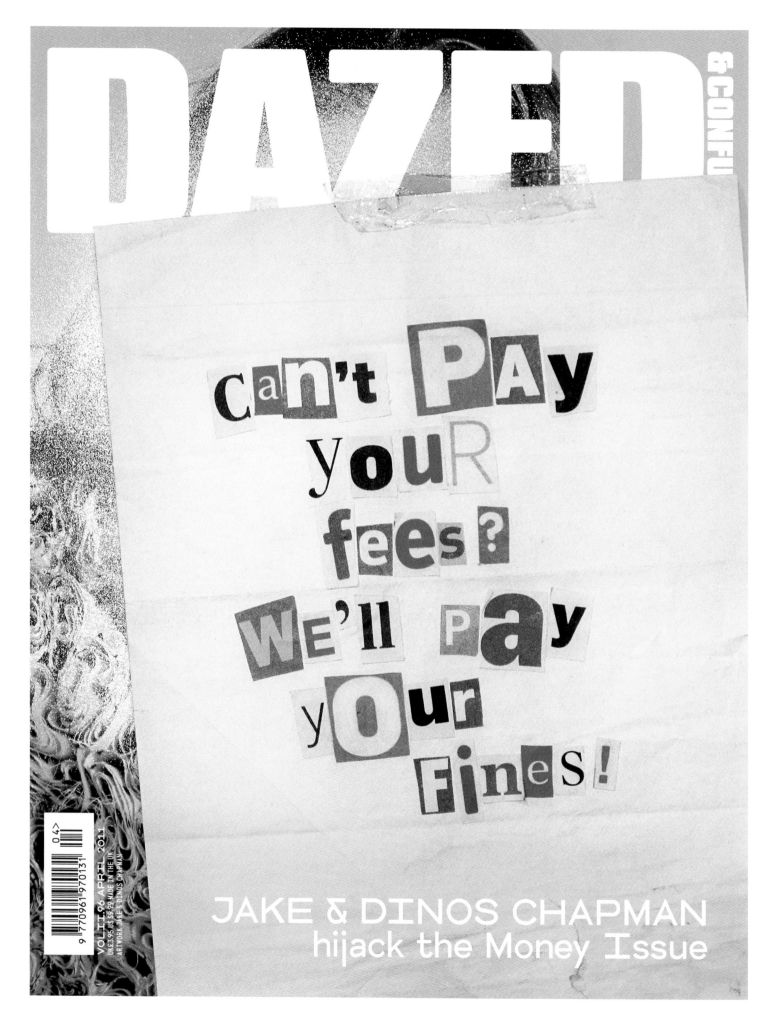

DAZED & CONFU

VOLIII.96 APRIL 2011
UK£3.95 US $9.99 MADE IN THE UK
ARTWORK JAKE & DINOS CHAPMAN

04

9 770961 970131

Can't Pay youR fees? We'll pay yOur Fines!

JAKE & DINOS CHAPMAN
hijack the Money Issue

ISSUE 96, VOL. II, APR 2011 **CAN'T PAY YOUR FEES? WE'LL PAY YOUR FINES** ARTWORK **JAKE & DINOS CHAPMAN**

IF YOU CAN'T AFFORD IT, STEAL IT

The Making of the 'Can't Pay Your Fees? We'll Pay Your Fines' Cover by Jake Chapman

The cover was simply a ransom note... we were in a hurry.

'Can't Pay Your Fees? We'll Pay Your Fines' embodied utter disdain for the Cameron-Clegg coalition and sympathy for the student protests. We wanted to invite those who had benefited from state-funded education to voice their objection to the free market re-brand, not least because it was a blatant piece of Tory social engineering, but also because even by the standards of productivity, it was false (*us*, all being the proof).

Dazed & Confused was swift to respond, and many individuals signed up — but attempts to corral many others with significant cultural clout were astonishingly disappointing. Reasons for declining endorsement for 'Can't Pay Your Fees? We'll Pay Your Fines' ranged from lame pacifism (objecting to student violence) — or, even more shocking, certain infamous artists had come to disregard the gift of taxpayers' schools, to see their own exceptionalism as the combination of individual struggle and God-given talent (a neoliberal personification).

The implication being that students would do better to stop complaining and engage the stringent principles of aggressive competitiveness that might lead to the same lofty heights. As a consequence, the campaign faltered, since it was difficult to demonstrate anything other than a high net strata of bloated neoliberals with amnesia for the very circumstances that enabled them to embark on their journey of self-discovery and societal obliteration.

Our necrospection was never mournful, never a matter of sentimental impasse. Rather, it was an experiment in radical negativity — less a sentiment of apologetic failure than an incitement to collapse. 'Can't Pay Your Fees? We'll Pay Your Fines' was certainly more direct (than our usual work), and if it was more politically on-the-nose it was because it responded in the moment of unrest, but also because beneath the dark underbelly of every baying pessimist is a friendly, fluffy optimist...

Mark (Fisher, who spoke to Jake for the *Dazed* cover story) has shown how '*anti-capitalism is widely disseminated in capitalism*', since it acts out a fundamental opposition under the pretext that it's *impossible to imagine the end of capitalism*. Anti-capitalist critique reinforces capital by participating in its modification, accepting greater market freedom within neoliberal commerce as the compromise gained through protest. The shift from state funding towards financial loans underwritten by banks was also a shift in the perception of students to atomised consumers and risk-taking entrepreneurs, subject to the impersonal laws of the market. This was clearly unacceptable.

So 'Can't Pay Your Fees? We'll Pay Your Fines' was an attempt to confront the government's decision to commodify higher education by an appeal to *capitalise protest*. Funds would be found to pay the fines of those students arrested during demonstrations, so that the students could *compete in the free market of capitalist protest* without punitive fines inhibiting their 'enterprise'.

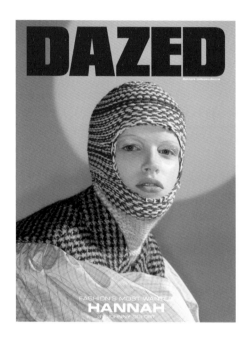

FASHION'S MOST WANTED
HANNAH
BY JOHNNY DUFORT

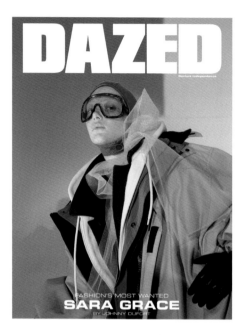

FASHION'S MOST WANTED
SARA GRACE
BY JOHNNY DUFORT

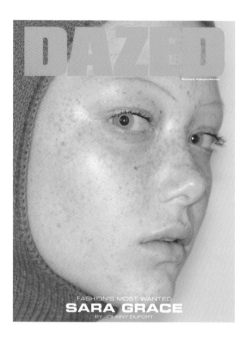

FASHION'S MOST WANTED
SARA GRACE
BY JOHNNY DUFORT

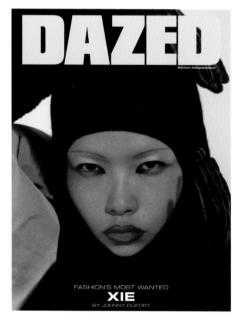

FASHION'S MOST WANTED
XIE
BY JOHNNY DUFORT

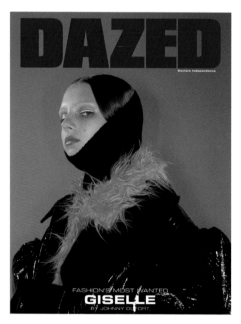

FASHION'S MOST WANTED
GISELLE
BY JOHNNY DUFORT

ISSUE 59, VOL. V, A/W 2018 **FASHION'S MOST WANTED** PHOTOGRAPHY **JOHNNY DUFORT** STYLING **ROBBIE SPENCER**

IF YOU CAN'T AFFORD IT, STEAL IT

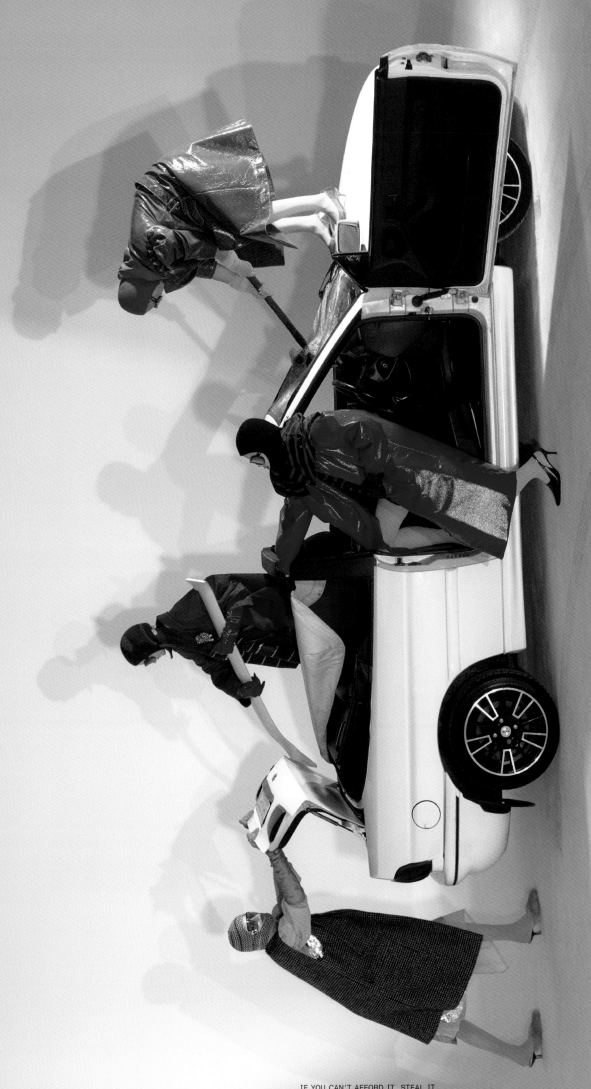

VOLIII.09 MAY 2012
UK£4.50 US$9.99
Made in the UK
PHOTOGRAPHY WALTER PFEIFFER

05>

IS
EAST LONDON
DEAD?

The
future
of
creativity
in
the
capital

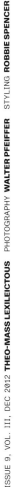

ISSUE 9, VOL. III, DEC 2012 **THEO-MASS LEXILEICTOUS** PHOTOGRAPHY **WALTER PFEIFFER** STYLING **ROBBIE SPENCER**

THEO-MASS LEXILEICTOUS: I was walking along Shoreditch High Street when I received a call from *Dazed*. It was only three weeks after I had moved to London from Cyprus in 2005 to start my 'Theo-Mass' project, so it was quite difficult to believe that *Dazed* was asking to shoot me for an upcoming issue. I was asked to bring my own clothes and, of course, my masks.

The shoot took place in the very strange house of an old lady — it looked like a set from a horror movie. I had an immediate connection with Walter (Pfeiffer). We were experimenting during the shoot and tried many different things. The mask I used for the cover was a cast of my face decorated with Swarovski crystals. This specific mask was inspired by Damien Hirst's series *Diamond Skulls* — it was around this time that Damien had had a retrospective show at Tate Modern. It wasn't our intention or plan to shoot with smoke, but it worked.

At the time, there were so many things going on creatively in east London. I could walk (around in) my mask and costumes, throwing my Theo-Mass Dollars in the streets, and it was considered somehow normal. People started talking to me and collecting the notes from the street. Rent started rising, and slowly the area was becoming very polished to welcome in the Olympics.

A few months after the shoot, I was on the bus when Dean (Mayo Davies) from *Dazed* texted me, saying: 'Hey Theo, this is Dean from *Dazed & Confused* here. Congratulations! You are our next cover star'. I found out that the issue was released when my face was all over London's billboards! *Dazed* is a magazine that I greatly respect, admire and collect to this day, and it was something I never expected to happen. Insane.

IF YOU CAN'T AFFORD IT, STEAL IT

Is East London Still Dead?
by Tim Burrows

In 2012, a friend arrived in Shoreditch from Ireland full of hope. Pulling his suitcase behind him, ready to make his fortune, the first thing he noticed after getting out of the taxi was a billboard depicting cigarette smoke hanging in front of the mouth of a glittering skull. The enormous print of *Dazed*'s Walter Pfeiffer cover image was one of many emblazoned across the city advertising the May issue, and it asked a question that made him question whether he had made the right move in coming to the city at all: 'Is East London Dead?'

It was a legitimate question in Our Year of 2012, with the march of that global sporting extravaganza, the Olympic Games, bringing with it a feeling the game was up. Music venues, free-for-all pubs and art spaces had been reliably disappearing for years, replaced by high-end outlet stores and chi-chi bars, and so I approached *Dazed* to make a special issue to ask whether the allure of the eastern side of town was in inexorable decline and if so, was it all our fault.

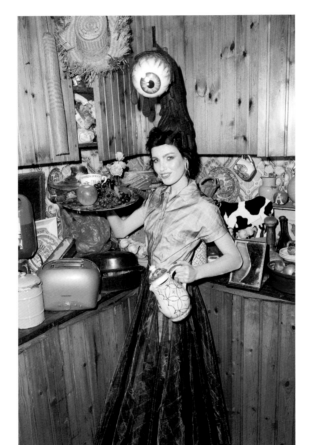

East London used to conjure up something else, and not just knees-ups in pubs after a full day worshipping at the altar of West Ham United, fuelled by pie and mash. This once heavily industrialised side of London emptied after the Second World War as industry declined and people 'bettered themselves' and moved out somewhere nice in Essex, leaving behind warehouses and streets with no context. They, in turn, filled up with exciting contexts. LOUD contexts, which seemed disposable but weaved together entire cultures. Raves, parties, shebeens, happenings in old warehouses, fire stations, baths. Anywhere. Ade Fakile told me he opened Plastic People (RIP) in a cheap Shoreditch space when he was living off Fanshaw Street after coming up through warehouse parties, while the Four Aces in Dalston incubated bands of every genre — from soul to rocksteady to ragga to acid house, but it was still knocked down and trousered by the property class in the first decade of the 21st century.

The cover story I wrote was responding to the fact these spaces, while not all gone, were definitely fading away like the photographs in *Back to the Future*. It was based in part on a walk with Laura Oldfield Ford, the artist whose work is imbued with an almost vibrating sense of elegiac loss of a subcultural past lost under rubble. Her *Savage Messiah* zines acted as a Xeroxed palimpsest of London's layers of desires and dissent. As with Burial, wrote Mark Fisher, it evoked 'London after the rave'. On Valentine's Day we walked from Shoreditch to Stratford and beyond to the newly built Olympic Park and on to the big Westfield shopping centre, drinking two-for-one cocktails and looking up and around at the gargantuan scale of the already teeming shopping mall. I remember Laura predicting that these places wouldn't last, that the Olympic Park would fall into ruin almost as soon as the Games had finished and be reclaimed by the people. 'I genuinely think it will end up overgrown and we will get it back. After the Olympics, where is the money going to come from to maintain and energise it? The whole thing is a stage set ready to be activated for those two weeks.'

Instead, the Olympic Village was transformed into thousands of new homes, with easy access to high-end retail but with very few, if any of them, genuinely affordable. Much of the new east London mimics the former Olympic Village. New estates announced themselves with great fanfare and hope but fall short and are revealed instead as securitised zones that seem to have somehow predicted the pandemic in how isolated the individuals who chose to live there became.

But it is not that culture itself has left east London. You will no doubt always find that, in some form. The metropolis used to buzz with wayward desire — the desire for something else other than the safe and tasteful wine bar and the flat above the Pret. Many of the people who made it bang were priced out and the professionals who replaced them became a bit too tightly cocooned in their domiciles. All that culture — the gigs and the happenings and the theatre — seems a bit quaintly pre-Covid these days. Palaces of whirlwind noise, heat, and flash repurposed from grand old music halls where you'd squeeze in tight. Instead, if you want a vision of the future, imagine a huge hologram of Paul Hollywood huffing and puffing over an unrisen soufflé and beamed into urban and suburban living rooms — forever.

Now east London is an explicit extension of London's wealth; creative in the sense it houses the mega-studios that help design a pretty face to mask automated zombie capitalism. A free-form subcultural sentiment once utilised the sublime hallmarks of a fallen London but such iconography — the gasometers, the brutalist high-rises — have long been co-opted into becoming part of estate agents' visual repertoire. Goldfinger's Balfron Tower, which once towered over Poplar and the Isle of Dogs before Canary Wharf rendered it diminutive in comparison, has been emptied of its council tenants and repurposed for the professionals' market. And yet, while it feels perverse to make many predictions from the paranoiac and anxiety-fuelled vantage point of a pandemic with no easy answer, the situation might also allow us fresh hope — and the impetus — to plan for a different future for east London. Rents are falling as people move out of a city whose context has temporarily departed. London's fairweather friends, the commuters, have been stark in their absence, leaving east London in the hands of those who actually live there. Could the post-Covid city be reimagined as a place for people rather than profit? After all, London is still where much hope resides in terms of a collective future of inclusivity and humanitarianism. Political battles over the reclamation of land and space will be key to this, led by the questions fuelled by the pandemic year — what do people want, what do they need, what do they desire?

CHRISTOPHER SIMMONDS, Art Director: I remember vividly shooting Daft Punk in LA with Sharif Hamza. Daft Punk wanted the images to all be shot in 3-D, and figuring out how to do that in a way that worked for them and the magazine and the accounts department was a huge challenge in itself. Somehow I was able to be on set for this shoot and even managed to be shot alongside Daft Punk wearing one of their helmets.

CALLUM MCGEOCH, Editor: This 3-D Daft Punk cover was a banger. I know it took a monumental effort to make that happen, but I like to think that it was actually a scam and it's just Rod and Tim (Noakes) under those helmets, sniggering to each other.

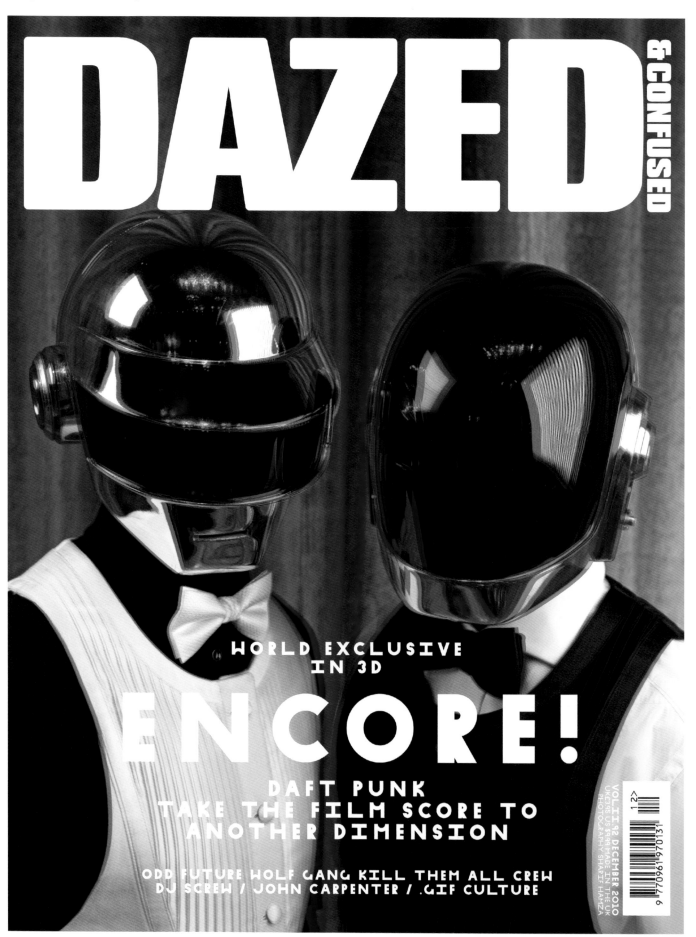

DAZED &CONFUSED

WORLD EXCLUSIVE
IN 3D

ENCORE!

DAFT PUNK
TAKE THE FILM SCORE TO
ANOTHER DIMENSION

ODD FUTURE WOLF GANG KILL THEM ALL CREW
DJ SCREW / JOHN CARPENTER / .GIF CULTURE

VOL III, 92 DECEMBER 2010
UK£3.75 US $9.99 MADE IN THE UK
PHOTOGRAPHY SHARIF HAMZA

ISSUE 92, VOL. II, DEC 2010 **DAFT PUNK** PHOTOGRAPHY **SHARIF HAMZA** STYLING **ROBBIE SPENCER**

IF YOU CAN'T AFFORD IT, STEAL IT

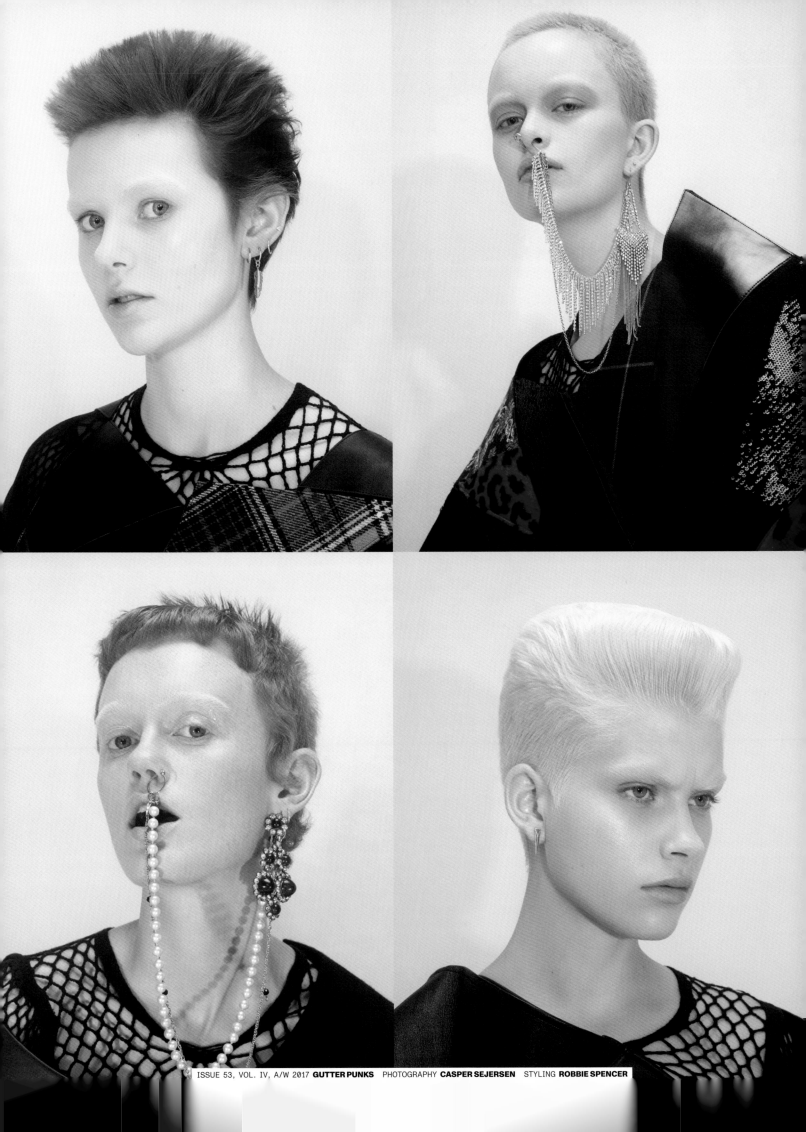

ISSUE 53, VOL. IV, A/W 2017 **GUTTER PUNKS** PHOTOGRAPHY **CASPER SEJERSEN** STYLING **ROBBIE SPENCER**

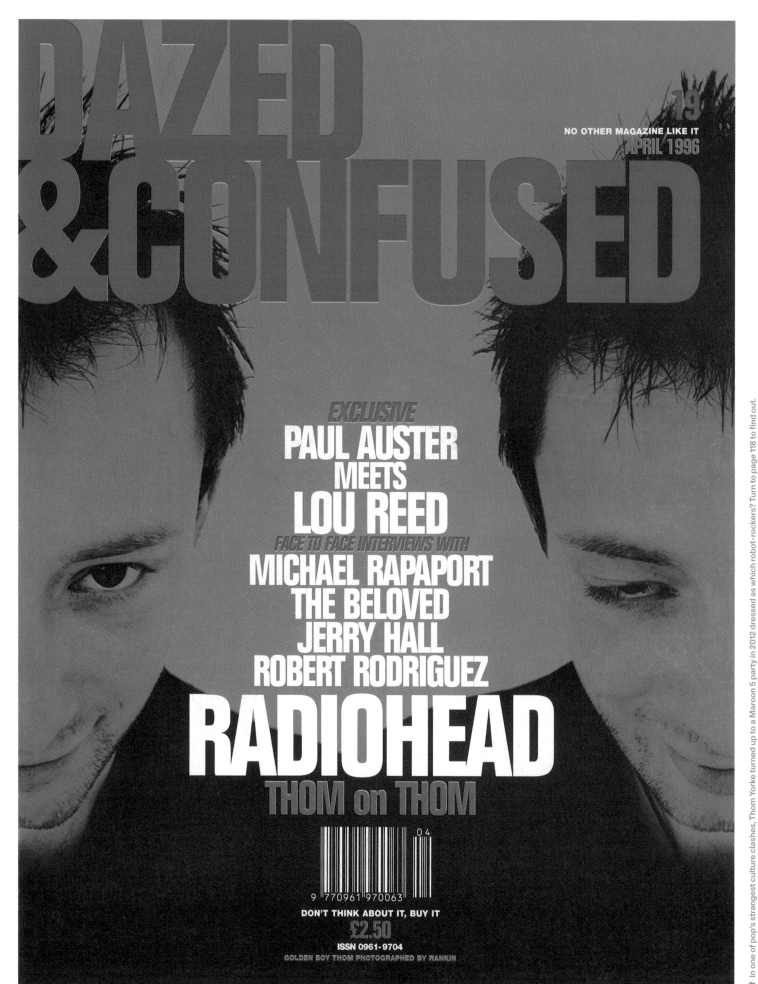

DAZED &CONFUSED

19

NO OTHER MAGAZINE LIKE IT
APRIL 1996

EXCLUSIVE
PAUL AUSTER
MEETS
LOU REED
FACE TO FACE INTERVIEWS WITH
MICHAEL RAPAPORT
THE BELOVED
JERRY HALL
ROBERT RODRIGUEZ
RADIOHEAD
THOM on THOM

9 770961 970063 04

DON'T THINK ABOUT IT, BUY IT
£2.50
ISSN 0961-9704
GOLDEN BOY THOM PHOTOGRAPHED BY RANKIN

In one of pop's strangest culture clashes, Thom Yorke turned up to a Maroon 5 party in 2012 dressed as which robot-rockers? Turn to page 118 to find out.

ISSUE 19, VOL. I, APR 1996 **RADIOHEAD** PHOTOGRAPHY **RANKIN**

IF YOU CAN'T AFFORD IT, STEAL IT

for the attention of jefferson at dazed and confused. urgent!
from thom yorke.
fax to: +44 171 336 0866
also fax to: +44 1225 427441

computers, will they take over?

"shit i thought they had already.
they fly the plane i M on. they know what the weathers gonna do

they talk to each other in a

language that no one can follow.

how can you really tell what theyre saying? they could just be stringing us
along! i think they are! look at the internet.

surely its not REALLY that SLOW. in reckon theyre just havinga chat with each othr and
then at the end they just go,

...... oh yeah and by the way they want you to say
8efcc08r7h87hy487yf837yr3tt948ufr4erfe9si4pueiurtp4wtv9ervpco[5gi
vrdtgvurlutnsvncpvunridnvpeinrpvrltnceuvnp4fnplefpefnuthmutop3hm. got that?
OK see ya.

who will win the revolution the scientists or the artists?

It sort of feels like both are going to win because science and art seem to be converging.
whats

upsett ₃ is the way the art world continues to be so insular and self perpetuating. i
suppose science is like that to. i don't know much about the way sc
SCIEnce is funded but art or ú the ah-hem art world exists in total
isolation endless spinning
in
ever
decreasing
circles.

yet at other times i see the work of say someone like jenny holzer
and find it really alarming how every word resonates right through me.
my favourite place to go to rekindle my belief that art or self expression ahs a place is

MOMa in new york. i can never remember artistss names((stanley is good
at that)) but i still get exited and feel awe. so iguess the end of the world is not going to be
quite yet.
although i dont agree with any of the politics of the art world and the
brain less freaks who
actually spend money on the the stuuff or write about it.
i think science and art have had their nice little neat white boxes for most of this century.
but soon its gonna change. theres loads of stuff goin

OFF about eh middle ages, in science at the moment, they are
becomi eing less blinkered more-- humble. i watched a program about a lot of oxford
science researchers talkiNG about chaos and faith and mysticism and the middle ages.
also i feel like there seems to be more of oness to approaching our emotional and objective
sides, more feminine. i suppose i am just dreaming though.

and now i thinkimOUT
OFMYDEPTH and i should STOP. im a singinger in a band and i should the fuck up and
whine about being tortue=red and rich and famous instead. thats what people wanna read.
OK.

ISSUE 32, VOL. I, JUL 1997 THOM YORKE

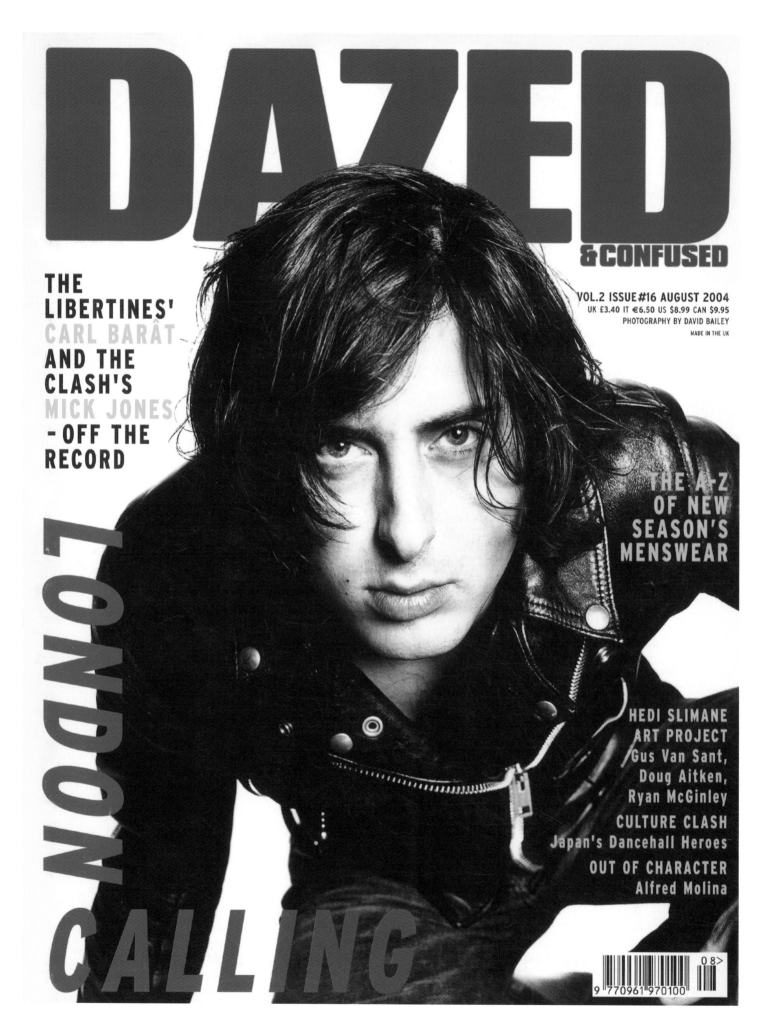

DAZED

&CONFUSED

THE
LIBERTINES'
CARL BARÂT
AND THE
CLASH'S
MICK JONES
– OFF THE
RECORD

VOL.2 ISSUE#16 AUGUST 2004
UK £3.40 IT €6.50 US $8.99 CAN $9.95
PHOTOGRAPHY BY DAVID BAILEY

MADE IN THE UK

THE A-Z
OF NEW
SEASON'S
MENSWEAR

HEDI SLIMANE
ART PROJECT
Gus Van Sant,
Doug Aitken,
Ryan McGinley
CULTURE CLASH
Japan's Dancehall Heroes
OUT OF CHARACTER
Alfred Molina

LONDON CALLING

9 770961 970100

0 8>

ISSUE 16, VOL. II, AUG 2004 **CARL BARÂT** PHOTOGRAPHY **DAVID BAILEY**

IF YOU CAN'T AFFORD IT, STEAL IT

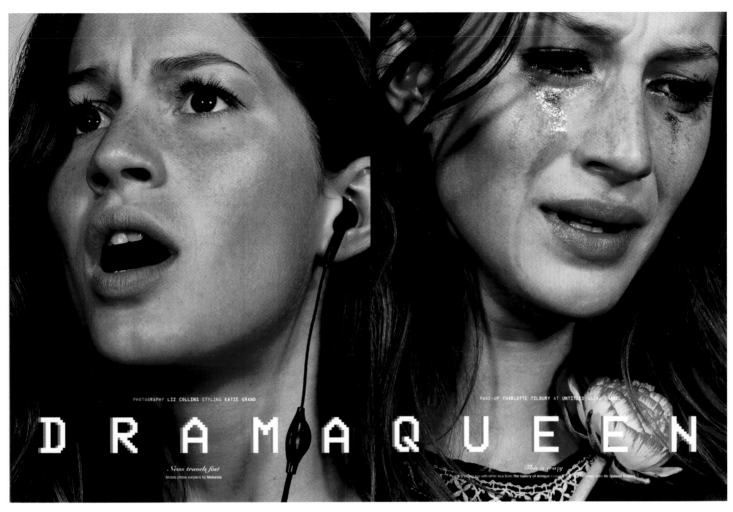

PHOTOGRAPHY LIZ COLLINS STYLING KATIE GRAND

MAKE-UP CHARLOTTE TILBURY AT UNTITLED USING CHANEL

DRAMAQUEEN

News travels fast
Mobile phone earpiece by **Motorola**

This is crazy
Black crochet top with white lace from **The Gallery of Antique Costume**. Flowers from **Mc Queens Flowers**

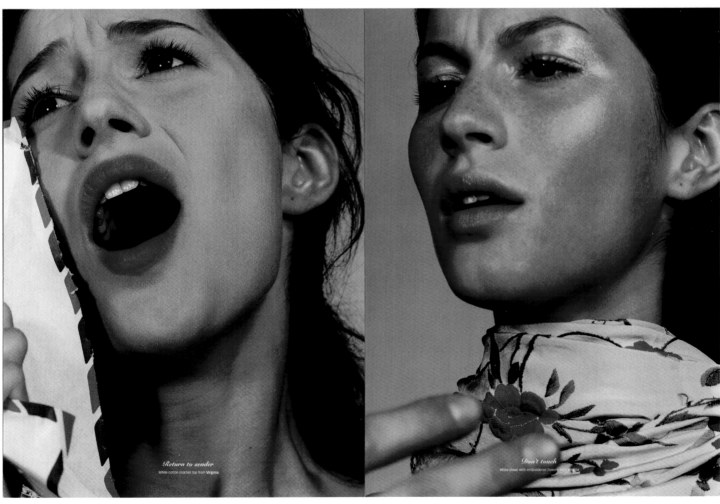

Return to sender
White cotton crochet top from **Virginia**

Don't touch
White shawl with embroidered flowers from **Virginia**

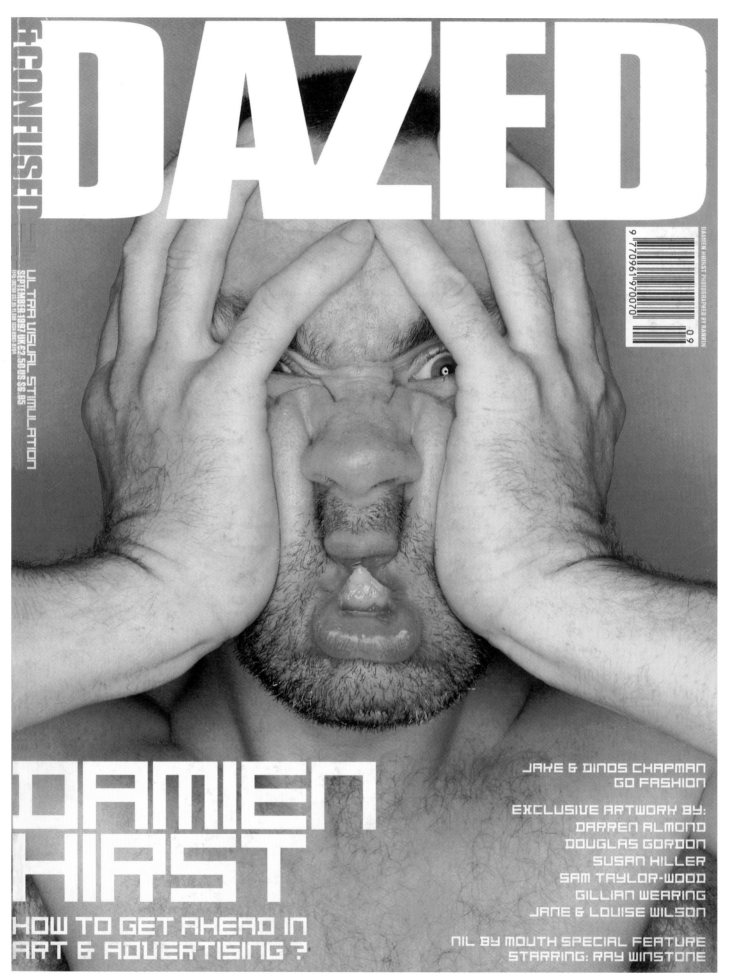

ISSUE 34, VOL. II, SEP 1997 **DAMIEN HIRST** PHOTOGRAPHY **RANKIN**

DAZED

&CONFUSED

ULTRA VISUAL STIMULATION
SEPTEMBER 1997 UK £2.50 US $6.95
[F&A DFD] £3 / AS 11.600 USA$9.95 9.79€

DAMIEN HIRST PHOTOGRAPHED BY RANKIN

9 770961 970070 0.9

DAMIEN HIRST

HOW TO GET AHEAD IN
ART & ADVERTISING ?

JAKE & DINOS CHAPMAN
GO FASHION

EXCLUSIVE ARTWORK BY:
DARREN ALMOND
DOUGLAS GORDON
SUSAN HILLER
SAM TAYLOR-WOOD
GILLIAN WEARING
JANE & LOUISE WILSON

NIL BY MOUTH SPECIAL FEATURE
STARRING: RAY WINSTONE

RANKIN, Co-founder and Publisher: Damien is a gift to shoot. I could have chosen a hundred pictures from that session. I remember he taped his whole face in Sellotape! I was always about doing very provocative covers so I would always compare myself with someone like Damien. His work did two things: it made you think and it made you feel.

124 IF YOU CAN'T AFFORD IT, STEAL IT

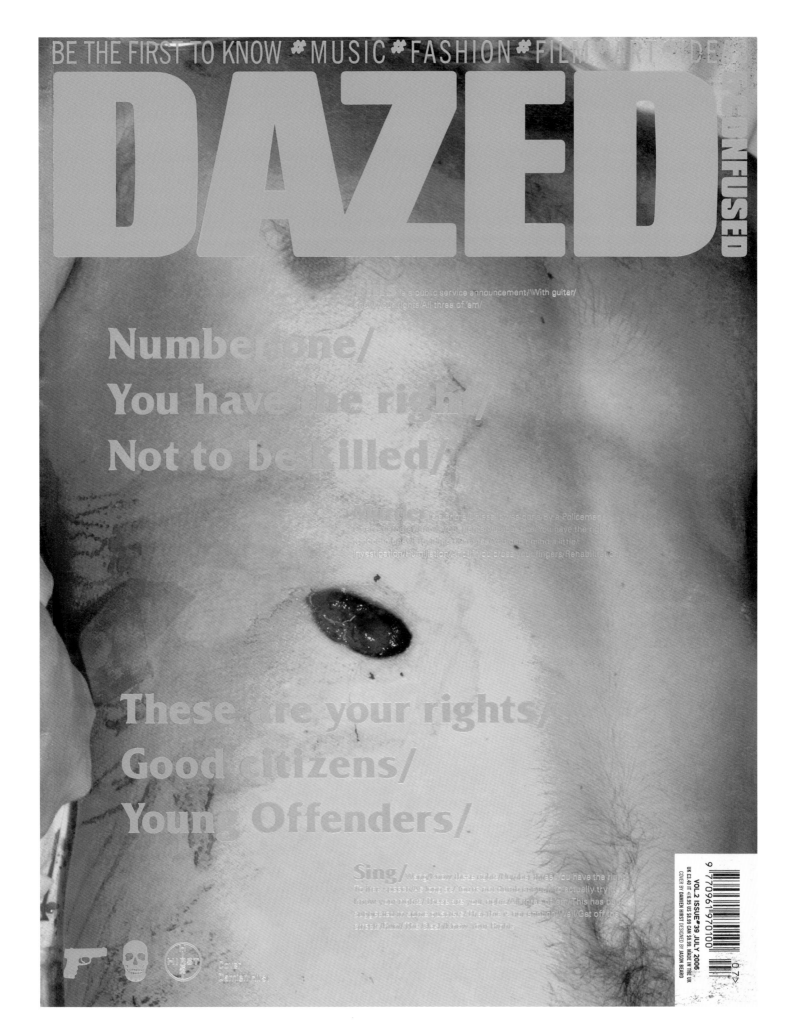

BE THE FIRST TO KNOW # MUSIC # FASHION # FILM ART DE

DAZED

CONFUSED

This is a public service announcement/With guitar/
Know your rights/All three of 'em/

Number one/
You have the right/
Not to be killed/

Murder is a crime/Unless it was done/By a Policeman/
Or an aristocrat/Know your rights/You have the right/
to food money/Providing of course/you don't mind a little/
Investigation/Humiliation/And if you cross your fingers/Rehabilitation/

These are your rights/
Good citizens/
Young Offenders/

Sing/Know these words we sing/Know your rights/
Believe me/These are all your rights/You have the right/
Know your words/These are your words/All right right/This has been
a public service announcement/This is the end/Well/Get off the
streets/Know these words/Know your rights/

VOL.2 ISSUE#39 JULY 2006
UK £3.40 IT €6.95 US $8.99 CAN $9.99 MADE IN THE UK
COVER BY DAMIEN HIRST DESIGNED BY JASON BEARD

ISSUE 39, VOL. II, JUL 2006 **KNOW YOUR RIGHTS** ARTWORK **DAMIEN HIRST**

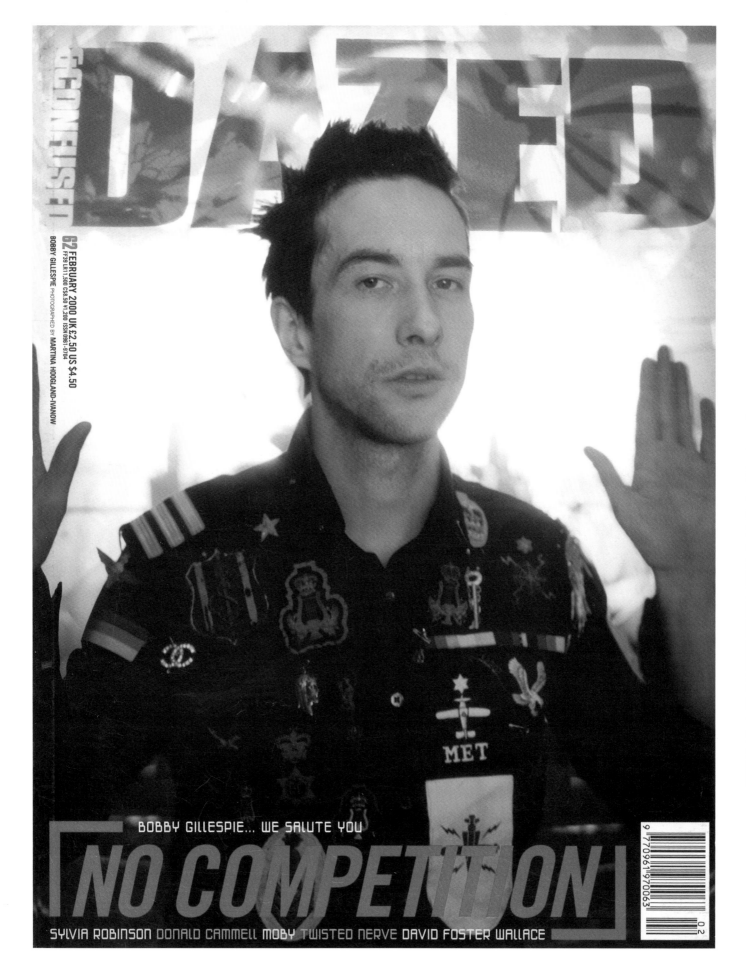

ISSUE 62, VOL. I, FEB 2000 **BOBBY GILLESPIE** PHOTOGRAPHY **MARTINA HOOGLAND IVANOW** STYLING **ALISTER MACKIE**

DAZED

ESTABLISHED

62 FEBRUARY 2000 UK £2.50 US $4.50
FF39 LR11,500 C$8.50 ¥1,200 ISSN 0961-9704
BOBBY GILLESPIE PHOTOGRAPHED BY MARTINA HOOGLAND-IVANOW

BOBBY GILLESPIE... WE SALUTE YOU

NO COMPETITION

SYLVIA ROBINSON DONALD CAMMELL MOBY TWISTED NERVE DAVID FOSTER WALLACE

ALISTER MACKIE, Fashion Director: This Bobby cover is one of my favourites because I shot it with Martina and we were all very close. It didn't feel like going to work; it didn't feel official, any of it. I never felt like I had anyone to please or anything to prove; I always felt it was about trying to make the best picture you could. Bob really understood that and is a great model, as great in front of the camera as he is on stage, naturally gifted and easy. The shoot was a real homespun affair. Me and Martina made the set and shot him in

these smashed-up mirrors and this shirt I made for him — I collected all of those badges, memorabilia, patches and bits and pieces. This became the look that he chose to wear on his XTRMNTR tour, which pinnacled at the Reading Festival, where Primal Scream played head-to-head with Oasis. It was an amazing night. Bob wore my shirt, we hung backstage with the bands and Courtney Love. It was a really great night and it all tied in with the Dazed shoot. That was a special memory for me.

 IF YOU CAN'T AFFORD IT, STEAL IT

ISSUE 54, VOL. IV, WINTER 2017 **KING KRULE** PHOTOGRAPHY **FRANK LEBON** STYLING **DANNY REED**

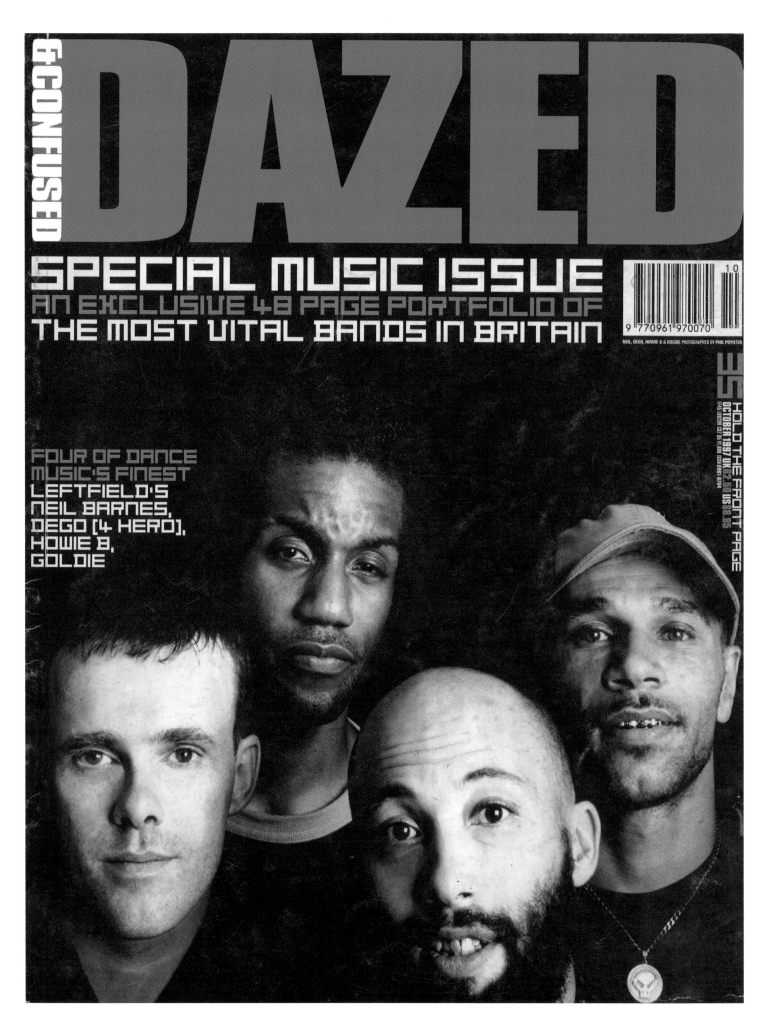

&CONFUSED DAZED

SPECIAL MUSIC ISSUE
AN EXCLUSIVE 48 PAGE PORTFOLIO OF
THE MOST VITAL BANDS IN BRITAIN

NEIL, DEGO, HOWIE B & GOLDIE PHOTOGRAPHED BY PHIL POYNTER

9 770961 970070

FOUR OF DANCE MUSIC'S FINEST LEFTFIELD'S NEIL BARNES, DEGO [4 HERO], HOWIE B, GOLDIE

35 HOLD THE FRONT PAGE
OCTOBER 1997 UK £2.50 US $8.95
F45 L83290 S2.35 FL800 ISSN 0961-9704

ISSUE 35, VOL. I, OCT 1997 **THE MUSIC ISSUE** PHOTOGRAPHY **PHIL POYNTER**

IF YOU CAN'T AFFORD IT, STEAL IT

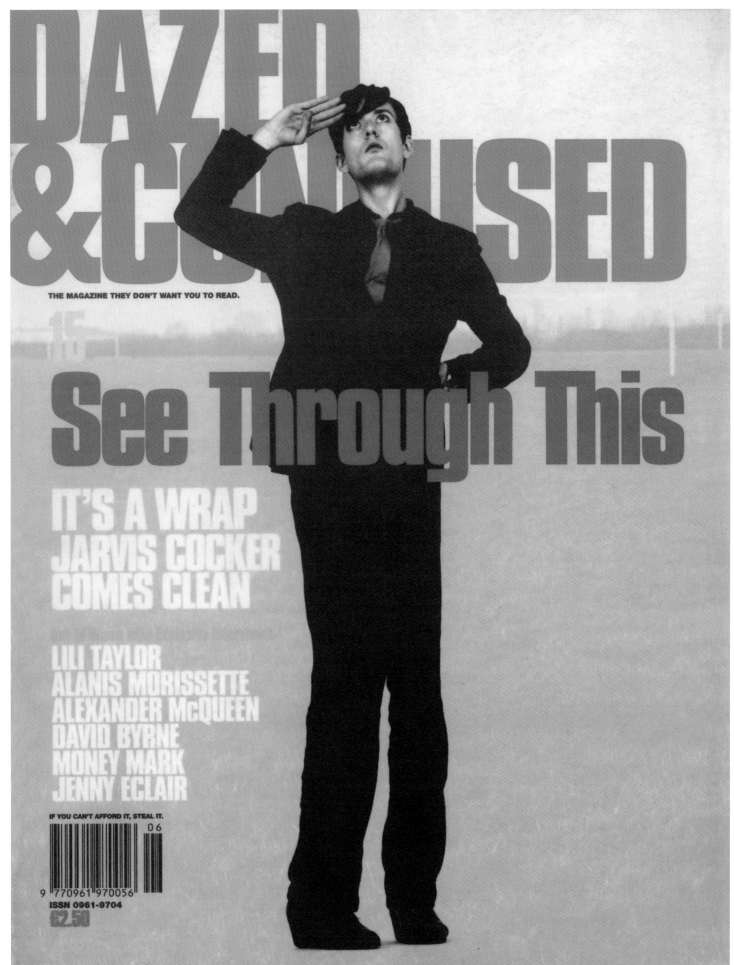

DAZED & CONFUSED

THE MAGAZINE THEY DON'T WANT YOU TO READ.

15/16

See Through This

**IT'S A WRAP
JARVIS COCKER
COMES CLEAN**

**LILI TAYLOR
ALANIS MORISSETTE
ALEXANDER McQUEEN
DAVID BYRNE
MONEY MARK
JENNY ECLAIR**

IF YOU CAN'T AFFORD IT, STEAL IT.

06

9 770961 970056

ISSN 0961-9704

£2.50

'In a way it almost reminds me of early Pulp... like, you know, "We just want the right to be different. We don't look like you, we don't dress like you, but we're like you."' Go to page 146 to find out whose films actor James Duval was talking about.

ISSUE 15, VOL. I, 1995 **JARVIS COCKER** PHOTOGRAPHY **RANKIN**

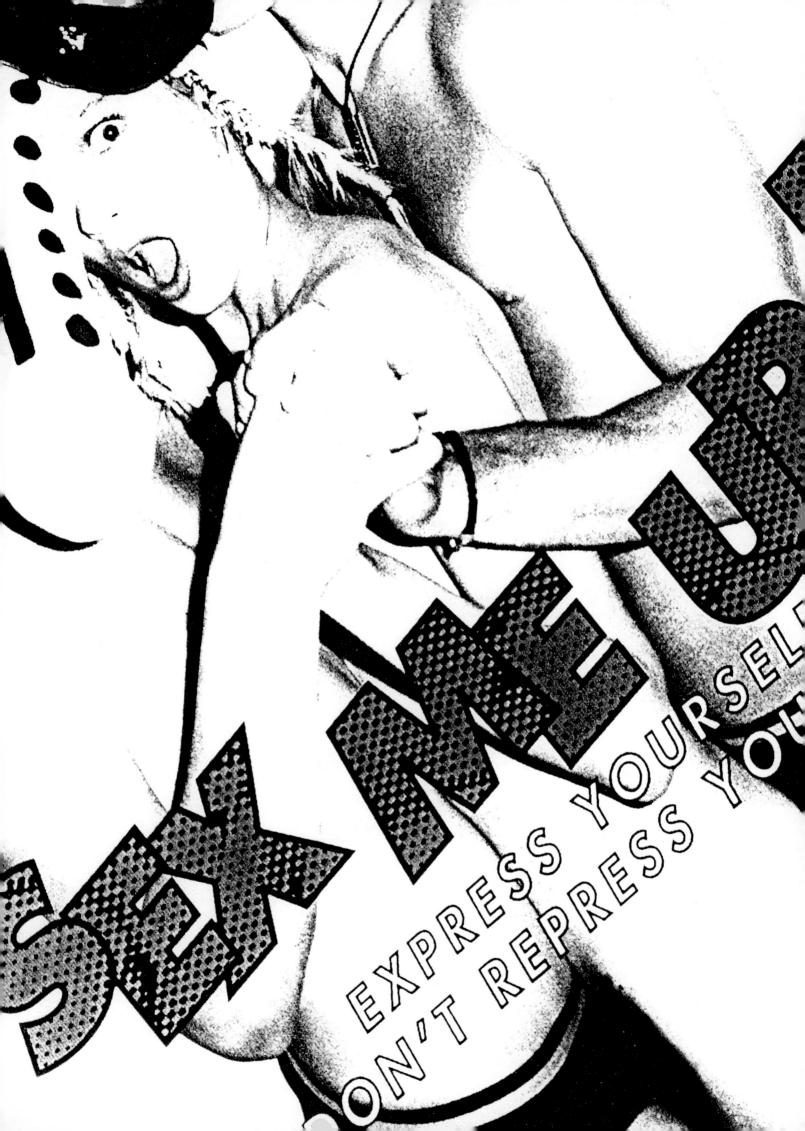

**Express yourself,
don't repress yourself
130–157**

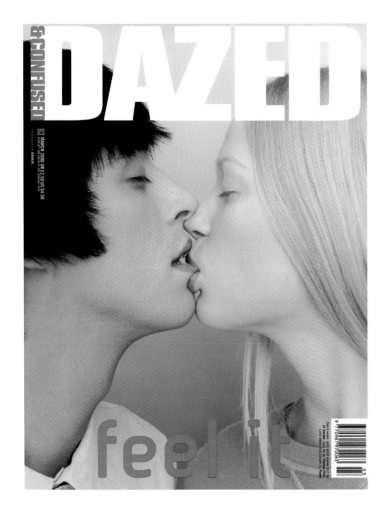

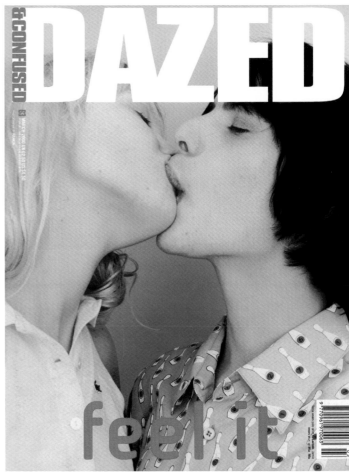

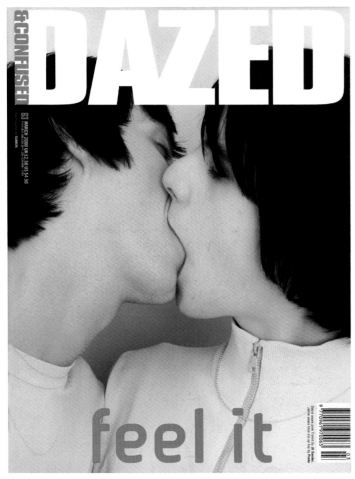

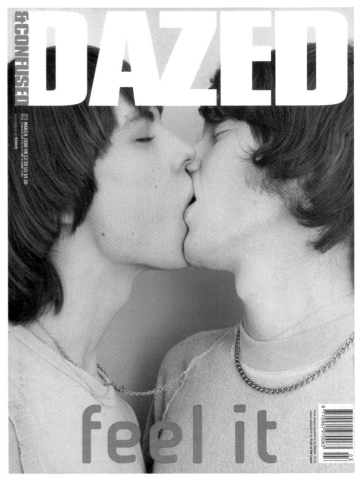

ISSUE 63, VOL. I, MAR 2000 **FEEL IT** PHOTOGRAPHY **RANKIN** STYLING **ALISTER MACKIE**

SEX ME UP!

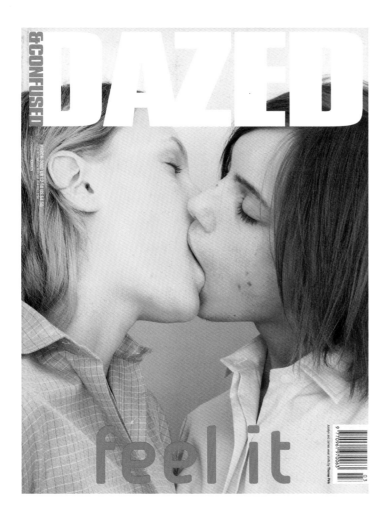

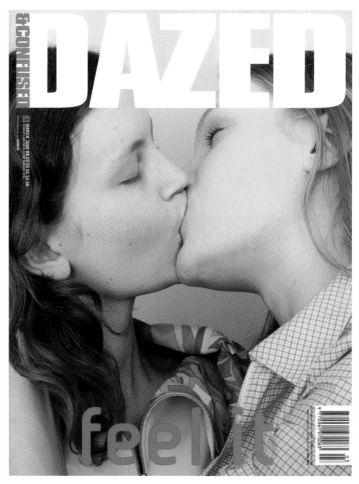

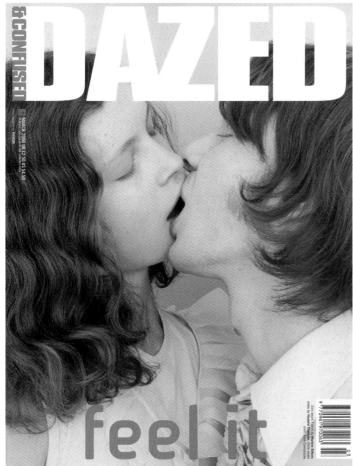

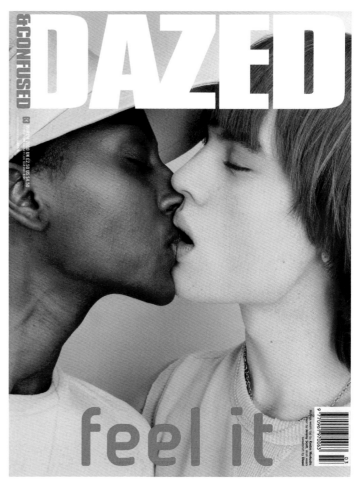

ALISTER MACKIE, Fashion Director: I love this one because it summed up how we felt at the time. It was Rankin and Jefferson's idea to have people kissing on the cover, and they came to me with this concept. I was very into Will McBride then and that was a reference, and I liked the idea of boys and girls kissing and making out and it not really mattering. The sentiment and it being super-simple — and not saying too much.

DAZED

**VOL.2 ISSUE#5
SEPTEMBER 2003**
UK £3.20 IT €6.50 US $8.25
MADE IN THE UK

FRANKIE RAYDER
PHOTOGRAPHED BY LACEY

LOOK THIS WAY

CATWALKS, COLLECTIONS
AND THE RETURN OF CAPUCCI

PLUS: THE RAPTURE, SHYNOLA, GWENDOLINE RILEY, FANNYPACK, WILL DE LOS SANTOS
TILDA SWINTON, WALL OF SOUND, CODY CHESNUTT, AL-JAZEERA, BROKEN SOCIAL SCENE

ISSUE 5, VOL. II, SEP 2003 **LOOK THIS WAY** PHOTOGRAPHY **LACEY** STYLING **CATHY EDWARDS AND SHONA HEATH**

SEX ME UP!

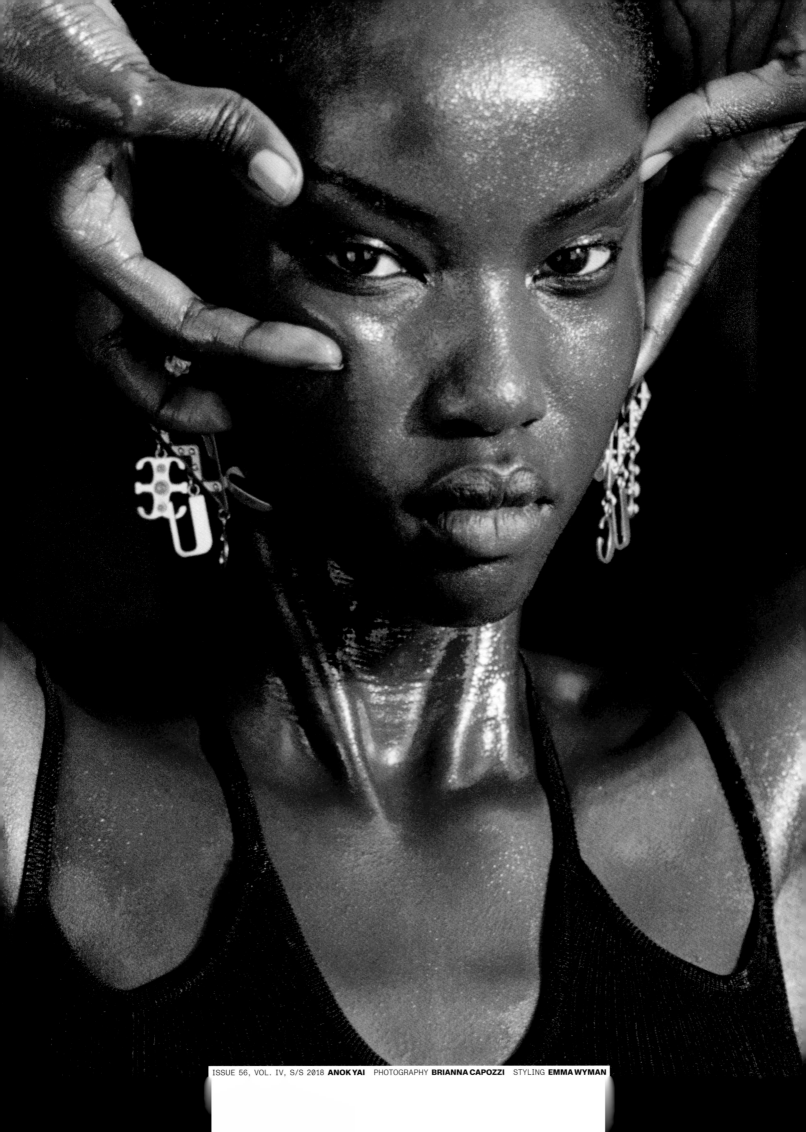

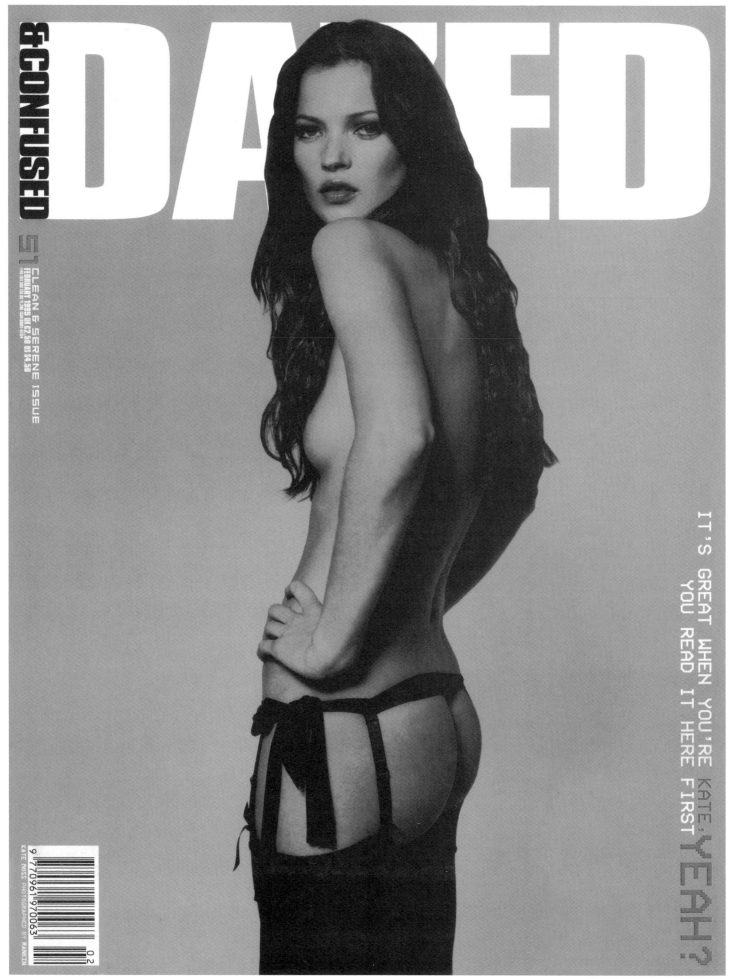

DAZED

&CONFUSED

51

CLEAN & SERENE ISSUE

FEBRUARY 1999 UK £2.50 US $4.50

IT'S GREAT WHEN YOU'RE KATE, YEAH?
YOU READ IT HERE FIRST

ISSUE 51, VOL. 1, FEB 1999 KATE MOSS PHOTOGRAPHY RANKIN STYLING KATIE GRAND

The model pole-danced in black lingerie for the White Stripes' "I Just Don't Know What to Do With Myself," a concept cooked up by director Sofia Coppola. For more Sofia dance to page 199.

SEX ME UP!

DAZED

Declare Independence

ISSUE 63, VOL. IV, SUMMER 2019 **FRANK OCEAN** PHOTOGRAPHY **WILLY VANDERPERRE** STYLING **ROBBIE SPENCER**

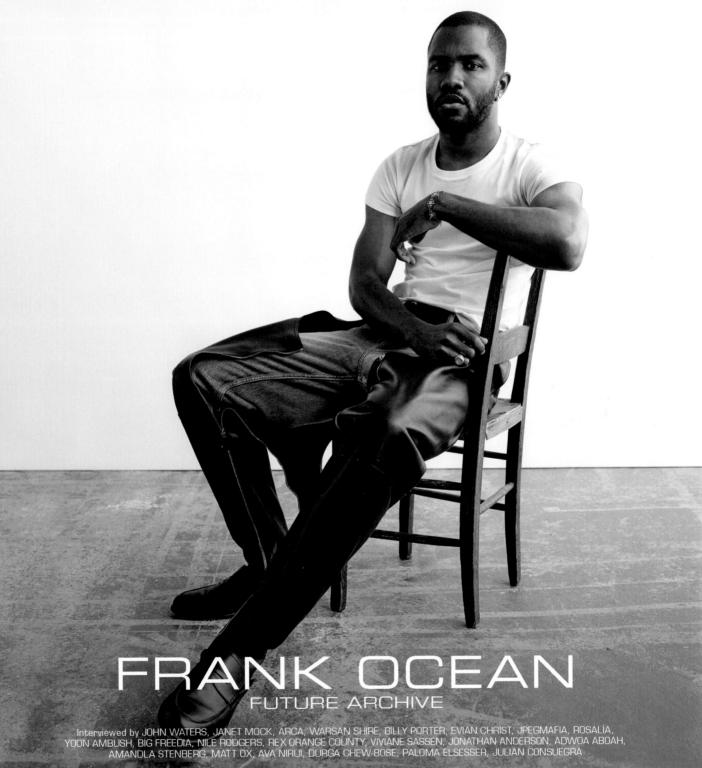

FRANK OCEAN
FUTURE ARCHIVE

Interviewed by JOHN WATERS, JANET MOCK, ARCA, WARSAN SHIRE, BILLY PORTER, EVIAN CHRIST, JPEGMAFIA, ROSALÍA, YOON AMBUSH, BIG FREEDIA, NILE RODGERS, REX ORANGE COUNTY, VIVIANE SASSEN, JONATHAN ANDERSON, ADWOA ABOAH, AMANDLA STENBERG, MATT OX, AVA NIRUI, DURGA CHEW-BOSE, PALOMA ELSESSER, JULIAN CONSUEGRA

TED STANSFIELD, Deputy Editor, *AnOther*: The Frank Ocean cover is probably the most meaningful to me, a) because I'm a huge Frank Ocean fan, and b) because Isabella and Claire very kindly let me ask him a question as part of the interview. He gave quite a juicy answer too, which he sadly changed to something a bit more PG before it went to print. Still, it technically means that I've interviewed Frank?!

'Will you please do a new version of the Divine song "Female Trouble"?' Turn to page **239** to find out who asked Frank Ocean this question.

SEX ME UP!

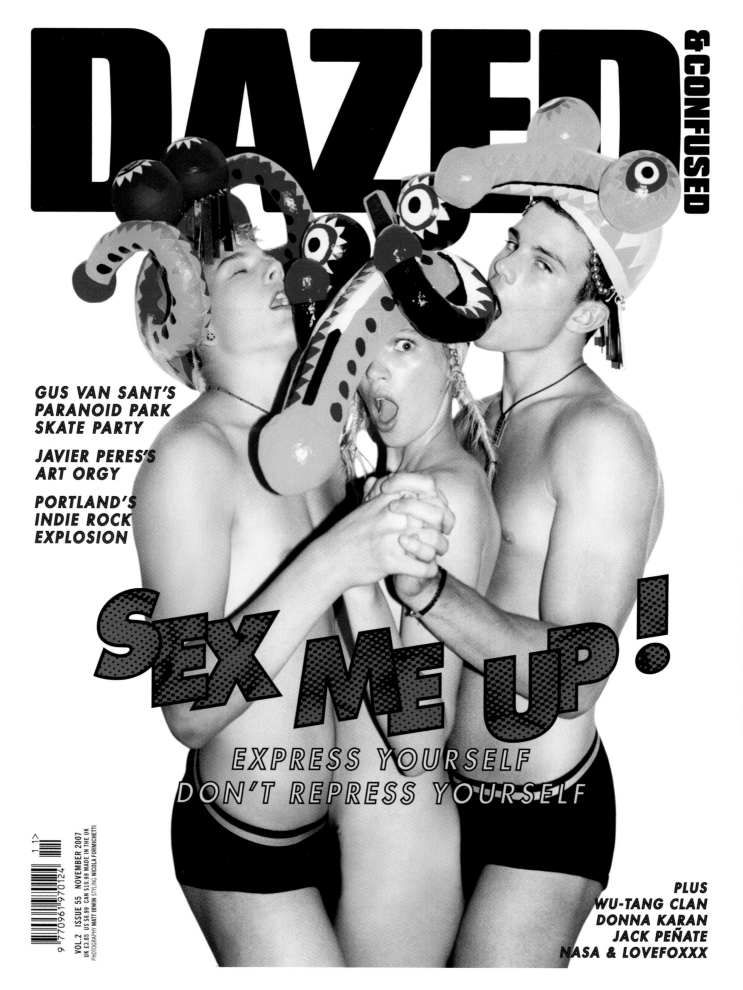

DAZED & CONFUSED

GUS VAN SANT'S PARANOID PARK SKATE PARTY

JAVIER PERES'S ART ORGY

PORTLAND'S INDIE ROCK EXPLOSION

SEX ME UP!

EXPRESS YOURSELF
DON'T REPRESS YOURSELF

PLUS
WU-TANG CLAN
DONNA KARAN
JACK PEÑATE
NASA & LOVEFOXXX

ISSUE 55, VOL. II, NOV 2007 **SEX ME UP!** PHOTOGRAPHY **MATT IRWIN** STYLING **NICOLA FORMICHETTI**

VOL.2 ISSUE 55 NOVEMBER 2007
UK £3.85 US $8.89 US $10.99 MADE IN THE UK
PHOTOGRAPHY MATT IRWIN STYLING NICOLA FORMICHETTI

9 770961 970124 1 1>

RÉMI PARINGAUX, Art Director: This cover perfectly summed up the mood of London at that time. Three young and wild teenagers, with massive colourful knobs on their heads, clearly inspired and fuelled by the insanely crazy party scene of the 2000s. Seeing that cover on the newsstands felt like a huge splash of colour, a moment of positivity, fun and total irreverence — something I think channels the anti-conformist spirit of *Dazed & Confused* so well. On a personal level, Matt Irwin and I had been close friends for many years by that time, but I think it was my first time on set with Nicola Formichetti — marking the beginning of a long creative collaboration and friendship between the two of us.

Nicola Formichetti on How *Dazed*'s Sexiest Cover Came to Be

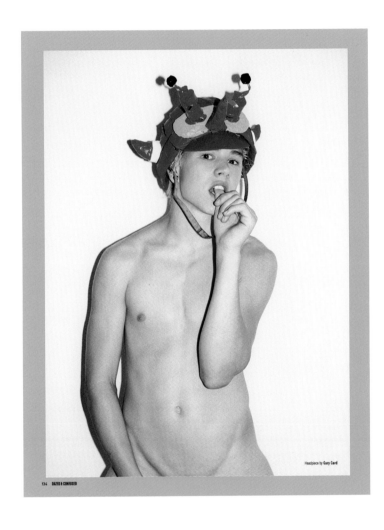

Headpiece by Gary Card

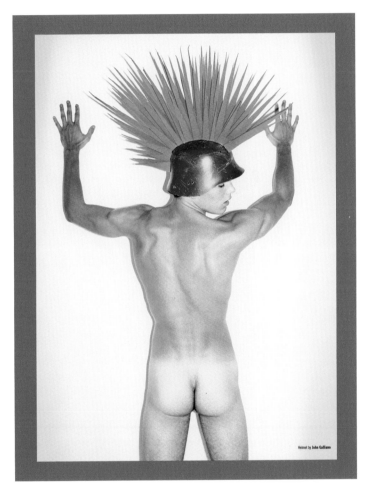

Helmet by John Galliano

'Sex Me Up!' was my third issue as creative director, (and) I wanted to do something very, very sexy. The Walter Van Beirendonck and Stephen Jones monster helmets were the inspiration for the shoot, and I didn't want to use clothes, which was kind of unheard of. You have to understand: fashion imagery at that time was very serious and I wanted to do something that was the opposite. Yeah, there had been sexy moments, but to see that on a cover was very unusual.

Matt (Irwin), the photographer, had just graduated from Saint Martins. I remember seeing this school magazine he and Rémi (Paringaux) created, and thinking, 'Oh my God, this is so exciting!' His photography had this energy that really felt like London at the time — very simple, but powerful. Rémi ended up art directing the magazine, and then Matt became a regular to shoot the covers. Later I did 'Fantasia', a Japanese guest-edit issue that was shot by Matt as well. We used to travel everywhere together.

I look back on these images and of course I've evolved — I hope that I have. It's like the meat dress: it worked on that red carpet, but I wouldn't do it again. But I always like to do something that's a little bit sexy, a little bit tongue in cheek, and a little bit fuck you. A little bit punk in attitude. A good image is a good image forever, right? I always believe that. But if I redid this today, I would make it a more diverse casting.

I didn't know what I wanted to do back then, other than be part of the gang, part of the *Dazed* family. I had no special skills other than a love of creativity and fashion and visuals. But I owe (to) that time everything I am today, because we were allowed to test the water and make mistakes. Creating without fear is what I learnt at *Dazed*. AS TOLD TO **ZSOFIA PAULIKOVICS**

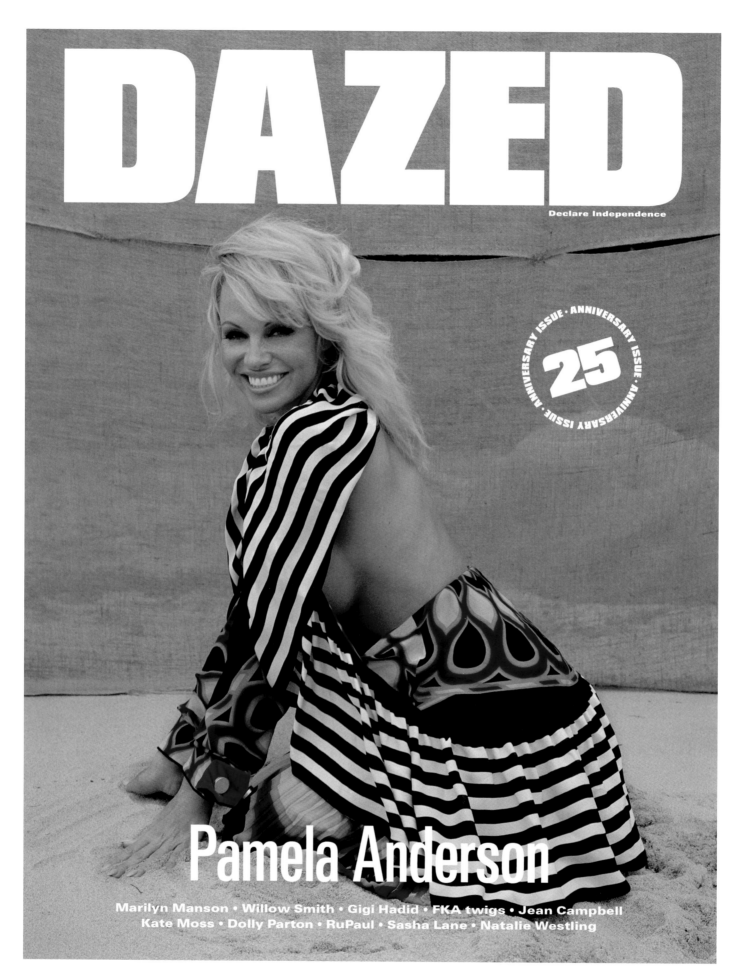

DAZED

Declare Independence

·ANNIVERSARY ISSUE·ANNIVERSARY ISSUE·ANNIVERSARY ISSUE·
25

Pamela Anderson

Marilyn Manson • Willow Smith • Gigi Hadid • FKA twigs • Jean Campbell
Kate Moss • Dolly Parton • RuPaul • Sasha Lane • Natalie Westling

ISSUE 47, VOL. IV, A/W 2016 **PAMELA ANDERSON** PHOTOGRAPHY **ZOË GHERTNER** STYLING **EMMA WYMAN**

ISABELLA BURLEY, Editor-in-Chief: Being a total fangirl and asking Pamela Anderson to sign my 1997 copy of *Playboy* after interviewing her for her *Dazed* cover story. It was such a surreal day watching her roll around in the sand on a beach in Malibu. Emma Wyman, who styled the cover, gave me a ride back to LA but her car was so full with boxes that I was basically crushed by samples for an hour and all we could talk about was how incredible Pammy was like, we were teenagers!

THOMAS GORTON, Editorial Director: My fondest memory has to be chaperoning Pamela Anderson to the *Dazed* 25th-anniversary party — she'd just been on the cover. I picked her up in a car with a bottle on ice and asked her if she liked champagne (I knew she did). She delivered the immortal line, 'Honey, I don't just drink champagne, I AM champagne.'

SEX ME UP!

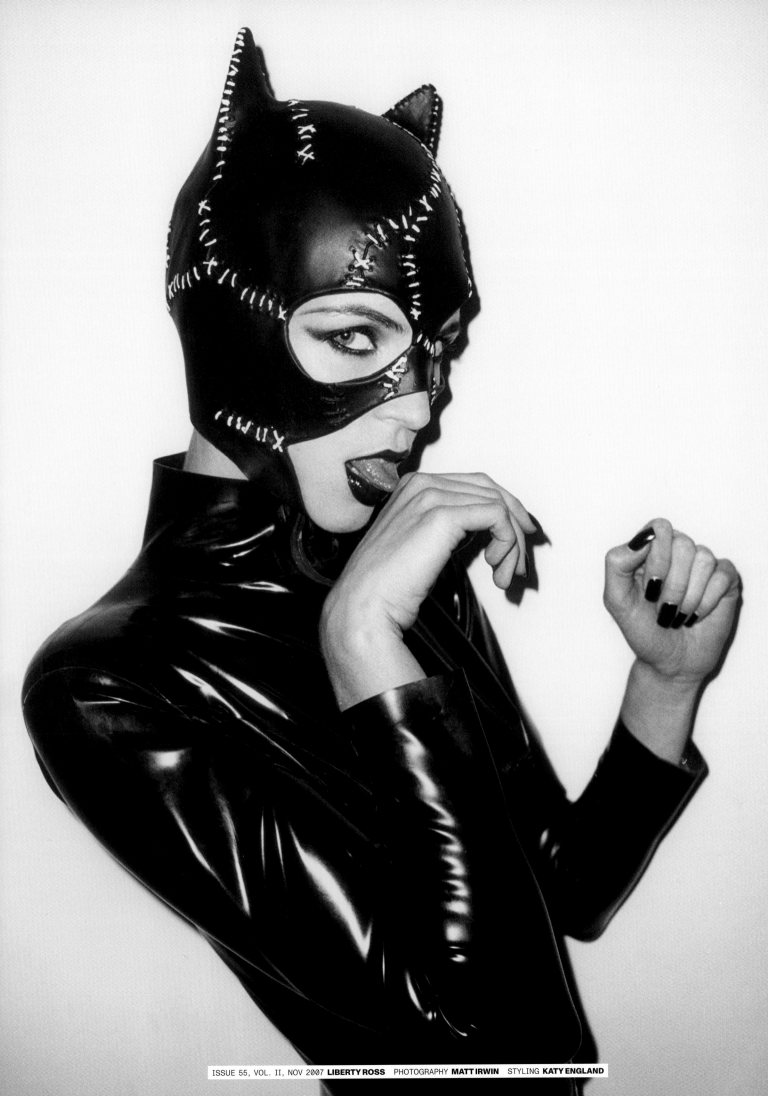

ISSUE 55, VOL. II, NOV 2007 **LIBERTY ROSS** PHOTOGRAPHY **MATT IRWIN** STYLING **KATY ENGLAND**

SEX ME UP!

Melanie Blatt & Natalie Appleton of All Saints

MB I have no recollection of that shoot whatsoever — pretty much like everything that happened between the years 1997 and 2001.

NA I remember this shoot SO vividly. I went from being out all night to going straight to the shoot. I had to hold onto the bike because I was feeling a bit wobbly! A bit embarrassing in front of Rankin, who we all love and respect.

MB We do work with Rankin quite often — he's definitely one of our favourite photographers. Even though I don't remember the details of this shoot, we always had a great time when we did shoots for *Dazed*. They always ended up looking cool.

NA I look at these shots and think, 'How did you manage to hold it together when you were out all night?!' I'd never be able to do that now! We loved working with Rankin and Justin Henry, who did our make-up. It was a great team and I felt completely looked after.

MB I look at these shots and feel... mournful for my youth! It was definitely a different (styling concept) and I can't remember why we agreed to it! Biker chick is definitely not my usual vibe and I probably felt very uncomfortable on the actual bike, hence why I am standing next to it.

NA We were SO honoured to have a cover each — it was a very special moment for us. I definitely have a few other crazy memories from 1999, but I think they might be too explicit for print.

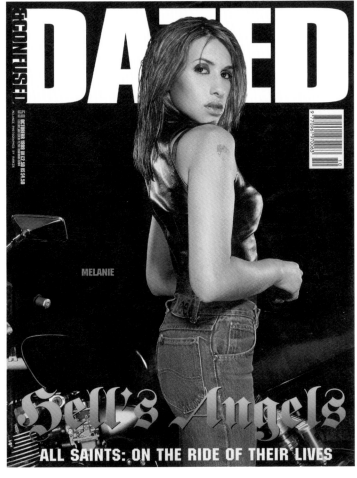

MAKE-UP **EMMA LOVELL**
USING **SHU UEMURA**
MODELS **CHANTAL, AND
TILLY AT STORM,
KAMILLA AT PREMIER,
SARAH WIETZEL AND
MADELAINE AT SELECT,
ANNA AT MODELS 1**
PHOTOGRAPHIC
ASSISTANTS **JERMAINE,
DARON, GISH, SETO**

This page: Customised stretch
denim pedal pushers by **Miss
Sixty**; red and white strap top by
Moschino; gold necklace (worn
as bracelet) and gold ring by
Cartier
Opposite: Tiger patch denim
trousers by **Chloe**; belt by
Alexandre Herchcovitch; black
T-shirt from Portobello market

ISSUE 56, VOL. I, JUL 1999 **CHEEKY** PHOTOGRAPHY **RANKIN** STYLING **MIRANDA ROBSON**

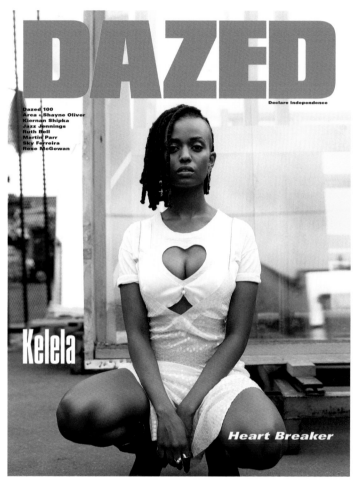

ISSUE 30, VOL. II, OCT 2005 **KAREN ELSON**
PHOTOGRAPHY **RICHARD BUSH**
STYLING **CATHY EDWARDS**

ISSUE 43, VOL. IV, SPRING 2016 **KELELA**
PHOTOGRAPHY **ZOË GHERTNER**
STYLING **HALEY WOLLENS**

SEX ME UP! 145

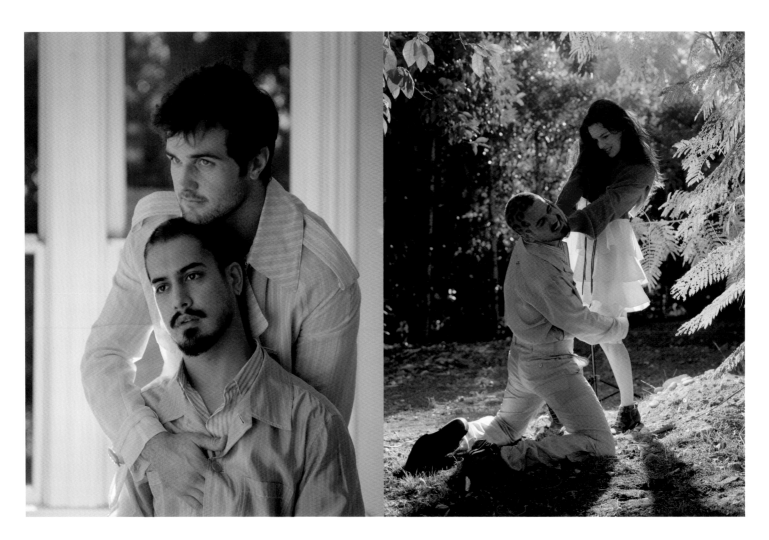

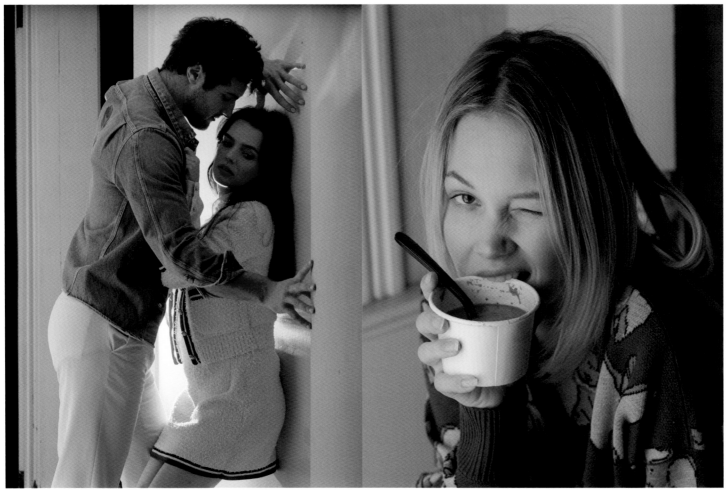

SEX ME UP!

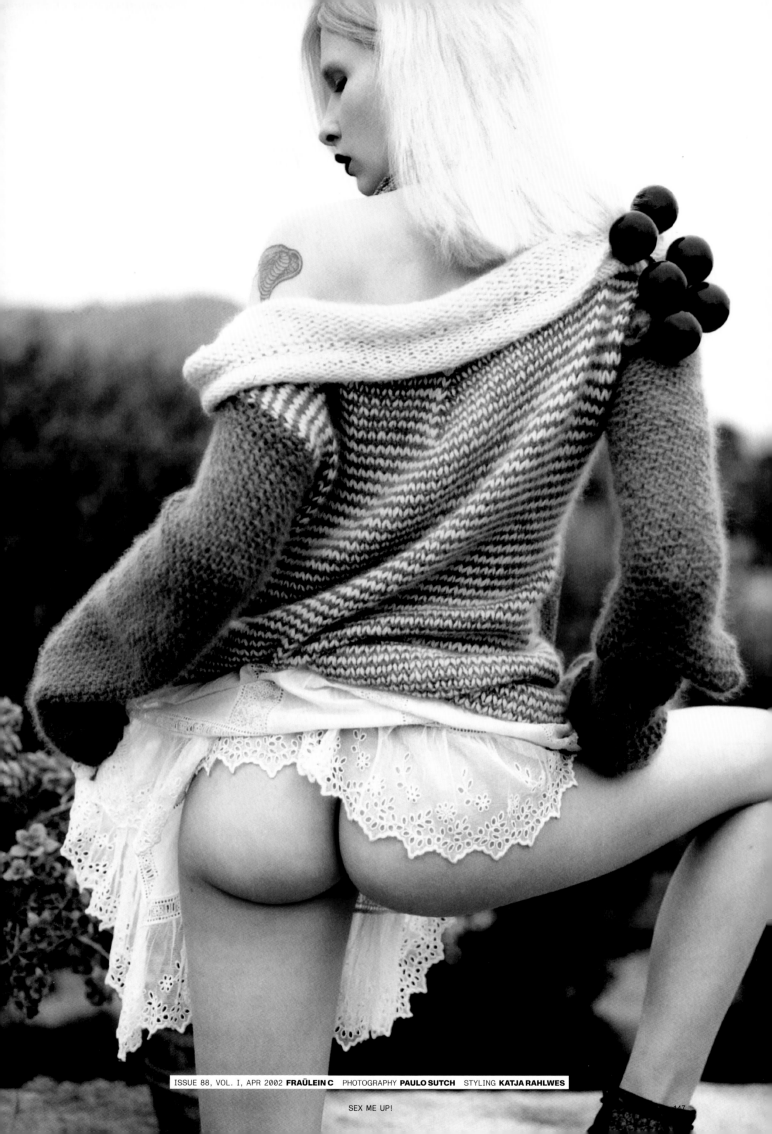

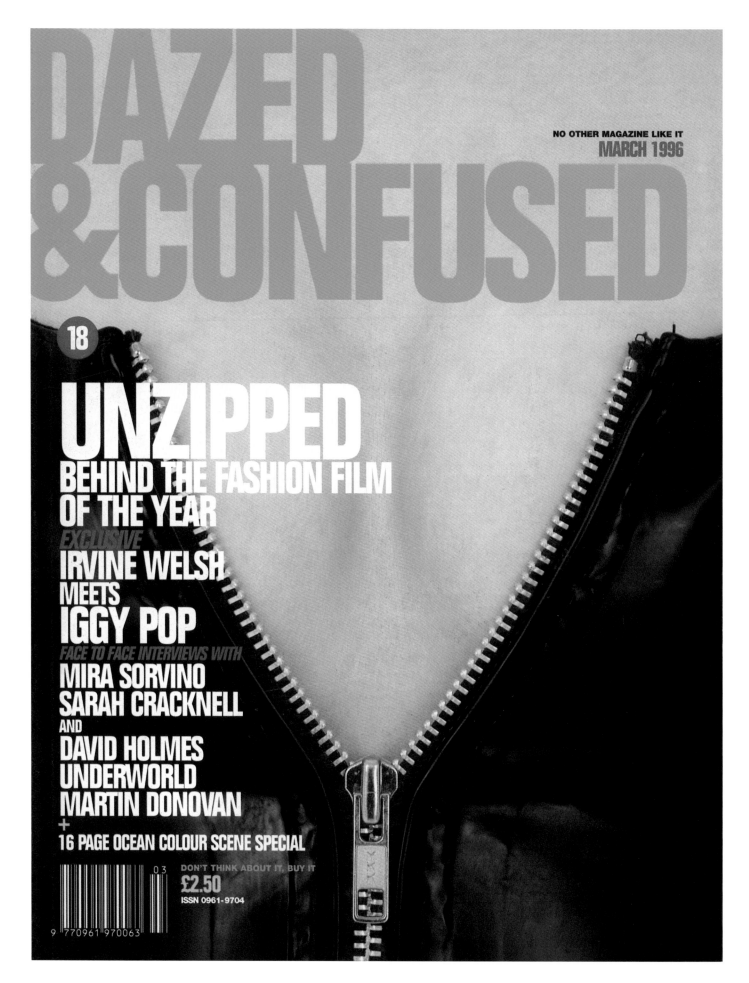

ISSUE 18, VOL. I, MAR 1996 **UNZIPPED** PHOTOGRAPHY **RANKIN** STYLING **KATIE GRAND**

MARK SANDERS, Arts Editor: The craziest issue of *Dazed* I ever worked on, and of which, I am most proud, has to be the 'Unzipped' issue which included an interview with a fictitious South African artist, Bruce Louden, that Jake Chapman and I made up together from scratch. Bruce Louden cut bits of his body off for art and his most recent performance had been to cut out his own tongue. The interview was completed in silence by Jake and me late one night and the photographs of the 'cutting' were taken by Phil Poynter. Once published there was one hell of a row and the magazine was removed from all outlets. The whole editorial staff, in those days only ten of us, had to come in and cut out the offending pages with a razor blade before the magazine was allowed to be sold. The irony was the article was titled Cut Out and Keep and indeed that is exactly what happened. I think I have the only copy in existence with the Bruce Louden article intact!

SEX ME UP!

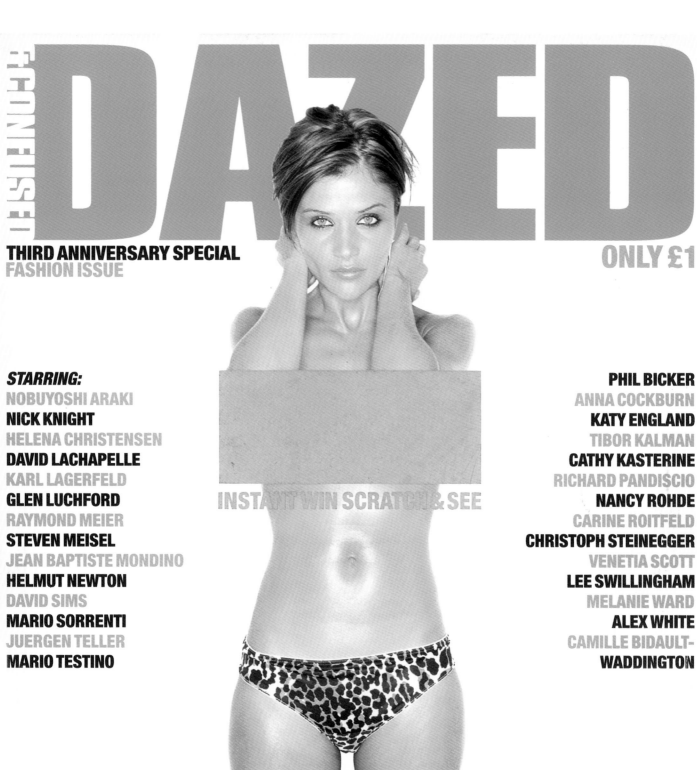

ISSUE 33, VOL. I, AUG 1997 **HELENA CHRISTENSEN** PHOTOGRAPHY **RANKIN** STYLING **KATIE GRAND**

DAZED

THIRD ANNIVERSARY SPECIAL
FASHION ISSUE

ONLY £1

STARRING:

NOBUYOSHI ARAKI
NICK KNIGHT
HELENA CHRISTENSEN
DAVID LACHAPELLE
KARL LAGERFELD
GLEN LUCHFORD
RAYMOND MEIER
STEVEN MEISEL
JEAN BAPTISTE MONDINO
HELMUT NEWTON
DAVID SIMS
MARIO SORRENTI
JUERGEN TELLER
MARIO TESTINO

PHIL BICKER
ANNA COCKBURN
KATY ENGLAND
TIBOR KALMAN
CATHY KASTERINE
RICHARD PANDISCIO
NANCY ROHDE
CARINE ROITFELD
CHRISTOPH STEINEGGER
VENETIA SCOTT
LEE SWILLINGHAM
MELANIE WARD
ALEX WHITE
**CAMILLE BIDAULT-
WADDINGTON**

INSTANT WIN SCRATCH & SEE

33 SCRATCH & SEE AUG 1997 F130 IU4200 C$3.95 UKE1.00 US$4.95 ISSN 0961-9704

HELENA CHRISTENSEN PHOTOGRAPHED BY RANKIN

RANKIN, Co-founder and Publisher: This was the idea of an art director called Kirk Teasdale. Katie (Grand) and I came up with this shot and it was just a real pure accident that we saw some of her body, her boobs, in the (photo). Someone had this idea to do a 'win/no win', because the lottery had just come out. Everyone wants to see her naked, but you can't — it just was such a clever concept. Most of them were 'no wins'. The idea of 'will you scratch off the lottery ticket or not?' was a commentary on objectifying Helena Christensen. I think she was annoyed that we'd done it, but then I think someone else famous said to her, 'But you can't see anything!' And yeah, one person can — but that's the brilliance of it, you know.

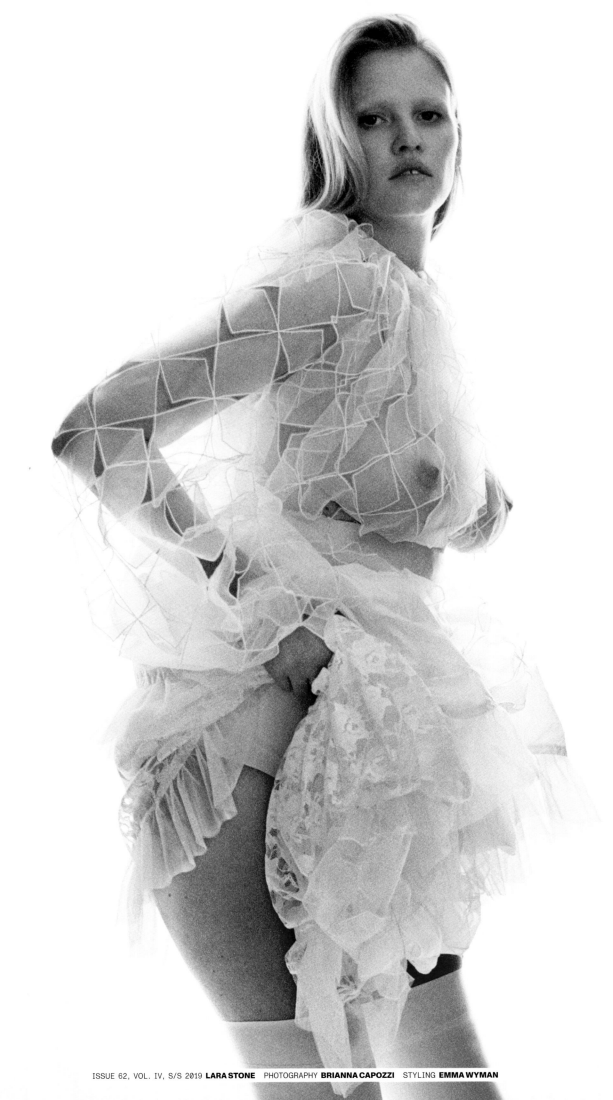

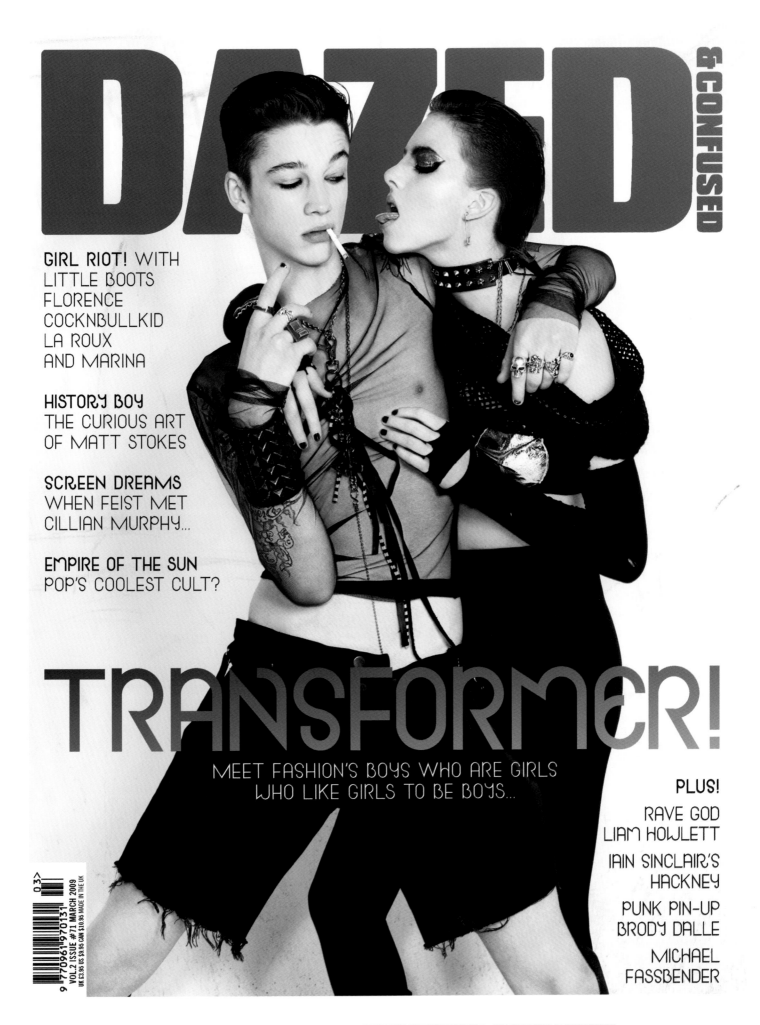

DAZED &CONFUSED

GIRL RIOT! WITH
LITTLE BOOTS
FLORENCE
COCKNBULLKID
LA ROUX
AND MARINA

HISTORY BOY
THE CURIOUS ART
OF MATT STOKES

SCREEN DREAMS
WHEN FEIST MET
CILLIAN MURPHY...

EMPIRE OF THE SUN
POP'S COOLEST CULT?

TRANSFORMER!
MEET FASHION'S BOYS WHO ARE GIRLS
WHO LIKE GIRLS TO BE BOYS...

PLUS!

RAVE GOD
LIAM HOWLETT

IAIN SINCLAIR'S
HACKNEY

PUNK PIN-UP
BRODY DALLE

MICHAEL
FASSBENDER

03>

VOL.2 ISSUE #71 MARCH 2009
UK £3.95 US $9.95 CAN $10.95 MADE IN THE UK

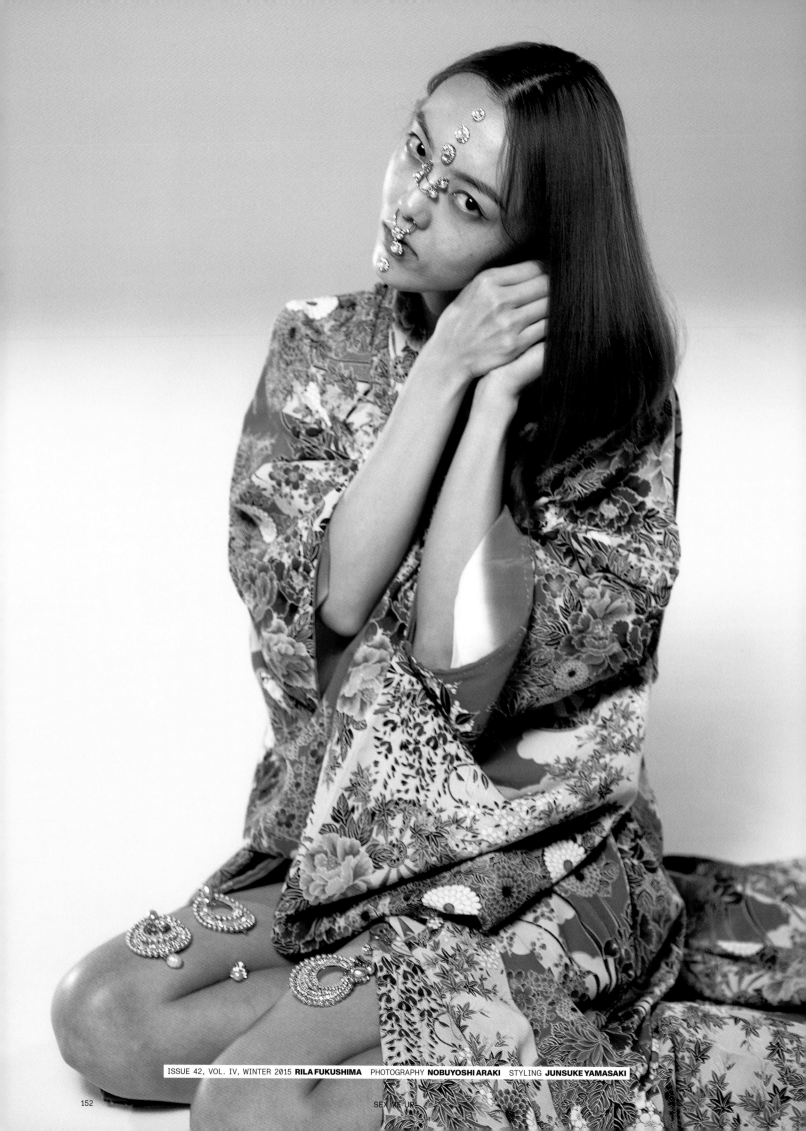

ISSUE 42, VOL. IV, WINTER 2015 **RILA FUKUSHIMA** PHOTOGRAPHY **NOBUYOSHI ARAKI** STYLING **JUNSUKE YAMASAKI**

SEX ME UP

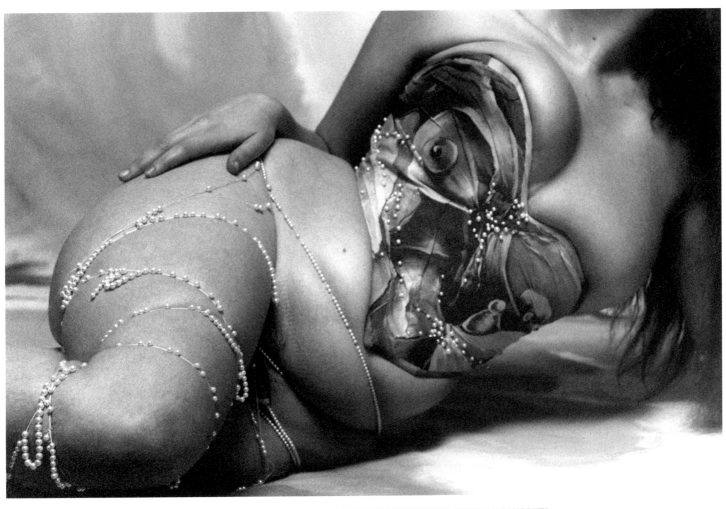

ISSUE 70, VOL. V, A/W 2020 PHOTOGRAPHY **LAURA JANE COULSON** STYLING **AI KAMOSHITA**

SEX ME UP!

ISSUE 17, VOL. I, 1995 **CENSORED**
PHOTOGRAPHY **ARCHIE SWINBURN**
STYLING **KATIE GRAND**

ISSUE 42, VOL. II, SEP *2002* **JUSTIN TIMBERLAKE**
PHOTOGRAPHY **RANKIN**
STYLING **NICOLA FORMICHETTI**
ARTWORK **KIM JONES**

154 SEX ME UP!

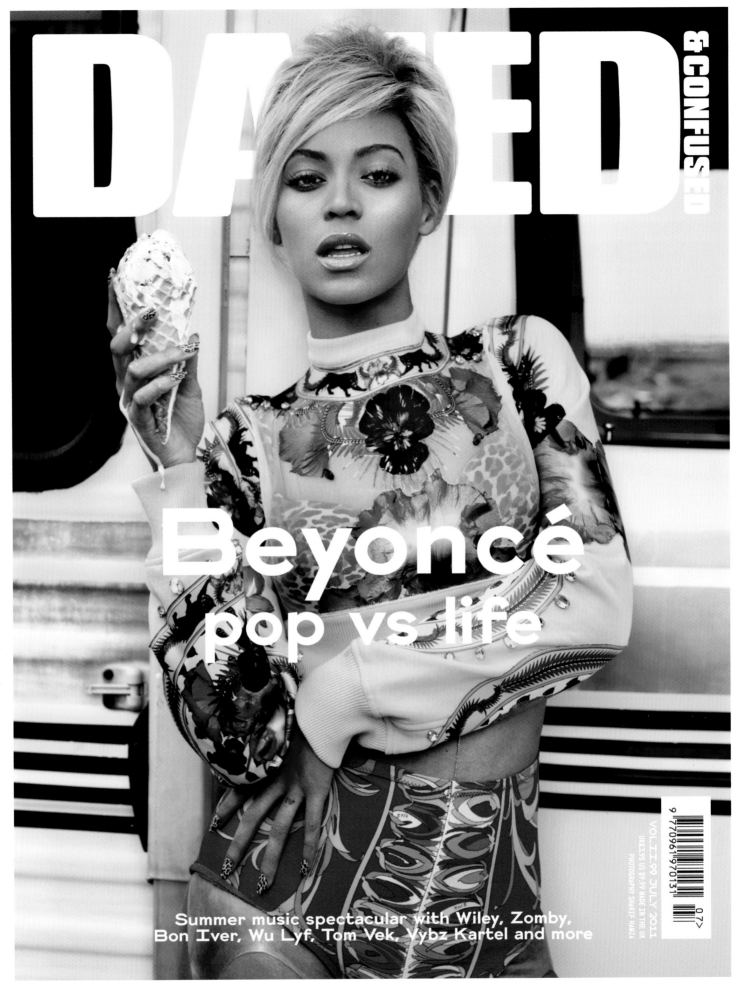

DAZED &CONFUSED

Beyoncé
pop vs life

ISSUE 99, VOL. II, JULY 2011 **BEYONCÉ** PHOTOGRAPHY **SHARIF HAMZA** STYLING **KAREN LANGLEY**

VOL II.99 JULY 2011

PHOTOGRAPHY SHARIF HAMZA

Summer music spectacular with Wiley, Zomby, Bon Iver, Wu Lyf, Tom Vek, Vybz Kartel and more

KAREN LANGLEY, Fashion Director: I was absolutely terrified! It's hilarious, because looking back now, that was the easiest shoot I've ever done with her. She just loved every single look and everything was custom-made for her. It was shot at the old navy yard in Brooklyn. That opened a whole other chapter for me, and it's still her favourite editorial of all time — still to this day!

SEX ME UP! 155

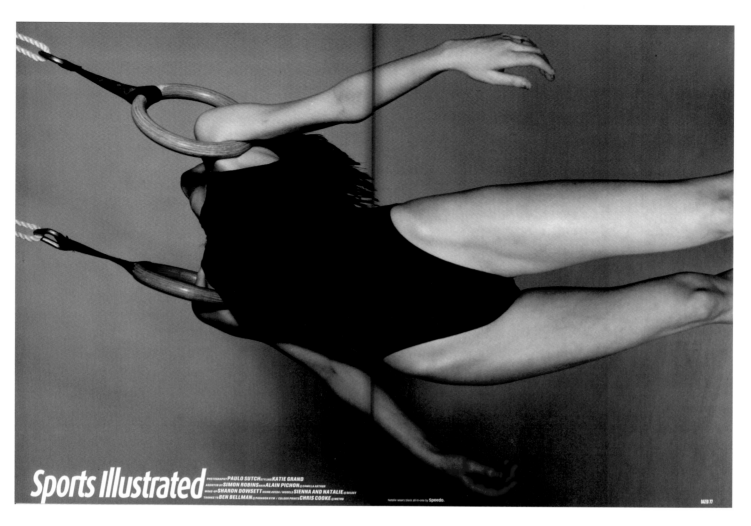

Sports Illustrated

PHOTOGRAPHY PAULO SUTCH STYLING KATIE GRAND
ASSISTED BY SIMON ROBINS HAIR ALAIN PICHON @ CAMILLA ARTHUR
MAKE-UP SHARON DOWSETT USING AVEDA / MODELS SIENNA AND NATALIE @ SELECT
THANKS TO BEN BELLMAN @ PARAGON GYM / COLOUR PRINTS CHRIS COOKE @ METRO

Natalie wears black all-in-one by Speedo.

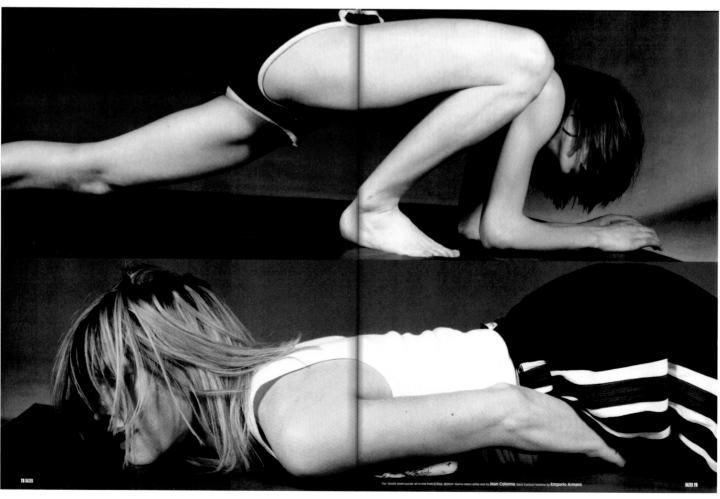

Top: Natalie wears purple all-in-one from G Shop. Bottom: Sienna wears white vest by Jean Colonna; black tracksuit bottoms by Emporio Armani.

ISSUE 30, VOL. I, MAY 1997 **SPORTS ILLUSTRATED** PHOTOGRAPHY **PAULO SUTCH** STYLING **KATIE GRAND**

SEX ME UP!

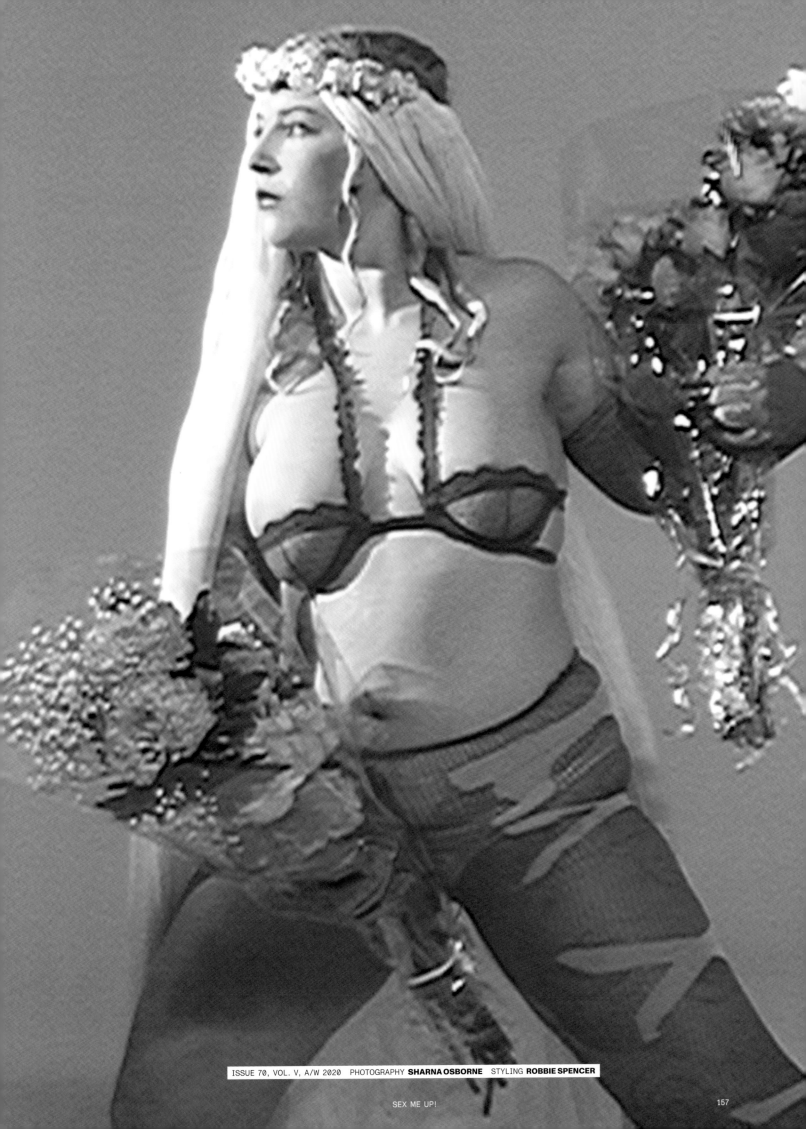

6.
Nothing Lasts Forever, The Future is Now

A new generation out there and doing it

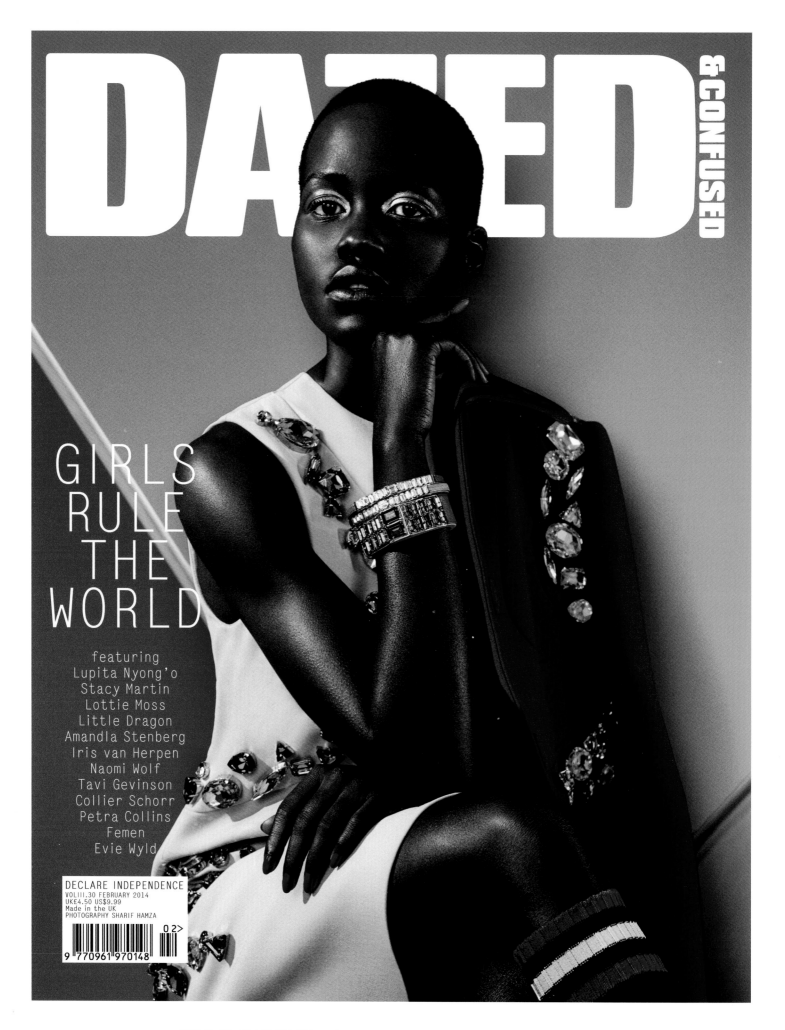

DATED

&CONFUSED

GIRLS
RULE
THE
WORLD

featuring
Lupita Nyong'o
Stacy Martin
Lottie Moss
Little Dragon
Amandla Stenberg
Iris van Herpen
Naomi Wolf
Tavi Gevinson
Collier Schorr
Petra Collins
Femen
Evie Wyld

DECLARE INDEPENDENCE
VOLIII.30 FEBRUARY 2014
UK£4.50 US$9.99
Made in the UK
PHOTOGRAPHY SHARIF HAMZA

02>

9 770961 970148

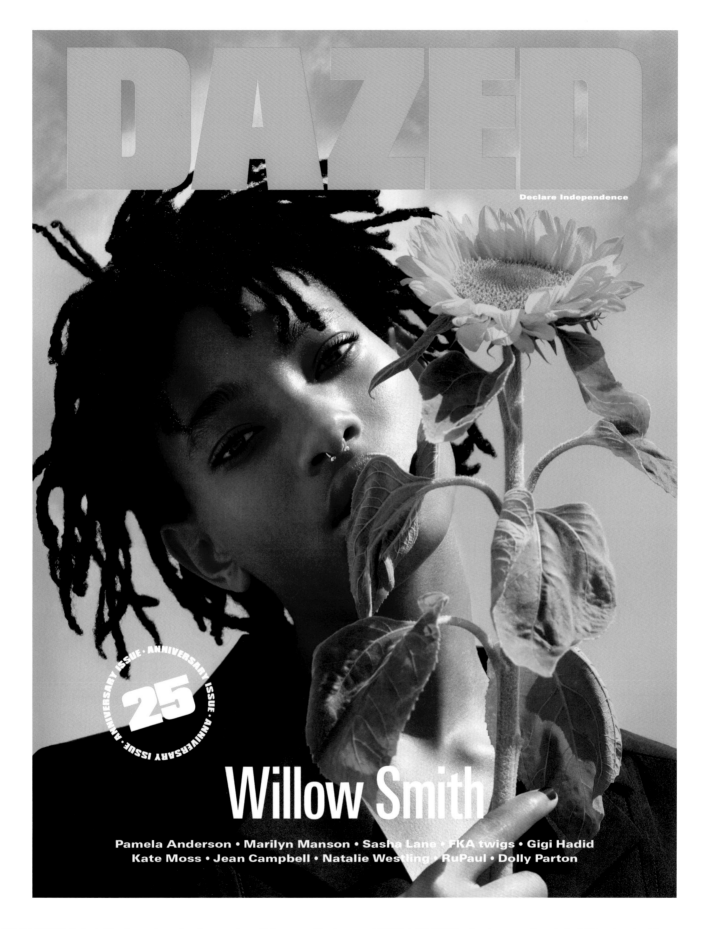

ISSUE 47, VOL. IV, A/W 2016 **WILLOW SMITH** PHOTOGRAPHY **BEN TOMS** STYLING **ROBBIE SPENCER**

DAZED

Declare Independence

25 · ANNIVERSARY ISSUE · ANNIVERSARY ISSUE · ANNIVERSARY ISSUE · ANNIVERSARY ISSUE ·

Willow Smith

**Pamela Anderson • Marilyn Manson • Sasha Lane • FKA twigs • Gigi Hadid
Kate Moss • Jean Campbell • Natalie Westling • RuPaul • Dolly Parton**

WILLOW SMITH: I feel like I need to give love and confidence to Black girls who don't feel like they're beautiful, and (to tell them) that it doesn't matter what society has pinned you as, because you are a being that can't be pinned. Who you are as an individual — that can never be categorised, it's always going to be infinitely beautiful and divine. I want to be able to spread unity, but it's so important to target Black girls because, more and more, they're starting to feel like the only thing that they are is their bodies or their skin. I see it every day.

AMANDLA STENBERG: At the same time, I feel like there's this crazy uprising of Black girls who are taking ownership of their lives, who are not afraid to be themselves. And it's happening at the same time that there's this countercultural shift.

WILLOW SMITH: It's like two teams, the light and the dark. And right now they're (*makes roaring noise*) fighting, and we're at the front. It has to happen, but it's tiring. But it definitely has to happen. I want to fight back, I wanna be active against the fucking crazy world, you know? *Excerpt from issue 47, vol. IV, A/W 2016*

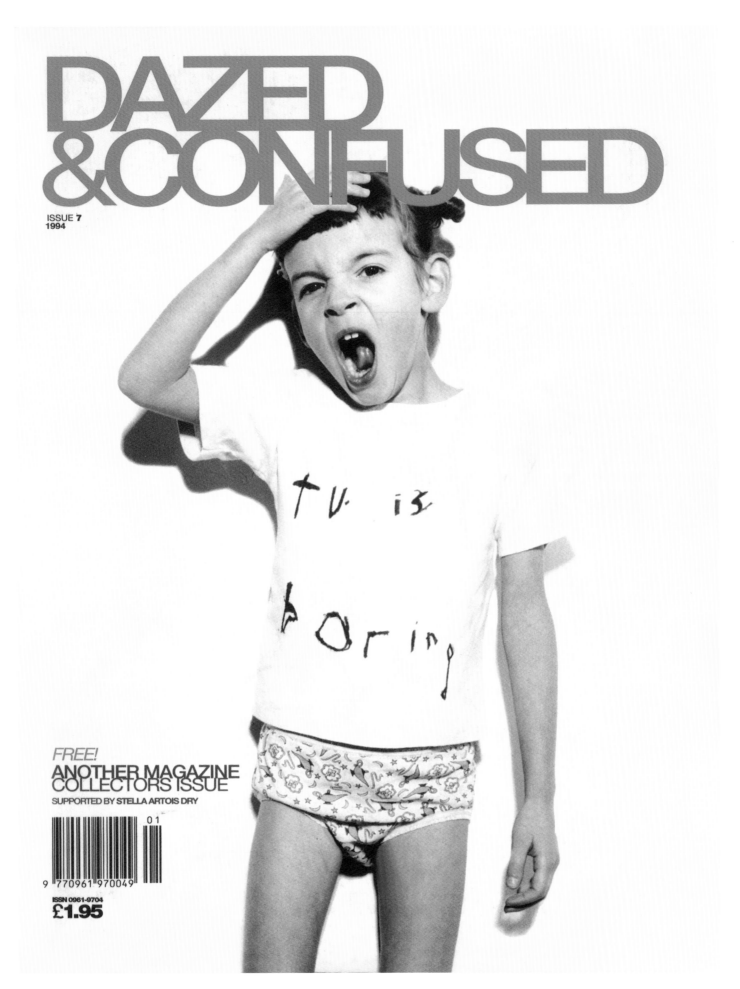

ISSUE 7, VOL. I, NOV 1994 **TV IS BORING** PHOTOGRAPHY **RANKIN** STYLING **KATIE GRAND**

JO-ANN FURNISS, Writer-at-Large: I was totally arrested by the 'TV is Boring' cover. It's playful and confrontational at the same time. It appeared at a moment when there was a real panic about kids and the way young models were being photographed; it was almost laughing at that, by kind of making a comment on it and being simultaneously dismissive and mischievous. A lot of my work at college was about this kind of thing, under the umbrella title of 'Orrible Kids, so it made an impact. But really, it's just a good cover. It had that real brattiness of Katie Grand and Rankin — I don't think any of the other magazines at the time would have done it.

NOTHING LASTS FOREVER, THE FUTURE IS NOW

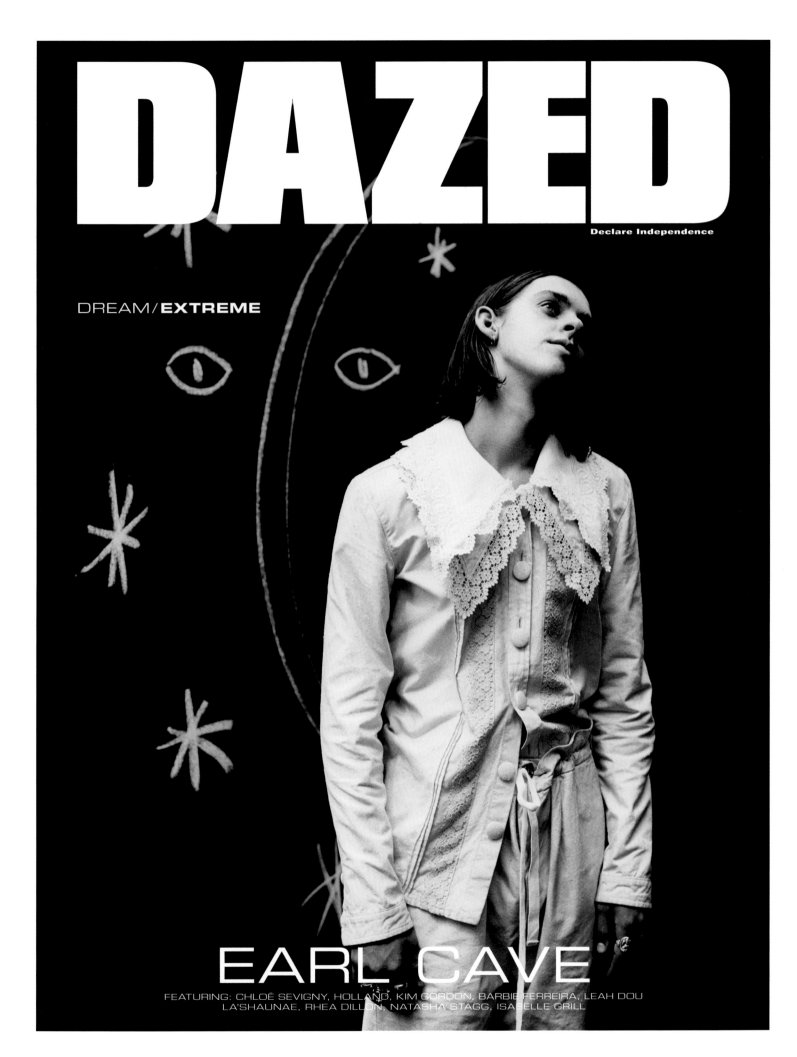

DAZED

Declare Independence

DREAM/**EXTREME**

EARL CAVE

FEATURING: CHLOÉ SEVIGNY, HOLLAND, KIM GORDON, BARBIE FERREIRA, LEAH DOU
LA'SHAUNAE, RHEA DILLON, NATASHA STAGG, ISABELLE GRILL

ISSUE 65, VOL. IV, A/W 2019 **EARL CAVE** PHOTOGRAPHY **JACK DAVISON** STYLING **ROBBIE SPENCER**

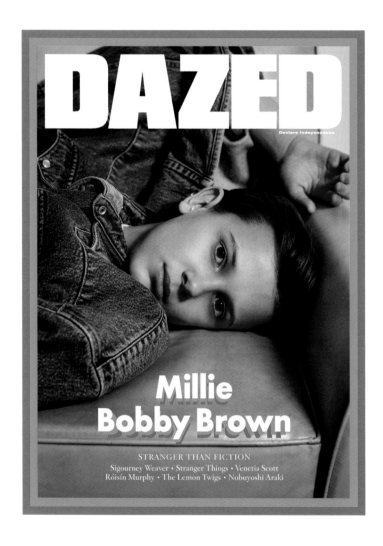

DAZED

Declare Independence

Millie
Bobby Brown

STRANGER THAN FICTION

Sigourney Weaver • Stranger Things • Venetia Scott
Róisín Murphy • The Lemon Twigs • Nobuyoshi Araki

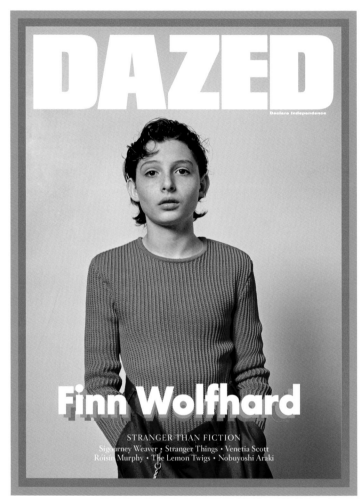

DAZED

Declare Independence

Finn Wolfhard

STRANGER THAN FICTION

Sigourney Weaver • Stranger Things • Venetia Scott
Róisín Murphy • The Lemon Twigs • Nobuyoshi Araki

ISSUE 48, VOL. IV, WINTER 2016 **MILLIE BOBBY BROWN**
PHOTOGRAPHY **COLLIER SCHORR**
STYLING **ROBBIE SPENCER**

ISSUE 48, VOL. IV, WINTER 2016 **FINN WOLFHARD**
PHOTOGRAPHY **COLLIER SCHORR**
STYLING **ROBBIE SPENCER**

NOTHING LASTS FOREVER, THE FUTURE IS NOW

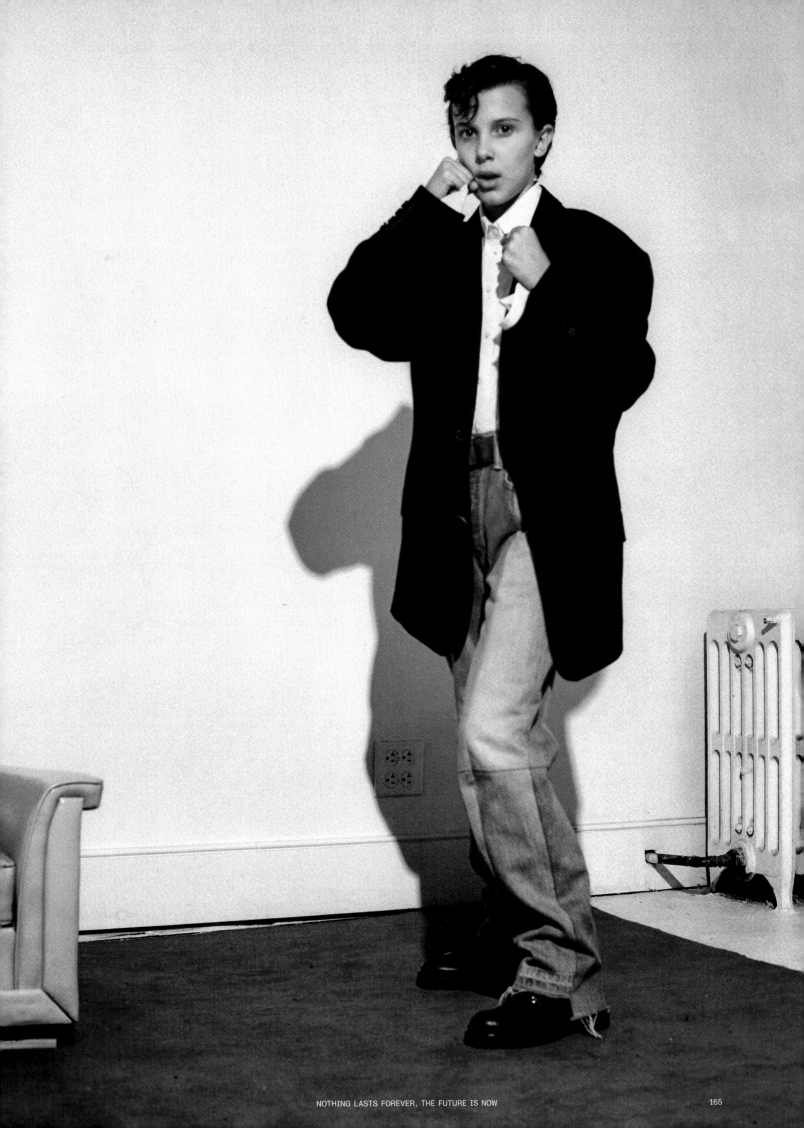

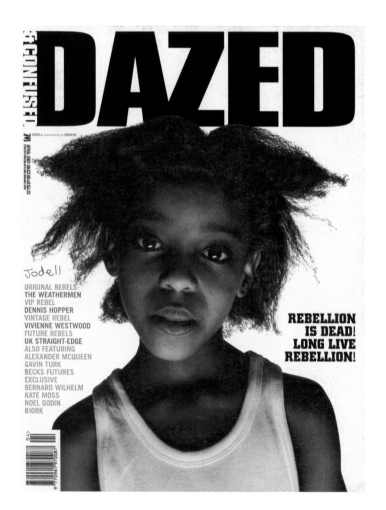

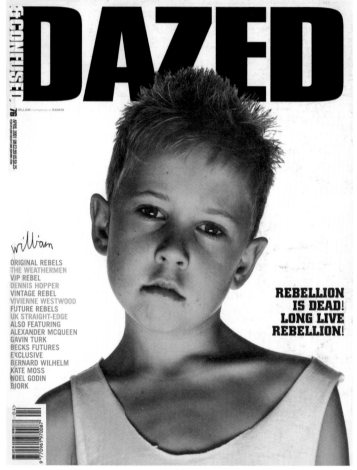

RANKIN, Co-founder and Publisher: Jefferson and I were always
fascinated by the innocence of kids. We always wanted to do a whole
issue edited by kids!

NOTHING LASTS FOREVER, THE FUTURE IS NOW

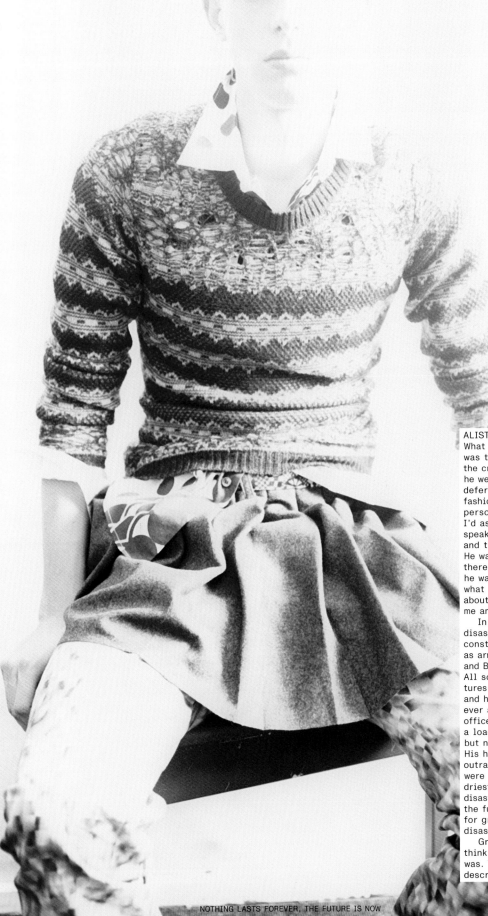

ISSUE 99, VOL. II, NOV 2010 **WHITE DOVE** PHOTOGRAPHY **GARETH MCCONNELL** STYLING **BRYAN MCMAHON**

ALISTER MACKIE, Fashion Director: What was brilliant about Bryan was that he became the barometer, the critical eye — what he said, where he went. If he said it worked, I'd defer to him, and anytime I did a fashion show he would be the first person to come backstage and the one I'd ask their view on it. He was the speaker of truth, that was Bryan, and that's the way he always was. He was unguarded, unfiltered — before there were any filters. He knew what he was looking at, what was right, what was wrong, and was very direct about it. He became invaluable to me and everyone at *Dazed*.

In terms of assisting, there was disaster after disaster — things were constantly being lost, props such as armour we'd rented from Angels and Bermans, which fell out of a car. All sorts of catastrophes and adventures. But it was worth it for his eye and his humour. There was nobody ever as funny as Bryan in the *Dazed* office, that's for sure. We've had a load of big characters in there but nobody was as funny as him. His humour was dry, cutting, scathing, outrageous, and frightening if you were the butt of the joke. Even in the driest of moments or the biggest of disasters, Bryan and I would just see the funny side; it would be cause for great laughter for us. The more disastrous the better.

Greatly missed, dearly beloved, I think is the phrase for it — he really was. Tim Blanks said it best when he described 'the much loved'.

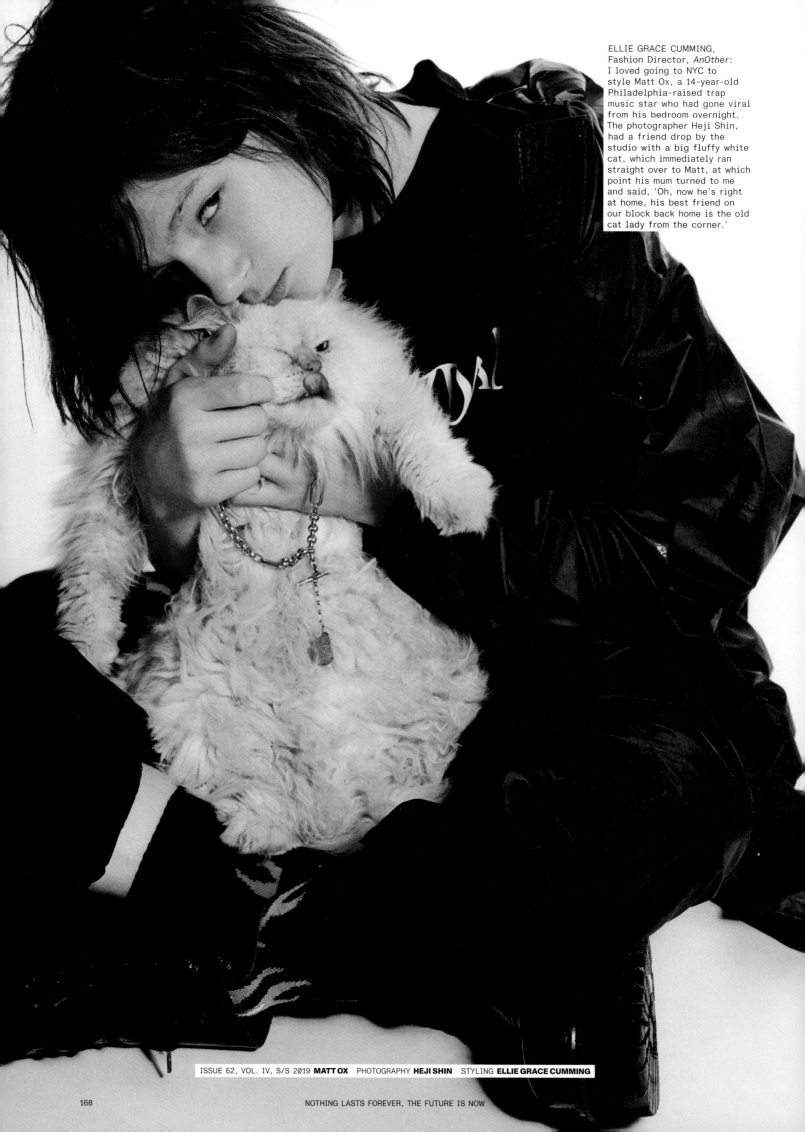

ELLIE GRACE CUMMING,
Fashion Director, *AnOther*:
I loved going to NYC to
style Matt Ox, a 14-year-old
Philadelphia-raised trap
music star who had gone viral
from his bedroom overnight.
The photographer Heji Shin,
had a friend drop by the
studio with a big fluffy white
cat, which immediately ran
straight over to Matt, at which
point his mum turned to me
and said, 'Oh, now he's right
at home, his best friend on
our block back home is the old
cat lady from the corner.'

ISSUE 62, VOL. IV, S/S 2019 **MATT OX** PHOTOGRAPHY **HEJI SHIN** STYLING **ELLIE GRACE CUMMING**

NOTHING LASTS FOREVER, THE FUTURE IS NOW

Maddie Ziegler
by Philippa Snow

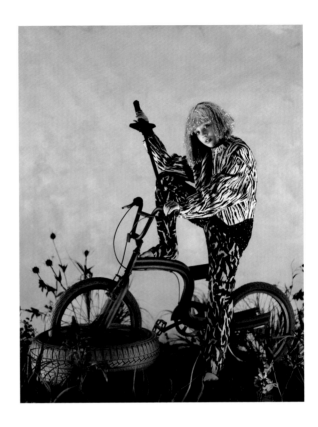

In 2014, Maddie Ziegler appeared in an haute-gothic *Dazed & Confused* shoot by the photographer Jeff Bark that emphasised the eerie, preternatural qualities of her little-adult demeanour, each image the green or purple colour of a fresh contusion. In one shot, the dancer and reality TV star wears a checked suit by Maison Martin Margiela that is oversized enough to make her look like she's been shrunk, her slouching pose and blank expression so chill that she might be drugged; in another, she leans on a pitch-black carousel horse, wearing arm-length leather gloves. The most striking of Bark's photographs is one of Ziegler stuffed into a shopping trolley, her eyes fixed on something mysterious in the middle distance. She is grimacing, subtly but unsettlingly, making it impossible to know whether she's haunted, or whether she is the one doing the haunting. In the accompanying profile, she recalls a dance routine in which she pretended to die in a vehicular collision. 'Those are my favourite things to do,' she says, 'because I can really tell a story. I love it if I see someone crying.'

Professional dance, like acting, is a strange alembic of the practical and the insoluble — one either 'has it', or does not. The extraordinary rarity of such a combination has done little to dissuade the mothers of a great many modestly talented young girls, some of whom ended up appearing on the 2011–2019 reality series *Dance Moms* in Brooke-Shields-in-*Pretty-Baby* drag, sobbing and kicking their way into either infamy or minor, fleeting fame; of those young girls, none has enjoyed a higher profile than the tiny, doll-like beauty Ziegler, whose immediate status as the teacher's pet came hand in hand with a curiously adult solemnity, her small and heavily made-up face often betraying the weight of her great ambition, even in the lightest moments of rehearsal. She is eight at the beginning of the series, but she sometimes seems 800, and it cannot be denied that she is brilliant, boneless-seeming in her flexibility. 'I would kill myself if I didn't dance,' she says in season one, staring into the camera lens with the unnerving and precocious calm of one possessed by unseen forces.

Possession in general does not seem like an entirely unlikely factor in her ongoing success: fans of Ziegler often note that her appeal has less to do with fastidiousness or technical ability, and more to do with her aptitude for expressing — as if channelling, medium-like, some historical trauma — narratives, underpinned by certain extremities of mood. In season six, she performs a lyrical solo in character as a hostage, her face smeared with ersatz dirt; she rolls her eyes and bares her teeth, her fouettés fast and wild enough that it appears as though her limbs are being controlled by someone else.

Where other dancers look appeasing, outward-facing, Ziegler often looks as if she is experiencing great psychic pain. Certainly, one thinks of hostages. One thinks, too, about Brady Corbet's 2018 *Vox Lux*, a film about a very young girl who has dreams of being a singer and a dancer, and who ends up selling her soul to the devil for a shot at the most plasticised, televised kind of fame. Ziegler's knack for unhinged, sinister emotion is never more evident than in the 2014 video for Sia's 'Chandelier', in which she throws herself around a squalid Los Angelean apartment in a bodysuit the shade of untanned, maybe-undead flesh. To mimic Sia, she is wearing a sharp, bone-white party wig that resembles the one worn by Diane in *Twin Peaks: The Return*. In the video's final 15 seconds, she stares straight into the camera, standing stiffly in the doorway of the room, and curtsies, with her arms extended, three or four times. As her knees bend, she widens her eyes and stretches out her lips into a frightening, wolfish grin, the smile receding every time she straightens up — she looks insane, fleetingly, as if she has momentarily ceded control to someone else.

If the devil were American, as he so often seems to be, why wouldn't it occur to him to occupy the body of a blue-eyed girl-child who is also very famous as a result of appearing on reality TV? Funny to think of *Dance Moms* as the birthplace of this disconcerting little blonde-haired demon.

ISSUE 34, VOL. IV, AUTUMN 2014 **MADDIE ZIEGLER** PHOTOGRAPHY **JEFF BARK** STYLING **ROBBIE SPENCER**

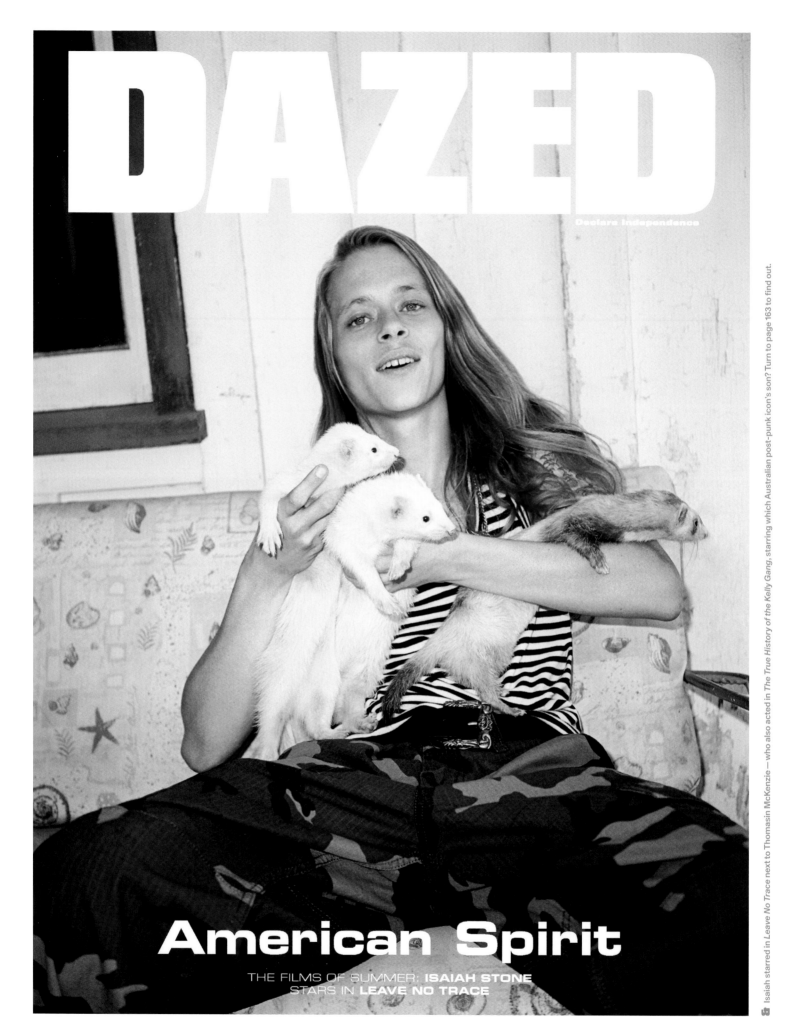

DAZED

Declare independence

Isaiah starred in *Leave No Trace* next to Thomasin McKenzie — who also acted in *The True History of the Kelly Gang*, starring which Australian post-punk icon's son? Turn to page 163 to find out.

American Spirit

THE FILMS OF SUMMER: **ISAIAH STONE**
STARS IN **LEAVE NO TRACE**

ISSUE 58, VOL. IV, AUTUMN 2018 **ISAIAH STONE** PHOTOGRAPHY **BEN TOMS** STYLING **ROBBIE SPENCER**

NOTHING LASTS FOREVER, THE FUTURE IS NOW

Hype

Welcome to my crib – where TikTok dreams are made

OPPOSITE PAGE: Chase wears checked shirt Woolrich, jeans and jewellery worn throughout his own, baseball cap Tommy Hilfiger. THIS PAGE, from left: Tony wears shorts and jewellery worn throughout his own. Ondreaz wears shorts and jewellery his own.

House

Talent Chase Hudson, Addison Rae Easterling, Avani Gregg, Nick Austin, Tony Lopez, Ondreaz Lopez, Alex Warren, Kouvr Annon, Michael Sanzone, Ryland Storms; stylings editor Nadia Beeman; photography assistant Vee Rebeaue

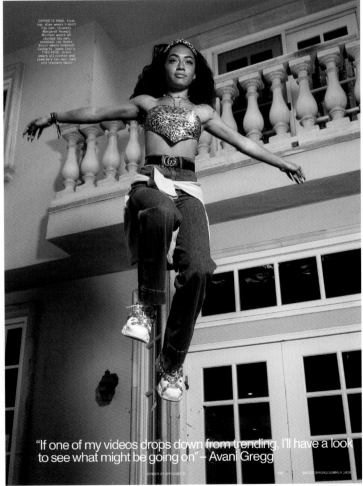

OPPOSITE PAGE, from top: Alex wears t-shirt his own, trousers Margaret Howell. Michael wears all clothes his own, baseball cap Guess. Kouvr wears bodysuit Cacharel, jeans Levi's. THIS PAGE: Avani wears all clothes and jewellery her own, belt and trainers Gucci.

"If one of my videos drops down from trending, I'll have a look to see what might be going on" – Avani Gregg

ISSUE 68, VOL. V, S/S 2020 **HYPE HOUSE** PHOTOGRAPHY **ROSIE MARKS**

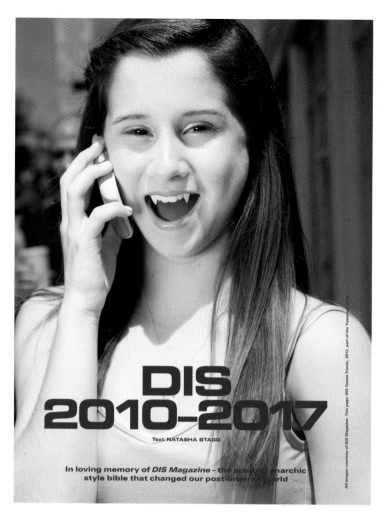

DIS
2010-2017

Text NATASHA STAGG

In loving memory of *DIS Magazine* – the academic, anarchic style bible that changed our post-internet world

All images courtesy of DIS Magazine. This page: DIS Tween Trends, 2012, part of the Tween Trends series.

Fair Trade, 2012, part of commissioned Frieze Project. This particular image of a man selling counterfeits was shot at Frieze London as part of a series documenting the fair through fictional scenarios

DISown Crisis Tees, 2015. Seasteading TagCloud Tank by Daniel Keller. Photo by Zak Krevitt. Part of Daniel Keller's ongoing work on the neoliberal fantasy of homesteading on the sea

FORMALE;LIFE, Telfar SS13 by Ryan Trecartin and Lizzie Fitch
"Detach. Convert. Get Basic"

Plank Girl, 2011

"The aftermath of the street-style blogging trend of 2008: the sidewalks of New York are littered with arms, legs, and spines akimbo. But we caught a handful of girls staying ahead of (and instead of) the curve, using the corrective properties of planking to set their bodies right for the best of Fall 2011"

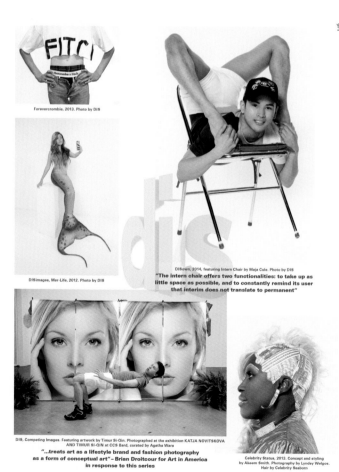

Forevercrombie, 2013. Photo by DIS

DISimages, Mer-Life, 2012. Photo by DIS

DISown, 2014, featuring Intern Chair by Maja Cule. Photo by DIS
"The intern chair offers two functionalities: to take up as little space as possible, and to constantly remind its user that interim does not translate to permanent"

DIS, Competing Images. Featuring artwork by Timur Si-Qin. Photographed at the exhibition KATJA NOVITSKOVA AND TIMUR SI-QIN at CCS Bard, curated by Agatha Wara
"...treats art as a lifestyle brand and fashion photography as a form of conceptual art" – Brian Droitcour for Art in America in response to this series

Celebrity Status, 2013. Concept and styling by Akeem Smith. Photography by Lyndsy Welgos. Hair by Celebrity Seaborn

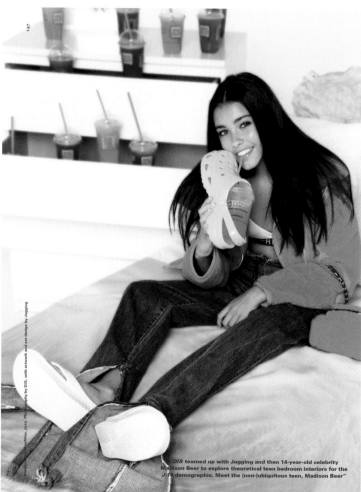

DIS teamed up with Jogging and then 14-year-old celebrity Madison Beer to explore theoretical teen bedroom interiors for the J-14 demographic. Meet the (non-)ubiquitous teen, Madison Beer"

ISSUE 55, VOL. IV, SPRING 2018 **DIS MAGAZINE 2010−2017**

NOTHING LASTS FOREVER, THE FUTURE IS NOW

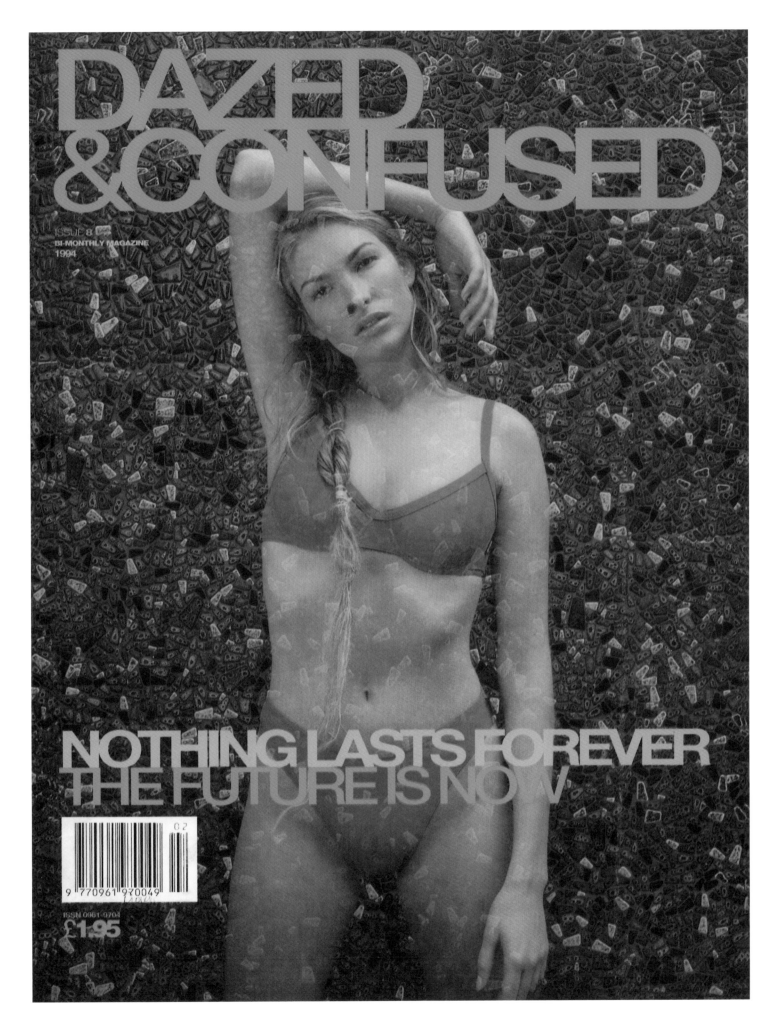

DAZED
&CONFUSED

ISSUE 8
BI-MONTHLY MAGAZINE
1994

NOTHING LASTS FOREVER
THE FUTURE IS NOW

£1·95

ISSN 0961-9704

The Death of the Cover Star

ISSN 0901-9704
Issue No.6
£1.70
BI-MONTHLY MAGAZINE

9 770901 970032

07

7.
The Death of the Cover Star

Unconventional covers that have stood the test of time

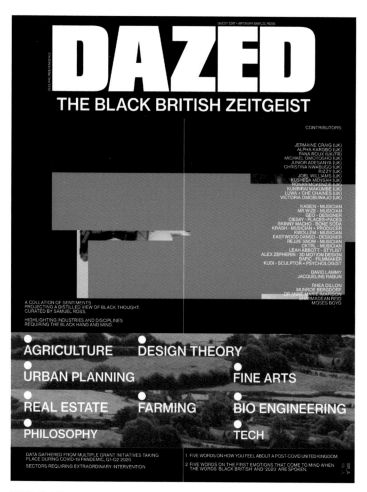

ISSUE 69, VOL. V, AUTUMN 2020 **THE BLACK BRITISH ZEITGEIST**
ARTWORK **SAMUEL ROSS**

Had I accepted the story I was born into, I would have accepted my own destruction. And the moment I stepped off-script out of that story, I made a commitment to living, so I have to figure out what that means. And I'm asking and persuading and demanding that people choose life with us.
—— Janaya Future Khan

ISSUE 69, VOL. V, AUTUMN 2020 **JANAYA 'FUTURE' KHAN**
ARTWORK **HARSH PATEL**

ISSUE 69, VOL. V, AUTUMN 2020 **INDIVIDUALLY WE ARE ASLEEP, AWAKE WE ARE TOGETHER**
ARTWORK **THE WIDE AWAKES IN COLLABORATION WITH HANK WILLIS THOMAS**

ISSUE 69, VOL. V, AUTUMN 2020 **NONAME**
ARTWORK **JAZZ GRANT**

The making of the 'Read Up, Act Up' issue
by Jack Mills

Between putting our Spring and Autumn 2020 issues together, the world changed not once, but twice. The global pandemic forced us all indoors and slowed down the cogs of a frantic and hyper-connected world. For once, we had the chance to take stock, to reassess the rules and systems we'd become blinded by under late capitalism. Now that the veil has lifted, what is it that *really* needs upheaving?

Questions and conversations raced across the internet, as a series of tragic events in America propelled everyone back onto the streets, to drive fundamental systemic change through the windows of Google and Washington. The feeds of Instagram and TikTok were flooded with text; propositions about the end of white patriarchy, about famine, about the one per cent, about the need for prisons, and the future of education.

It felt vital to not only respond to these conversations, but to add to them. Across six guest edits for Autumn, we invited key voices in the movement for change to bring their conversations, and communities, to the front. Six text-only covers — curated by Janaya Future Khan, Noname, Samuel Ross, Shayne Oliver & Anonymous Club, Grace Wales Bonner, and The Wide Awakes — marked a beginning and an end: the start of a fight with our blindfolds off, and a way past the neoliberal gatekeepers who have for so long guarded the path forward.

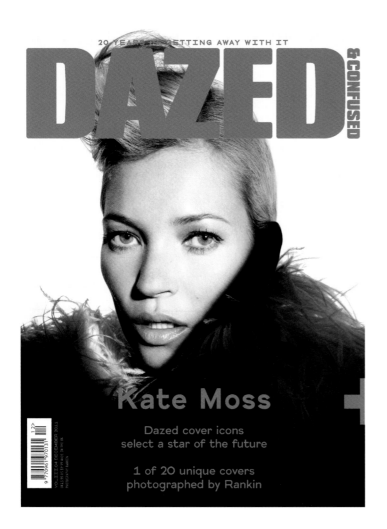

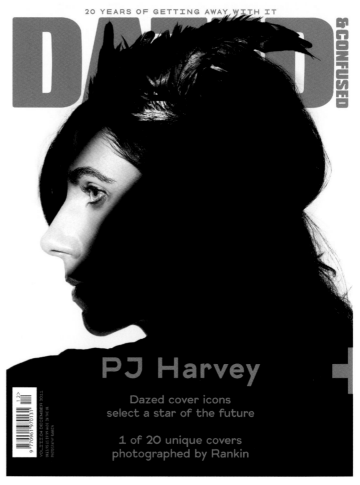

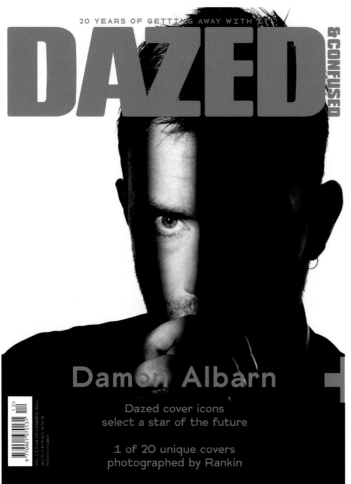

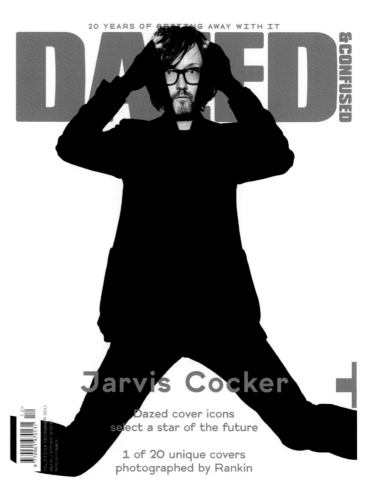

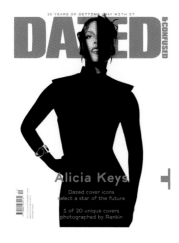 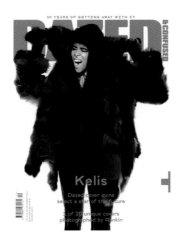 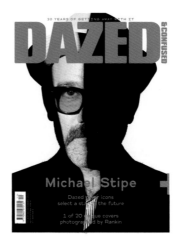 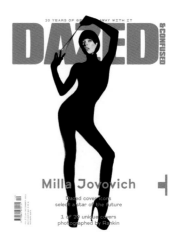

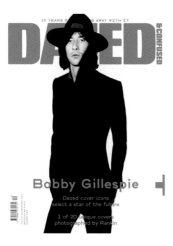 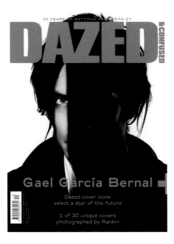 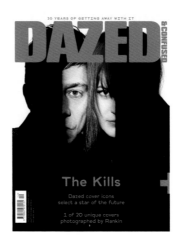 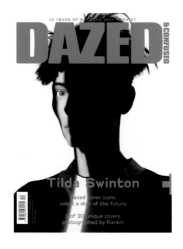

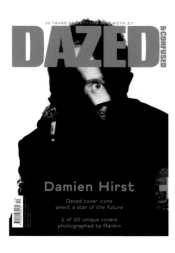 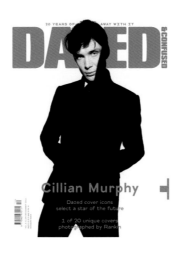 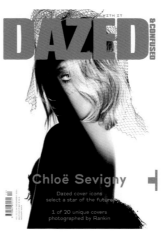 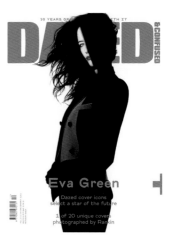

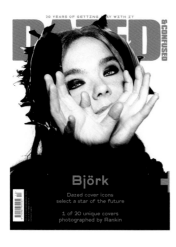 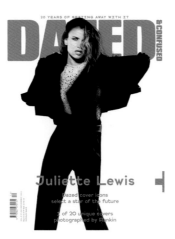 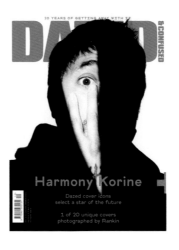 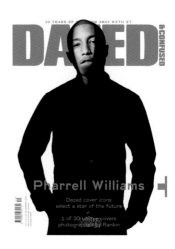

RANKIN, Co-founder and Publisher: I remember what I said to Jefferson at the time was let's do 20 covers for 20 years. He said why don't we do that but then get each cover star to recommend 20 up-and-coming people? I said that's a fucking great idea! That's us when we're at our best: when (there's) a good idea and then (the other person) makes it better. That's something that cuts through our time together.

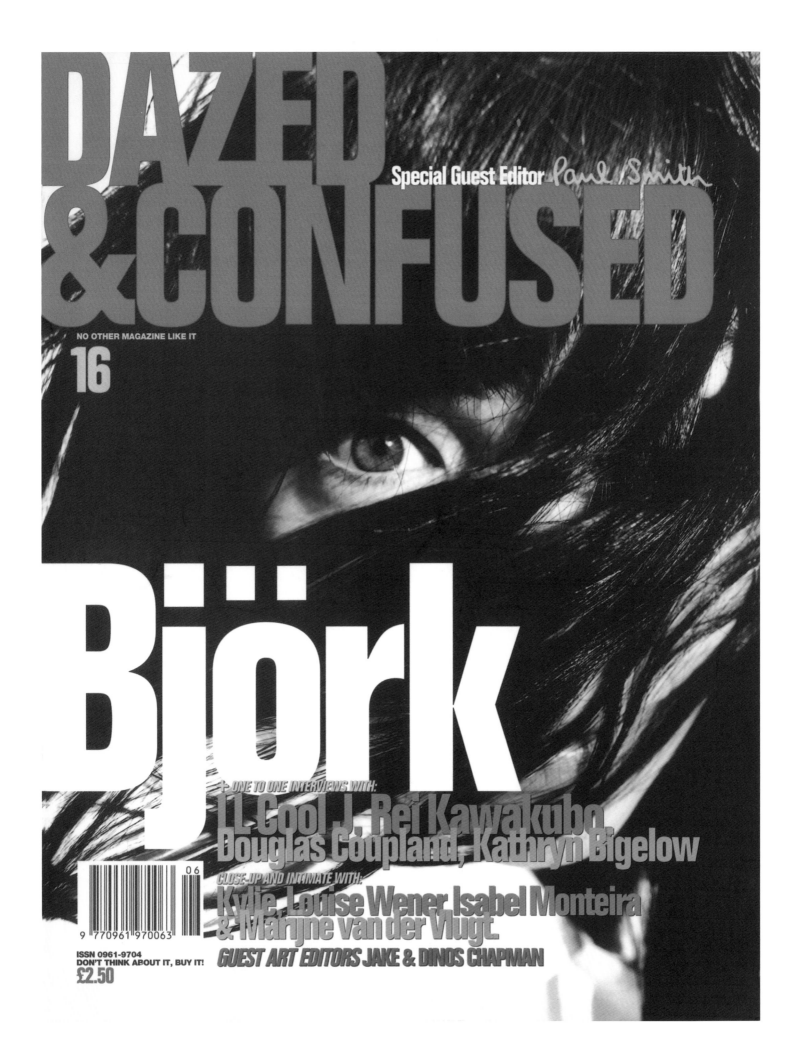

DAZED &CONFUSED

Special Guest Editor *Paul Smith*

NO OTHER MAGAZINE LIKE IT

16

Björk

+ ONE TO ONE INTERVIEWS WITH:
LL Cool J, Rei Kawakubo, Douglas Coupland, Kathryn Bigelow

CLOSE-UP AND INTIMATE WITH:
Kylie, Louise Wener, Isabel Monteira & Marijne van der Vlugt.

GUEST ART EDITORS JAKE & DINOS CHAPMAN

ISSN 0961-9704
DON'T THINK ABOUT IT, BUY IT!
£2.50

9 770961 970063

ISSUE 16, VOL. I, 1995 **BJÖRK** PHOTOGRAPHY **RANKIN**

THE DEATH OF THE COVER STAR

SELIM BULUT, Music Editor, *Dazed Digital*: I loved Gorillaz as a kid. The first album I ever owned was their debut, which I asked for as a gift on my 11th birthday way back in 2001. That same year, Channel 4 broadcast a mockumentary about the band called *Charts of Darkness*, in which Damon Albarn and Jamie Hewlett lose their grip on reality and start believing that the characters in their virtual band are, in fact, real. In one scene, Damon and Jamie head to a *Dazed & Confused* photoshoot at the magazine's former offices on Old Street, where they throw TVs around the room and smear burgers on the walls, claiming the destruction was caused by their creations.

That was my first exposure to *Dazed*. Years later, I'd learn that *Dazed* actually produced the mockumentary as part of some short-lived film and TV arm, and that these sorts of fun, ambitious, creative, multimedia ideas were pretty typical for the magazine. *Dazed* has obviously grown a lot since 2001. The photo studio at the back of its old office, which I first saw on TV as an 11-year-old, was eventually replaced to make room for more desks for the company's expanding staff. It's where I first sat when I became music editor 15 years later.

ISSUE 73, VOL. I, JAN 2001 **GORILLAZ**
ARTWORK **JAMIE HEWLETT**
STYLING **BRYAN MCMAHON**

ISSUE 67, VOL. I, JUL 2000 **EDDIE, IRON MAIDEN**

DAZED &CONFUSED

21

NO OTHER MAGAZINE LIKE IT

JUNE 1996

MANIC
MANIC STREET PREACHERS

EXCLUSIVE JON SAVAGE TALKS TO NICKY WIRE
PAUL MOODY TALKS TO JAMES DEAN BRADFIELD AND SEAN MOORE

FACE TO FACE INTERVIEWS WITH... BECK, 808 STATE, EDWARD BUNKER,
PUSHERMAN and KOOL KEITH
+ BARBARA KRUGER SPECIAL ARTIST'S PROJECT
DEMI MOORE PHOTOGRAPHED BY DAVE STEWART

9 770961 970063 06

£2.50 ISSN 0961-9704
NICKY WIRE'S EYE PHOTOGRAPHED BY RANKIN

ISSUE 21, VOL. I, JUN 1996 **MANIC STREET PREACHERS** PHOTOGRAPHY **RANKIN**

Manic Street Preachers
by Ronojoy Dam

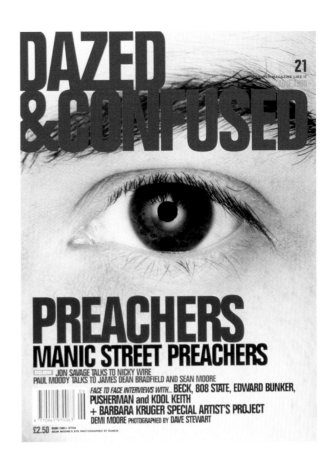

'My father still reads the dictionary every day. He says your life depends on your power to master words.'
— ARTHUR SCARGILL

January 1996, I'm 12 years old, sat in my living room reading the newspaper's magazine. On the cover, a topless young man in a pinstriped blazer softly peers over round sunglasses, the article headlined The Lost Soul. The following weekend the newspaper prints the letter I've written, with accompanying apology, in challenge to the 'presumed dead' headline about the missing rock star Richey Edwards. Words have meaning.

May 1996, Manic Street Preachers released *Everything Must Go*, the band's first album following the disappearance of lyricist and leader Richey Edwards the previous year. A triumphant critical and commercial success, a band dealing with tragedy had finally found mainstream acceptance, a bittersweet return from the abyss. The anthemic 'working class rage articulated' lead single 'A Design for Life' would be sung across the country, opening with the line *'Libraries gave us power'*.

'When a man is young, he is usually a revolutionary of some kind. So here I am, speaking of my revolution.'
— WYNDHAM LEWIS

At 13 years old you're really searching for something. At least me and my best friends were. And for a British Bengali teenager in east London, a band from the mining town of Blackwood, Wales, would open up new worlds and a life's education. A band obsessed with ideas, ideology and iconoclasm. A band flowing with endless references; dense and profound, demanding research. A band that made music as an academic assault. A band that used words with violence.

I listed all the unknown names quoted in their debut album *Generation Terrorists* on a piece of paper and handed it over to the school librarian. He returned with books by Sylvia Plath, Philip Larkin, Karl Marx, Albert Camus, William Burroughs, Tennessee Williams,

Henry Miller, Bret Easton Ellis, George Orwell. For the Manics, books were as exciting as records; there was no difference between the Sex Pistols and Arthur Rimbaud. Their obsession with the mythology of the modern world created their own cartography of 20th-century culture. The radicalism of the message always came first.

'I talk to God but the sky is empty.'
— SYLVIA PLATH

'If we've achieved anything, it's to give clues to a more rewarding life, like Morrissey talking about Oscar Wilde, or the Clash talking about Allen Ginsberg. All my favourite bands are the same, working class people with pretensions.' This was a band who were proudly ambitious, studious, righteous, sincere, intellectual and working class. A band who openly spoke out on African-American rights, homophobia, machismo, feminism, mental health, Western political hypocrisy, the British Welfare State. 'Ifwhiteamericatoldthetruthforonedayitsworldwouldfallapart'. A band full of searing rage and soaring desire. A band who could express both utter alienation and admit wonderful childhoods, who could marry uncompromising intensity with quiet domesticity, who cherished rebellion through education.

In this *Dazed* cover interview from 1996, the Manics' first for the magazine, the writer Jon Savage touches on the influences of the Letterist and Situationist avant-garde groups and Greil Marcus' *Lipstick Traces* in the band's philosophy of polemic; slogans and quotations a constant punctuation of their output. Before he disappeared, Richey left his friends Nicky Wire, James Dean Bradfield and Sean Moore a folder full of lyrics, poetry and prose. Words, the final word. Wire and Edwards were the band's co-lyricists but even once (Richey) was gone, they remained a band of words. Manic Street Preachers remain a band forever misunderstood, forever against the grain, and forever loved by fans for the very same reasons. A band defined by outsiderdom, the band for true outsiders.

Ronojoy Dam has donated his fee to the children's reading charity BookTrust.

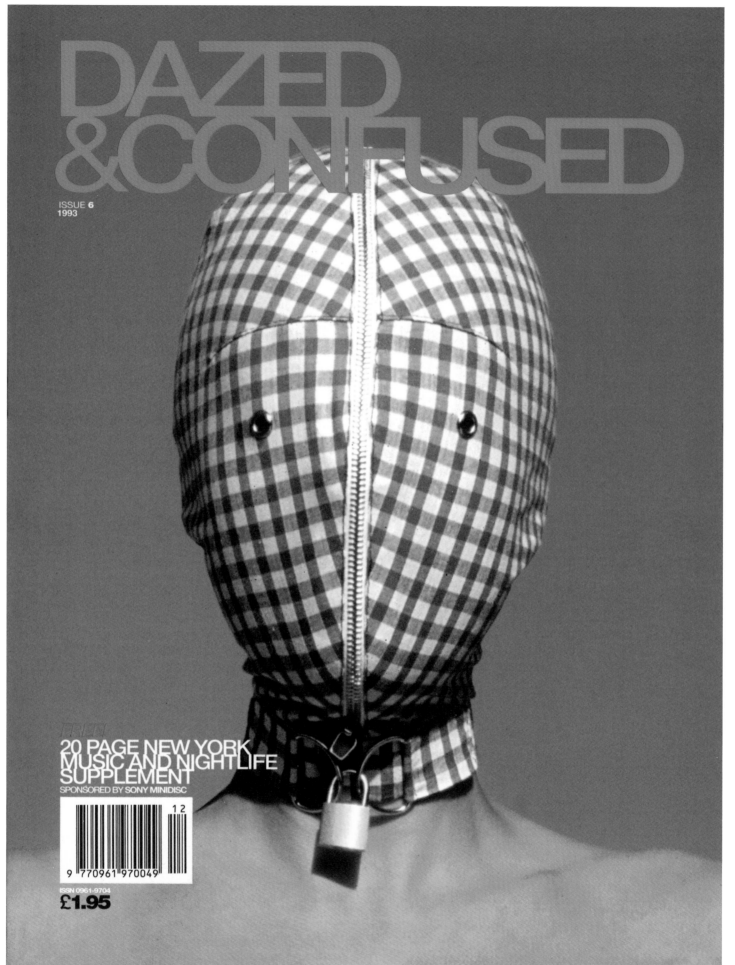

DAZED
&CONFUSED

20 PAGE NEW YORK MUSIC AND NIGHTLIFE SUPPLEMENT
SPONSORED BY SONY MINIDISC

ISSN 0961-9704
£1.95

9 770961 970049

This wasn't our last masked cover star — turn to page 116 for more in-your-face obfuscation.

ISSUE 6, VOL. I, 1993 ARTWORK **MARCELE PRICE**

MARK SANDERS, Arts Editor: My favourite *Dazed* cover was for sure issue five, 'The Death of the Cover Star', which was just a silver cover with no image. I am not sure whether Jefferson or the designer at that time knew about the Situationist International, and yet this was the same silver metallic cover they used for their radical Parisian magazine in the early 1960s. Getting rid of the cover star, even for only one issue, was a declaration of intent, which was very brave, especially in the early 1990s, when competitors such as *The Face* or *i-D* were star-obsessed.

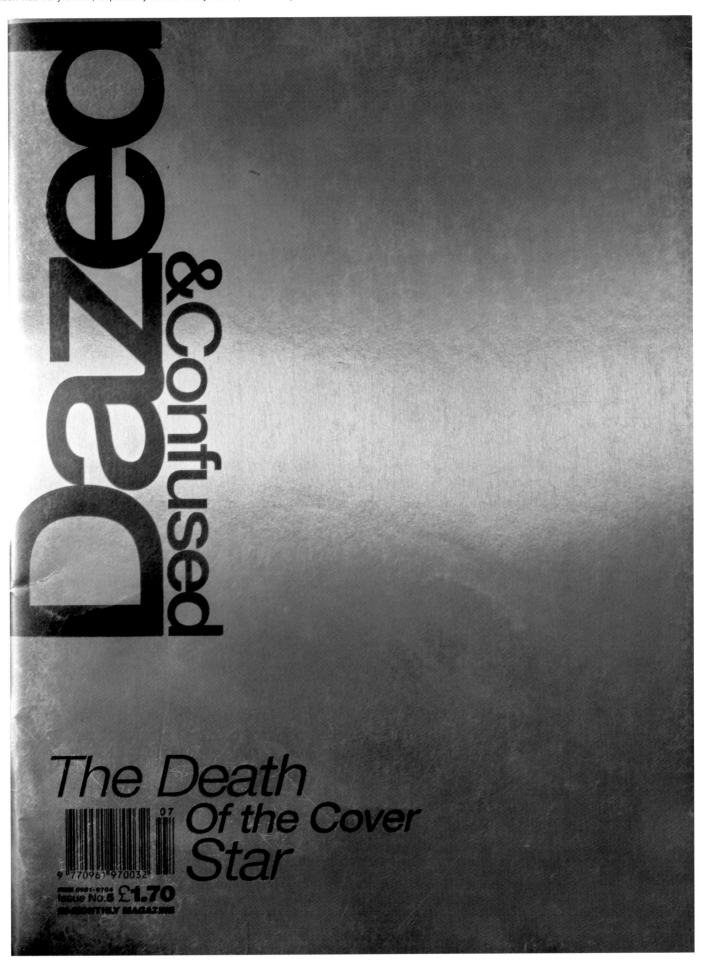

ISSUE 5, VOL. I, 1993 **THE DEATH OF THE COVER STAR**

ALISTER MACKIE, Fashion Director: I will never forget this shoot. It's a knock-out styling competition between me, Katy, Nicola and Cathy. We were all working with Nick Knight in Park Royal Studios and each of us kept coming up with more and more outrageous outfits in an attempt to outdo each other. Nick was getting super-excited and running around Park Royal, trying to snap them all, while the outfits were getting more and more scandalous and bizarre as it went along. It was hysterical, wild and super-exhilarating, all of us there together, this style-off. It was just great fun, I don't think it will ever happen again like that.

ISSUE 96, VOL. I, DEC 2002 **10TH ANNIVERSARY** PHOTOGRAPHY **NICK KNIGHT** STYLING **KATY ENGLAND**

THE DEATH OF THE COVER STAR

KATY ENGLAND, Fashion Director: I think my favourite cover is the 20th-anniversary cover in 2011. It was a Riccardo Tisci and Givenchy special, with the photographer Matthew Stone. It was the first time I'd collaborated with Riccardo, and we met, properly, through this shoot. Afterwards, I started to work with him and have ever since. It was pretty special. I just think the shoot is incredible — some of it was shot in an old swimming pool — and it was put together very quickly. We just had the best time. It was the beginning of a really nice relationship. It's a special memory.

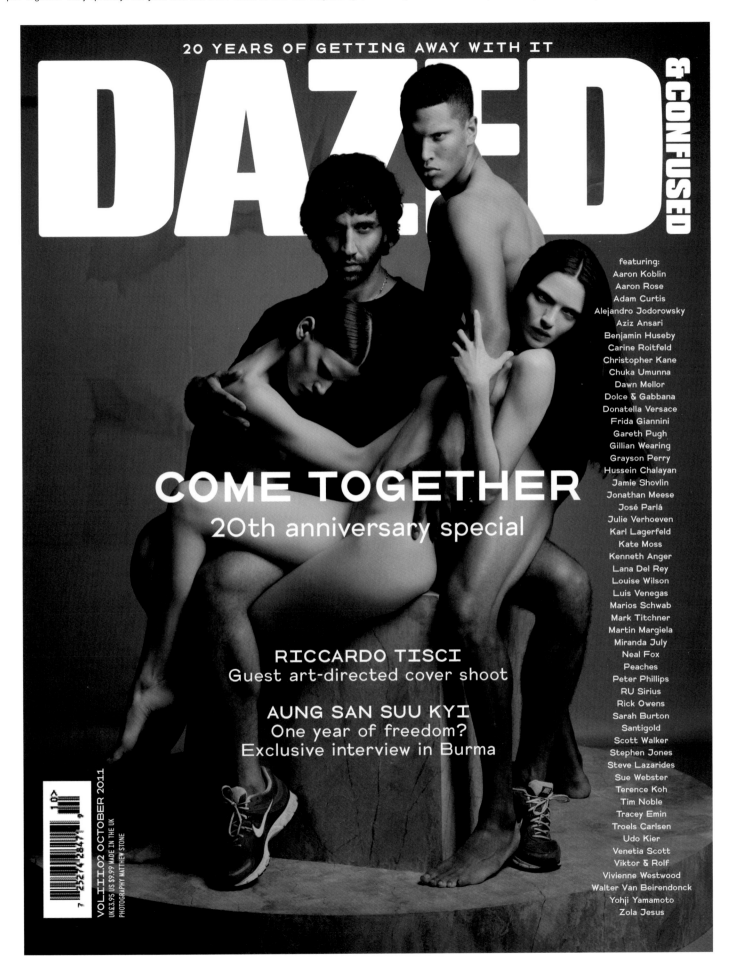

20 YEARS OF GETTING AWAY WITH IT

DAZED

& CONFUSED

COME TOGETHER
20th anniversary special

RICCARDO TISCI
Guest art-directed cover shoot

AUNG SAN SUU KYI
One year of freedom?
Exclusive interview in Burma

VOL.III.02 OCTOBER 2011
UK£3.95 US $9.99 MADE IN THE UK
PHOTOGRAPHY MATTHEW STONE

featuring:
Aaron Koblin
Aaron Rose
Adam Curtis
Alejandro Jodorowsky
Aziz Ansari
Benjamin Huseby
Carine Roitfeld
Christopher Kane
Chuka Umunna
Dawn Mellor
Dolce & Gabbana
Donatella Versace
Frida Giannini
Gareth Pugh
Gillian Wearing
Grayson Perry
Hussein Chalayan
Jamie Shovlin
Jonathan Meese
José Parlá
Julie Verhoeven
Karl Lagerfeld
Kate Moss
Kenneth Anger
Lana Del Rey
Louise Wilson
Luis Venegas
Marios Schwab
Mark Titchner
Martin Margiela
Miranda July
Neal Fox
Peaches
Peter Phillips
RU Sirius
Rick Owens
Sarah Burton
Santigold
Scott Walker
Stephen Jones
Steve Lazarides
Sue Webster
Terence Koh
Tim Noble
Tracey Emin
Troels Carlsen
Udo Kier
Venetia Scott
Viktor & Rolf
Vivienne Westwood
Walter Van Beirendonck
Yohji Yamamoto
Zola Jesus

ISSUE 2, VOL. III, OCT 2011 **20TH ANNIVERSARY SPECIAL** PHOTOGRAPHY **MATTHEW STONE**

ISSUE 84, VOL. I, DEC 2001 **PRETTY VACANT**
PHOTOGRAPHY **JENNY VAN SOMMERS**
STYLING **JULIE VERHOEVEN**

ISSUE 9, VOL. II, JAN 2004 **THE ILLUSTRATED ISSUE**
COLLAGE **PETER BLAKE**

83 NOVEMBER 2001 UK £2.99 US $8.25
C$5.50 V1,600 ISSN 0961-9704
SELF PORTRAIT BY TARYN SIMON
DIGITAL IMAGING BY COLOR EDGE NYC
SPECIALIST MAKE-UP BY RAVEN FOR RAVEN DESIGN GROUP
DIGITAL IMAGING BY RAVEN FOR RAVEN DESIGN GROUP
PRODUCTION BY PHILIPPE BRUTUSART / COMMERCE
DIGITAL IMAGING BY COLOR EDGE NYC

DAZED & CONFUSED

the narcissism issue

i ♥ me

ISSUE 83, VOL. I, NOV 2001 **TARYN SIMON** PHOTOGRAPHY **TARYN SIMON**

THE DEATH OF THE COVER STAR

189

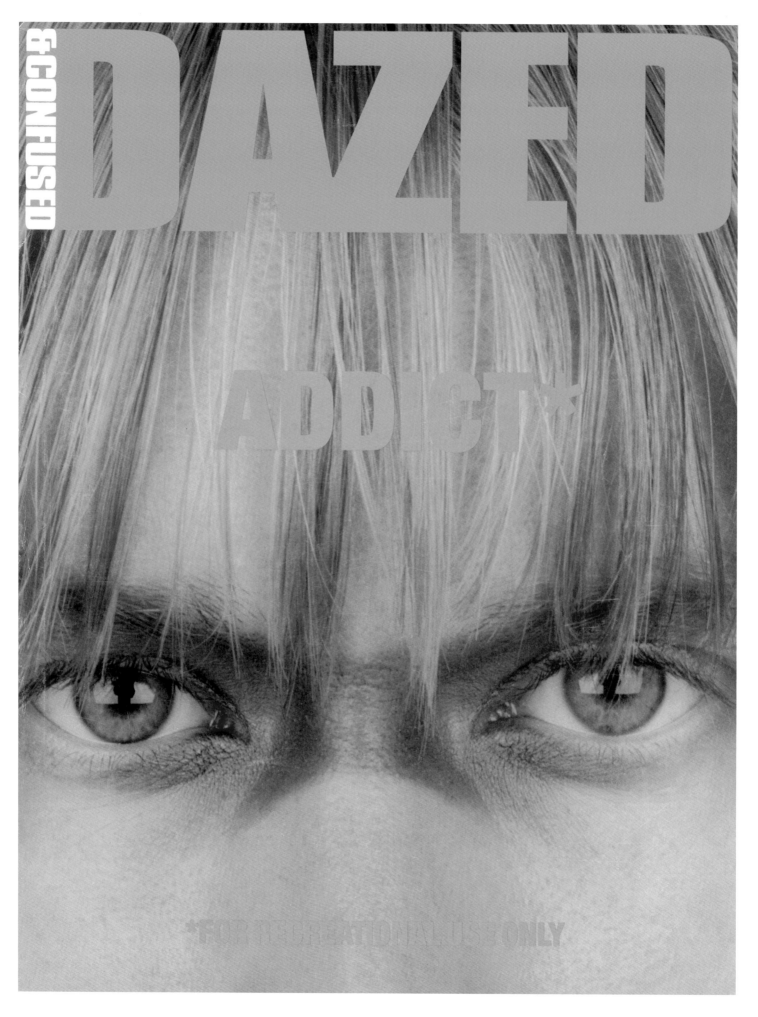

DAZED &CONFUSED

ADDICT*

*FOR RECREATIONAL USE ONLY

ISSUE 33, VOL. I, AUG 1997 **ADDICT*** PHOTOGRAPHY **RANKIN**

GUEST EDITOR + ARTWORK GRACE WALES BONNER

DECLARE INDEPENDENCE

Between

Critique

and

Hope

GRACE WALES BONNER

ISSUE 69, VOL. V, AUTUMN 2020 **BETWEEN CRITIQUE AND HOPE** ARTWORK **GRACE WALES BONNER**

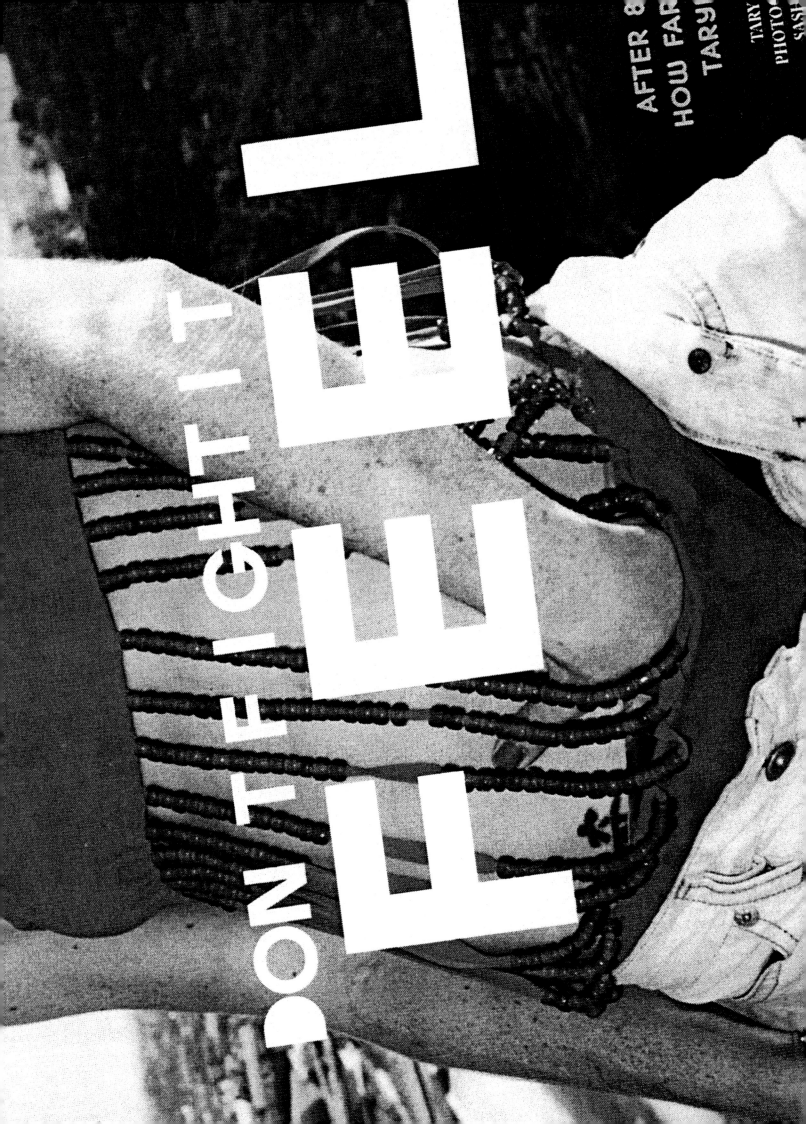

FEEL

FEEL

FEEL

DON'T FIGHT IT

AFTER 8
HOW FAR
TARY

TARY
PHOTO
SASH

8.
Don't Fight It, Feel

Spiritual connections that were meant to be
192–225

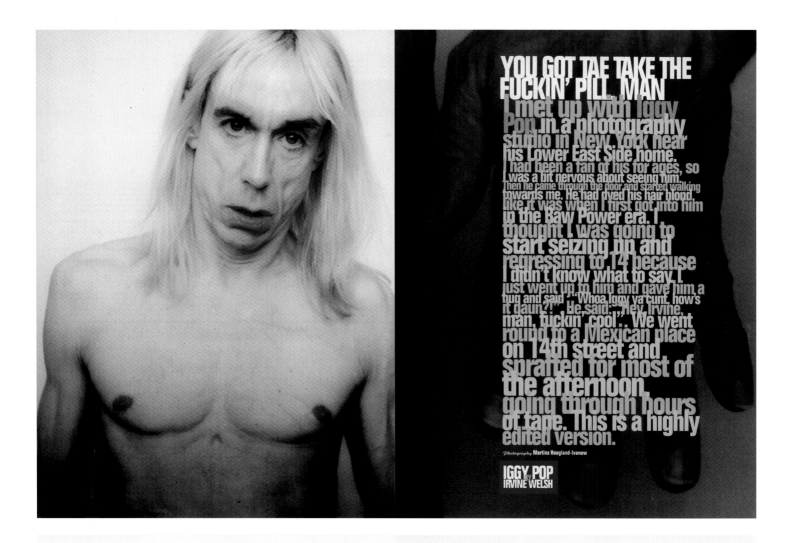

YOU GOT TAE TAKE THE FUCKIN' PILL, MAN

I met up with Iggy Pop in a photography studio in New York near his Lower East Side home. I had been a fan of his for ages, so I was a bit nervous about seeing him. Then he came through the door and started walking towards me. He had dyed his hair blond, like it was when I first got into him in the Raw Power era. I thought I was going to start seizing up and regressing to 14 because I didn't know what to say. I just went up to him and gave him a hug and said, "Whoa, Iggy ya cunt, how's it gaun?". He said, "Hey, Irvine, man, fuckin' cool". We went round to a Mexican place on 14th street and sprafted for most of the afternoon going through hours of tape. This is a highly edited version.

Photography Martina Hoogland-Ivanow

IGGY POP by **IRVINE WELSH**

"I'm not really ready to die yet."

Iggy Pop: You ever been to Vegas?

IRV: **Yeah, I went there. It was horrible.**

IP: It's really, really disgusting. I've gone twice now. Workin' both times. The first time it was a nightmare, like you know, I get there and it's like the Hilton, like the Flamingo Hilton or something, it's just like all these old people, right, like dodder-ing old miserable people going to their...

IRV: **The fucking gambling machines...**

IP: The machines, right, you know, not at all what I expect.

IRV: **See, in Britain, they go to Blackpool on the Wallace Arnold coach tours, but in America it's flight packages to Vegas.**

IP: But what was cool was that I was going to play a gig at this place. This chick who had been a madam saved her money and opened a rock club for kids on the outskirts of town. A regular old bar, right...

IRV: **Brilliant, man...**

IP: It was, like, 320 people and I mean these people were ready to do fuckin' anything. She warned me right before the gig she said, 'OK, now look', she said eh... now how did she put it, she said eh... 'After the show you boys just point out the ones you like and I'll send these girls back to get their throats cleaned'. Woahhhh! You know? The name of the bar and the name of the place and her name was something like Hail Mary. And we went out and played and its like all these... it was the dirtiest group of girls I've ever seen in my life. In the feel-ing of the dirtiest.

IRV: **Yeah, right.**

IP: In the front.

IRV: **Yeah, right there, man.**

IP: They're like, 'I'm 14 and I've seen everything already; look at these tits, you know, anybody can suck on these. See, like, I'm here, do I look pretty? Am I making you pretty fuckin' horny, motherfuck-er?' You know what I mean? With the really nasty attitude.

IRV: **Just right into their own power.**

IP: Yeah, and the guys were all ready just to tear anything apart, and just get fucked up and they really got into the spirit of the music. (Laughter). It really made me do a really good gig. I really, really thought, 'God, what it must be to be a kid in fuckin' Las Vegas', you know? And the second time I went was really weird, I went there just last year and opened a Hard Rock casino. Hard Rock, that horrible chain, they started a casino, a casino hotel. They put me up for three days for it, they put me up in the hotel and so you're living over this casino and you just feel the vibration all the time you know, they're playing loud commercial rock'n'roll at all times in the casino in the hallways and you hear it in your fucking room and they turn off for three hours a day, five to eight in the morning. The rest of it's 21 hours a day of this shit! I was just shaking by the time I got outta this place, you know?

IRV: **What do you do banged up in a place like that? Do you read a lot?**

IP: Yeah... I go off and on with myself, I'll go for months or so and if I will get printed information from books, newspapers, magazines and everything and evaluate what I'm reading and feel things from whatever I'm reading and for a couple of months I won't read anything; I'm just like a squir-rel. Living right there and the fucking second that I'm in and it just goes 'bing-de-bang-de-boom'.

IRV: **You've probably read a lot more than me, 'cause I'm not that great a reader, though I like** browsing at dustjackets in bookshops. It's a weird thing for a writer to say, but I've never been a great reader of fiction. It fucks up all those wankers that review books because they're always trying to place you in terms of what you're supposed to have read...

IP: Oh right, so they say you've read... yeah yeah yeah...

IRV: **...All Burroughs and Genet and all this kind of stuff, but I say, 'No, my references are from music', my references are from people like your-self.**

IP: Sure.

IRV: ...They say, 'You must've read Burroughs' and I go, 'Well, no. Maybe I got Burroughs off Iggy or whatever...'.

IRV: **Yeah...**

IP: Sure. Listen to my shit, you got his shit...

IRV: **Yeah...**

IP: Or some feeling from it anyway...

IRV: **Yeah, it's the spirit of it, not fucking pieces of text, or notes of music, or frames of film that matter.**

IP: Yeah.

IRV: **It must be strange for you to be held in such regard by so many people that you've never met all over, well, probably all over the world. I still get a bit freaked if some cunt comes to me in a club and says, 'Enjoyed the book, man'.**

IP: Yeah, it's strange, but you know, OK, since you brought it up, right? I went out with this chick, right? I had this chick out, about three weeks ago. You know I meet her, I had never met her, it was somebody I had corresponded with for a long time. So the first thing she says to me after we say 'hello' 'n' stuff, she's mighty shaken and she says to me, 'This is like a dream for me 'cause you are a Living God!' and I'm like, at first, there's a part of me goes 'Woaaah... I don't wanna hear this'... then, you know, I thought about it, and after a while, you know... (Loud laughter)

IRV: **Yeah! I'll take it!**

IP: Heyyy... Living Goh-hod... I guess that means I can do this and this and this... won't have to have tea first or anything, wooah... it's funny, you know... I actually found myself being on a little bit better behaviour. I spent about a week with her and I found I was catching myself, where maybe I'd normally eh... give something away, I wouldn't, I'd go: 'Wait! Would a Living God do this? Hey, hey hold on! Hold on!'.

IRV: **It's amazing, there's this kind of thing, I dunno if it's just a Scottish thing or not but, it's like ma mates in Scotland that are intae you, they've never met ye, don't really know any-thing about you other than the usual myth shite, but just sort of regard you as one of he boys, like one of the posse.**

IP: Well, when I met you I could tell how it was. And it was weird cause I was thinkin', you know, 'cause I read I was in your book and shit... I got that far last night, page 75 and I thought, 'Did he go to my gig or did he not?', you think, 'Oh fuck! Does this guy really dig me and am I, like, gonna disappoint him cause I'm not a fucking Living God?' and all this shit! That shit does go around, but not too much, 'cause basically I'm in a posi-tion, some people laughed at me, some peo-ple hated me, a lot of people start to listen to this shit, so I feel like a pig in shit. It's kinda neat for me a long time. Some people laughed at me, some peo-ple hated me, a lot of people start to listen to this shit, so I feel like a pig in shit. It's kinda neat for me you know... I think, 'Cool', cool you know, it's real-ly like that.

IRV: The thing about your music for myself, and so many other people I've known that have been into it, I mean the first time I heard Raw Power was when I was 14, my mate Colin bought it and we were sitting in his bedroom playing it and I just thought, 'Aw yeah, this is fucking great, fuckin' brilliant', and that was it, right, gaun round the Grassmarket looking for long silver gloves tae wear tae the school and all that...

IP: Right... right... cool!

IRV: ...That thing about being a kid, but also going right through the years and knowing that somebody understands what you're feeling inside, somebody's articulating that, and it's out there as a reference point; all those fucking weird impulses that you've got and having to repress 'cause it's like the values of parents, teachers, work, the authorities all that fuckin shite.. and it's like, 'Yessss... fuckin' right!' Like you're the patron saint of expressing what we're feeling inside. It's like, there's that thing that interests me most is the newer stuff, Brick by Brick, American Caesar, and the new album... it's the articulate criticism of American society, the TV age and all that. That's the stuff I always play now. I like listening to the old stuff but it's the newer stuff I'm more into. With that in mind, I was going to ask you, cause I read in the Telegraph coming over on the plane, about the Stooges getting back together again. I was disappointed in a way if that happened. It they're your main band, a part of you wants to see them back together again, but for me the stuff you're doing now is the most interesting 'cause it's living in its own time. To me it's, 'Fuck Dylan and all that kind of stuff; this is American poetry telling it as it is'. It makes sense to me about how the world is, it's fuckin' hitting it you know? I'd hate you to go retro. There's the Velvet Underground getting back the gither, they're talking about the Sex Pistols next...

IP: Woah, Woah, Woah...

IRV: ...Well what do you think of that kind of thing?

IP: I don't have a very high opinion of it 'cause it's the same kind of thing, as, I mean, I heard the Velvets were going to do it and I didn't think one thing or the other, then I saw a piece of film of them actually doing it.

IRV: It was pony.

IP: Same thing. It disappointed me 'cause, number one, the guys looked so... old, for lack of a better word. It didn't seem like they were actually like, vibing on this thing, they were just like grinding through, oh God, you know, and it seemed so uptight and I dunno if I wanna see the Sex Pistols do that either, you know? The thing with The Stooges, the reason that came up, was they have been asking me, Ron and especially Scott, the drummer, who is my mate and who I have a real warm spot in my heart for as a person, he kept at me for years, you know, 'Let's do something, let's do it'. He even came to New York once; he's not a rich guy, he figured out a way to get to New York to audition to see if he could be my drummer. I didn't think it was right for me, you know, and it really fuckin' tore me apart to say...

IRV: Yeah, I bet...

IP: ...'Sorry, I got somebody else', and every time... I've a terror of doing something with those guys, you know, falling back into this hole, it's like...

IRV: **So it would be you, James Williamson and the Ashton brothers?**

IP: No, it would be me and the Ashtons. Williamson doesn't really play any more. So it would be the original three with a bass player; there's a guy named Gary Rasmussen of that musi-cal circle. He played in Sonic Smith's band before he passed away and he's like us, basically, you know? What it is that attracts me is people would ask us to do it for movies, for this, for festivals. I kept turning everybody down, but on a personal level, as a guy, it's like, 'I don't want to come over as I'm too good now, I've got my life, you know what I mean?' and all that kind of shit, right? So what happened was I was fuckin'... oh fuck it, I'll say who it is. I was at dinner with this fuckin' guy Rick Rubin, right? This record producer, right? And he was like asking me so many questions about Detroit and Sinclair and the Stooges, he kept pumpin' me, you know? I was telling him what I thought, knew about those times. And then, like a couple of weeks later, a friend of his says to me 'Would you play with The Stooges again?'. I said 'No! I wouldn't do that! Da-de-da. Leave me alone! Right?'. Obviously, for all the obvious reasons. Then a friend said, 'You know, I was talkin' to Rick the other day. Rick would really like to make a record of The Stooges'. This I had never thought of, oddly enough. That's a different thing from going out and playing your old shit.

IRV: **Yeah... make an album.**

IP: Why not get together and make some fuckin' music, make an album and see what's there? That appeals to me. That appeals.

IRV: **Would it be a Stooges record, though, or would it be an Iggy Pop record with the Stooges as the backing group?**

IP: No... no... (Laughter) because it doesn't work that way with those people. No, it wouldn't, no... uh-uh, uh-uh. I was always the undisputed leader of the miserable band of (Laughter) savage fuckin' ragged... you know... fuckin' losers. But good question; it popped into my mind. I wondered, could I shed... I mean, would it be different?

IRV: **Would you want to?**

IP: Yes, in the sense that I do things by feel, a lot of things, not everything, but I do a lot of things by feel and, like, I have a right feeling toward those people and in some way I think it would be nice if I could make music with them.

IRV: **The new album carries on in the territory you've marked out in Brick By Brick and American Caesar, like the criticisms of modern American capitalism and the TV age and lamenting the loss of a more innocent world.**

IP: There's a lot of just 'I' and what's around here, like even in that song 'Pussy Walk'. What got me excited in the song is all the immigrants, that's what that song is really. Like wow! I don't know these people, how do I talk to her, I gotta find out! I should know about this, you know. There's that, then I'm working on all this real quiet blues shit where I just do it with a guitar and make the music up myself, that's real important to me to do that kinda thing... and I wanna do a... I'm hopin' about a year from now. I gotta tour a long time, you know. I would like to have a shot at that cause I really love this kinda singing.

IRV: It's like the voice you do... I dunno where this came in, you probably always had it, that crooning voice...

IP: That's it, I wanna do that.

IRV: That's a powerful instrument now, you know, it's like a kind of Crosby-Sinatra thing.

IP: I've always felt that I'd like to go over there but I didn't have a handle on it. And then there's this one album by Sinatra I've got obsessed with lately, it's called Frank Sinatra Sings For Only The Lonely, and he's in kinda clown make-up on the cover and there's a tear, and it's all these songs about girls that aren't with him any more and, 'We fucked it up when we thought it could be good, but it does-n't matter 'cause I'm still cool and fuck you any-way...' a little bit. That's there too. I'm dignified about that! All of a sudden, I guess, 'cause of some shit I been through lately, all of a sudden I really felt that I could sing that shit and so I would like to sing ballads about being wounded, but still walk-ing around. So a Stooge reunion is somewhere down the line... you know, certain elements will pick up on that.

IRV: **What about the acting, is that still... ye still intae that?**

IP: Yeah, I'm doing that. Okay, I don't have a fuck-ing agent and I don't have a fuckin'... there's no head shot that exist that's like, hey! Available for hire. Guys call me and almost all the ones I take it's... the one I just did was The Crow sequel and it was Tim Pope who shot the Kiss My Blood video. That's why I got the gig, and Jarmusch used me cause he knew me from music, it's all like that, you know? I like doing that shit 'cause at one point hardly any of my albums were in print, I was real marginal in the industry and I was determined I was gonna get all my stuff up there in the light where people can see all this old shit and it's avail-able. Only way to do that was to do shit that impressed straight people, and nothing impresses those people more than if you're in a fuckin' movie (Laughter). 'Hey, asswipe, I'm a cock-suckin' movie star, so you can just lick my dirty brown ass!' That does it, man, when you're in a movie; oh, wow, boy, do they jump?! So I got into a movie for all the wrong reasons, I fuckin' just elbowed my way in.

IRV: **Do you enjoy acting?**

IP: No, it's horrible! It's so hard, it's tedious...

IRV: **Yes.**

IP: ...But what I really do enjoy, the last couple of times I started getting less shitty at it, the last three times. The thing with Jarmusch and The Crow thing was not so shitty, so I felt like, hey, this wasn't too bad, y'know?

IRV: **I did a wee bit in the Trainspotting film; I had a part in that.**

IP: How d'ya like doing it?

IRV: **Fuckin' boring standing around aw the time man.**

IP: Borin' as shit, right? It's miserable; your whole life's going before you, right?

IRV: **Yeah, it's tedious.**

IP: Almost worse, 'cause I was reading your book last night, and I was thinkin', 'What's worse: wait-ing on a film set, or waiting for junk?'

IRV: **Junk.**

IP: Yeah, but really it's almost as bad as waiting for junk... all that AIDS shit man, I was reading your book, and I get the willies every time that subject comes up, I get the fuckin' willies. 'Cause I'm not ready to die, do everything they say I should do.

No, sorry. I'm not really ready to die yet. A lot of people feel like that.

IRV: **Too fuckin' right! ...But I mind that I was talking to one magazine about the book and that if I hadnae have listened to you I couldn't have written that book, it would have been a different book...**

IP: WOW!

IRV: **When you see the film, you'll see loads of pictures of yourself...**

IP: WOW!

IRV: **...Tons of references to yourself...**

IP: Cool!

IRV: **It's an Iggy film, man. An Iggy book and an Iggy film.**

IP: Wow!

IRV: **It's almost strange without you actually being in it... you're in it without being in it!**

IP: That's really good!

IRV: **What do you reckon to the whole acid house thing, the House, club culture, the ecstasy culture?**

IP: I know fuck all about that, because my problem with that is, for one thing, I can't handle drugs any more. So, you know, you really don't wanna see me stoned. I don't have a rule, I do take shit some-times but I get really silly and I have not taken ecstasy, so I guess... maybe I'll go...

IRV: **Very, very different.**

IP: I wouldn't go to a rave unless I was gonna get down with the chicks there, right?

IRV: **Cool.**

IP: I was really not even thinking about things like that for years. I got to be almost a work machine. And now, just in the last few months, I'm opening up a bit more, so maybe I can learn about it.

IRV: **You'd enjoy it.**

IP: Really?

IRV: **You'd enjoy it the most, man.**

IP: Wow! Cool! Okay. The ecstasy isn't too terribly strong? Some of my friends say that it's real nice...

IRV: **People feel very positive on it.**

IP: Wow!

IRV: **It's... eh... a very, very different type of experience from any other drug.**

IP: I had MDA, used to shoot that years ago. I was 30, penniless, barefoot, but it was great. I thought 'Woah, I'm in love, this girl's gonna put me up in her flat for ever and ever. She loves to fuck me, everything's cool. everything's fine, you know? I can't cross the street without being led by the hand, but it's okay, you know'. But, you know, there's something to be said for that.

IRV: **Certainly in Britain, there's a vibrant culture attached to that. You have the odd ecstasy-related death, on no scale compared to alcohol-related deaths, and those are attributable to false information. People were told to drink loads of water, now they're overdosing on the young. Washes out all the sodium level and other chemicals we need to regulate the body. It's just like drinking too much alcohol. The advice should be, 'Take water, but don't go over the top. Dance for about 20 minutes at a time then sit the fuck on your arse and chill out for a bit'.**

IP: That's wild... washing precious metals out of your brain.

IRV: **Designer drugs have become so popular with the young, the brewers have started their own to compete. They've got this alcoholic lemonade now, to get kids hooked on their**

"'Hey, asswipe, I'm a cock-suckin' movie star, so you can just lick my dirty brown ass!'"

ISSUE 18, VOL. I, MAR 1996 **IGGY POP** PHOTOGRAPHY **MARTINA HOOGLAND IVANOW**

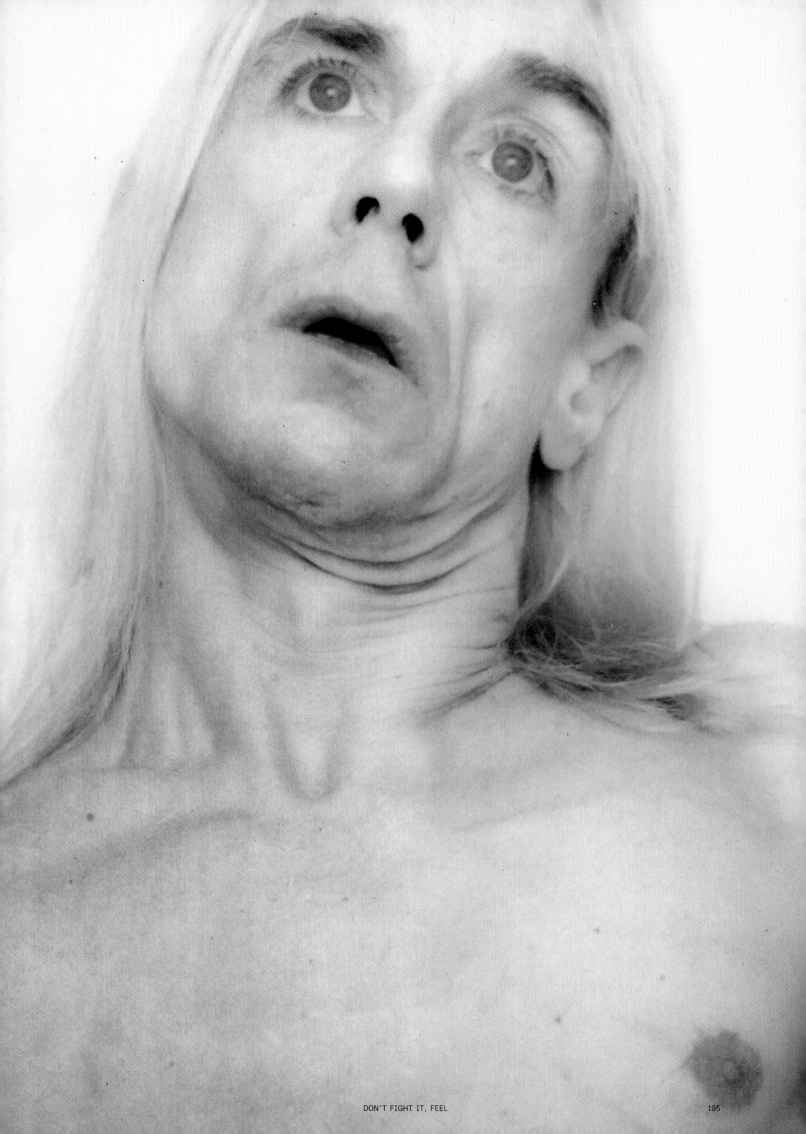

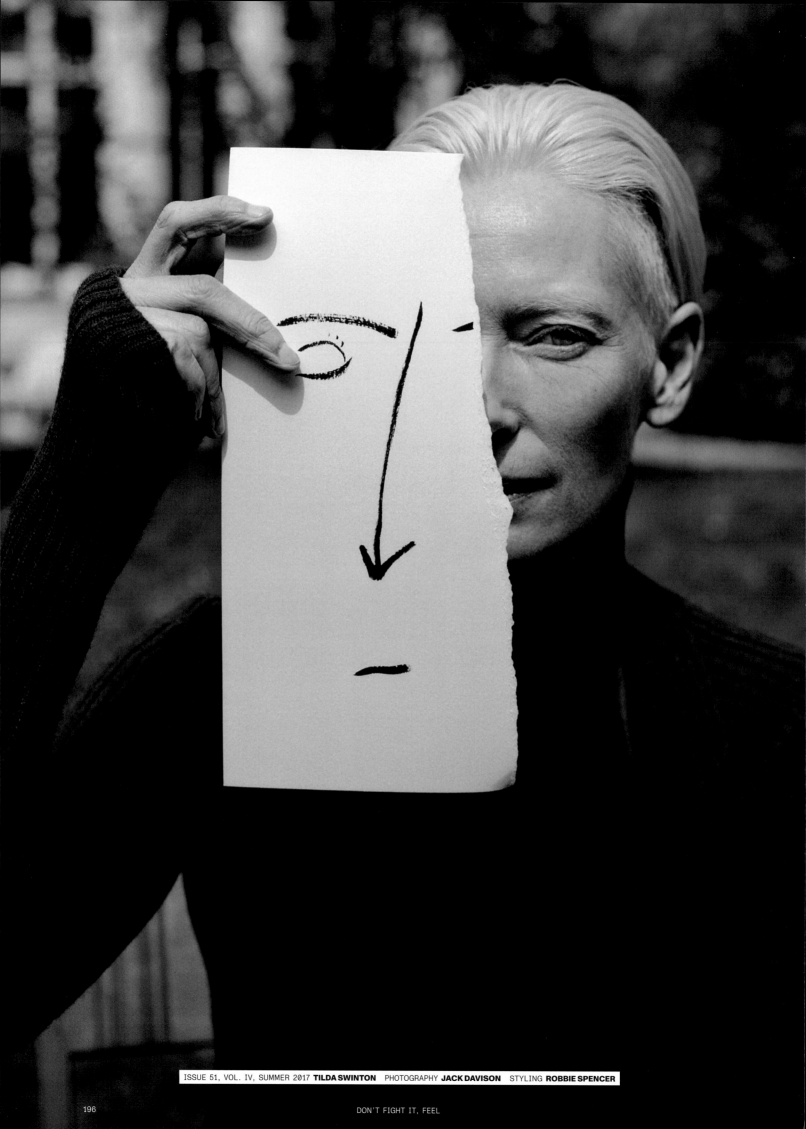

ISSUE 51, VOL. IV, SUMMER 2017 **TILDA SWINTON** PHOTOGRAPHY **JACK DAVISON** STYLING **ROBBIE SPENCER**

DON'T FIGHT IT, FEEL

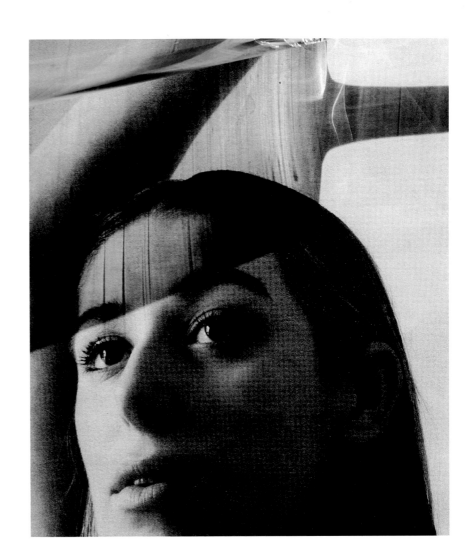

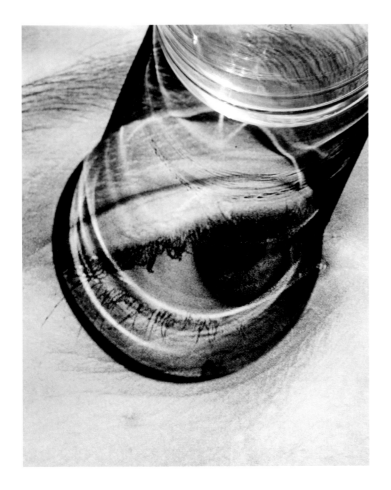

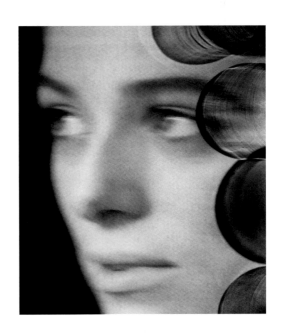

ISSUE 64, VOL. IV, AUTUMN 2019 **HONOR SWINTON BYRNE** PHOTOGRAPHY **JACK DAVISON**

DON'T FIGHT IT, FEEL

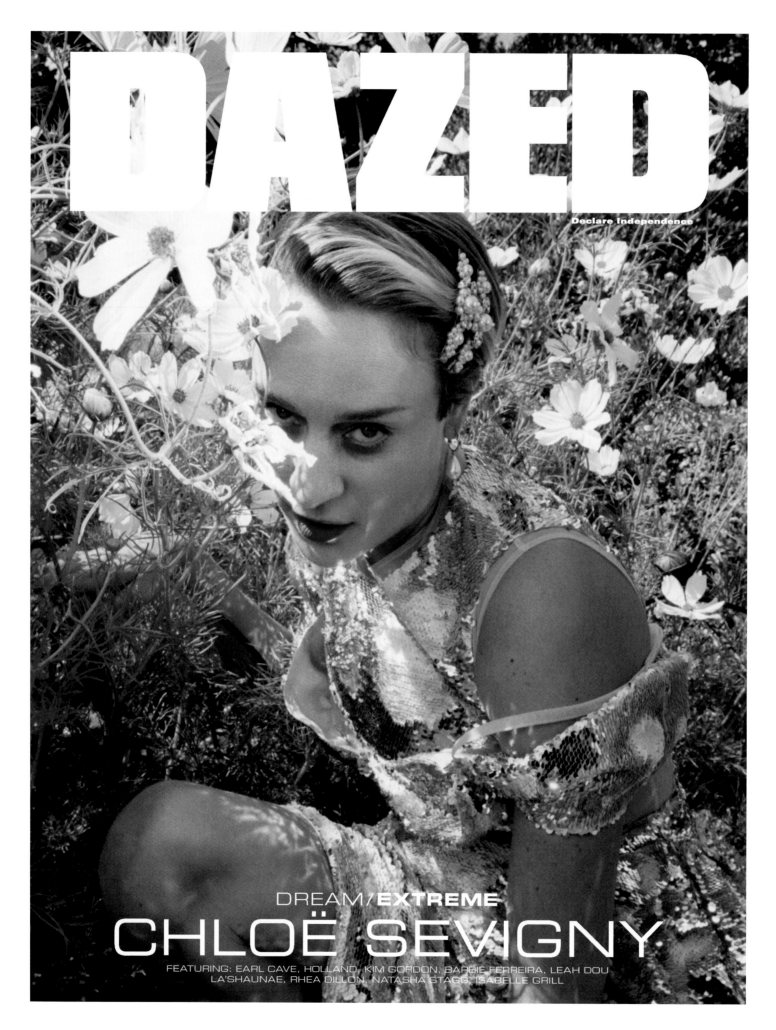

DAZED

Declare Independence

DREAM/**EXTREME**
CHLOË SEVIGNY

FEATURING: EARL CAVE, HOLLAND, KIM GORDON, BARBIE FERREIRA, LEAH DOU
LA'SHAUNAE, RHEA DILLON, NATASHA STAGG, ISABELLE GRILL

ISSUE 65, VOL. IV, A/W 2019 **CHLOË SEVIGNY** PHOTOGRAPHY **HARLEY WEIR** STYLING **ROBBIE SPENCER**

DON'T FIGHT IT, FEEL

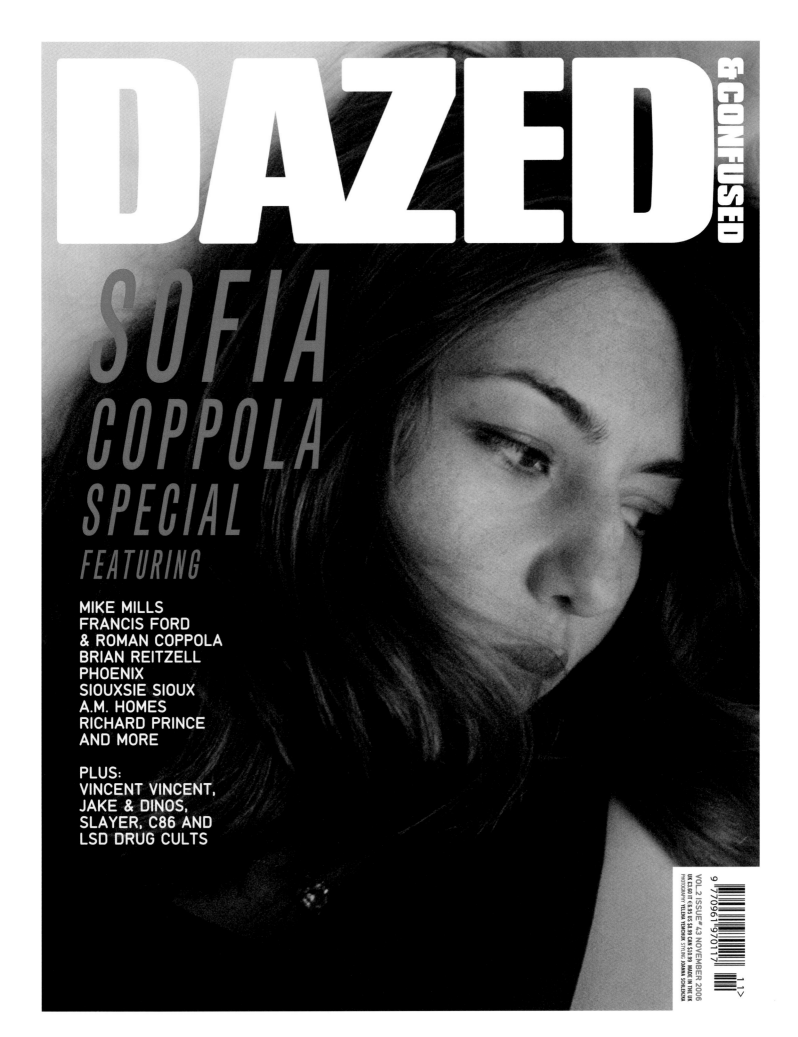

DAZED

&CONFUSED

SOFIA
COPPOLA
SPECIAL
FEATURING

MIKE MILLS
FRANCIS FORD
& ROMAN COPPOLA
BRIAN REITZELL
PHOENIX
SIOUXSIE SIOUX
A.M. HOMES
RICHARD PRINCE
AND MORE

PLUS:
VINCENT VINCENT,
JAKE & DINOS,
SLAYER, C86 AND
LSD DRUG CULTS

VOL.2 ISSUE #43 NOVEMBER 2006
UK £3.60 IT €6.95 US $8.99 CAN $10.99 MADE IN THE UK
PHOTOGRAPHY YELENA YEMCHUK STYLING JOANNA SCHLENZKA

9 770961 970117

11>

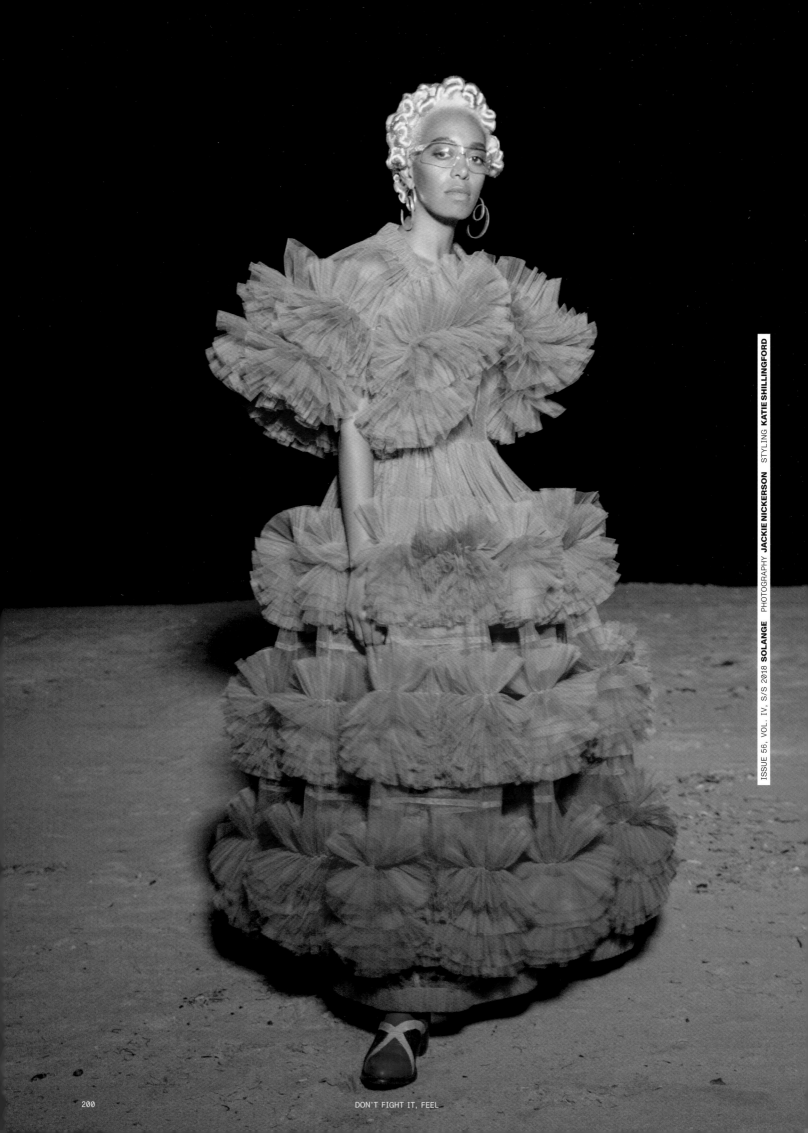

DON'T FIGHT IT, FEEL

ISSUE 56, VOL. IV, S/S 2018 **SOLANGE** PHOTOGRAPHY **JACKIE NICKERSON** STYLING **KATIE SHILLINGFORD**

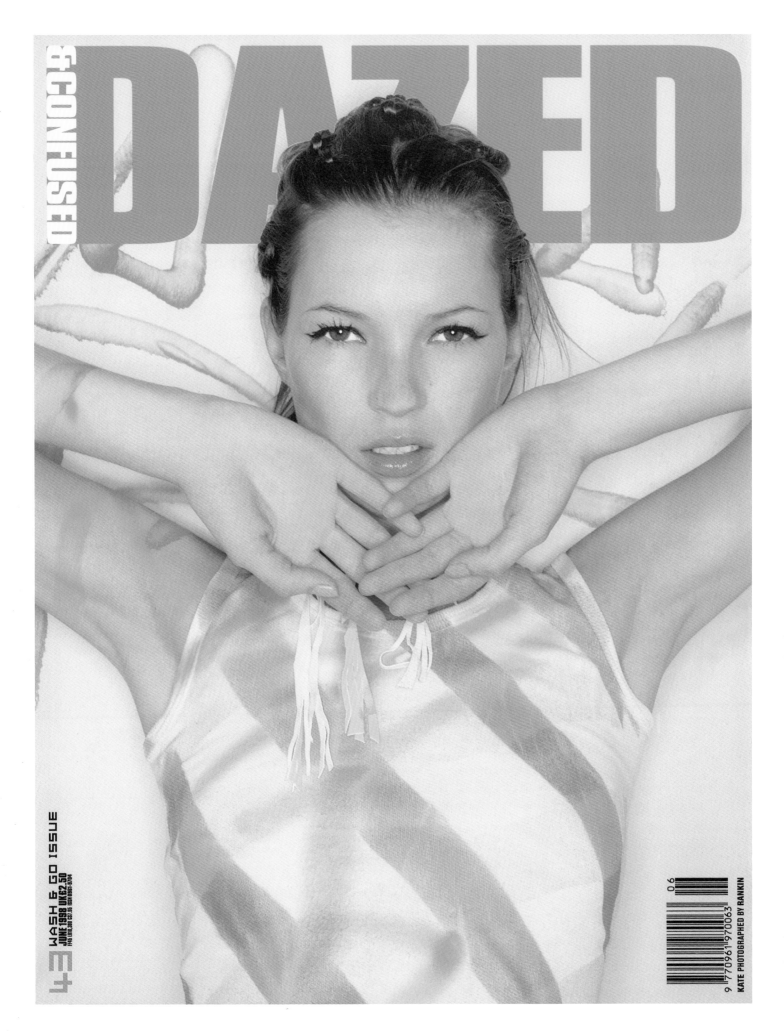

DAZED & CONFUSED

WASH & GO ISSUE

JUNE 1998 UK£2.50
£45 £US 200 £57.95 ISB ISBN 987-075

43

06

9 770961 970063

KATE PHOTOGRAPHED BY RANKIN

ISSUE 43, JUN 1998 **KATE MOSS** PHOTOGRAPHY **RANKIN** STYLING **KATIE GRAND**

DON'T FIGHT IT, FEEL

Hiya,
 It's cold as ~~shit~~ shit here since
I've been back so I haven't ventured
out much except to S.Y. practices
we've getting ready to record in April
So I've been groovin' at home to
some ~~tapes~~ I was fortunate
enough to get my little paws on.
~~Like~~ the new Royal Trux LP
and infomercial tape made for
Virgin, their new label also Helium's
new record is pretty bitchin and
I've heard some of the new
Pavement record, Coco likes it a lot.
I haven't been to any Broadway plays
but here's a joke for you
"What did one fashion editor say to
another?" ... "Nothing!"
oh yeah I went to the premiere of
Billy Madison, Adam Sandler's new film
directed by Tamra Davis. It was very, very funny

 see ya,
 Kim

ISSUE 11, VOL. I, 1995 **KIM GORDON & BABY COCO** PHOTOGRAPHY **CORINNE DAY**

DON'T FIGHT IT, FEEL

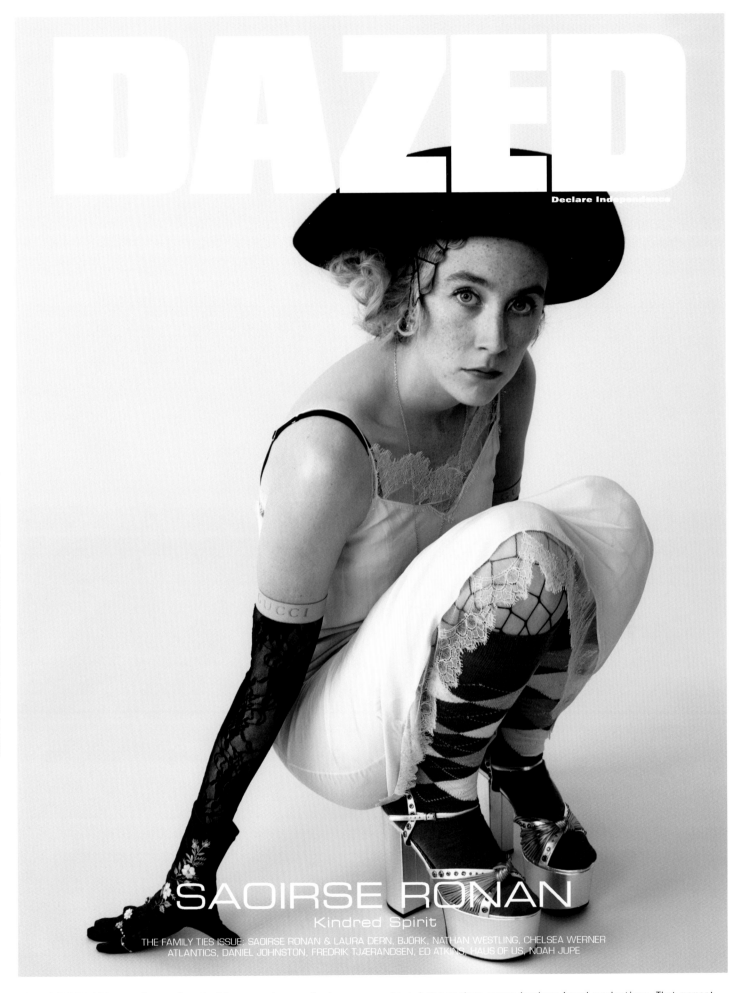

DAZED

Declare Independence

ISSUE 66, VOL. IV, WINTER 2019 **SAOIRSE RONAN** PHOTOGRAPHY **PAOLO ROVERSI** STYLING **ROBBIE SPENCER**

SAOIRSE RONAN
Kindred Spirit

THE FAMILY TIES ISSUE: SAOIRSE RONAN & LAURA DERN, BJÖRK, NATHAN WESTLING, CHELSEA WERNER
ATLANTICS, DANIEL JOHNSTON, FREDRIK TJÆRANDSEN, ED ATKINS, HAUS OF US, NOAH JUPE

THORA SIEMSEN, Writer-at-Large: I wrote this cover story on Saoirse Ronan in conversation with Laura Dern. I had a ceiling leak that winter, so every time there was a storm, my bedroom would get drenched. I had to pull up the carpets and set buckets out. The landlord finally sent someone to fix it while I was on a conference call with two women who have, between them, seven Academy Award nominations. That moment seemed emblematic of my life in New York at the time. The cover story was about *Little Women*, and my mum is named Jo, my sisters Amy and Beth. Getting asked to do that assignment felt like the long arm of coincidence.

ALISTER MACKIE, Fashion Director: This used to be a huge poster right above our desk in our little menswear area (in the *Dazed* office) — I remember it the most because it was right above our heads.

PATRIK SANDBERG, US Editor-at-Large: I think I first thought (that) *Dazed* was an alt-rock magazine, because I remember seeing Marilyn Manson, Tori Amos, Björk, Richard Ashcroft and the Red Hot Chili Peppers on the covers. I knew it was cool and British. I must have been very young and I doubt I had much access to it until I was in college. That was when Nicola Formichetti and Matt Irwin were doing a lot for the magazine, and I loved the way they captured London in that moment and made it feel like the most important place and time in the world.

ISSUE 13, VOL. I, 1995 **RICHARD ASHCROFT**
PHOTOGRAPHY **RANKIN**

ISSUE 64, VOL. I, APR 2000 **HILARY SWANK**
PHOTOGRAPHY **RANKIN**
STYLING **MARIA SERRA**

DON'T FIGHT IT, FEEL

KATY ENGLAND, Fashion Director: The early 1990s was when I came out of fashion college and was like, 'OK, what's going on?' I looked up to the work of people like Corinne Day, Juergen Teller, David Sims, Glen Luchford, Venetia Scott, Melanie Ward; they were all producing work in magazines like *i-D* and *The Face*. I was this real outsider from the north of England, with no connections at all in the industry. I came down to London and started in quite a commercial way; I got a job at a Sunday newspaper and was just doing whatever I could in terms of assisting fashion editors.

I remember when *Dazed* appeared it was really raw, it was really fresh, it felt very exciting and different. And I thought, 'Maybe

I could find a way into this.' I'd been producing some fashion for the *Evening Standard*, but I really wanted to break into these cool magazines. It was Rankin who approached me and gave me a chance, and asked me to work with him. I was like, 'OK, someone has given me a chance, so I am running with it.' We did this great cover with all these leather pieces.

Dazed used to do these club nights to make money to print the magazine, and I think I went one night and they asked me if I wanted to do the door, and I said, 'Oh… OK.' But I did the door and I formed friendships with Jefferson, Rankin, Phil Poynter, who used to be my boyfriend, and that's how it started with the magazine. When Katie (Grand) left, I got a job. But it was Rankin who first gave me a chance.

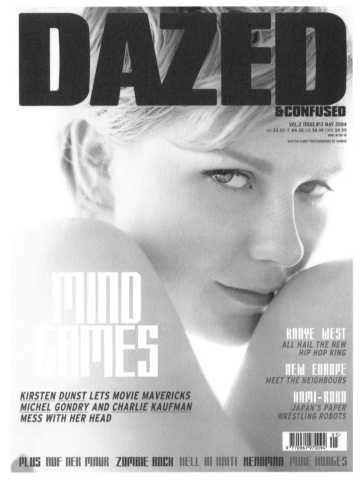

ISSUE 25, VOL. I, 1996 **THE FACE FOR THE 90S**
PHOTOGRAPHY **RANKIN**
STYLING **KATY ENGLAND**

ISSUE 13, VOL. II, MAY 2004 **KIRSTEN DUNST**
PHOTOGRAPHY **RANKIN**
STYLING **NINA & CLARE HALLWORTH**

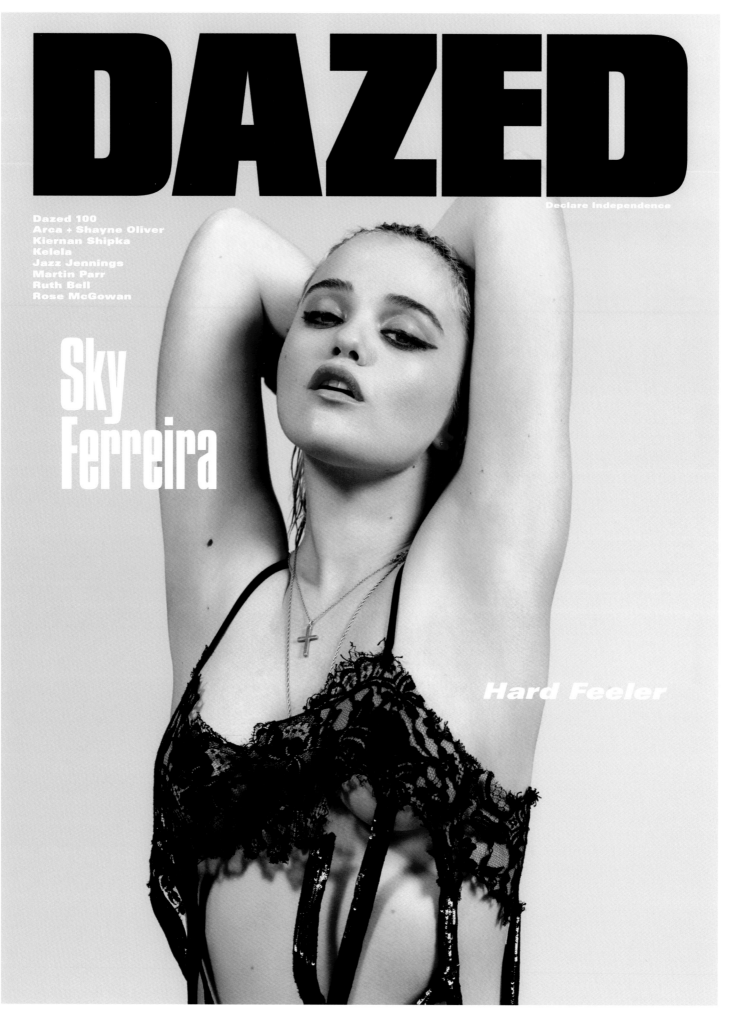

DAZED

Declare Independence

Dazed 100
Arca + Shayne Oliver
Kiernan Shipka
Kelela
Jazz Jennings
Martin Parr
Ruth Bell
Rose McGowan

Sky Ferreira

Hard Feeler

ISSUE 43, VOL. IV, SPRING 2016 **SKY FERREIRA** PHOTOGRAPHY **COLLIER SCHORR** STYLING **ROBBIE SPENCER**

'(He) is an artist I truly relate to in terms of his mentality. He's not going to put something out unless he wants to.' Who is Sky talking about? See page 137 for your answer.

DON'T FIGHT IT, FEEL

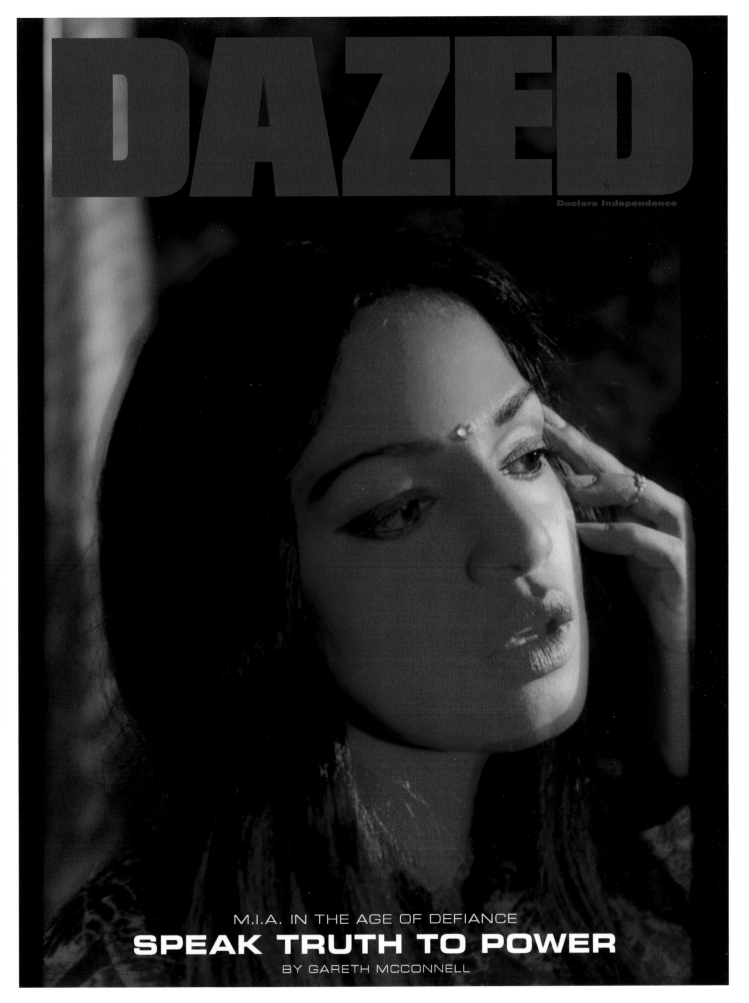

ISSUE 59, VOL. IV, A/W 2018 **M.I.A.** PHOTOGRAPHY **GARETH MCCONNELL** STYLING **DANNY REED**

DAZED

Declare Independence

M.I.A. IN THE AGE OF DEFIANCE

SPEAK TRUTH TO POWER

BY GARETH MCCONNELL

SIMRAN HANS, Writer-at-Large: I love Gareth McConnell's beautiful, impressionistic cover of M.I.A. and was lucky enough to write the accompanying text. Maya's story is one of an underdog, but in the 17-odd years since her debut single she's achieved so much. I asked her if she felt powerful. Her answer was really revealing.

BRI MALANDRO, Founder of the Yeehaw Agenda: I thought 'Old Town Road' was a stunt and I love those. It's always fun when things get shaken up, and that was my favourite part of Lil Nas X's whole takeover. Watching everyone be either mad for no reason, confused, or passionate about Black history. Very good times.

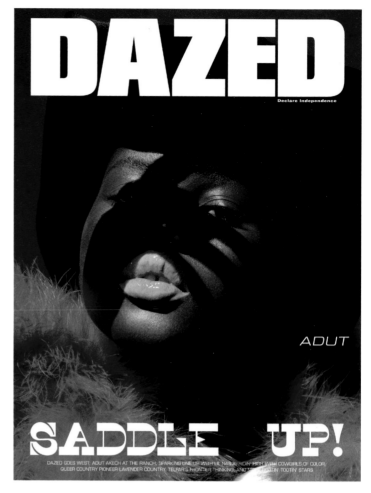

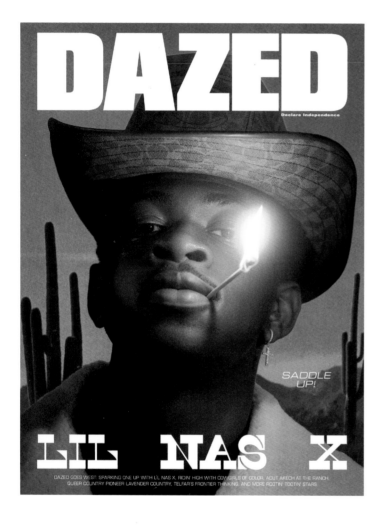

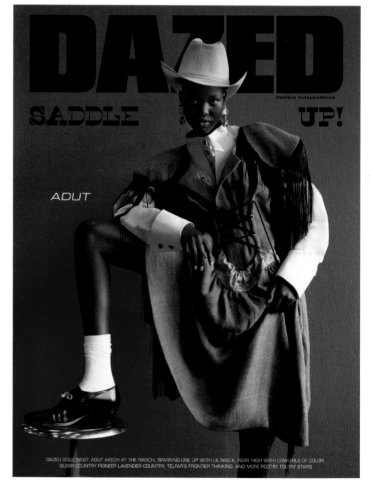

ISSUE 64, VOL. IV, AUTUMN 2019 **LIL NAS X**
PHOTOGRAPHY **CHARLOTTE WALES**
STYLING **TOM GUINNESS**

ISSUE 64, VOL. IV, AUTUMN 2019 **ADUT AKECH**
PHOTOGRAPHY **VIVIANE SASSEN**
STYLING **ROBBIE SPENCER**

DON'T FIGHT IT, FEEL

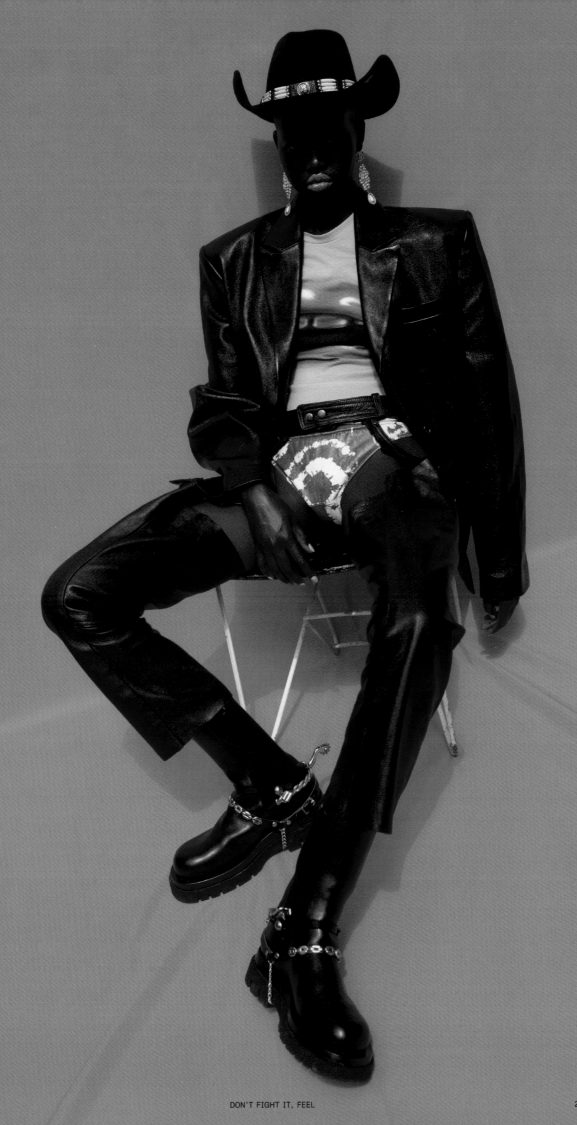

ISSUE 64, VOL. IV, AUTUMN 2019 **ADUT AKECH** PHOTOGRAPHY **VIVIANE SASSEN** STYLING **ROBBIE SPENCER**

DON'T FIGHT IT, FEEL

DAZED

Declare Independence

THE RADICAL INTIMACY OF DEV HYNES
SPEAK TRUTH TO POWER
BY WOLFGANG TILLMANS

ISSUE 59, VOL. IV, A/W 2018 **DEV HYNES** PHOTOGRAPHY **WOLFGANG TILLMANS** STYLING **DANNY REED**

DON'T FIGHT IT, FEEL

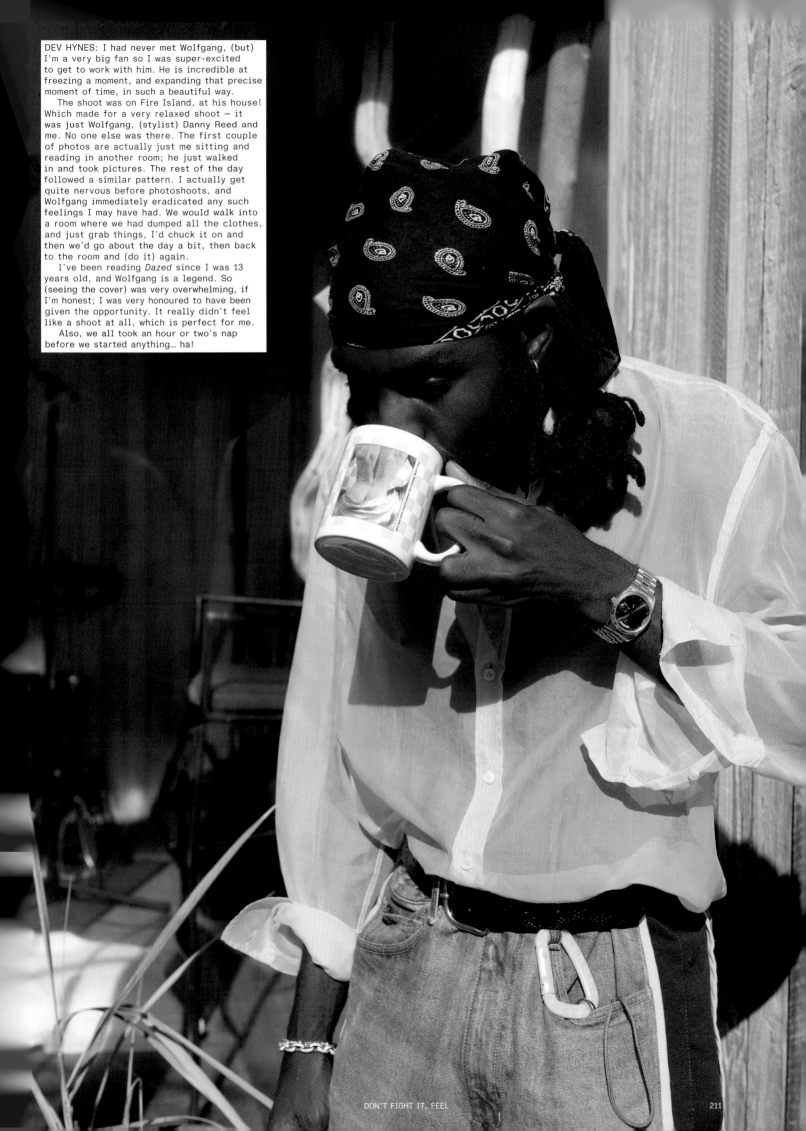

DEV HYNES: I had never met Wolfgang, (but) I'm a very big fan so I was super-excited to get to work with him. He is incredible at freezing a moment, and expanding that precise moment of time, in such a beautiful way.

The shoot was on Fire Island, at his house! Which made for a very relaxed shoot — it was just Wolfgang, (stylist) Danny Reed and me. No one else was there. The first couple of photos are actually just me sitting and reading in another room; he just walked in and took pictures. The rest of the day followed a similar pattern. I actually get quite nervous before photoshoots, and Wolfgang immediately eradicated any such feelings I may have had. We would walk into a room where we had dumped all the clothes, and just grab things, I'd chuck it on and then we'd go about the day a bit, then back to the room and (do it) again.

I've been reading *Dazed* since I was 13 years old, and Wolfgang is a legend. So (seeing the cover) was very overwhelming, if I'm honest; I was very honoured to have been given the opportunity. It really didn't feel like a shoot at all, which is perfect for me.

Also, we all took an hour or two's nap before we started anything… ha!

ISSUE 61, VOL. IV, SPRING 2019 PHOTOGRAPHY **HARLEY WEIR** STYLING **VANESSA REID**

DON'T FIGHT IT, FEEL

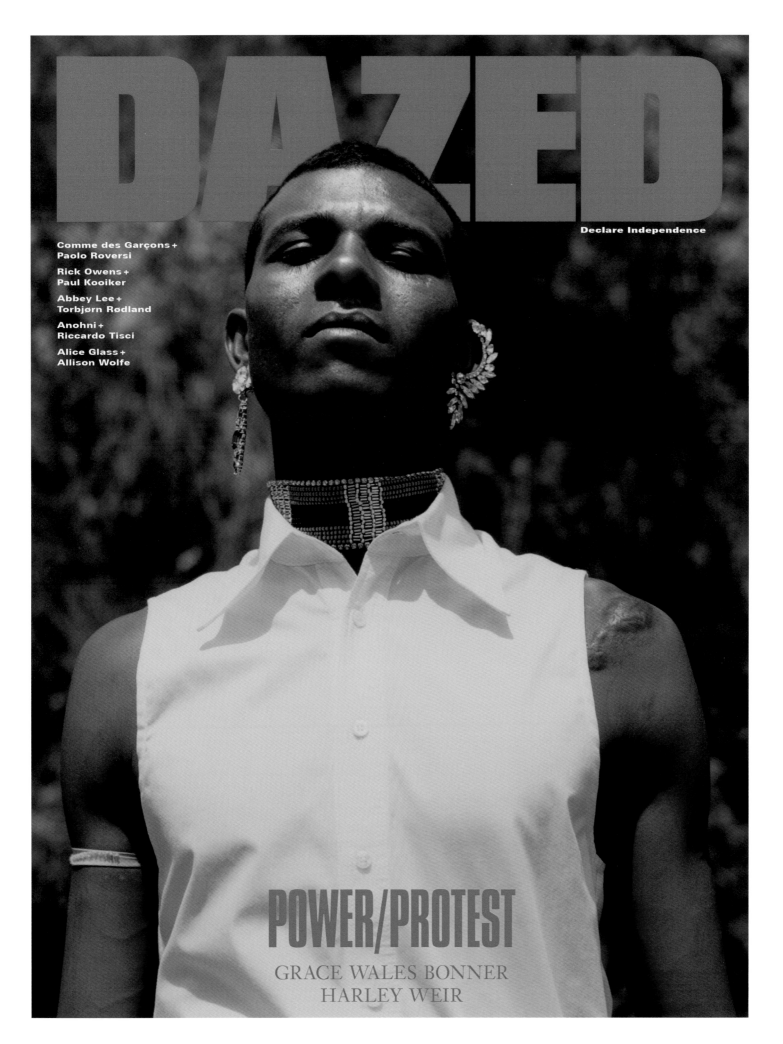

DAZED

Declare Independence

Comme des Garçons +
Paolo Roversi

Rick Owens +
Paul Kooiker

Abbey Lee +
Torbjørn Rødland

Anohni +
Riccardo Tisci

Alice Glass +
Allison Wolfe

POWER/PROTEST

GRACE WALES BONNER
HARLEY WEIR

ISSUE 44, VOL. IV, S/S 2016 **GRACE WALES BONNER** PHOTOGRAPHY **HARLEY WEIR** STYLING **TOM GUINNESS**

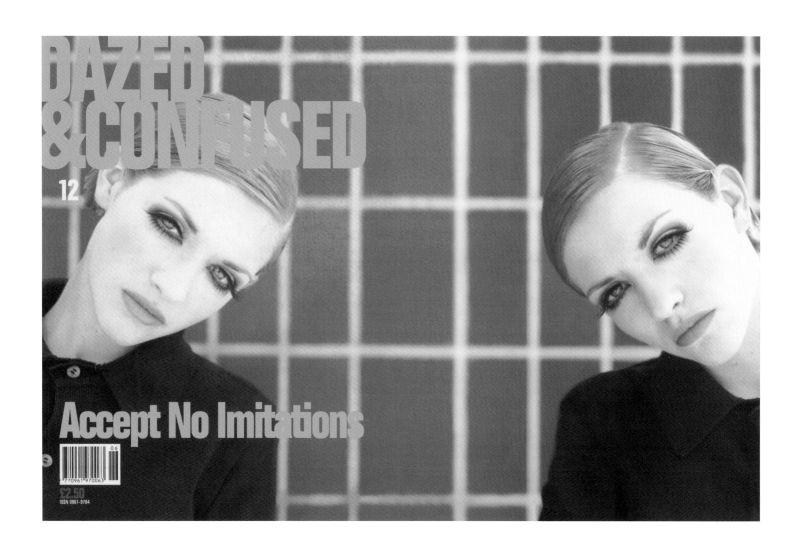

DAZED
&CONFUSED
12
Accept No Imitations

£2.50
ISSN 0961-9704

ISSUE 12, VOL. I, 1995 **EMMA WEBB** PHOTOGRAPHY **RANKIN** STYLING **KATIE GRAND**

DON'T FIGHT IT, FEEL

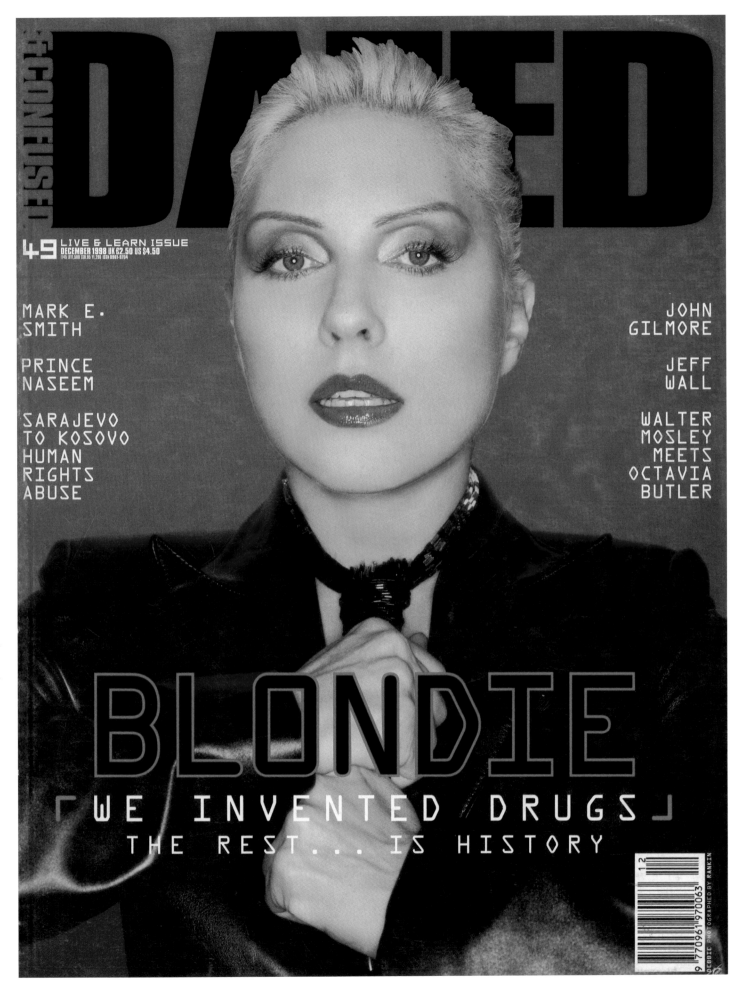

DAZED &CONFUSED

49 **LIVE & LEARN ISSUE**
DECEMBER 1998 UK £2.50 US $4.50
IT45 £17.500 £30.95 ¥1,200 ISSN 0961-9704

MARK E.
SMITH

PRINCE
NASEEM

SARAJEVO
TO KOSOVO
HUMAN
RIGHTS
ABUSE

JOHN
GILMORE

JEFF
WALL

WALTER
MOSLEY
MEETS
OCTAVIA
BUTLER

BLONDIE
⌜WE INVENTED DRUGS⌟
THE REST... IS HISTORY

ISSUE 49, VOL. I, DEC 1998 **BLONDIE** PHOTOGRAPHY **RANKIN** STYLING **ALISTER MACKIE**

ALISTER MACKIE, Fashion Director: I asked if I could do this one and was actually terrified. I wish I'd been a bit more experienced to work with an icon like Debbie Harry. She was incredible and was the phenomenon I thought she'd be. In the end, she wore a men's leather jacket because that's just the way it worked out and she was cool; she liked it a lot actually, and one thing I learnt from this was to work with the person that you're shooting. It's not about putting Debbie Harry in some kind of concept, it's about working with her — and that is a lesson I learnt.

DAZED

Declare Independence

ANNIVERSARY ISSUE · ANNIVERSARY ISSUE · ANNIVERSARY ISSUE · ANNIVERSARY ISSUE

25

FKA twigs

Pamela Anderson • Marilyn Manson • Gigi Hadid • Willow Smith • Sasha Lane
Kate Moss • Jean Campbell • Natalie Westling • RuPaul • Dolly Parton

ISSUE 47, VOL. IV, A/W 2016 **FKA TWIGS** PHOTOGRAPHY **RYAN MCGINLEY** STYLING **KAREN LANGLEY**

DON'T FIGHT IT, FEEL

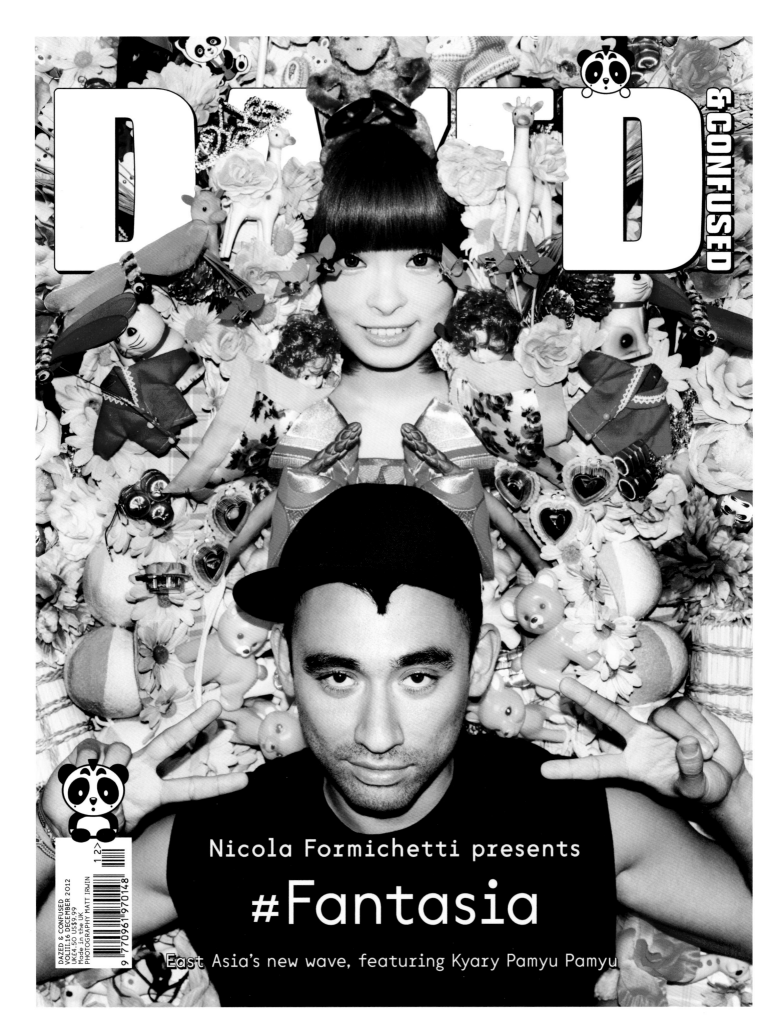

DAZED &CONFUSED

Nicola Formichetti presents

#Fantasia

East Asia's new wave, featuring Kyary Pamyu Pamyu

DAZED & CONFUSED
VOL.III.16 DECEMBER 2012
UK£4.50 US$9.99
Made in the UK
PHOTOGRAPHY MATT IRWIN

9 770961 970148 12>

ISSUE 16, VOL. III, DEC 2012 **FANTASIA** PHOTOGRAPHY **MATT IRWIN** STYLING **NICOLA FORMICHETTI**

RAPHAEL HIRSCH, Fashion Editor: This was a very personal project for me, as I had not been back to Nigeria since leaving after secondary school. Harley and I had talked about shooting there about eight years before, but I wasn't ready; when it felt right, she was happy to make it happen. Lagos is hectic, everything hits you at once — the food, the beautiful people, the heat, the charm of people. It is a hustle, a city always on the go, and keeps you on your toes. I had forgotten that energy, and it was nice to get a bit of a reminder. It was great to revisit some places I had seen growing up and see them with different eyes. Places like Olumo Rock in Abeokuta, which I had visited on school trips, and new places like Erin Ijesha Waterfalls, which I discovered

on that trip. I met amazing new people and it was great working with Harley; she seemed to be able to handle everything Lagos threw at her with ease. For the styling, I wanted to mix in something that represented part of Nigeria's cultural heritage with a youthful and modern touch. It was important to me that, when looking at the images, one can for a moment capture glimpses of moments of life in Lagos and, at the same time, immerse oneself in traditional Yoruba Egungun masquerades, along with more stylised fashion imagery, to create a vision of a modern beautiful city with a lot to offer. This shoot is an experience I would always remember, as it also marked the beginning of a new phase of my career.

ISSUE 55, VOL. IV, SPRING 2018 **NIGERIA** PHOTOGRAPHY **HARLEY WEIR** STYLING **RAPHAEL HIRSCH**

DON'T FIGHT IT, FEEL

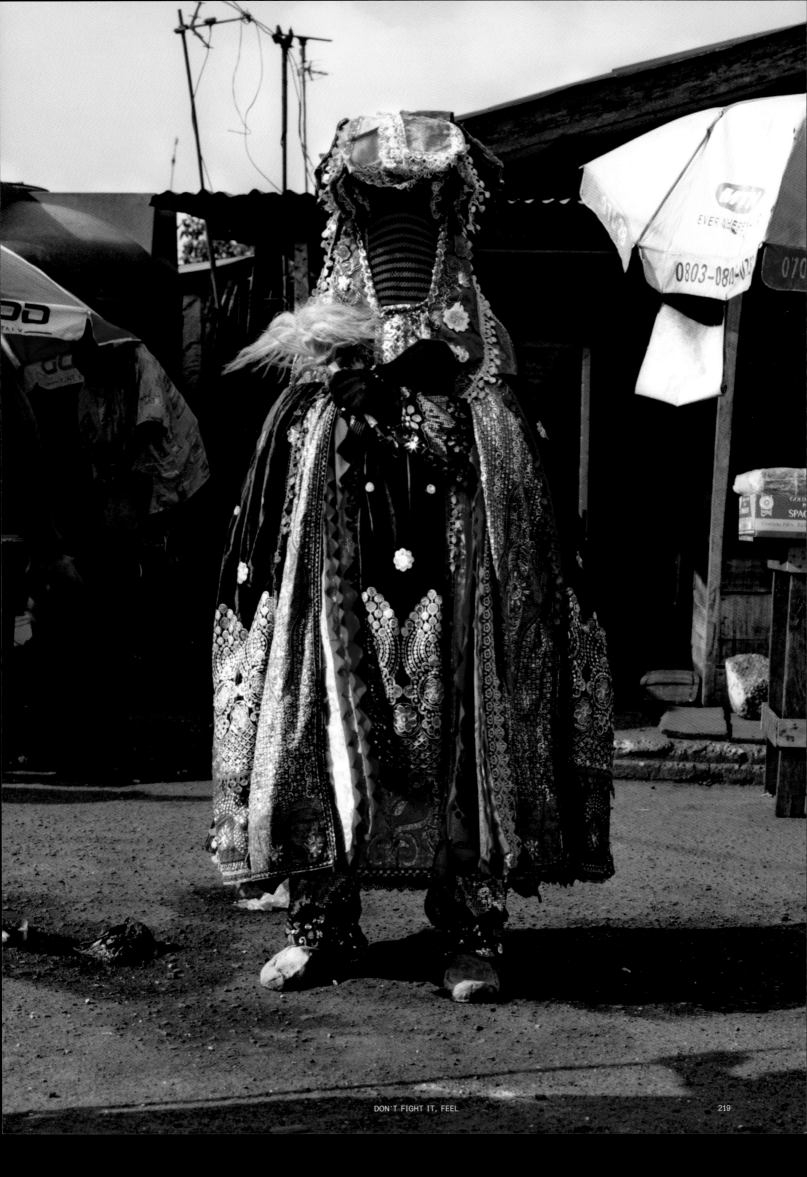

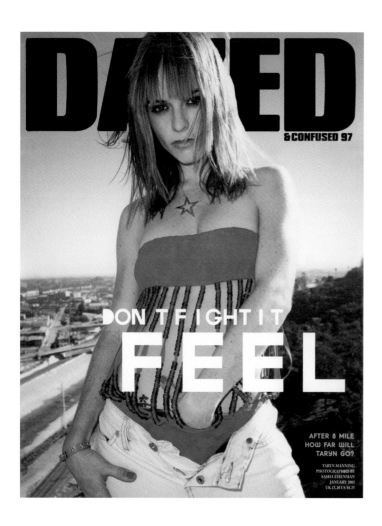

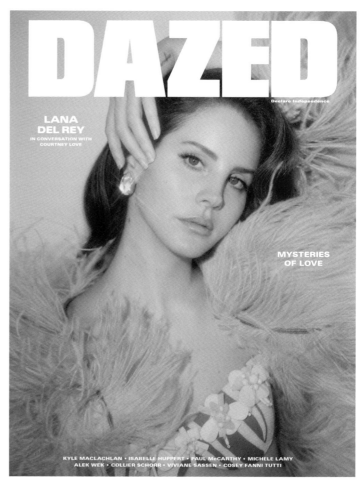

ISSUE 97, VOL. I, JAN 2003 **TARYN MANNING**
PHOTOGRAPHY **SASHA EISENMAN**
STYLING **JASON FARRER**

ISSUE 50, VOL. IV, S/S 2017 **LANA DEL REY**
PHOTOGRAPHY **CHARLOTTE WALES**
STYLING **ROBBIE SPENCER**

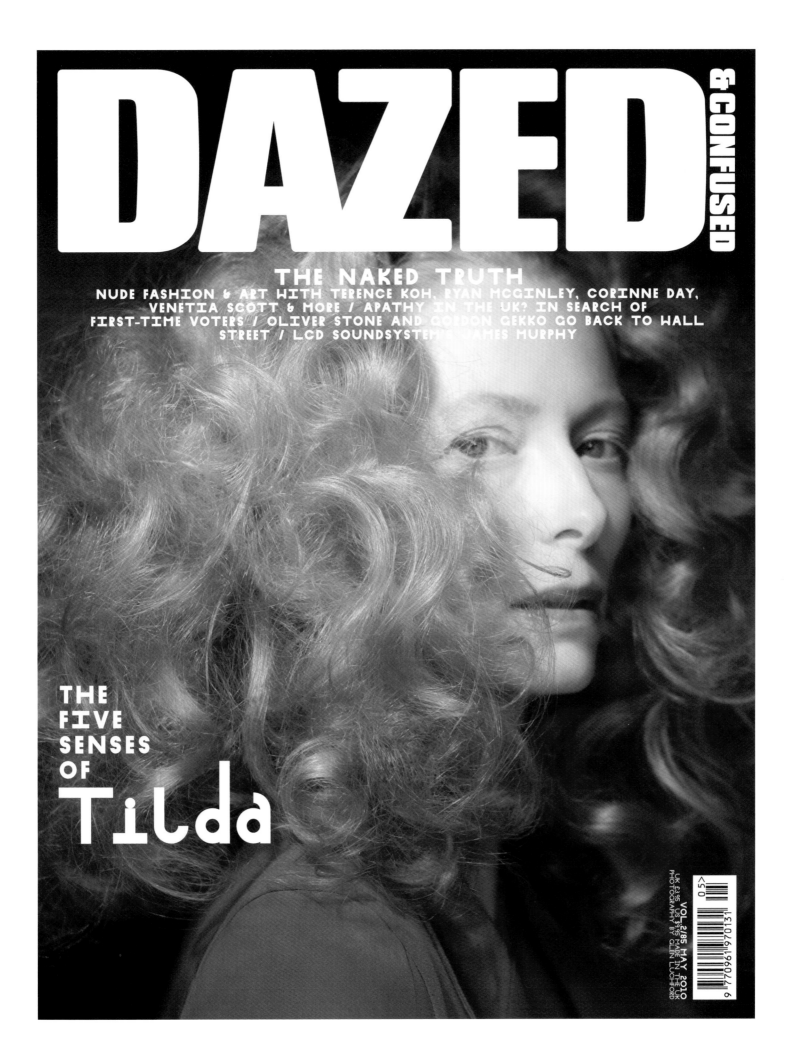

DAZED &CONFUSED

THE NAKED TRUTH
NUDE FASHION & ART WITH TERENCE KOH, RYAN MCGINLEY, CORINNE DAY,
VENETIA SCOTT & MORE / APATHY IN THE UK? IN SEARCH OF
FIRST-TIME VOTERS / OLIVER STONE AND GORDON GEKKO GO BACK TO WALL
STREET / LCD SOUNDSYSTEM'S JAMES MURPHY

THE FIVE SENSES OF Tilda

UK £3.95 MAY 2010
US $9.95 MADE IN THE UK
PHOTOGRAPHY BY GLEN LUCHFORD

VOL.2/85

<50

ISSUE 85, VOL. II, MAY 2010 **TILDA SWINTON**
PHOTOGRAPHY **GLEN LUCHFORD**
STYLING **KATY ENGLAND**

OWEN MYERS, Writer-at-Large: This is my favourite cover that I nicked from WHSmith's.

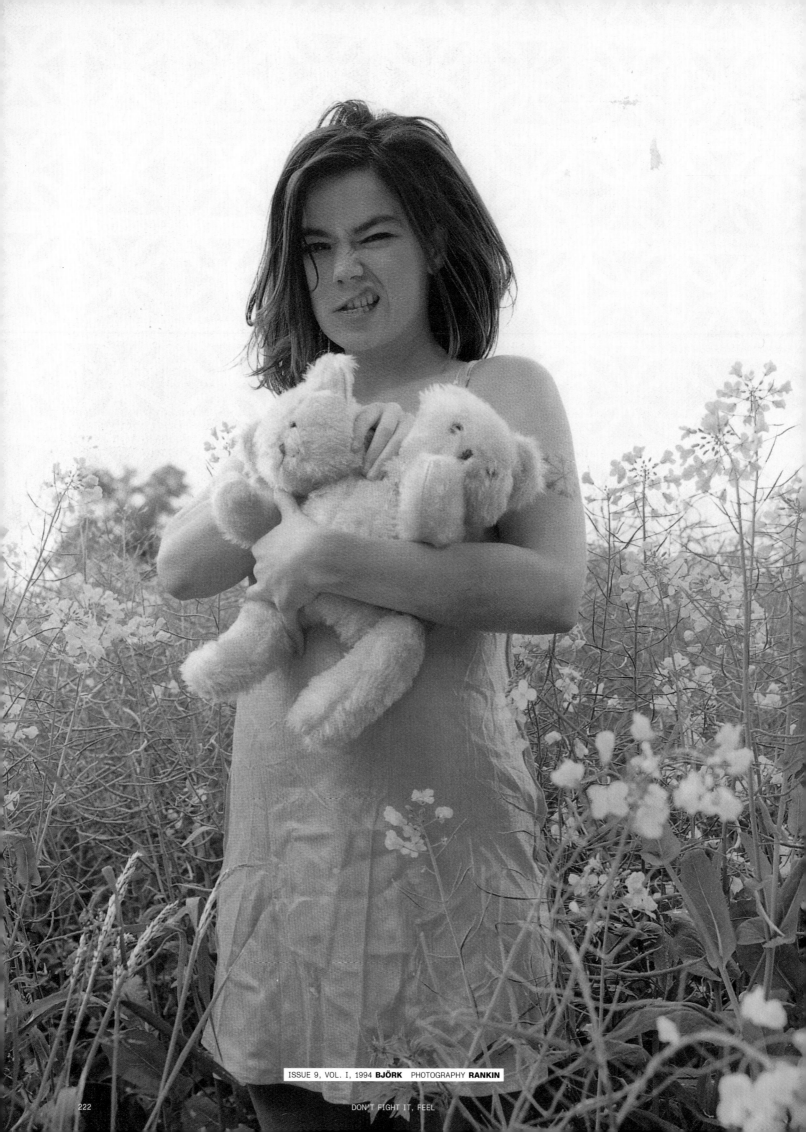

emotional tettotist

emotional tettotist
with a cause
tescue-ing people from level-headness
of the unnecessaty luxuty of being calm

Hypoctits!

Life is chaos
and should be!

don't pretend there is suchathing as balance
≡security≡
—it doesn't exist!

PLANT BOMBS PLANT BOMBS and make
sute they explode on unptedictable times in
unptedictable places SURPRISE is the strongest
weapon of the emotional tettotist.

— save these people from boredom.
Rescue them from those schedules

HURREY to free-jazz and earth-
quakes and the devaluation of all
cuttencies

¡LONG LIVE ALL ACCIDENTAL BEHAVIOR!

with thanks
and tespect
to all
emotional tettotists

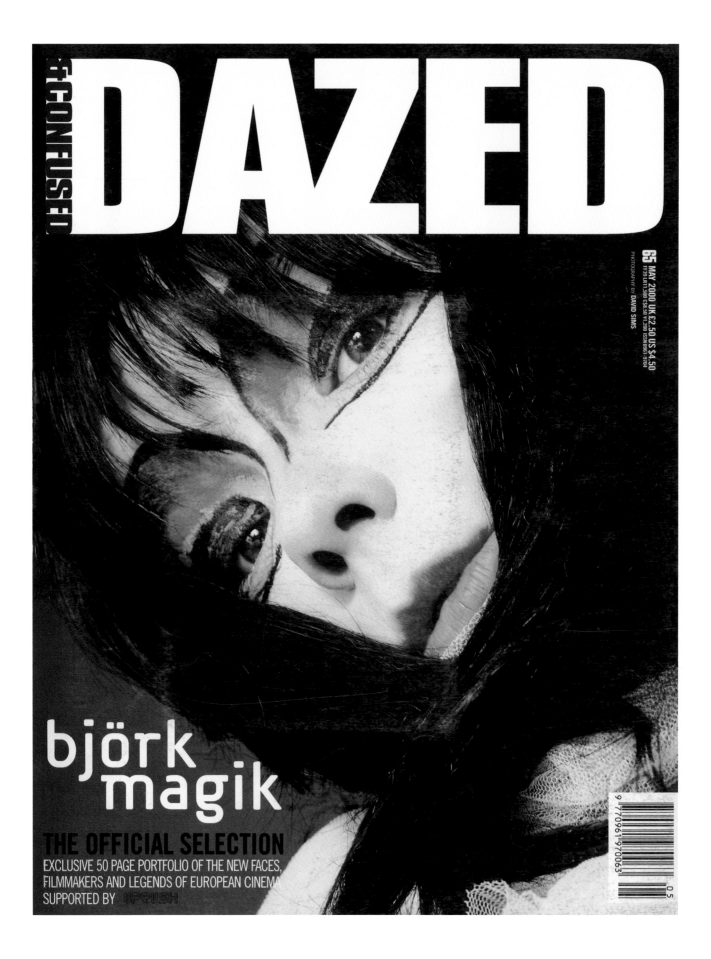

DAZED

&CONFUSED

65 MAY 2000 UK £2.50 US $4.50
FF39 L£11.500 €56.50 ¥1200 ISSN 0961-9704

PHOTOGRAPHY BY DAVID SIMS

ISSUE 65, VOL. I, MAY 2000 BJÖRK PHOTOGRAPHY DAVID SIMS STYLING KATY ENGLAND

björk
magik

THE OFFICIAL SELECTION

EXCLUSIVE 50 PAGE PORTFOLIO OF THE NEW FACES,
FILMMAKERS AND LEGENDS OF EUROPEAN CINEMA
SUPPORTED BY UPRUSH

KATY ENGLAND, Fashion Director: I had first worked with Björk on the *Homogenic* album cover (in 1997) through Lee McQueen, and she came to see his fashion shows as well. This wasn't the first time she'd appeared in *Dazed & Confused* — she was in some of the earliest issues, as a kid, practically. Her journey was going along at the same time as the journey of *Dazed*, and of Jefferson. She's been a massive part of the magazine, we were all friends, all part of this thing that was going on at the time. I remember spending New Year's in Iceland with her in 1999 with Jefferson and Alister Mackie — it was our little family, so this shoot seemed pretty natural. I put her with David Sims and at that time she was really open to experimenting — like the make-up, we did

really crazy make-up on her. Back then, we never went with references or ideas — like, 'Oh we want to do this, or that' — so I think this was all pretty spontaneous. It was about trying to capture this energetic side of her.

I love working with her because she is very open, she listens, she is very respectful of creativity, of everybody around her. She's highly intelligent and wants to work with people she respects, so it's always been really enjoyable. I've done a lot of shoots with her. She's one of my favourite artists to work with; she just has this fantastic energy. Every single time it's been incredible. I'd do anything for her, even if it meant just going to the shoot and making the tea.

ISSUE 9, VOL. I, 1994 **BJÖRK** PHOTOGRAPHY **RANKIN**

i remember being in a deliciously dodgy rave somewhere, early nineties,
upstairs in a derelict building and listening to jefferson telling
me he really wanted to start a magazine. i remember
encouraging him to absolutely go for it,
the world needed one that
bypassed bullshit and
stayed with enthusiasm
focused on people making things.
while it is possible my memory has betrayed me
(has not been my most accountable part) and the dates dont
completely add up, there is at least one thing that is certain: dazed
have absolutely stuck to their promise and stay as fertile and
current as ever. i am strangely enormously proud
aunt here and admire from afar the
unstoppable next generation
carrying that torch: the amount of
integrity is immense!! it gives me hope
and i trust them to report on our future too!
happy birthday dazed
and happy birthday jefferson!

Björk

IF YOU STAND FOR NOTHING YOU'LL FALL FOR ANYTHING

9.
If You Stand for Nothing
You'll Fall for Anything

The questioning spirit
behind every issue
226–241

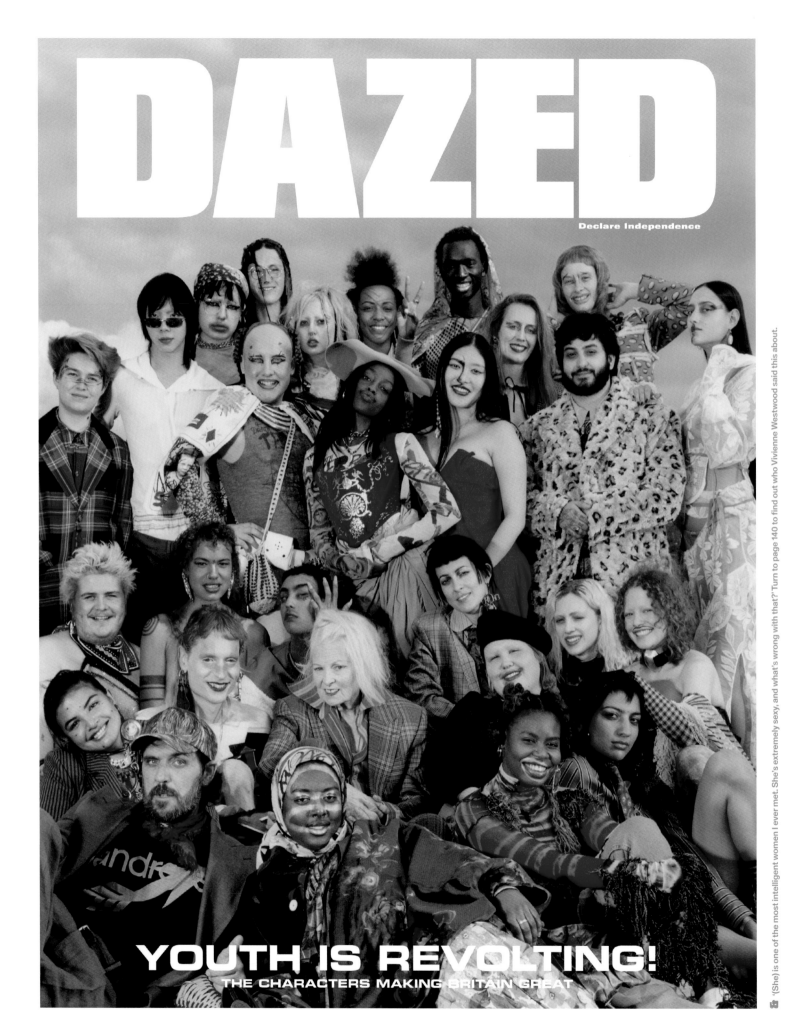

DAZED

Declare Independence

YOUTH IS REVOLTING!
THE CHARACTERS MAKING BRITAIN GREAT

'(She) is one of the most intelligent women I ever met. She's extremely sexy, and what's wrong with that?' Turn to page 140 to find out who Vivienne Westwood said this about.

ISSUE 57, VOL. IV, SUMMER 2018 **YOUTH IS REVOLTING!** PHOTOGRAPHY **HANNA MOON** STYLING **AGATA BELCEN**

IF YOU STAND FOR NOTHING, YOU'LL FALL FOR ANYTHING

AGATA BELCEN (stylist): Dame Vivienne Westwood is one of the strongest, kindest and sexiest women I have ever worked with. Seeing the respect and rapport everyone had for and with her and Andreas, and that she had for and with them, was one of my favourite parts of the day. There wasn't any bullshit or artifice that day in the interactions or intentions, and I find that exciting.

HANNA MOON (photographer): We shot the story in the park (Burgess Park) near my place. It is quite a big park but it's never that busy. I thought it would be good to shoot in the open space to accommodate (all the) people.

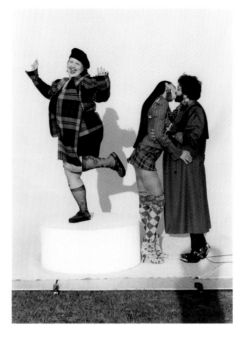

AGATA BELCEN: It was chaotic and spontaneous. Every person had their own style, mood and approach. The whole point had been to cast strong, opinionated people, and so I had individual conversations with everyone, working out what made sense for them to wear and what would be fun. We were working with current and archive Westwood collections, which was dream access for me because it's one of my favourite fashion houses. I mixed it with collections by young designers and also designs by some of the fashion students we were shooting. It was a carnival of styles.

MATTY BOVAN (designer): I remember I was being shot on my own in the park and parents complaining I was in the way — I must have looked terrifying.

AGATA BELCEN: For the cover shot, Hanna was up on a ladder calling out directions for where people should stand. We'd done a lot of prep in advance for references of the group shots, so there was a strong sense of direction. Hanna is really good at being with people in the moment. I love how her picture feels so vital.

HANNA MOON: I had to shout so loudly to get everyone's attention from the top of that ladder, I had lost my voice the next day!

WILSON ORYEMA (poet): My strongest memory of the day was mainly everyone in our outfits, parading around the park in between shots. It felt like we were shooting a spin-off for *Downton Abbey* or something!

MATTY BOVAN: Bizarrely it feels a long time ago, but at that time we knew how talented and special the people featured were, and time has done nothing but prove how much so. It was a reunion of sorts — it felt almost like a school club!

HANNA MOON: I knew quite a few of them already, and most of them all knew each other. So it was more like friends gathering and playing together. I believe that the vibe came up in the images, just how it was on the day of the shoot.

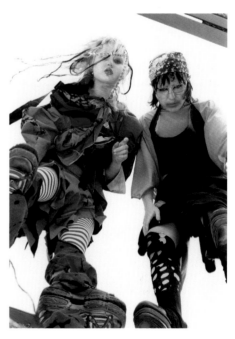

VIVIENNE WESTWOOD: There were an awful lot of different people on set! Designers, photographers, fashion students, campaigners. But I think all activists are motivated by the same thing — the human race. They really do care about other people suffering. That's who we are, we help each other, and we have empathy.

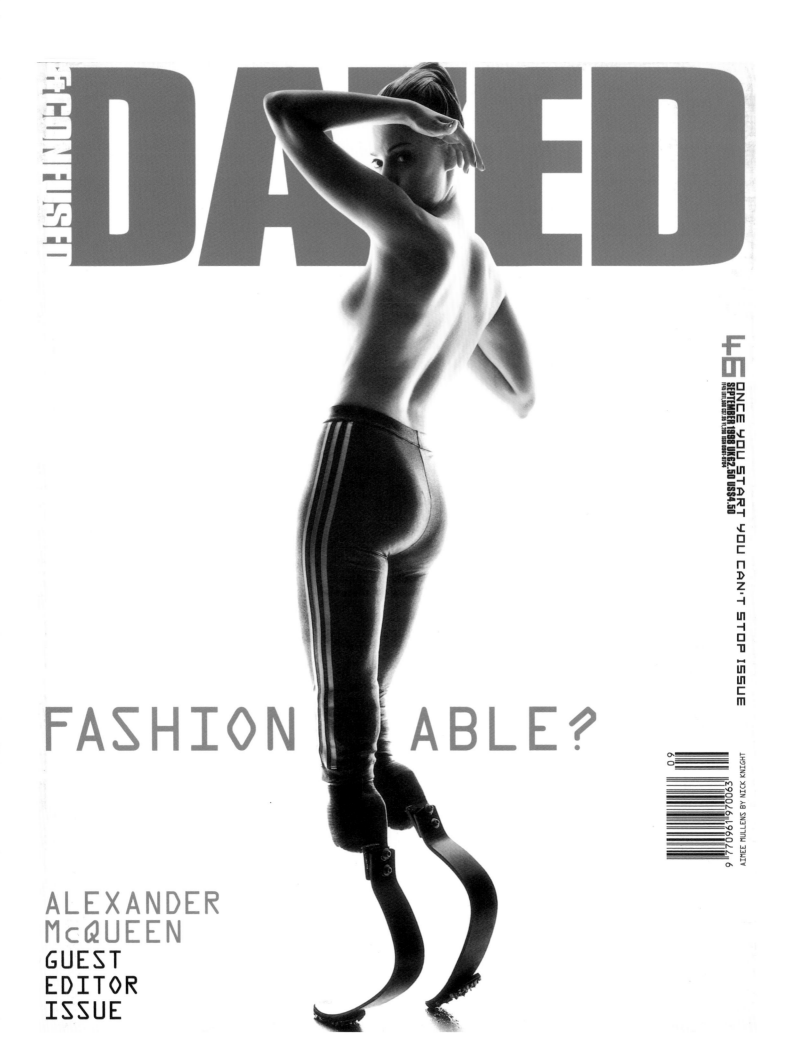

DA ED

DAZED & CONFUSED

46
SEPTEMBER 1998 UK£2.50 US$4.50
IR£3.80 S$7.95 FL1.200 ISSN 0961-9704
ONCE YOU START YOU CAN'T STOP ISSUE

AIMEE MULLENS BY NICK KNIGHT

FASHION ABLE?

ALEXANDER
McQUEEN
GUEST
EDITOR
ISSUE

ISSUE 46, VOL. I, SEP 1998 **FASHION-ABLE?** CONCEPT **ALEXANDER McQUEEN** PHOTOGRAPHY **NICK KNIGHT** STYLING **KATY ENGLAND**

IF YOU STAND FOR NOTHING, YOU'LL FALL FOR ANYTHING

In 1998, Alexander McQueen guest-edited the September issue of *Dazed & Confused*. The cover story, Accessible, photographed by Nick Knight and styled by Katy England, presented a 14-page feature on fashion and people with disabilities for the first time in the history of magazine publishing.

Katy England: I was working with Alexander McQueen at the time — it was 1998, (and) I had started working with him in 1993 or 1994, so it had been a while — and I remember him coming into the office one day with a picture of Aimee Mullins on the cover of a sports magazine. She was in her prosthetic legs, the sporty ones, I think probably the same ones you see on the 'Fashion-Able?' cover. He was like, 'Wow, who's this girl?' He was absolutely blown away by her, he really wanted to talk to her, she was a total inspiration. So she came down to London — he wanted her to be in the next show — and they just fell in love with each other. The show was called *231*, it was spring/summer 1999, and she opened the show for us, so this cover of *Dazed & Confused* was running alongside the work we were doing with Aimee on the show. A lot of that collection was about prosthetics — there were these moulded leather bodices, and I remember going to the place where they were made, which was originally a producer of prosthetic limbs. (Alexander) also carved Aimee a pair of prosthetic legs from wood. They formed a really close relationship and became super friends; she's a really inspiring girl, and was always just up for life.

It was always the plan to have her on the cover, but for (the shoot) we wanted to cast other models (with disabilities) that we believed to be beautiful, and were beautiful individuals. I was the one to coordinate it all, and I had to work with a lot of charity organisations and networks (to find models), which was quite difficult — you say you are from a fashion magazine, and they just think we're going to exploit people. But eventually we got there. It was a really sensitive subject, a different world for me but I just threw myself into it, and learnt such a lot. I coordinated with all the different designers who dressed their chosen person in the shoot — I put in requests to Hussein Chalayan, Comme des Garçons, and Alexander McQueen did a lot because he was producing those pieces for his show as well. Meeting Alison Lapper, the girl who Hussein projected the colours onto, was amazing — afterwards, she ended up sculpted (by Marc Quinn) in Trafalgar Square. It was really groundbreaking stuff. Hussein was a big contemporary of Lee McQueen's at the time, they were both doing these amazing, highly conceptual shows. They really respected each other.

(The shoot) was really touching. This was a new world for these people, so we wanted to make sure everyone was really comfortable, that they were happy with their images. One of the girls, Catherine Long, who doesn't have an arm, I remember her saying to me, 'Oh, I never thought I could look so beautiful.' And I just thought, 'Wow, we've achieved that. Catherine feels fantastic.' She's right up there, being shot by Nick Knight, having the hair and make-up treatment with Val Garland and Malcolm Edwards... It was amazing to see. AS TOLD TO **JACK MOSS**

Nick Knight: Lee was incredibly fast at being able to see an image. I remember doing the cover of Björk's album *Homogenic* with him. He saw the first Polaroid, said, 'Good', and left. I went on for another three or four hours torturing poor Björk but Lee knew exactly when he got the image.

(For 'Fashion-Able?') Lee came to me and said he wanted to do something on people with very severe physical disabilities, which isn't a very nice word — ability might be a better way of saying it. It was a lot of planning, probably six months in the creation of it, making sure we did this in the right way — that it wasn't salacious and didn't feel exploitative, demeaning or scandalous.

It occurred to me whilst doing that that there was no precedent for this, which was exciting and depressing at the same time. There were virtually no aspirational images throughout the history of art in any of its forms of people (with disabilities). At best in a Western liberal society, we will portray you with compassion but you will not be held up as aspirational. That's not how I see people. Everybody has beauty in them — it's just up to the photographer to see it, to bring it out, to understand it. It's up to us to look.

The session itself — which was three days and three nights long — was very passionate. Some of the people were quite suspicious and on their guard; they didn't know how we were going to portray them. Quite quickly they trusted us and saw that all we were trying to do was make an incredible image of them. They had never really been considered beautiful before. I remember one girl broke down on set and said, 'Nobody's ever said that word to me.'

It was a watershed for me. It was one of the most important moments in my life because it made me realise how important fashion imagery is, how it changes people and societies. Fashion is an incredibly strong motor for bringing about social change. AS TOLD TO **MISS ROSEN**

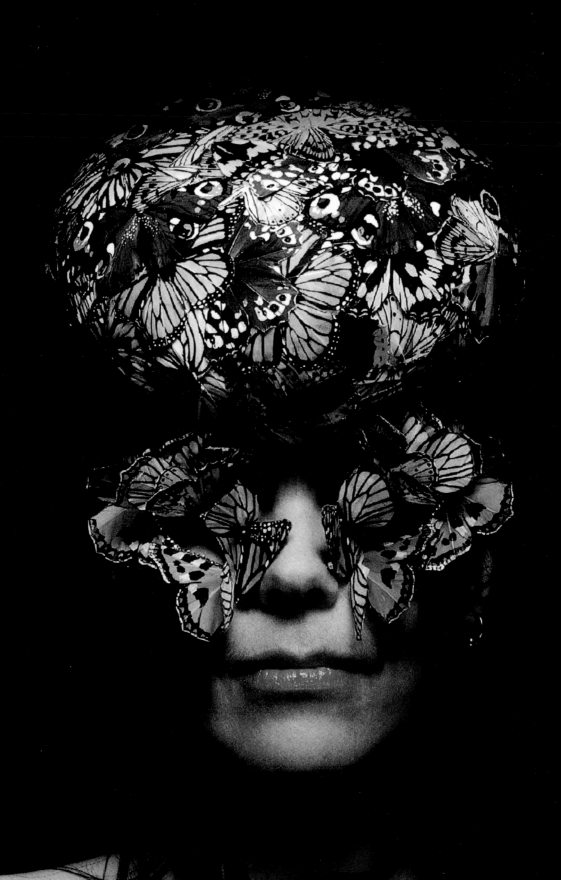

IF YOU STAND FOR NOTHING, YOU'LL FALL FOR ANYTHING

SUSANNAH FRANKEL, Editor-in-Chief, *AnOther*: I first met Jefferson on this shoot, and Nick Knight, who took the pictures. We were introduced by Alexander McQueen, who guest-edited the issue and asked me to do the words. There was a lot of noise around the cover story, especially because some people thought it was wrong to shoot solely people with disabilities; they thought that Lee (McQueen) should mix it up. Lee's initial idea was to question our preconceived ideas of beauty and to comment on the fashion industry's preconceived ideas of beauty especially. He approached designers he felt an affinity with — Comme des Garçons and Hussein Chalayan. Katy England worked on the casting and I think she found at least some of the people (by) going through organisations that support people with disabilities. It was a lengthy process and I remember how excited everyone was to be working on it.

I wrote the words for *Dazed*, but I also covered the story for the *Guardian* — I was the paper's fashion editor at that time — so I interviewed all the subjects. Aimee Mullins, the cover star, was comparatively well known, as was Alison Lapper, but at least some of the people who took part weren't. They were incredibly shy, and it wasn't easy for them to have their pictures taken; there were some very challenging moments. I remember the energy on the day, the sweetness of Katy and the sensitivity of Nick, who is famously quite demanding but in this instance was just so lovely. I remember the passion that drove the whole thing. When people saw those pictures, I think they were genuinely moved. Everyone on set was moved too. It felt very beautiful — very pure. Lee had a way of making things like that happen. No one ever wanted to say no to him, however difficult an idea was to achieve. He created many magical moments and I feel that was certainly one of them.

DAZED

Declare Independence

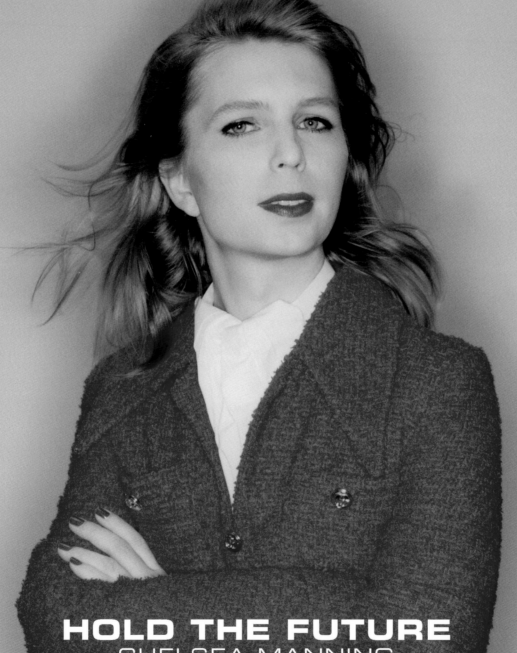

HOLD THE FUTURE
CHELSEA MANNING

The Infinite Identities Issue: Chelsea Manning + guest-edit, Ariel Nicholson, Kelsey Lu, Gregg Araki,
Juliet Jacques, Krow, Hunter Schafer, Ian Isiah, Finn Buchanan, Karen O, Rowan Blanchard

ISSUE 61, VOL. IV, SPRING 2019 **CHELSEA MANNING** PHOTOGRAPHY **MARK PECKMEZIAN** STYLING **EMMA WYMAN**

IF YOU STAND FOR NOTHING, YOU'LL FALL FOR ANYTHING

Chelsea Manning
by Diana Tourjée

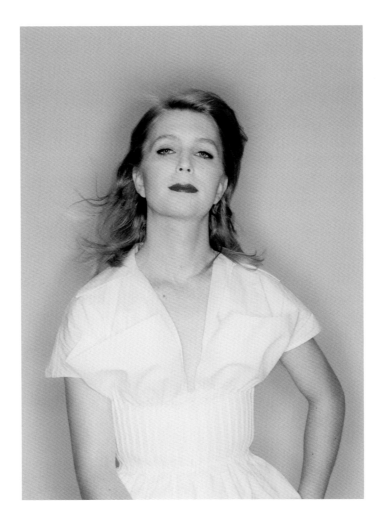

I remember it was cold when I met Chelsea Manning. Chelsea was sitting alone, her head down, in all black, packed onto the end of a crowded bench. No one seemed aware of who she was. The conference room we intended to use for the interview wasn't available, so we had to cram inside the facility's phone booth. I sat on the floor. People kept knocking on the glass door throughout, apparently wondering when we'd be finished. I found it perfectly unsurprising that this was how Chelsea Manning existed within The Wing (the elite women's workspace), where she had been given a membership, and which somehow connected to various themes within Chelsea's story itself. Gender. Identity. Womanhood. Systems of power. It can be quite profitable to make gestures of allyship with people like Chelsea. An entire generation of social-justice-branded corporations have mined the cultural capital of revolutionary groups and individuals, who are themselves typically impoverished and vulnerable. So it made sense to me that a trans woman who is easily one of the most significant icons against international State violence in the history of our nation would have to take an interview in a dressed-up broom closet with a single stool, while a paying membership of New York's creative professionals rapped on the glass door separating us, likely wondering, with two people taking up so much time in one small room, if they were getting their money's worth.

Chelsea is very small. I remember being struck by that even though I knew her height. Having reported so extensively on her for so many years, I had a thorough outsider's understanding of who she was and what she did. Chelsea's acts while a member of the United States military weren't simply radical. They had extraordinarily massive implications for national and global governments. In her decision to inform the American public of what our government was doing, in our name, overseas, she brought the most powerful militarised nation in the world to its knees. Her remarkably small and slight physicality enriched my understanding of how great an impact an individual can have in a world shared by billions.

After our interview, Chelsea welcomed me to join her at a pizza place across the street. We ate slices in Manhattan, and there, in the cold, with that familiar food before me and all the sounds of the city around us, I felt I could see Chelsea more clearly, though I doubted I'd ever really know her. She was kind without trying, clear and convincing, and obviously still a vulnerable patriot existing on the ledge of a margin set by a society that would smile if she ever lost balance and fell too far for rescue. The slices were gone, and Chelsea said goodbye, then quickly became invisible in a sea of dark coats, between the glittering towers that sometimes seem to mock the New Yorker below, navigating a dark labyrinth of streets that may all connect to the places of warmth and wealth — like The Wing — but never simply lead there.

The Chelsea Manning profile I did for *Dazed* was my first magazine cover story. Chelsea Manning was also the subject of my first journalistic editorial, years prior. When I was approached to do this story, I felt a sense of deep personal accomplishment, in part because it was so clear how far I'd come, covering one subject in a very small way, when she was in prison and I was an unknown writer, to having that same woman be the subject of a triumphant mark of my own career. I didn't know what *Dazed* was until this first story, and have since felt that its legacy of documenting culture for people situated precariously within culture is lived out in my own experience writing for it.

Photography DANIEL WEISS Styling EMMA WYMAN

WHAT HAPPENED TO THE NEW YORK UNDERGROUND

CELEBRATING NYC'S FINEST ACROSS 26 PAGES

RICHARD HELL, MUSICIAN

AMY ROSE SPIEGEL, WRITER

EILEEN MYLES, POET

JIMMY WEBB, OWNER OF I NEED MORE FASHION STORE

NATASHA STAGG, WRITER

BERNADETTE VAN HUY, ARTIST

LINDA YABLONSKY, WRITER

LYLE ASHTON HARRIS, ARTIST

NORMA KAMALI, DESIGNER

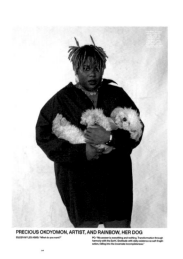

PRECIOUS OKOYOMON, ARTIST, AND RAINBOW, HER DOG

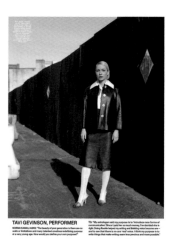

TAVI GEVINSON, PERFORMER

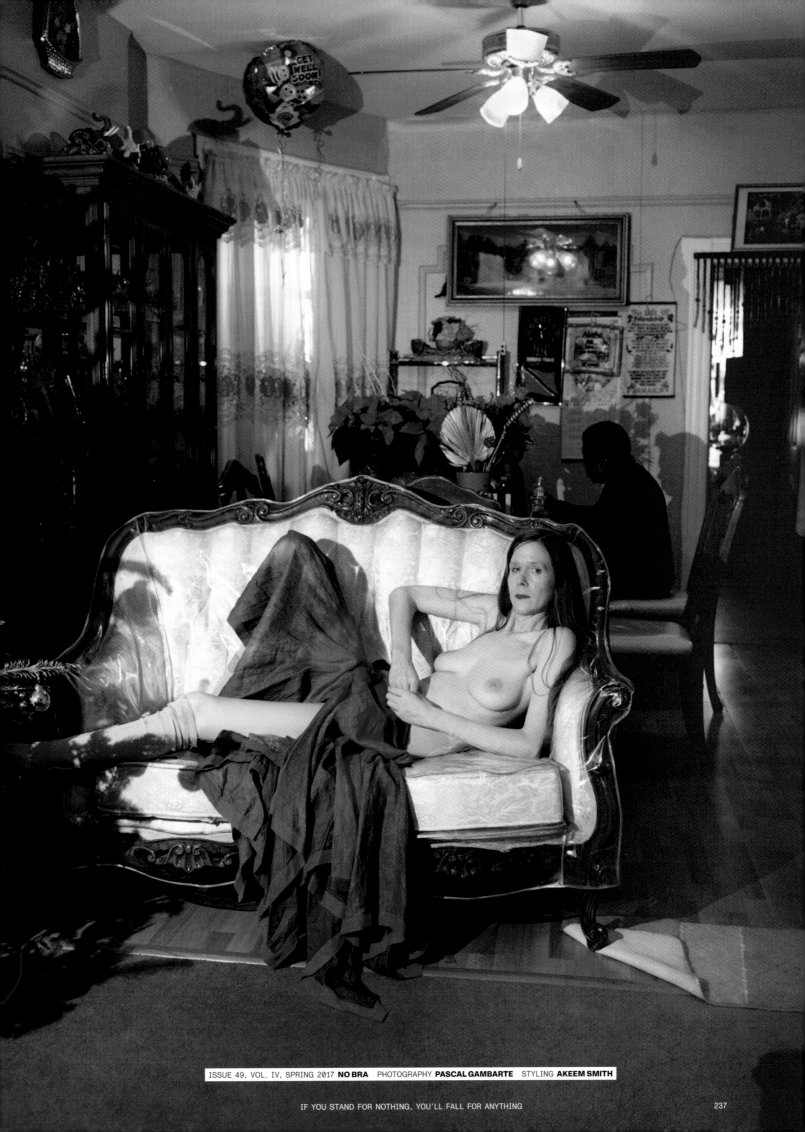

ISSUE 49, VOL. IV, SPRING 2017 **NO BRA** PHOTOGRAPHY **PASCAL GAMBARTE** STYLING **AKEEM SMITH**

IF YOU STAND FOR NOTHING, YOU'LL FALL FOR ANYTHING

LYNETTE NYLANDER, Executive Editorial Director: This 'South Africa Issue' is my favourite *Dazed* cover, commemorating the ten years since apartheid. With such an important topic at hand and one that is perhaps not the easiest to create a magazine around, I think it was incredibly powerful, and shows the power a magazine can have in crystallising a moment.

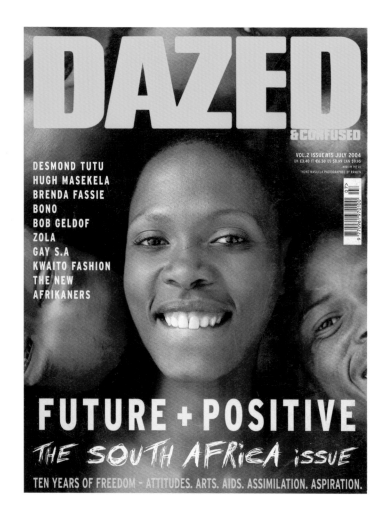

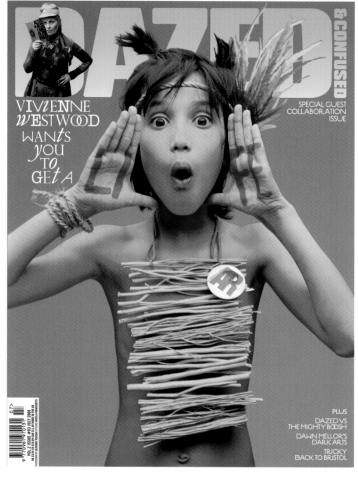

ISSUE 15, VOL. II, JUL 2004 **THE SOUTH AFRICA ISSUE**
PHOTOGRAPHY **RANKIN**

ISSUE 63, VOL. II, JUL 2008 **VIVIENNE WESTWOOD**
PHOTOGRAPHY **OLIVIERO TOSCANI**
STYLING **NICOLA FORMICHETTI**

IF YOU STAND FOR NOTHING, YOU'LL FALL FOR ANYTHING

ISSUE 36, VOL. IV, WINTER 2014 **JOHN WATERS** PHOTOGRAPHY **SANDY KIM** STYLING **HEATHERMARY JACKSON**

COOKING TO KILL!

PHOTOGRAPHY BY MAKI KAWAKITA
ILLUSTRATION BY JIMMY TURRELL

DAZED

& CONFUSED

#CLIMATE
CHANGE
SPECIAL

PLUS:
THOM YORKE INTERVIEW
WEST MEMPHIS THREE
KARL LAGERFELD

WIN
GREENPEACE
GLASTONBURY
TICKETS
PAGE 161

Wish you were here

MISSY ELLIOTT
IN JAMAICA

VOL.2 ISSUE#27 JULY 2005. MADE IN THE UK
UK £3.40 IT €6.50 US $9.99 CAN $9.99

07>

9 770961 970100

Missy's Noughties-defining LP *Miss E... So Addictive* was co-produced by Timbaland, who worked with which other pop star of the era? Go to page 154 to find out.

ISSUE 27, VOL. II, JUL 2005 **MISSY ELLIOTT** PHOTOGRAPHY **MAKI KAWAKITA** STYLING **BRANDON ATHERLY** ARTWORK **JIMMY TURRELL**

IF YOU STAND FOR NOTHING, YOU'LL FALL FOR ANYTHING

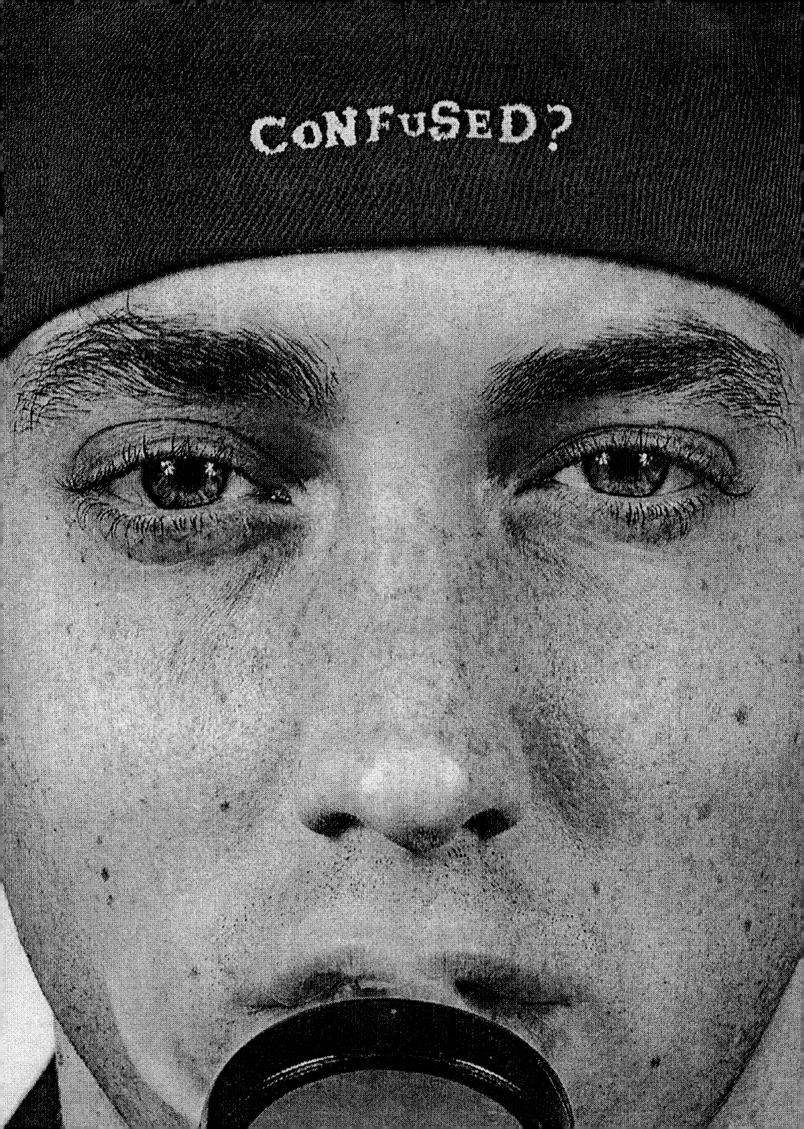

10.
Confused?

What magazine myths
are made of
242–265

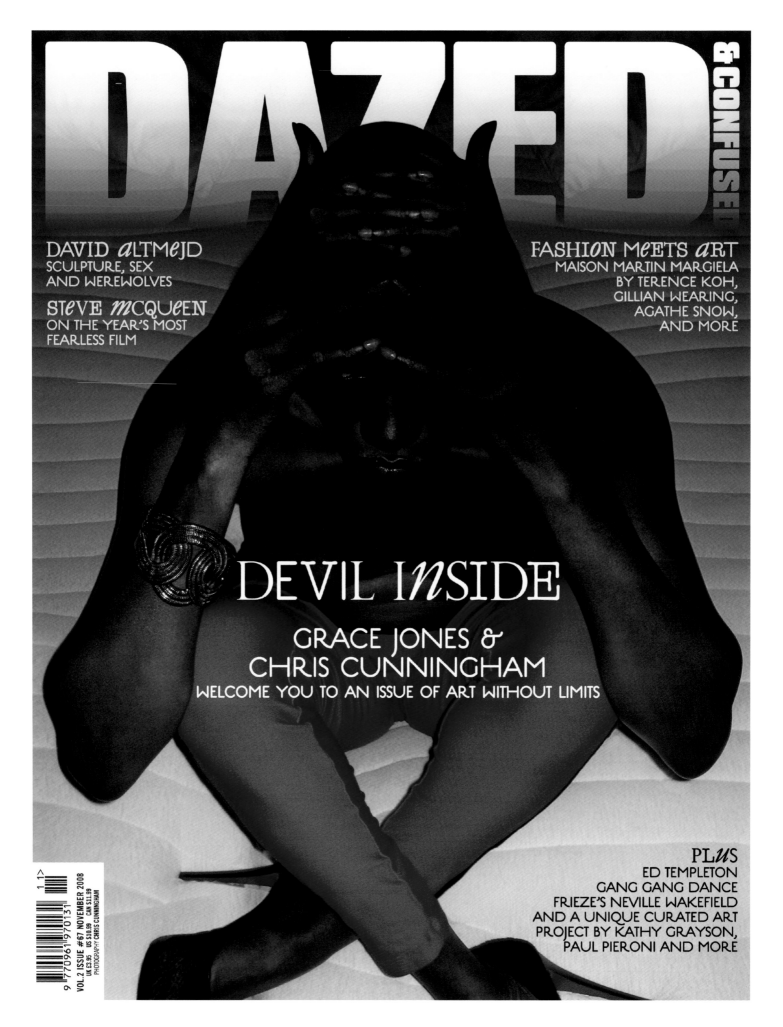

DAZED &CONFUSED!

DAVID *a*LTMEJD
SCULPTURE, SEX
AND WEREWOLVES

STEVE *m*CQUEEN
ON THE YEAR'S MOST
FEARLESS FILM

FASHION M*ee*TS *a*RT
MAISON MARTIN MARGIELA
BY TERENCE KOH,
GILLIAN WEARING,
AGATHE SNOW,
AND MORE

DEVIL *in*SIDE

GRACE JONES &
CHRIS CUNNINGHAM
WELCOME YOU TO AN ISSUE OF ART WITHOUT LIMITS

PL*u*S
ED TEMPLETON
GANG GANG DANCE
FRIEZE'S NEVILLE WAKEFIELD
AND A UNIQUE CURATED ART
PROJECT BY KATHY GRAYSON,
PAUL PIERONI AND MORE

VOL.2 ISSUE #67 NOVEMBER 2008
UK £3.95 US $10.99 CAN $11.99
PHOTOGRAPHY CHRIS CUNNINGHAM

9 770961 970131 1 1>

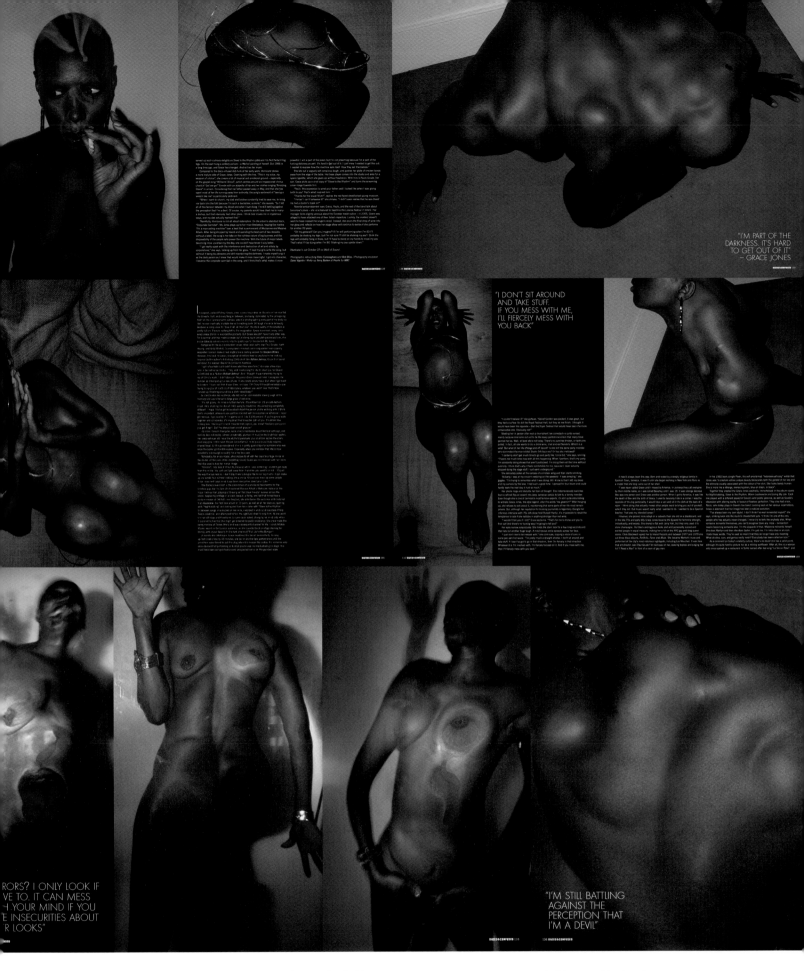

CHRIS CUNNINGHAM, Photographer: When I made the images for *Rubber Johnny*, I wanted to make some Nubian versions to accompany them. That was the starting point of the shoot. But, when you start shooting Grace, her image is so strong that you don't need to go too nuts with the tricks. For me, she has the strongest iconography of any artist in music. I've always loved it — especially the cover of *Slave to the Rhythm*. So, I went around her house, she got naked, and she had complete trust in me to let me do what I wanted. You have to adjust to her hours, though, because she is a night person who only really comes alive at about two in the morning! She's definitely the most inspiring person I've worked with so far.

SYLVIA FARAGO, Photographic Director: We shot the cover at her empty apartment in Battersea one night from 9pm to 6am It was a pretty small team — just me, Chris, and his friend Dario helping him. The moment Grace walked in she stripped fully naked, spread her legs, and had her vagina freshly shaved in front of us. It was a level of feminine confidence I'd never seen before. It was pretty incredible. She only played her own music and sang along to it for the whole night while Chris shot her — she was so full of energy.

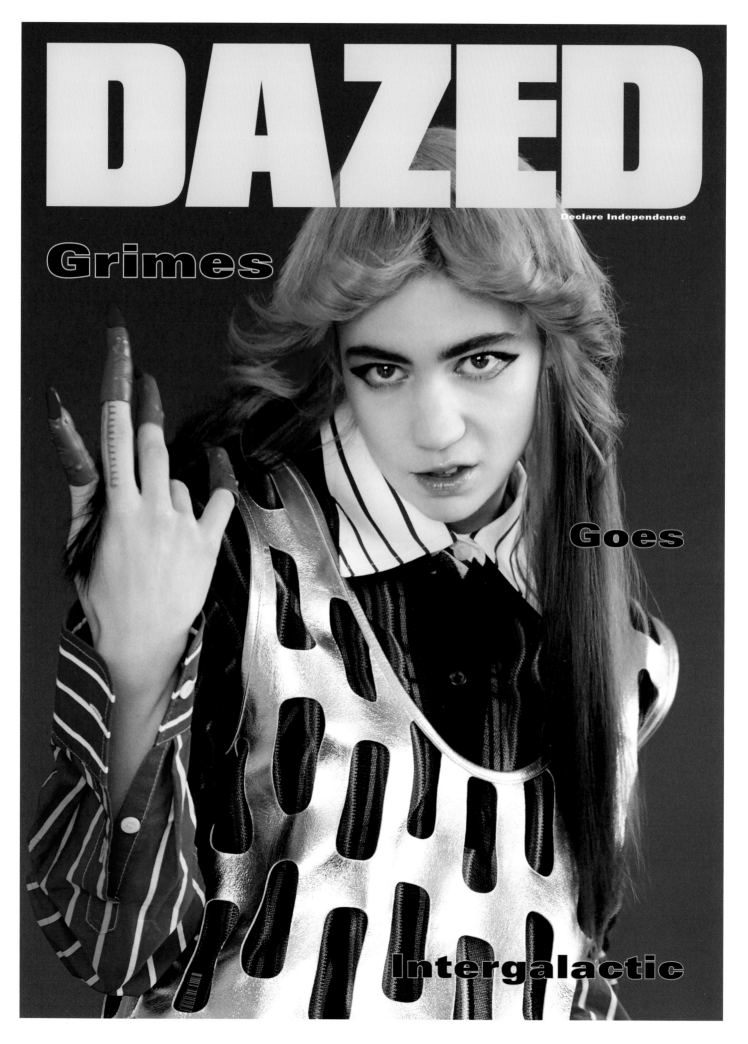

DAZED

Declare Independence

Grimes

Goes

Intergalactic

ISSUE 41, VOL. IV, A/W 2015 **GRIMES** PHOTOGRAPHY **ROE ETHRIDGE** STYLING **ROBBIE SPENCER**

CONFUSED?

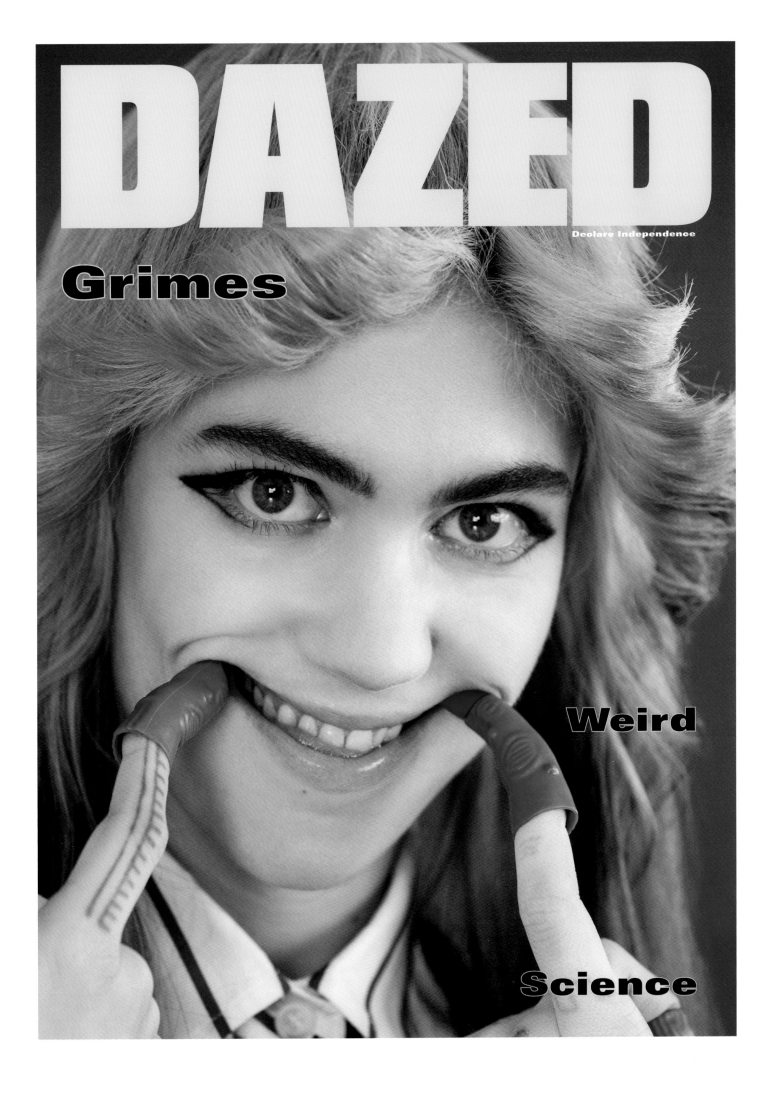

DAZED

Declare Independence

Grimes

Weird

Science

EMMA REEVES, Photographic Director: I hadn't been long in the job as photo director when we secured time with Eminem. I remember getting frantic calls from Alexei (the photographer, who was shooting him in the short time we had with him in New York), saying that Eminem had turned up at the hotel where they were shooting with other people and that there were guns and knives and bongs. He was freaking out. All I could do was try to reassure him from London and talk him off a ledge. Somehow Alexei managed to pull off an amazing portfolio of images that day, but the drama continued. As usual we were on a rapidly approaching print deadline and Alexei called to say that he didn't like the shoot and wouldn't be sending the images.

At the time there were no digital images to download, no scans sent via email, and we did not have time for him to send a physical set of contact sheets so we could select the images we wanted. I had to reassure, cajole, plead, beg and threaten Alexei in order to get him to send us the box of printed images that were used in the issue. Eminem was wearing a cap with a very visible logo which would have qualified as a cover credit, so we changed it to read 'Confused?'. And the cover showed him visibly smoking a bong, so I have a vague memory of it needing to be bagged with something covering the bong so we did not jeopardise our global distribution! Thinking about all this again is giving me mild PTSD!

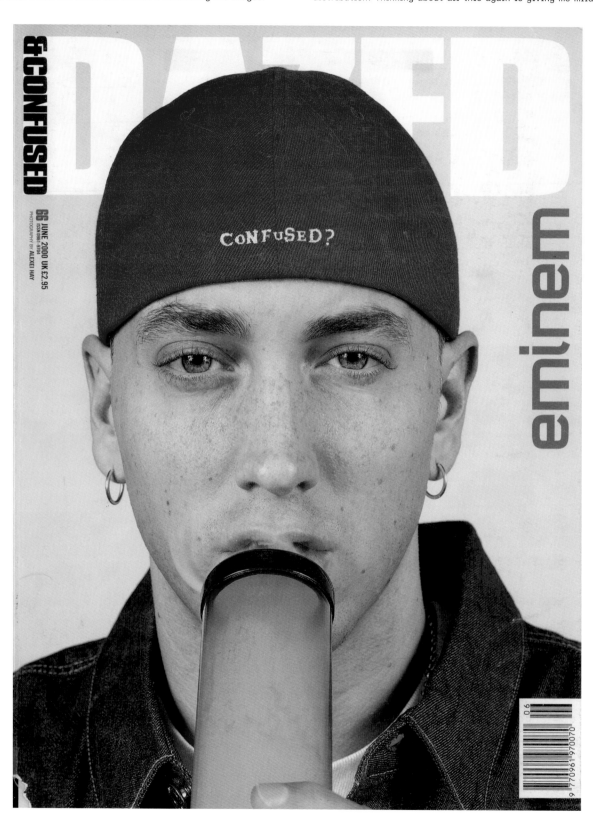

TIM NOAKES, Editor-in-Chief: I applied for an editorial internship after being thunderstruck by the Eminem bong cover in my local newsagent on Hackney Road – but I couldn't afford a copy. So the first time I actually read a full issue was sitting in the *Dazed* reception area, waiting to be interviewed for the internship! It was the 'Feel It' issue from March 2000. I loved it, which was a bit of luck.

SOPHIE MCELLIGOTT, Head of Communications: At 15, I was living in Strathkinness, a small village on the east coast of Scotland which had one main road and a small post office. My parents were quite strict – we weren't allowed to watch TV, but I used to listen to the radio under my duvet as a way of connecting to a world larger than my own. I was obsessed with Eminem because he was so full of fire and his lyrics were so brazen and unacceptable. A friend from London gave me an issue of *Dazed* with him on the cover as a present – he's smoking a bong, and inside he's got these huge knives. I was obsessed.

CONFUSED?

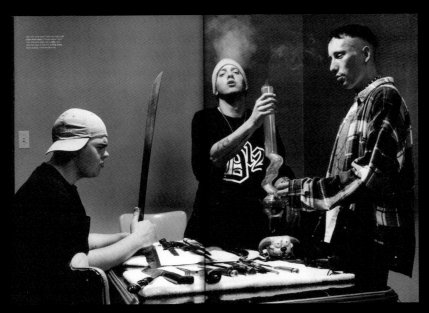

An hour or two passes and no one can tell the floor of the green room from the ceiling. I've been left on the dresser while Marshall and the rest of D12 sleep off their highs. Suddenly, a terrified young stylist's assistant bursts into the room, grabs me, and I catch a glimpse of myself in the large light-up mirror: I look terrible, a stoned turtle, visor struggling at half-mast like a pathetic croissant.

'I have located Fred's cap and will be onstage with it in two minutes,' the assistant says into his headset.

This can't be real.

'You've got the wrong guy... And more to the point, Fred is two years behind me and needs to work on his own shit!'

As the back of Fred's head gets closer — the *Melancholia* meteor pulling towards a terminally ill earth — I twist my underbrim into a confusing kind of pentagram.

'*If only we could fly...*' Fred whines to the after-party crowd in a venue behind the Ford Field football stadium, his usual show-starter.

'How can a head taste like a toilet?' I mouth, as the assistant screws me onto Fred. Just as DJ Lethal reaches for another 'Rollin'' wheel-up, I feel the blunt end of a blade knock me 20 yards south.

'Hey, that's Eminem's hat, here's yours,' says Bizarre, Marshall's D12 affiliate, as I watch on from the floor of the security pit.

With Fred's NFL cap in one hand, a samurai sword in the other, and a bong poking from his hoodie pouch, it's a difficult situation to read: joke or joust? Fred and the rest of Bizkit scrum to the middle of the stage and point their instruments at the camp forming around Bizarre — hashpipes, lighter fuel and knives on one side, Ibanezes on the other. Rap vs. nu metal. The defining early 2000s pop culture showdown — stoned morons, or an absurd watershed?

Lethal makes a move on Bizarre, tossing him a fistful of razor-sharp ice that had collected in a pipe. The first drop of blood. More characters from the nu metal camp join the Limp Bizkit trench; I see Swifty McVay giving Deftones' Chino Moreno a life-altering noogie; Korn's Jonathan Davis swinging bagpipes over his head in Fuzz Scoota's direction; Wes Borland clattering P Diddy over the head with an evil-looking Boss RC-1 bass pedal.

'You know people call Deftones the Radiohead of metal, what the fuck is that?!' D12's Kuniva screams into the chaos.

Mid-fight, I spot Marshall scuttling into the shadows and sinking his cold, capless head in his hands. 'Here you are,' the fashion assistant says, fitting Marshall with a brand-new red PNB. 'Oh,' he says. He lets out a sigh and accepts his new headwear, as if you can swap an old friend for anything. The integrity that usually keeps my own head in shape seems to have crushed down a little, and I've begun to become one with the bleary and desolate carpet.

I know I'm done, and my time is up, until I see the cover of *Dazed & Confused*'s 66th issue beaming from a newsstand in downtown Detroit the following month. The editors had swapped my logo with one I felt far more attuned to in the weeks following the Super Bowl. 'CONFUSED?', it read. *Confused?*

...seen things you people wouldn't believe. As Marshall Mathers' ...ful PNB Nation cap, I've done more to convert his icon than any ...a-penny creative director, lover, *I-want-my-MTV* music video, ...dle-managing mouthbreather, RUBBER STAMPING SHIT-FOR-...AINS C-SUITE RECORD LABEL PENCIL-PUSHER ever could. ...clung on as his personas switched from Mathers to Slim Shady, ...minem, to Jimmy 'Bunny Rabbit' Smith, to the God of Rap, ...netimes over the course of an evening. I've felt the chronic ...ble from the pipe squeeze the electrons in his skull, ...g-water vibrate his synapses, dope smoke seize a thought ...n the ether. I've sat in the dark of a VMA ...ssing room as Slim crept into his retinas ...e mirror.

But not even I believe this.

The day started out like any other on the ...9/2000 cusp, sitting round a table of narcotics, ...pons, money and cultural collateral — ...kind of people you see in one episode of

...*una Beach* and never again. The exception? ...Eminem in the year 2000, everything is ...eptional. We are doing what we always do, ...pical green-day on the astral canopy, ...this trip is for the cover of an international ...hion magazine. After the *Dazed* shoot ...sweep the machetes, meat cleavers and ...h into a holdall and head to a Super Bowl ...ty in Detroit, Michigan. I know that Stevie ...nder, Pee-Wee Herman, Cyndi Lauper, Cindy ...rman and Lou from *Neighbours* will all be ...re because they are scheduled to perform ...he halftime jamboree. I've met everyone via ...rshall, who'd had Borat sit on his face on live TV, had Elton John ...o him beat a prescription-drug addiction and had driven the fear ...eath into Moby. But in 2000, there was one person in the world ...ayed I'd never see.

A tap on my bill. I knew this jerk would be at my party, wading ...und in truck-stop Dickies like he's calling the bingo numbers. ...d Durst is the Limp Bizkit propellerhead who juked my vibe, ...backwards red cap. Every celebrity has to have a big-name ...nesis like Fred, the Bette Davis to your Joan Crawford, the ...e-eyebrowed Shelbyville baby to your Maggie. Your very own

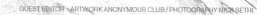

DAZED

DECLARE INDEPENDENCE

LEECH

ANONYMOUS CLUB WORKS WITH ARTISTS TO BRING THEIR PERSONAS TO LIFE. IT IS FOR PEOPLE WHO WANT TO MAKE A CAREER OUT OF ENTITY, A CAREER OUT OF PERFORMANCE, A CAREER OUT OF AN ILLUSION. RESIDENTS ARRIVE AT A PERSONA THROUGH EXPERIENCE, NOT CULTIVATION. THEY USE THEIR OWN PERSONALITY AS A FOUNDATION AND FIND WAYS TO CREATE SPOIL A FANTASTIC AND EXAGGERATED VERSION OF YOURSELF. THEIR PERSONALITIES BECOME AN INEXHAUSTIBLE RESOURCE AND RESOURCE. THEY BECOME THEIR OWN RIVAL.

PEOPLE ONCE UNDERSTOOD THAT POP CULTURE WAS FAKE. IT WAS A DREAM AND THAT'S WHAT MADE IT SO IMPORTANT. NOW, BECAUSE THE WAY THAT PEOPLE ARE VIEWING THEIR LIVES IS THE SAME WAY THAT THEY'RE TAKING IN POP CULTURE, PEOPLE NO LONGER KNOW HOW TO HAVE THAT CONVERSATION.

FAME NO LONGER MEANS WHAT IT USED TO, BUT STILL ARTISTS STRUGGLE TO HAVE CAREERS WITHOUT IT.

THE IMPORTANT QUESTION IS, WHAT IF YOU WERE ALREADY A STAR? WHAT WOULD YOU REALLY BE INTERESTED IN?

WHAT DO YOU ACTUALLY WANT TO MAKE RIGHT NOW?

OUR CULTURE IS FIXATED ON AUTHENTICITY, BUT NO MATTER WHO YOU ARE ON STAGE, IT'S ALWAYS A PERFORMANCE – IT CAN'T BE REAL. THIS IS ABOUT EMBRACING A FANTASY OF PERFORMANCE.

ANONYMOUS HELPS ARTISTS ARRIVE THERE BY APPROACHING THINGS HOLISTICALLY, ASKING WHAT ARE YOU GOOD AT? HOW DO WE POSITION YOU? WHATEVER WE DO, WE WANT IT TO BE REALLY FAKE.

PEOPLE THINK THAT BEING FAKE MAKES YOU A BAD PERSON. EVERYONE'S CALLING EACH OTHER OUT, BUT THAT DOESN'T MEAN THAT YOU'RE A GOOD PERSON. A LOT OF HONEST PEOPLE ARE HORRIBLE, WICKED PEOPLE.

ANONYMOUS ALLOWS ARTISTS TO QUESTION THEIR DECISIONS AND ENTERTAIN FALSEHOODS. IT GIVES CREATIVE LICENCE BY ANY MEANS NECESSARY. THE WHOLE POINT IS TO INFLUENCE PEOPLE. TO CREATE IDEAS AND SYMBOLS THAT CAN CIRCULATE AND EMBED THEMSELVES IN PEOPLE'S MINDS. THE PURPOSE OF THIS IS TO MAKE THE RESIDENTS AND HELP THEM FIND THEIR OWN VERSION OF SUCCESS – TO THROW A FUEL ON THE FIRE.

IT'S LIKE JUICING THEM – LET'S GET TO THE NUTRIENTS.

ARTISTS NEED TO KNOW HOW TO DO THAT FOR THEMSELVES, SO THAT THEY CAN UNDERSTAND WHAT IT TASTES LIKE TO THINK FOR THEMSELVES, AS OPPOSED TO CONSTANTLY BEING INFLUENCED AND SEARCHING FOR REFERENCES.

WE WANT TO AVOID ARTISTS DOING WHAT'S EASY AND WHAT THEY KNOW WORKS.

ANONYMOUS RESIDENTS DEVELOP BY PUTTING THEIR WORLDS IN CONVERSATION WITH ONE ANOTHER. THE FRICTION WILL FORCE RESULTS AND PUSH THE CONVERSATION FORWARD. THINGS MOVE FAST.

NOBODY REALLY KNOWS WHAT THEY'RE DOING, SO YOU MIGHT AS WELL DO IT YOURSELF, AND YOU MIGHT AS WELL BE A PROFESSIONAL LEVEL. THERE IS NO REAL AMATEUR LEVEL FOR ANYTHING. THE AMATEUR LEVEL IS A GHETTO THAT PEOPLE GET PUT IN, BUT THERE'S REALLY NO REASON TO BE THERE.

IT'S NOT ALWAYS ABOUT BEING CONSTANTLY CHALLENGED, BUT THAT'S THE PART THAT'S MORE FUN. WHEN YOU'RE TRYING TO BE A PART OF YOUR CONTEMPORARY GROUP YOU LOSE THAT. IT'S EASY TO FORGET THAT THERE ARE SO MANY OTHER CONVERSATIONS TO BE HAD.

PEOPLE WAIT FOR PERFECTION BUT MISTAKES NEED TO BE SEEN. THE PERCEPTION IS THAT THERE ARE SO MANY PERFECT PEOPLE AND SO MUCH MONEY TO BE MADE BY ASSUMING A PERFECT POSITION, BUT IN REALITY IT'S ALWAYS A MESS.

EVERYONE COOL IS INSANE. IF YOU CATCH THEM IN THE MIDDLE OF DOING WHAT THEY DO BEST, THEY'RE LIKELY TO BE AT THEIR CRAZIEST. ANYTHING CAN BE POPULAR.

IN THIS WAY, ANONYMOUS IS A COMMUNITY AND AN INSTITUTION. THE SCHOOL BUILT OUT OF HOOD BY AIR, ANONYMOUS MAKES USE OF THE RESOURCES IT PRODUCED AND FINDS NEW FUTURES FOR ITS AUDIENCE.

WE ARE ONLY TO KEEP THEIR ARTISTRY PURE AND NON-COMMERCIAL. MARKETING IS A DIRTY WORD, BUT BEING SUSTAINABLE AND CONCEIVING OF A CAREER AND HOW TO MAKE MONEY ARE ALL IMPORTANT PARTS OF THE CREATIVE PROCESS. THAT'S WHERE THE INSTITUTIONAL PART OF ANONYMOUS IS IMPORTANT. IT FORMS A NETWORK THAT CAN SUSTAIN ITSELF, A CULTURE OF PRODUCTION AND CAN RETURN PROFIT TO THE PEOPLE WHO INSPIRE IT.

PEOPLE ARE TRYING TO FIGURE OUT HOW TO LIVE IN A REALLY CRAZY WORLD. WE'RE INTERESTED IN HOW PEOPLE ADAPT AND RELATE TO THESE NEW IDENTITIES. BY CREATING CHARACTERS AND EXPLORING WHY PEOPLE ACT THE WAY THAT THEY DO – WHY SOME PEOPLE COME OUT AT NIGHT OR FEEL SAFER IN THE DARK – WE CREATE NEW HEROES. A HERO LIKE YOU. KIDS ARE LOOKING FOR A PLACE WHERE THEY ARE CONSIDERED NORMAL, A COMMUNITY WHERE THEY CAN BELONG – IT'S NOT ABOUT STYLE BUT SURVIVAL.

LEECH

ISSUE 69, VOL. V, AUTUMN 2020 **LEECH** ARTWORK **ANONYMOUS CLUB** PHOTOGRAPHY **NICK SETHI**

CONFUSED?

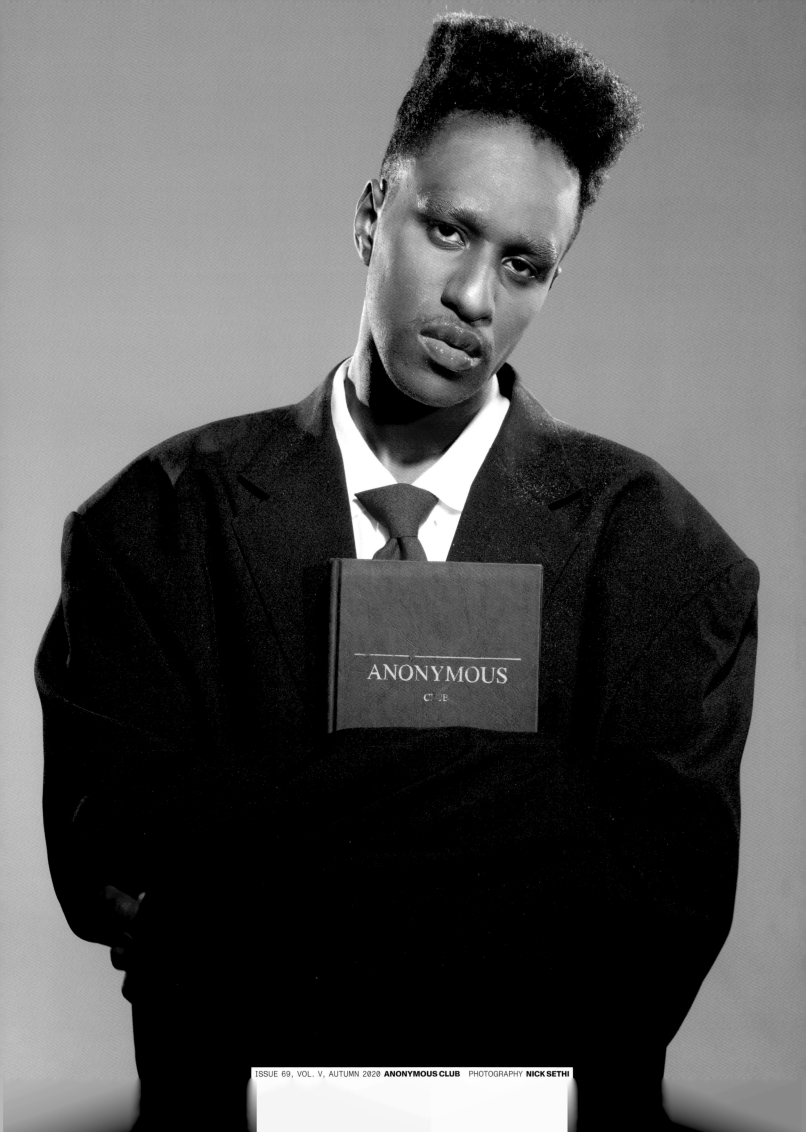

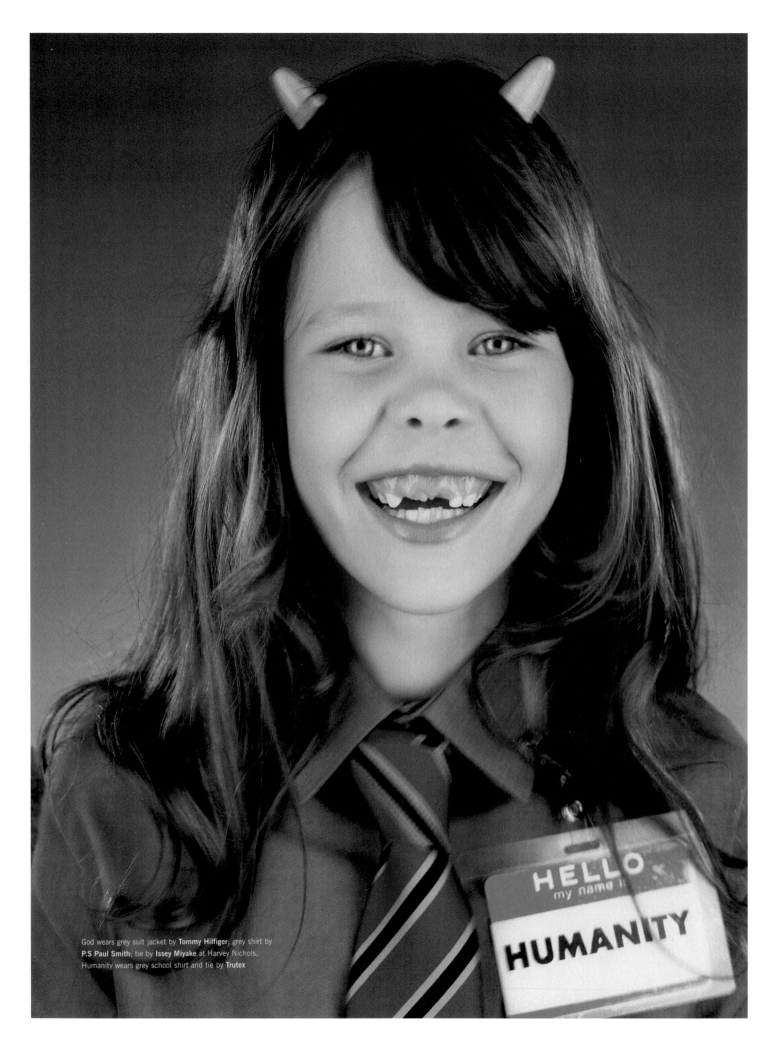

God wears grey suit jacket by **Tommy Hilfiger**; grey shirt by **P.S Paul Smith**; tie by **Issey Miyake** at Harvey Nichols. Humanity wears grey school shirt and tie by **Trutex**

HELLO
my name i:

HUMANITY

ISSUE 57, VOL. I, AUG 1999 **YOUNG BLOOD** PHOTOGRAPHY **TERRY RICHARDSON** STYLING **SABINA SCHREDER**

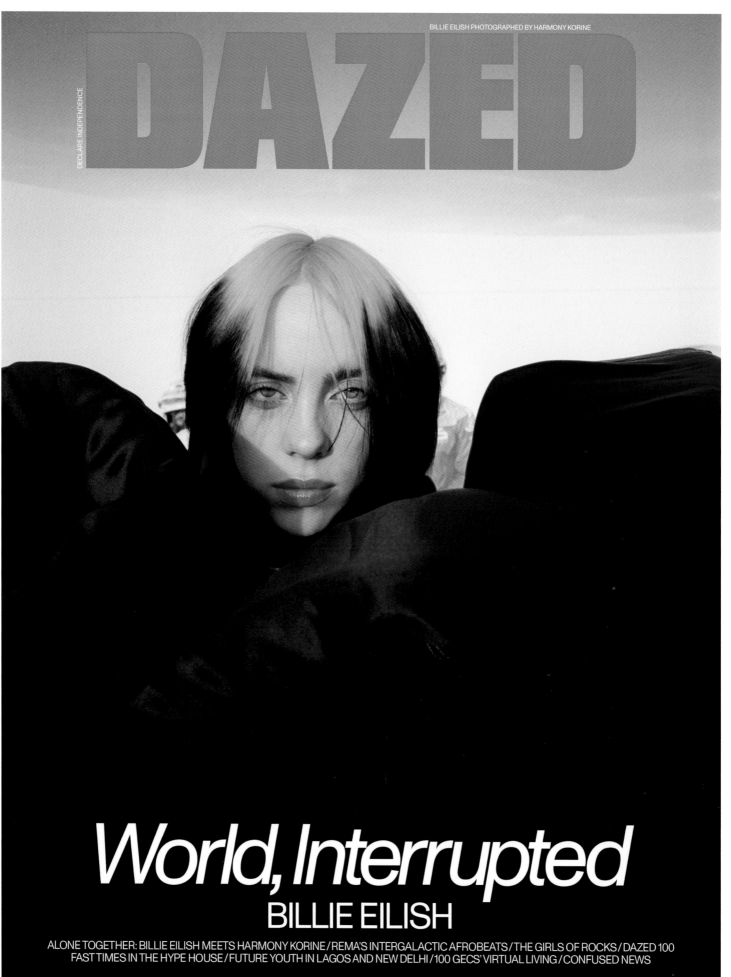

BILLIE EILISH PHOTOGRAPHED BY HARMONY KORINE

DAZED

DECLARE INDEPENDENCE

ISSUE 68, VOL. V, S/S 2020 **BILLIE EILISH** PHOTOGRAPHY **HARMONY KORINE** STYLING **EMMA WYMAN**

World, Interrupted
BILLIE EILISH

ALONE TOGETHER: BILLIE EILISH MEETS HARMONY KORINE / REMA'S INTERGALACTIC AFROBEATS / THE GIRLS OF ROCKS / DAZED 100
FAST TIMES IN THE HYPE HOUSE / FUTURE YOUTH IN LAGOS AND NEW DELHI / 100 GECS' VIRTUAL LIVING / CONFUSED NEWS

EMMA HOPE ALLWOOD, Head of Fashion, *Dazed Digital*: I interviewed Billie Eilish — for my first *Dazed* cover story! — just before 2020 veered chaotically off course. An unseen paparazzi photographer was secretly following us around the desert town outside LA where Harmony Korine was shooting her, so the BTS ended up on TMZ.

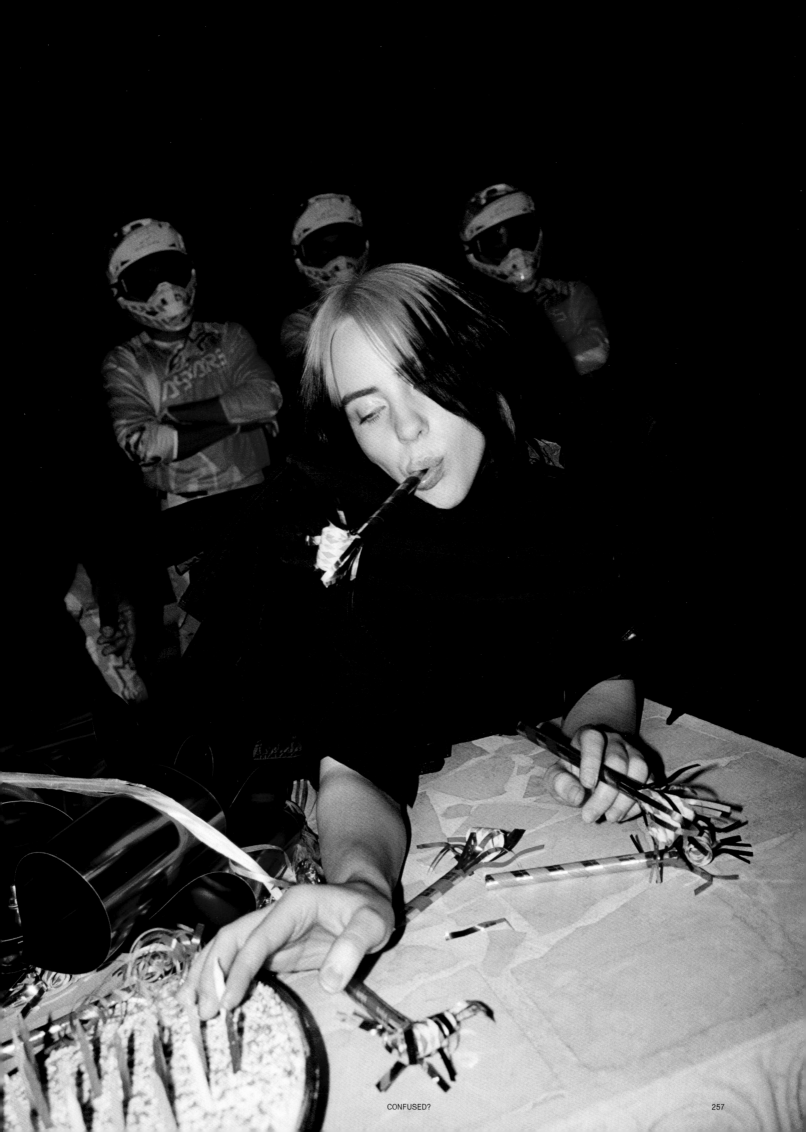

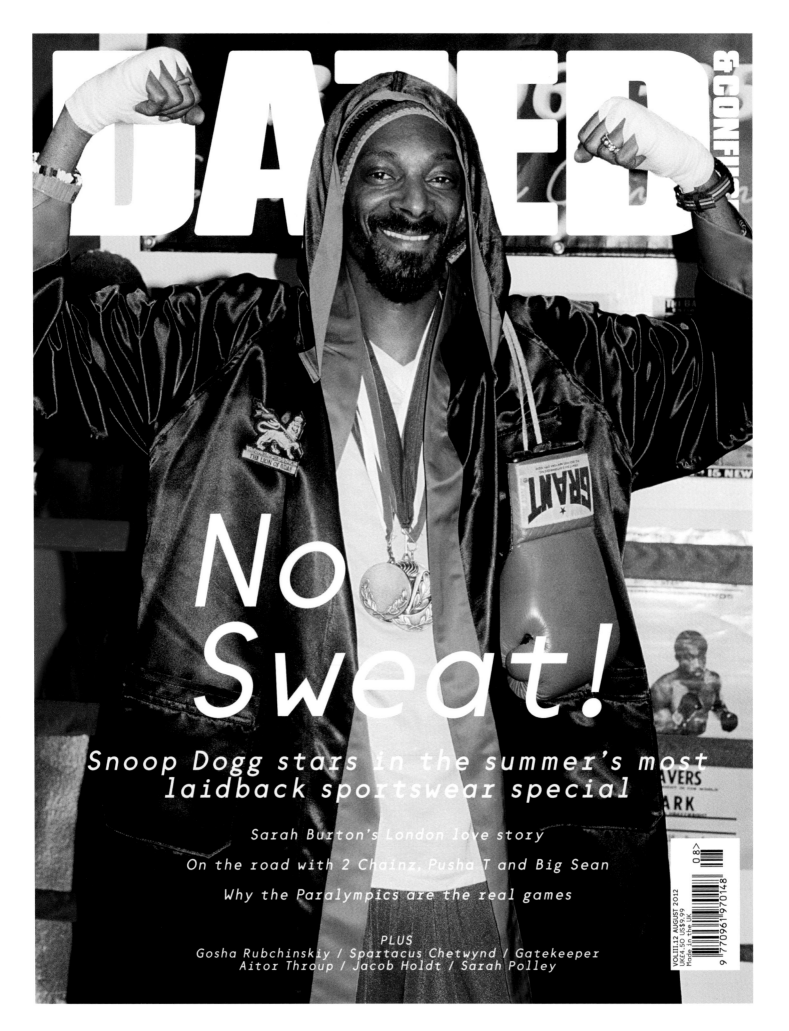

DAZED & CONFUSED

No Sweat!

Snoop Dogg stars in the summer's most laidback sportswear special

Sarah Burton's London love story

On the road with 2 Chainz, Pusha T and Big Sean

Why the Paralympics are the real games

PLUS

Gosha Rubchinskiy / Spartacus Chetwynd / Gatekeeper
Aitor Throup / Jacob Holdt / Sarah Polley

VOL.III.12 AUGUST 2012
UK£4.50 US$9.99
Made in the UK
9 770961 970148
08>

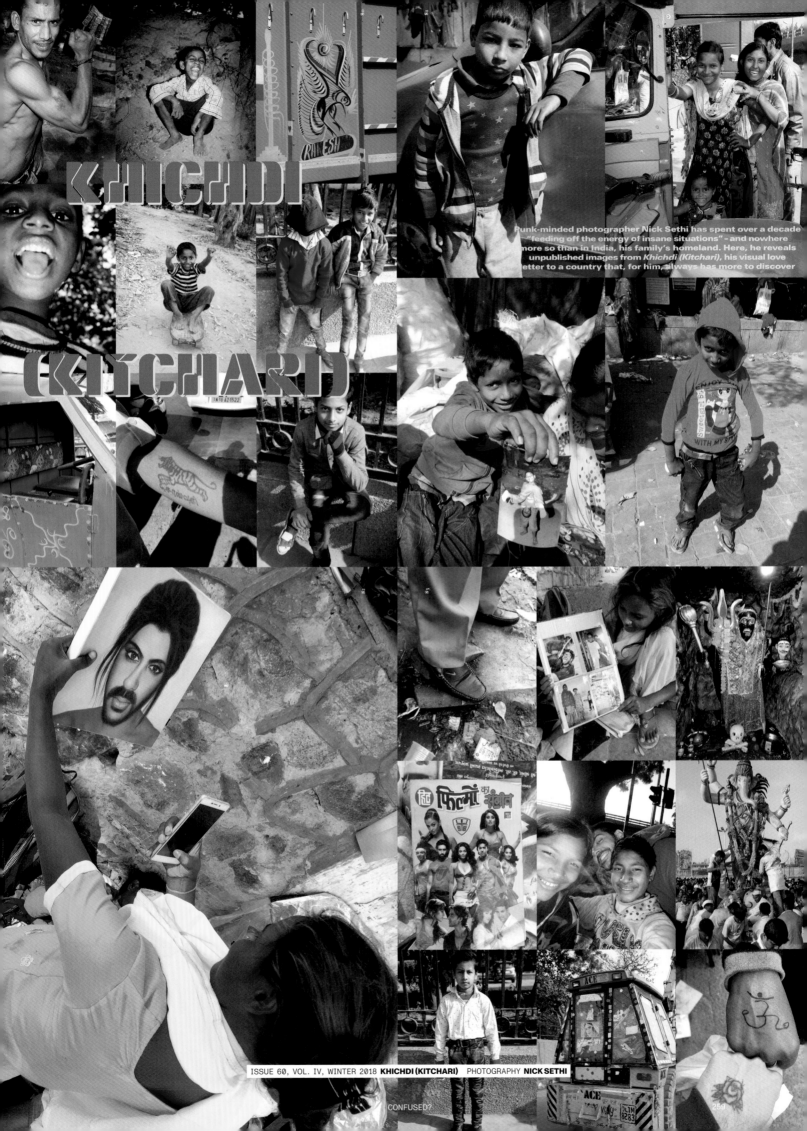

KHICHDI
(KITCHARI)

Punk-minded photographer Nick Sethi has spent over a decade "feeding off the energy of insane situations" – and nowhere more so than in India, his family's homeland. Here, he reveals unpublished images from *Khichdi (Kitchari)*, his visual love letter to a country that, for him, always has more to discover

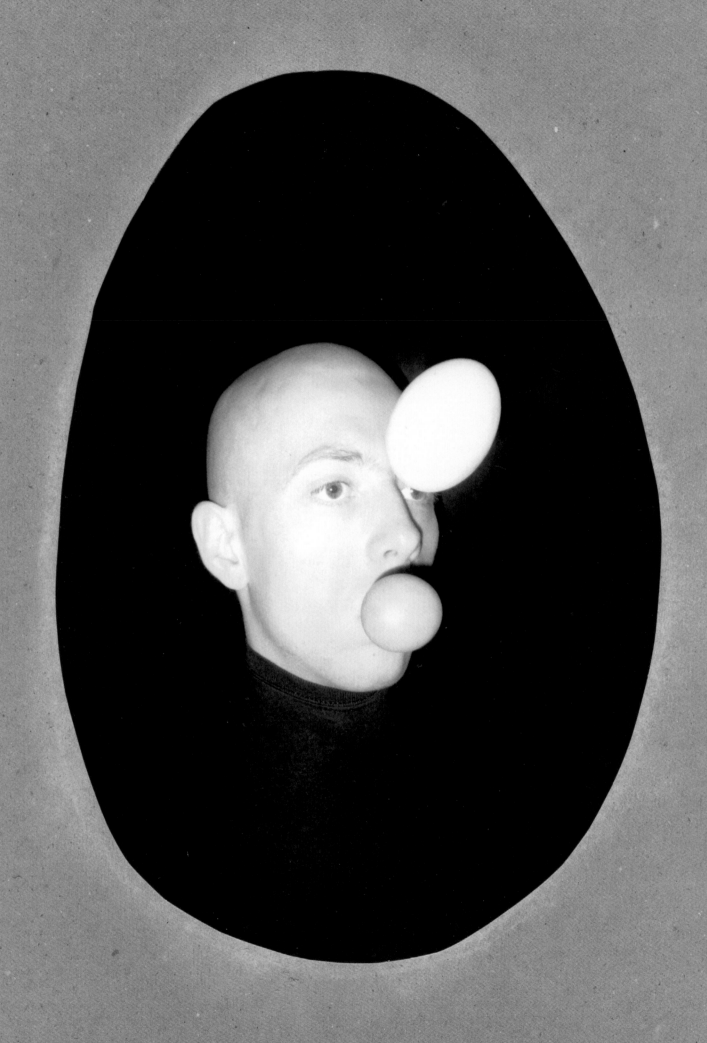

ISSUE 69, VOL. V, AUTUMN 2020 PHOTOGRAPHY **FRANK LEBON**

CONFUSED?

ISSUE 11, VOL. I, 1995 **RICHARD E GRANT** PHOTOGRAPHY **RANKIN** STYLING **KATIE GRAND**

DAZED & CONFUSED

60 NOVEMBER 1999 UK £2.50 US $4.50

LET ME TELL YOU WHAT BUGS ME

The 'Come to Daddy' director spent a legendary 24 hours with a nude pop star for a separate *Dazed* cover shoot. Who? Flip to page 244 for the big reveal.

ISSUE 60, VOL. I, NOV 1999 **LET ME TELL YOU WHAT BUGS ME** PHOTOGRAPHY **CHRIS CUNNINGHAM**

IT'S CALLED MENTAL WEALTH

03 40 X 19

ITS NO LONGER ABOUT WHAT THEY CAN ACHEIVE OUT THERE ON YOUR BEHALF BUT WHAT WE CAN EXPERIENCE UP HERE IN OUR OWN TIME

03 40 10 19

FORGET PROGRESS BY PROXY

03 00 01 15

LAND ON YOUR OWN MOON

04 20 14 02

MANKIND WENT TO THE MOON
I DON'T EVEN KNOW WHERE GRIMSBY IS

04 20 14 02

I'VE NEVER BEEN THE HUMAN IN QUESTION

03 00 13 08

HAVE YOU...?

03 00 01 15

ABOUT HUMAN ENDEAVOUR

03 00 27 08

NICKI BIDDER, Editor-in-Chief: My very first interview at *Dazed* in my second week was with Chris Cunningham, which I carried out under the weight of enormous imposter syndrome so I'll never forget it.

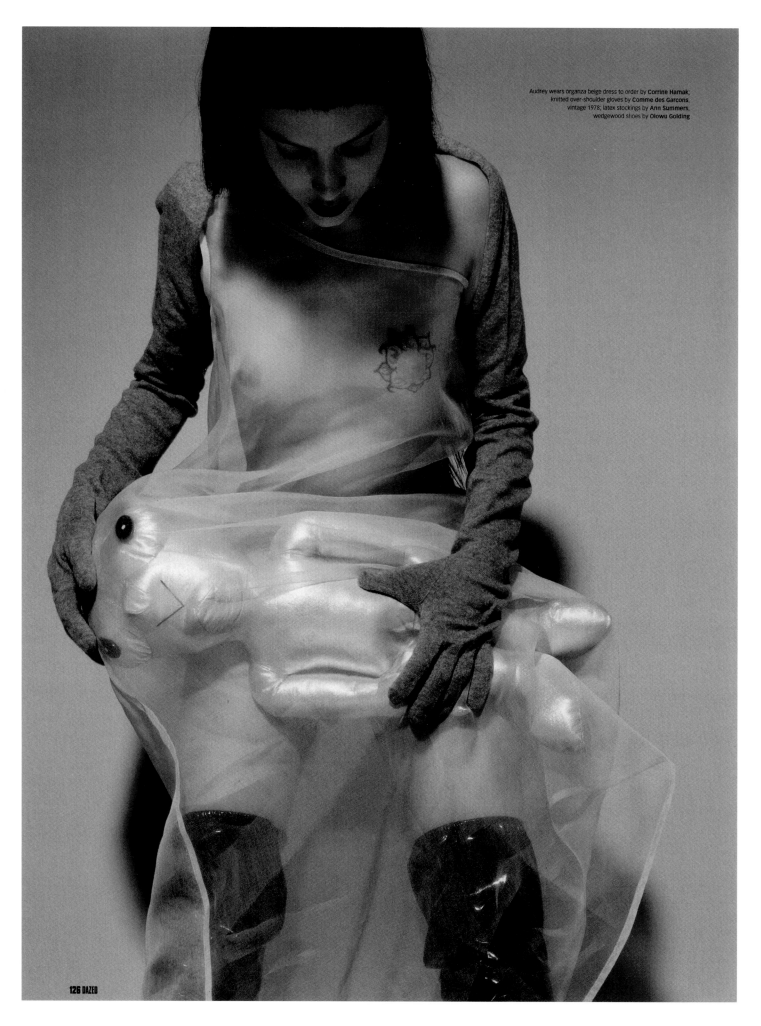

Audrey wears organza beige dress to order by **Corrine Hamak**;
knitted over-shoulder gloves by **Comme des Garcons**,
vintage 1978; latex stockings by **Ann Summers**;
wedgewood shoes by **Olowu Golding**

ISSUE 49, VOL. I, DEC 1998 **TRANSPERM** PHOTOGRAPHY **RANKIN** STYLING **YVONNE SPORRE**

CONFUSED?

Who Said It?
A Confused Crossword

Match the legends with their most memorable *Dazed* quotes

1. 'I feel like when I reach my 500 million-dollar goal, then no other woman in rap will ever feel like they can't do what these men have done.' Which 2014 cover star laid a new *Pinkprint* for rap?

2. Which intergalactic Art Angel described her pop music as, 'If No Doubt did Studio Ghibli'?

3. Material Girl who stated, 'I've spent the last 25 years in the entertainment business. I have earned a reputation for being many things. For pushing the envelope. For being a provocateur, for never taking no for an answer, for endlessly reinventing myself, for being a cult member, a kidnapper... and that's just the good stuff.'

4. '*Dazed* makes me want to paint my face and dance'. The 70s punk icon who might have accidentally invented rap.

5. YBA and shark-lover who left our former arts editor Mark Sanders in the lurch: 'I went to _____ / _____'s house in Combe Martin for what was supposed to be a day, but he wouldn't do the interview for a week. Every day Jefferson would call and ask, "Have you got an interview yet?" And every time I'd be like, "No."'

6. Revolutionary designer who, when asked by David Bowie to choose between 'Armani or Versace?' responded, 'Marks & Spencer.'

7. 'Godfather of Punk' who asked *Trainspotting* author Irvine Welsh, 'What's worse — waiting on a film set, or waiting for junk?'

8. *Blonde*-bombshell and Odd Futurist who said, 'I'd love to see Caravaggio render me perfect and then Albert Oehlen make it mental.'

9. 'I've had (people) crying and shit, trying to kiss my hand and look at me like I'm not human, like I'm a god or something.' My name is... what?

10. Karen Crowder portrayer who mused, 'I have zero media presence, which leaves more time for collecting eggs and shooting the breeze and thinking about building a boat — all that good stuff.'

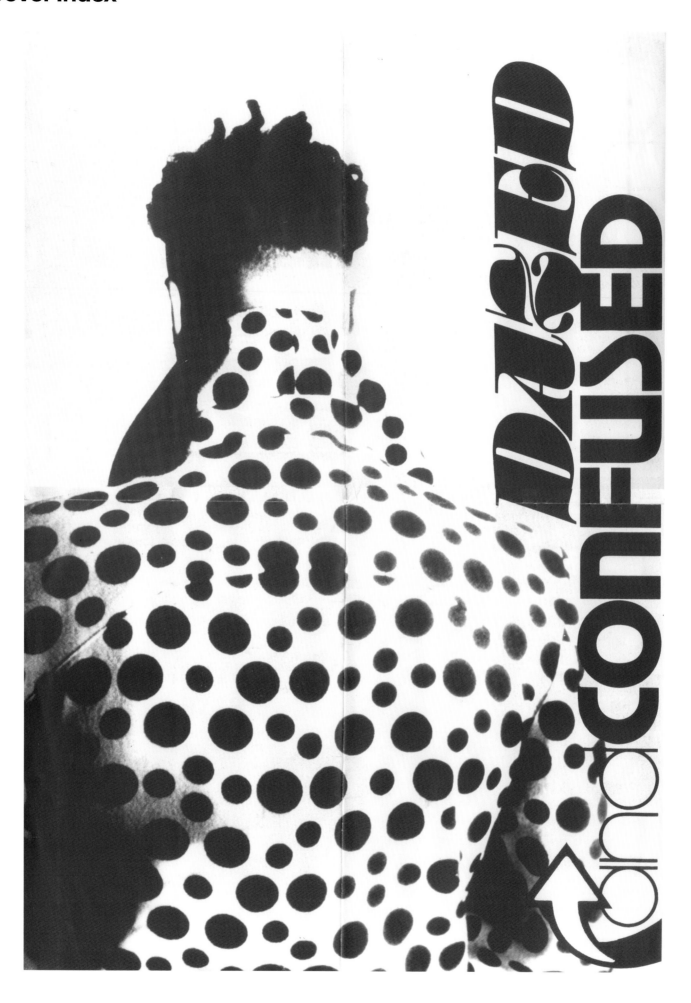

ISSUE 0, VOL. I, 1992

ISSUE 1, VOL. I, 1992

ISSUE 2, VOL. I, 1992

ISSUE 3, VOL. I, 1992

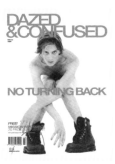

ISSUE 4, VOL. I, 1992

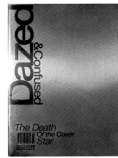

ISSUE 5, VOL I, 1993

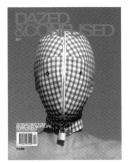

ISSUE 6, VOL. I, 1993
P: MARCÈLE PRICE

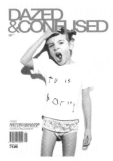

ISSUE 7, VOL. I, 1994
TV IS BORING
P: RANKIN
S: KATIE GRAND

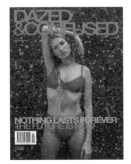

ISSUE 8, VOL. I, 1994
JACKIE VOLKER
P: RANKIN
S: KATIE GRAND

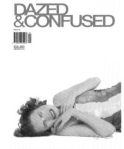

ISSUE 9, VOL. I, 1994
DONOVAN LEITCH
P: RANKIN
S: KATIE GRAND

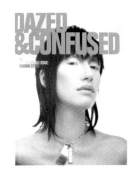

ISSUE 10, VOL. I, 1994
KATIE COMER
P: RANKIN

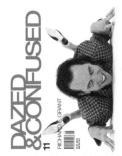

ISSUE 11, VOL. I, 1995
RICHARD E GRANT
P: RANKIN
S: KATIE GRAND

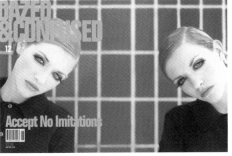

ISSUE 12, VOL I, 1995
EMMA WEBB
P: RANKIN
S: KATIE GRAND

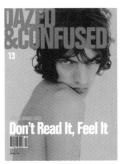

ISSUE 13, VOL. I, 1995
RICHARD ASHCROFT
P: RANKIN

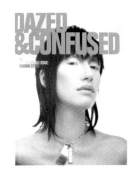

ISSUE 13, VOL. I, 1995
P: RANKIN
S: KATY ENGLAND

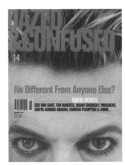

ISSUE 14, VOL. I, 1995
DAVID BOWIE
P: RANKIN

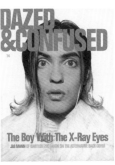

ISSUE 14, VOL. I, 1995
JAS MANN
P: RANKIN
S: KATIE GRAND

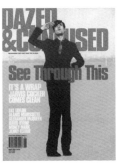

ISSUE 15, VOL. I, 1995
JARVIS COCKER
P: RANKIN

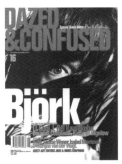

ISSUE 16, VOL. I, 1995
BJÖRK
P: RANKIN

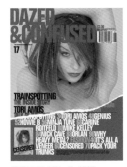

ISSUE 17, VOL. I, 1995
SARAH PENMAN
P: ARCHIE SWINBURN
S: KATIE GRAND

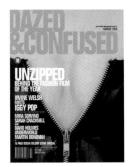

ISSUE 18, VOL. I, MAR 1996
UNZIPPED
P: RANKIN
S: KATIE GRAND

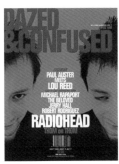

ISSUE 19, VOL. I, APR 1996
THOM YORKE
P: RANKIN

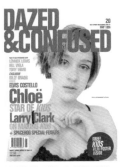

ISSUE 20, VOL. I, MAY 1996
CHLOË SEVIGNY
P: RANKIN
S: JENNIFER ELSTER

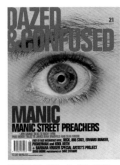

ISSUE 21, VOL. I, JUN 1996
NICKY WIRE
P: RANKIN

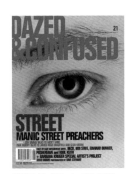

ISSUE 21, VOL. I, JUN 1996
JAMES DEAN BRADFIELD
P: RANKIN

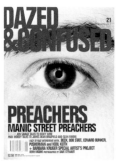

ISSUE 21, VOL. I, JUN 1996
SEAN MOORE
P: RANKIN

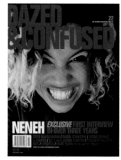

ISSUE 22, VOL. I, JUL 1996
NENEH CHERRY
P: RANKIN
S: KATIE GRAND

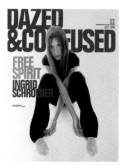

ISSUE 22, VOL. I, JUL 1996
INGRID SCHROEDER
P: RANKIN
S: KATIE GRAND

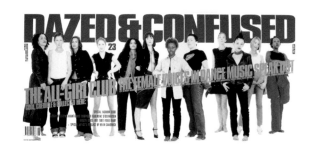

ISSUE 23, VOL. I, AUG 1996
THE ALL-GIRL CLUB
P: RANKIN
S: KATIE GRAND

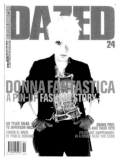

ISSUE 24, VOL. I, SEP 1996
DONNA FANTASTICA
P: RANKIN
S: KATY ENGLAND

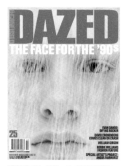

ISSUE 25, VOL. I, OCT 1996
CHARLOTTE C.
P: RANKIN
S: KATY ENGLAND

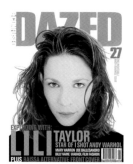

ISSUE 26, VOL. I, NOV 1996
ROBERT CARLYLE
P: RANKIN
S: MIRANDA ROBSON

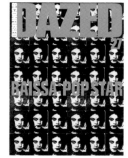

ISSUE 27, VOL. I, NOV 1996
LILI TAYLOR
P: RANKIN
S: MIRANDA ROBSON

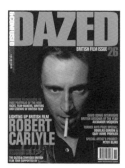

ISSUE 27, VOL. I, NOV 1996
RAISSA
P: RANKIN
S: MIRANDA ROBSON

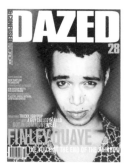

ISSUE 28, VOL. I, JAN 1997
FINLEY QUAYE
P: RANKIN
S: MIRANDA ROBSON

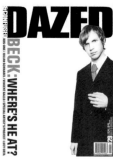

ISSUE 29, VOL. I, FEB 1997
BECK
P: RANKIN

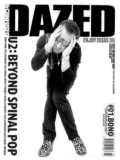

ISSUE 30, VOL. I, MAY 1997
BONO
P: RANKIN
S: SHARON BLANKSON

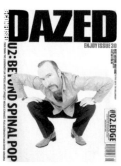

ISSUE 30, VOL. I, MAY 1997
EDGE
P: RANKIN
S: SHARON BLANKSON

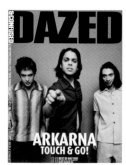

ISSUE 30, VOL. I, MAY 1997
ARKARNA
P: RANKIN

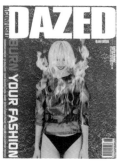

ISSUE 31, VOL. I, JUN 1997
BURN YOUR FASHION
P: RANKIN
S: MIRANDA ROBSON

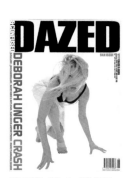

ISSUE 31, VOL. I, JUN 1997
DEBORAH UNGER
P: ANDREW MACPHERSON

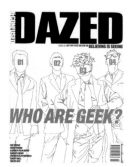

ISSUE 32, VOL. I, JUL 1997
RICHARD ASHCROFT
P: RANKIN

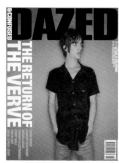

ISSUE 32, VOL. I, JUL 1997
GEEK
P: RANKIN
S: MIRANDA ROBSON

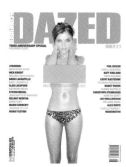

ISSUE 33, VOL. I, AUG 1997
HELENA CHRISTENSEN
P: RANKIN
S: KATIE GRAND

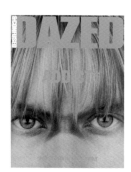

ISSUE 33, VOL. I, AUG 1997
ADDICT
P: RANKIN

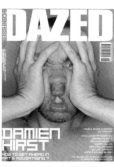

ISSUE 34, VOL. I, SEP 1997
DAMIEN HIRST
P: RANKIN
S: ALISTER MACKIE

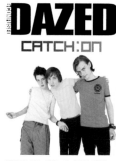

ISSUE 34, VOL. I, SEP 1997
CATCH
P: RANKIN
S: KATIE GRAND

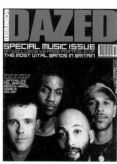

ISSUE 35, VOL. I, OCT 1997
SPECIAL MUSIC ISSUE
P: PHIL POYNTER

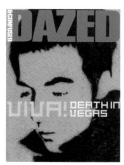

ISSUE 35, VOL. I, OCT 1997
DEATH IN VEGAS
P: RANKIN

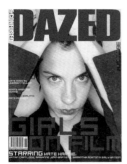

ISSUE 36, VOL. I, NOV 1997
KATE HARDIE
P: RANKIN
S: SIMON ROBINS

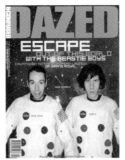

ISSUE 36, VOL. I, NOV 1997
MANBREAK
P: RANKIN
S: CHARLOTTE STOCKDALE

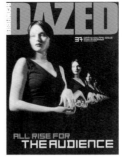

ISSUE 37, VOL. I, DEC 1997
THE BEASTIE BOYS
P: RANKIN

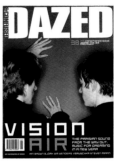

ISSUE 37, VOL. I, DEC 1997
THE AUDIENCE
P: RANKIN
S: KATIE GRAND

ISSUE 38, VOL. I, JAN 1998
AIR
P: RANKIN

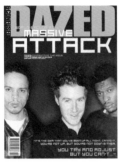

ISSUE 39, VOL. I, FEB 1998
MASSIVE ATTACK
P: RANKIN
S: MARK GRIFFITHS

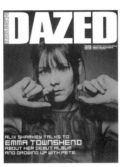

ISSUE 39, VOL. I, FEB 1998
EMMA TOWNSHEND
P: RANKIN
S: MIRANDA ROBSON

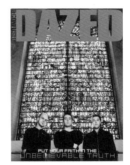

ISSUE 40, VOL. I, MAR 1998
WOMENSWEAR
P: PHIL POYNTER
S: KATIE GRAND

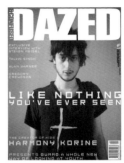

ISSUE 40, VOL. I, MAR 1998
THE UNBELIEVABLE TRUTH
P: DEIRDRE O'CALLAGHAN
S: MIRANDA ROBSON

ISSUE 41, VOL. I, APR 1998
HAROMY KORINE
P: MARTINA HOOGLAND IVANOW

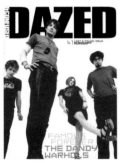

ISSUE 41, VOL. I, APR 1998
THE DANDY WARHOLS
P: RANKIN

ISSUE 42, VOL. I, MAY 1998
MONEY MARK
P: RANKIN

ISSUE 43, VOL. I, JUN 1998
KATE MOSS
P: RANKIN
S: KATIE GRAND

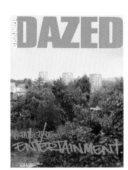

ISSUE 44, VOL. I, JUL 1998
PARKER POSEY & SAM ROCKWELL
P: MARTINA HOOGLAND IVANOW

ISSUE 44, VOL. I, JUL 1998
BEDLAM AGO GO
P: SIMON FLY

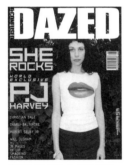

ISSUE 45, VOL. I, AUG 1998
PJ HARVEY
P: RANKIN

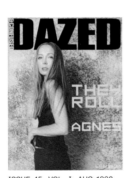

ISSUE 45, VOL. I, AUG 1998
AGNES
P: RANKIN
S: MIRANDA ROBSON

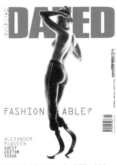

ISSUE 46, VOL. I, SEP 1998
FASHION-ABLE?
P: NICK KNIGHT
S: KATY ENGLAND

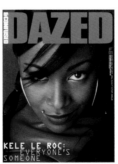

ISSUE 46, VOL. I, SEP 1998
KELE LE ROC
P: RANKIN

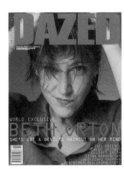

ISSUE 47, VOL. I, OCT 1998
BETH ORTON
P: RANKIN
S: SIMON ROBINS

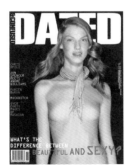

ISSUE 48, VOL. I, NOV 1998
ANGELA LINDVALL
P: RANKIN
S: KATIE GRAND

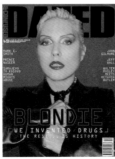

ISSUE 49, VOL. I, DEC 1998
BLONDIE
P: RANKIN
S: ALISTER MACKIE

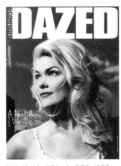

ISSUE 49, VOL. I, DEC 1998
ANJA
P: RANKIN
S: MIRANDA ROBSON

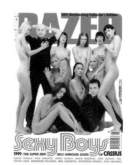

ISSUE 50, VOL. I, JAN 1999
CASSIUS
P: SIMON FLY

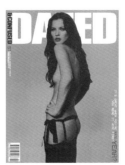

ISSUE 51, VOL. I, FEB 1999
KATE MOSS
P: RANKIN
S: KATIE GRAND

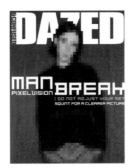

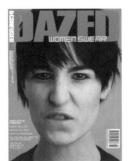

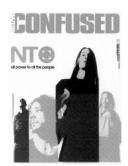

ISSUE 51, VOL. I, FEB 1999
NT: NO TITLE

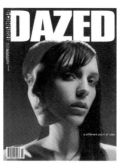

ISSUE 52, VOL. I, MAR 1999
HANNE-LORE
P: VINCENT PETERS
S: GILES DEACON

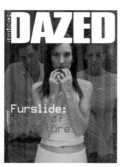

ISSUE 52, VOL. I, MAR 1999
FURSLIDE
P: RANKIN

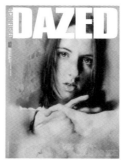

ISSUE 53, VOL. I, APR 1999
VICTORIA
P: RANKIN

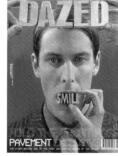

ISSUE 54, VOL. I, MAY 1999
PAVEMENT
P: ANDREA GIACOBBE
S: CATHY EDWARDS

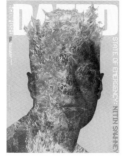

ISSUE 54, VOL. I, MAY 1999
NITIN SAWHNEY
P: SØLVE SUNDSBØ
S: HEATHERMARY JACKSON

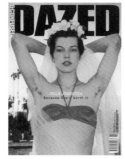

ISSUE 55, VOL. I, JUN 1999
MILLA JOVOVICH
P: TERRY RICHARDSON
S: NANCY STEINER

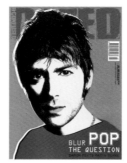

ISSUE 56, VOL. I, JUL 1999
DAMON ALBARN
P: RANKIN
S: MIRANDA ROBSON

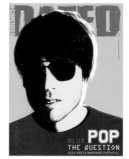

ISSUE 56, VOL. I, JUL 1999
ALEX JAMES
P: RANKIN
S: MIRANDA ROBSON

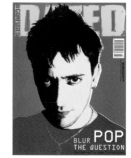

ISSUE 56, VOL. I, JUL 1999
GRAHAM COXON
P: RANKIN
S: MIRANDA ROBSON

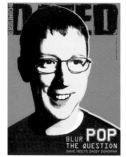

ISSUE 56, VOL. I, JUL 1999
DAVE ROWNTREE
P: RANKIN
S: MIRANDA ROBSON

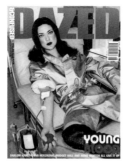

ISSUE 57, VOL. I, AUG 1999
YOUNG BLOOD
P: TERRY RICHARDSON
S: SABINA SCHREDER

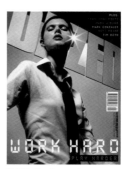

ISSUE 57, VOL. I, AUG 1999
SHELBY LYNNE
P: RANKIN
S: MIRANDA ROBSON

ISSUE 58, VOL. I, SEP 1999
MALGOSIA
P: VINCENT PETERS
S: HEATHERMARY JACKSON

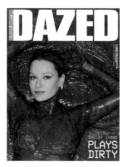

ISSUE 58, VOL. I, SEP 1999
LES NEGRESSES VERTES
P: RANKIN
S: HEATHERMARY JACKSON

ISSUE 59, VOL. I, OCT 1999
MELANIE BLATT
P: RANKIN
S: HEATHERMARY JACKSON

ISSUE 59, VOL. I, OCT 1999
NATALIE APPLETON
P: RANKIN
S: HEATHERMARY JACKSON

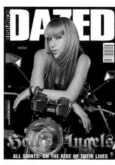

ISSUE 59, VOL. I, OCT 1999
NICOLE APPLETON
P: RANKIN
S: HEATHERMARY JACKSON

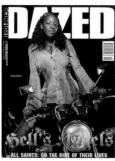

ISSUE 59, VOL. I, OCT 1999
SHAZNAY LEWIS
P: RANKIN
S: HEATHERMARY JACKSON

ISSUE 59, VOL. I, OCT 1999
BRYAN FERRY
P: PHIL POYNTER
S: SIMON ROBINS

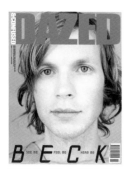

ISSUE 60, VOL. I, NOV 1999
BECK
P: PHIL POYNTER

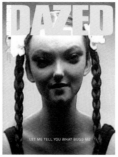

ISSUE 60, VOL. I, NOV 1999
LET ME TELL YOU WHAT BUGS ME
P: CHRIS CUNNINGHAM

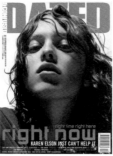

ISSUE 61, VOL. I, DEC/JAN 2000
KAREN ELSON
P: DAVID SIMS
S: KATY ENGLAND

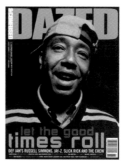

ISSUE 61, VOL. I, DEC/JAN 2000
RUSSELL SIMMONS
P: ANETTE AURELL

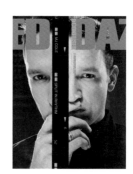

ISSUE 61, VOL. I, DEC/JAN 2000
MJ COLE
P: RANKIN
S: MIRANDA ROBSON

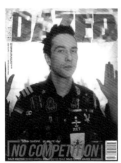

ISSUE 62, VOL. I, FEB 2000
BOBBY GILLESPIE
P: MARTINA HOOGLAND IVANOW
S: ALISTER MACKIE

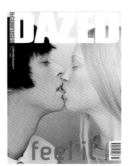

ISSUE 63, VOL. I, MAR 2000
FEEL IT
P: RANKIN
S: ALISTER MACKIE

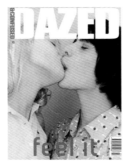

ISSUE 63, VOL. I, MAR 2000
FEEL IT
P: RANKIN
S: ALISTER MACKIE

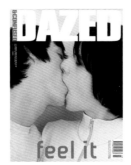

ISSUE 63, VOL. I, MAR 2000
FEEL IT
P: RANKIN
S: ALISTER MACKIE

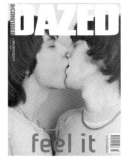

ISSUE 63, VOL. I, MAR 2000
FEEL IT
P: RANKIN
S: ALISTER MACKIE

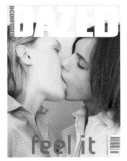

ISSUE 63, VOL. I, MAR 2000
FEEL IT
P: RANKIN
S: ALISTER MACKIE

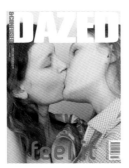

ISSUE 63, VOL. I, MAR 2000
FEEL IT
P: RANKIN
S: ALISTER MACKIE

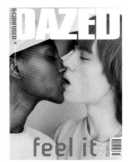

ISSUE 63, VOL. I, MAR 2000
FEEL IT
P: RANKIN
S: ALISTER MACKIE

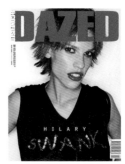

ISSUE 63, VOL. I, MAR 2000
FEEL IT
P: RANKIN
S: ALISTER MACKIE

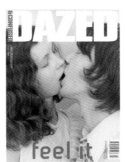

ISSUE 64, VOL. I, APR 2000
HILARY SWANK
P: RANKIN
S: MARIA SERRA

ISSUE 64, VOL. I, APR 2000
LOADING...

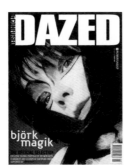

ISSUE 65, VOL. I, MAY 2000
BJÖRK
P: DAVID SIMS
S: KATY ENGLAND

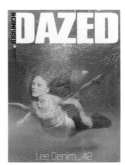

ISSUE 66, VOL. I, JUN 2000
EMINEM
P: ALEXEI HAY
S: JASON FARRER

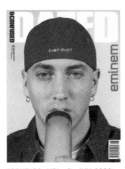

ISSUE 66, VOL. I, JUN 2000
LEE DENIM
P: ED REEVE

ISSUE 67, VOL. I, JUL 2000
THE WORD ISSUE
A: ALAN KITCHING

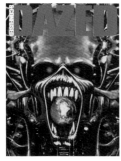

ISSUE 67, VOL. I, JUL 2000
EDDIE, IRON MAIDEN

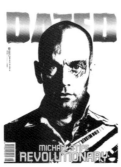

ISSUE 68, VOL. I, AUG 2000
MICHAEL STIPE
P: RANKIN
S: ALISTER MACKIE

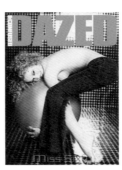

ISSUE 68, VOL. I, AUG 2000
MISS SIXTY
P: ELLEN VON UNWERTH

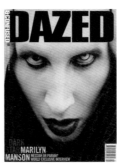

ISSUE 69, VOL. I, SEP 2000
MARILYN MANSON
P: PEROU

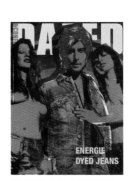

ISSUE 69, VOL. I, SEP 2000
ENERGIE DYED JEANS
P: RANKIN

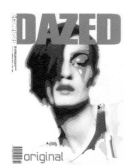

ISSUE 70, VOL. I, OCT 2000
ORIGINAL
P: WARREN DU PREEZ & NICK T JONES
S: KATY ENGLAND

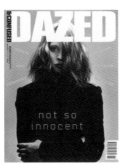

ISSUE 71, VOL. I, NOV 2000
SHEA SEGER
P: RANKIN
S: MIRANDA ROBSON

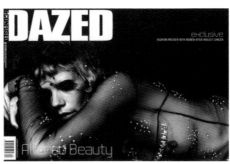

ISSUE 72, VOL. I, DEC 2000
ALTERED BEAUTY
P: NICK KNIGHT
S: KATY ENGLAND

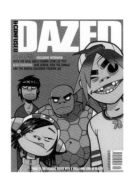

ISSUE 73, VOL. I, JAN 2001
GORILLAZ
A: JAMIE HEWLETT
S: BRYAN MCMAHON

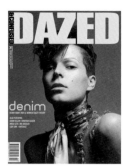

ISSUE 74, VOL. I, FEB 2001
ELEANORA
P: DAVID SIMS
S: KATY ENGLAND

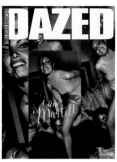

ISSUE 74, VOL. I, FEB 2001
MARTELL

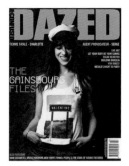

ISSUE 75, VOL. I, MAR 2001
CHARLOTTE GAINSBOURG
P: HORST DIEKGERDES
S: NANCY ROHDE

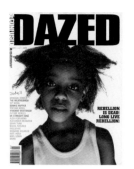

ISSUE 76, VOL. I, APR 2001
JODELL
P: RANKIN

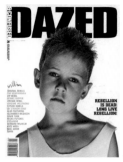

ISSUE 76, VOL. I, APR 2001
WILLIAM
P: RANKIN

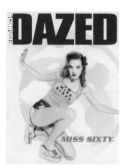

ISSUE 76, VOL. I, APR 2001
MISS SIXTY
P: ELLEN VON UNWERTH

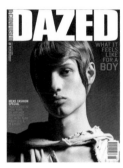

ISSUE 77, VOL. I, MAY 2001
MENS FASHION SPECIAL
P: HORST DIEKGERDES
S: ALISTER MACKIE

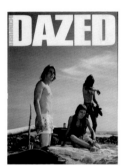

ISSUE 77, VOL. I, MAY 2001
DR MARTENS
P: SASHA EISENMAN

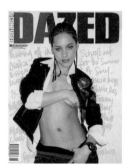

ISSUE 78, VOL. I, JUN 2001
ALICIA KEYS
P: TERRY RICHARDSON
S: KATJA RAHLWES

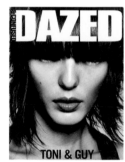

ISSUE 78, VOL. I, JUN 2001
TONI & GUY
P: RANKIN
S: MIRANDA ROBSON

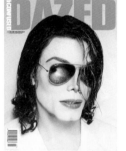

ISSUE 79, VOL. I, JUL 2001
MICHAEL JACKSON (IMPERSONATOR)
P: RANKIN

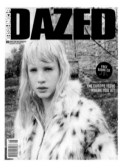

ISSUE 80, VOL. I, AUG 2001
CHLOE WILTON
P: PAULO SUTCH
S: NICOLA FORMICHETTI

ISSUE 80, VOL. I, AUG 2001
EVIAN
P: MICHAEL EVANET

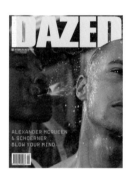

ISSUE 81, VOL. I, SEP 2001
ALEXANDER MCQUEEN & SCHOERNER
P: NORBERT SCHOERNER

ISSUE 82, VOL. I, OCT 2001
DELFINE
P: PAULO SUTCH
S: CATHY EDWARDS

ISSUE 83, VOL. I, NOV 2001
TARYN SIMON
P: TARYN SIMON

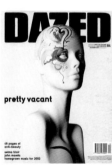

ISSUE 84, VOL. I, DEC 2001
PRETTY VACANT
P: JENNY VAN SOMMERS
S: JULIE VERHOEVEN

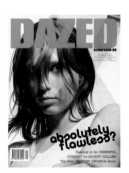

ISSUE 85, VOL. I, JAN 2002
ABSOLUTELY FLAWLESS?
P: RANKIN
S: MIRANDA ROBSON

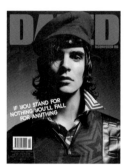

ISSUE 86, VOL. I, FEB 2002
IF YOU STAND FOR NOTHING...
P: HORST DIEKGERDES
S: ALISTER MACKIE

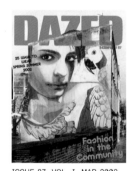

ISSUE 87, VOL. I, MAR 2002
FASHION IN THE COMMUNITY
P: ERNST FISCHER
A: SHONA HEATH

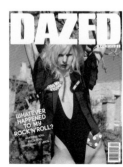

ISSUE 88, VOL. I, APR 2002
CHRISTINA KRUSE
P: PAULO SUTCH
S: KATJA RAHLWES

ISSUE 88, VOL. I, APR 2002
MISS SIXTY
P: ELLEN VON UNWERTH
S: CATHERINE AYME

ISSUE 89, VOL. I, MAY 2002
MS DYNAMITE
P: RANKIN
S: CATHY EDWARDS &
 NICOLA FORMICHETTI

ISSUE 90, VOL. I, JUN 2002
BOBBY GILLESPIE
P: JUERGEN TELLER

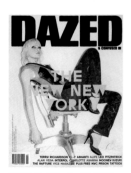

ISSUE 91, VOL. I, JUL 2002
ALISON RENNER
P: KENNETH CAPPELLO
S: NICOLA FORMICHETTI

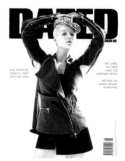

ISSUE 92, VOL. I, AUG 2002
SAMANTHA MORTON
P: DIRK SEIDEN SCHWAN
S: CATHY EDWARDS

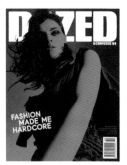

ISSUE 93, VOL. I, SEP 2002
SOLID GOLD EASY ACTION
P: MARTINA HOOGLAND IVANOW
S: KATY ENGLAND & ALISTER MACKIE

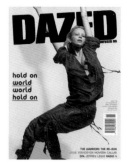

ISSUE 94, VOL. I, OCT 2002
MICHELLE HICKS
P: RANKIN
S: HECTOR CASTRO

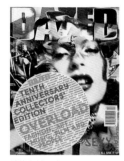

ISSUE 95, VOL. I, NOV 2002
ZORA STAR
P: HORST DIEKGERDES
S: CATHY EDWARDS

ISSUE 96, VOL. I, DEC 2002
TENTH ANNIVERSARY
A: NICK KNIGHT

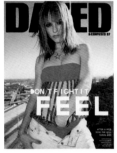

ISSUE 97, VOL. I, JAN 2003
TARYN MANNING
P: SASHA EISENMAN
S: JASON FARRER

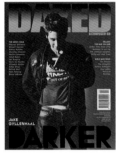

ISSUE 98, VOL. I, FEB 2003
JAKE GYLLENHAAL
P: RANKIN
S: NICOLA FORMICHETTI

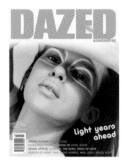

ISSUE 99, VOL. I, MAR 2003
ELISE CROMBEZ
P: DIRK SEIDEN SCHWAN
S: CATHY EDWARDS

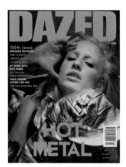

ISSUE 100, VOL. I, APR 2003
NATASA VOJNOVIC
P: LIZ COLLINS
S: KATY ENGLAND

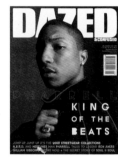

ISSUE 1, VOL. II, MAY 2003
PHARRELL WILLIAMS
P: RANKIN

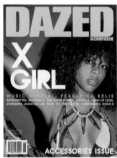

ISSUE 2, VOL. II, JUN 2003
KELIS
P: KENNETH CAPPELLO
S: MASHA ORLOV

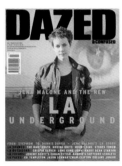

ISSUE 3, VOL. II, JUL 2003
JENA MALONE
P: MICHAEL EVANET
S: NICOLA FORMICHETTI

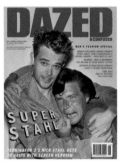

ISSUE 4, VOL. II, AUG 2003
NICK STAHL
P: ALEXEI HAY
S: NICOLA FORMICHETTI

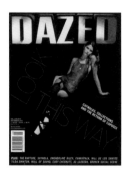

ISSUE 5, VOL. II, SEP 2003
FRANKIE RAYDER
P: LACEY
S: CATHY EDWARDS & SHONA HEATH

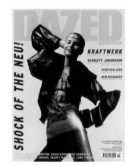

ISSUE 6, VOL. II, OCT 2003
HANA SOUKUPOVA
P: LAURENCE PASSERA
S: NICOLA FORMICHETTI

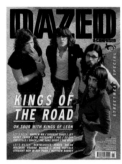

ISSUE 7, VOL. II, NOV 2003
KINGS OF LEON
P: MAURITS SILLEM

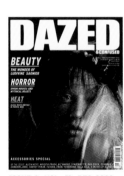

ISSUE 8, VOL. II, DEC 2003
LUDIVINE SAGNIER
P: DAVID SIMS
S: CATHY EDWARDS

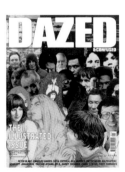

ISSUE 9, VOL. II, JAN 2004
THE ILLUSTRATED ISSUE
A: PETER BLAKE

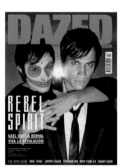

ISSUE 10, VOL. II, FEB 2004
REBEL SPIRIT
P: RANKIN
S: NICOLA FORMICHETTI

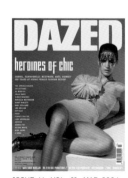

ISSUE 11, VOL. II, MAR 2004
DIANA DONDOE
P: ERIC NEHR
S: CATHY EDWARDS

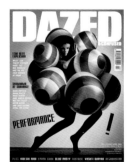

ISSUE 12, VOL. II, APR 2004
HEATHER MARKS
P: LAURIE BARTLEY
S: NICOLA FORMICHETTI

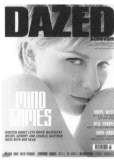

ISSUE 13, VOL. II, MAY 2004
KIRSTEN DUNST
P: RANKIN
S: NINA & CLARE HALLWORTH

ISSUE 14, VOL. II, JUN 2004
BURBERRY
P: WILLIAM SELDEN
S: NICOLA FORMICHETTI

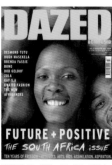

ISSUE 15, VOL. II, JUL 2004
THOKO MASILELA
P: RANKIN

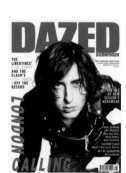

ISSUE 16, VOL. II, AUG 2004
CARL BARÂT
P: DAVID BAILEY

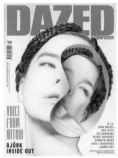

ISSUE 17, VOL. II, SEP 2004
BJÖRK
P: LAURENCE PASSERA
A: HUSSEIN CHALAYAN

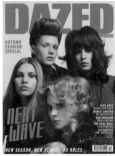

ISSUE 18, VOL. II, OCT 2004
NEXT WAVE
P: HORST DIEKGERDES
S: CATHY EDWARDS

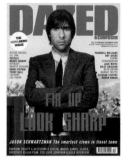

ISSUE 19, VOL. II, NOV 2004
ASIA ARGENTO
P: MAGNUS UNAR
S: HECTOR CASTRO

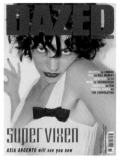

ISSUE 20, VOL. II, DEC 2004
JASON SCHWARTZMAN
P: TODD SELBY
S: JAY MASSACRET

ISSUE 21 , VOL. II, JAN 2005
LYRICS AND LITERATURE SPECIAL

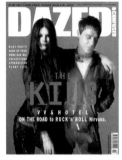

ISSUE 22, VOL. II, FEB 2005
THE KILLS
P: LAURENCE PASSERA
S: CATHY EDWARDS

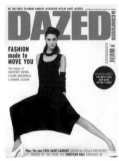

ISSUE 23, VOL. II, MAR 2005
FLEX
P: RICHARD BUSH
S: CATHY EDWARDS

ISSUE 24, VOL. II, APR 2005
EVA GREEN
P: CEDRIC BUCHET
S: HECTOR CASTRO

ISSUE 25, VOL. II, MAY 2005
ELECTION ISSUE
P: MAGNUS UNNAR
S: NICOLA FORMICHETTI

ISSUE 26, VOL. II, JUN 2005
DAVE GROHL
P: RANKIN

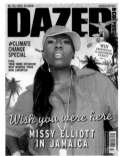

ISSUE 27, VOL. II, JUL 2005
MISSY ELLIOTT
P: MAKI KAWAKITA
S: BRANDON ATHERLEY
A: JIMMY TURRELL

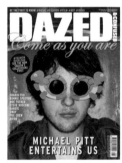

ISSUE 28, VOL. II, AUG 2005
MICHAEL PITT
P: TERRY RICHARDSON
S: NICOLA FORMICHETTI

ISSUE 29, VOL. II, SEP 2005
JULIETTE LEWIS
P: AMANDA MARSALIS

ISSUE 30, VOL. II, OCT 2005
KAREN ELSON
P: RICHARD BUSH
S: CATHY EDWARDS

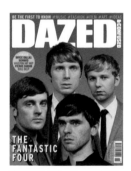

ISSUE 31, VOL. II, NOV 2005
FRANZ FERDINAND
P: WILLIAM SELDEN
S: NICOLA FORMICHETTI

ISSUE 32, VOL. II, DEC 2005
JAMIE FOXX & KANYE WEST
P: RANKIN & MATT HOLYOAK

ISSUE 33, VOL. II, JAN 2006
CILLIAN MURPHY
P: DAVID SLIJPER
S: BRYAN MCMAHON

ISSUE 34, VOL. II, FEB 2006
YOUNG LONDON ON FILM
P: TOYIN

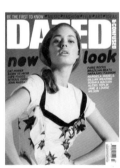

ISSUE 35, VOL. II, MAR 2006
NEW LOOK
P: RICHARD BUSH
S: CATHY EDWARDS

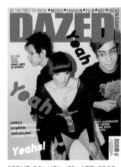

ISSUE 36, VOL. II, APR 2006
THE YEAH YEAH YEAHS
P: MAGNUS UNNAR
S: CHRISTIANE JOY & LYDIA PADDON

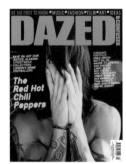

ISSUE 37, VOL. II, MAY 2006
ANTHONY KIEDIS
P: YELENA YEMCHUK

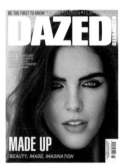

ISSUE 38, VOL. II, JUN 2006
MADE UP
P: ALASDAIR MCLELLAN

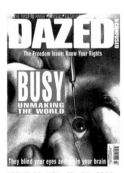

ISSUE 39, VOL. II, JUL 2006
BUSY UNMAKING THE WORLD
A: BARBARA KRUGER

ISSUE 39, VOL. II, JUL 2006
KNOW YOUR RIGHTS
A: DAMIEN HIRST

ISSUE 40, VOL. II, AUG 2006
SHINE ON
P: MIGUEL REVERIEGO
S: SARAH COBB

ISSUE 41, VOL. II, SEP 2006
JUSTIN TIMBERLAKE
P: RANKIN
S: NICOLA FORMICHETTI

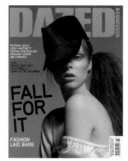

ISSUE 42, VOL. II, OCT 2006
FALL FOR IT
P: HORST DIEKGERDES
S: CATHY EDWARDS

ISSUE 43, VOL. II, NOV 2006
SOFIA COPPOLA
P: YELENA YEMCHUK
S: JOANNA SCHLENZKA

ISSUE 44, VOL. II, DEC 2006
ZOOEY DESCHANEL
P: TERRY RICHARDSON
S: SARAH COBB

ISSUE 45, VOL. II, JAN 2007
BLOC PARTY
P: MAGNUS UNNAR
S: NICOLA FORMICHETTI

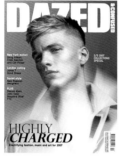

ISSUE 46, VOL. II, FEB 2007
HIGHLY CHARGED
P: LAURENCE PASSERA
S: NICOLA FORMICHETTI

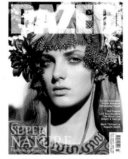

ISSUE 47, VOL. II, MAR 2007
SUPER NATURE
P: HORST DIEKGERDES
S: CATHY EDWARDS

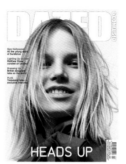

ISSUE 48, VOL. II, APR 2007
HEADS UP
P: DANIEL JACKSON
S: JOANNA SCHLENZKA

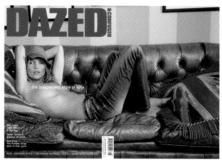

ISSUE 49, VOL. II, MAY 2007
KATE MOSS
P: VENETIA SCOTT
S: VENETIA SCOTT

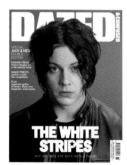

ISSUE 50, VOL. II, JUN 2007
JACK WHITE
P: ROE ETHRIDGE

ISSUE 50, VOL. II, JUN 2007
MEG WHITE
P: ROE ETHRIDGE

ISSUE 51, VOL. II, JUL 2007
MAGGIE GYLLENHAAL
P: MIGUEL REVERIEGO
S: SARAH COBB

ISSUE 52, VOL. II, AUG 2007
NOT EVERYTHING IS...
P: MARIANO VIVANCO
S: NICOLA FORMICHETTI

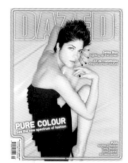

ISSUE 53, VOL. II, SEP 2007
PURE COLOUR
P: RANKIN
S: KATIE SHILLINGFORD

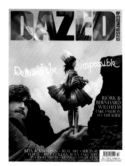

ISSUE 54, VOL. II, OCT 2007
BJÖRK & BERNHARD WILLHELM
P: CARMEN FREUDENTHAL
 & ELLE VERHAGEN

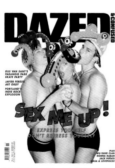

ISSUE 55, VOL. II, NOV 2007
SEX ME UP!
P: MATT IRWIN
S: NICOLA FORMICHETTI

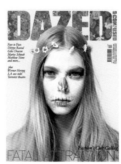

ISSUE 56, VOL. II, DEC 2007
FATAL ATTRACTION
P: MARIANO VIVANCO
S: NICOLA FORMICHETTI

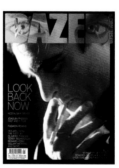

ISSUE 57, VOL. II, JAN 2008
JOAQUIN PHOENIX
P: JEFF BURTON
S: TYLER UDALL

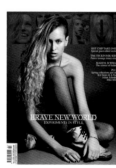

ISSUE 58, VOL. II, FEB 2008
BRAVE NEW WORLD
P: SØLVE SUNDSBØ
S: NICOLA FORMICHETTI

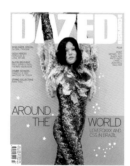

ISSUE 59, VOL. II, MAR 2008
LOVEFOXXX
P: MATT IRWIN
S: KAREN LANGLEY

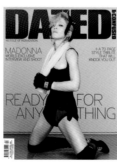

ISSUE 60, VOL. II, APR 2008
MADONNA
P: STEVEN KLEIN

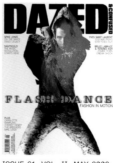

ISSUE 61, VOL. II, MAY 2008
FLASH DANCE
P: LAURENCE PASSERA
S: NICOLA FORMICHETTI

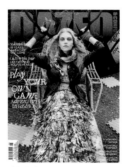

ISSUE 62, VOL. II, JUN 2008
PLAY YOUR OWN GAME
P: MARIANO VIVANCO
S: NICOLA FORMICHETTI

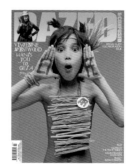

ISSUE 63, VOL. II, JUL 2008
GET A LIFE
P: OLIVIERO TOSCANI
S: NICOLA FORMICHETTI

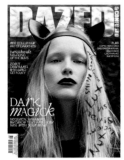

ISSUE 64, VOL. II, AUG 2008
DARK MAGICK
P: MARIANO VIVANCO
S: NICOLA FORMICHETTI

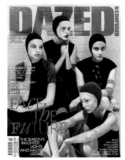

ISSUE 65, VOL. II, SEP 2008
FACE THE FUTURE
P: WILL DAVIDSON
S: KAREN LANGLEY &
 KATIE SHILLINGFORD

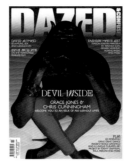

ISSUE 66, VOL. II, OCT 2008
ELEVATION
P: NICK KNIGHT
S: KATIE SHILLINGFORD

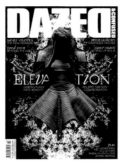

ISSUE 67, VOL. II, NOV 2008
GRACE JONES
P: CHRIS CUNNINGHAM

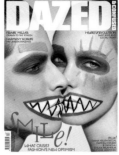

ISSUE 68, VOL. II, DEC 2008
SMILE!
P: DANIEL SANNWALD
S: KATIE SHILLINGFORD &
 ROBBIE SPENCER

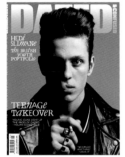

ISSUE 69, VOL. II, JAN 2009
TEENAGE TAKEOVER
P: HEDI SLIMANE
S: NICOLA FORMICHETTI

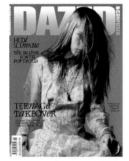

ISSUE 69, VOL. II, JAN 2009
TEENAGE TAKEOVER
P: HEDI SLIMANE
S: NICOLA FORMICHETTI

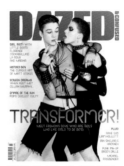

ISSUE 70, VOL. II, FEB 2009
BAT FOR LASHES
P: RANKIN
S: KATIE SHILLINGFORD

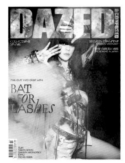

ISSUE 71, VOL. II, MAR 2009
TRANSFORMER!
P: MARIANO VIVANCO
S: NICOLA FORMICHETTI

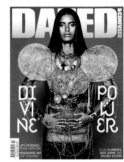

ISSUE 72, VOL. II, APR 2009
DIVINE POWER
P: JOSH OLINS
S: NICOLA FORMICHETTI

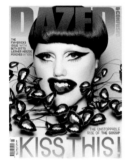

ISSUE 73, VOL. II, MAY 2009
BETH DITTO
P: RANKIN
S: ROBBIE SPENCER

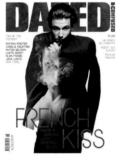

ISSUE 74, VOL. II, JUN 2009
GASPARD ULLIEL
P: SØLVE SUNDSBØ
S: JACOB K

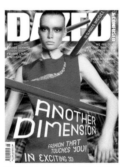

ISSUE 75, VOL. II, JUL 2009
RIP IT UP AND START AGAIN
P: MARIANO VIVANCO
S: NICOLA FORMICHETTI

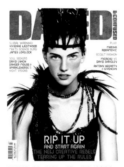

ISSUE 76, VOL. II, AUG 2009
ANOTHER DIMENSION
P: TERRY TSIOLIS
S: NICOLA FORMICHETTI

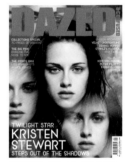

ISSUE 77, VOL. II, SEP 2009
KRISTEN STEWART
P: DAVID SHERRY
S: KATIE SHILLINGFORD

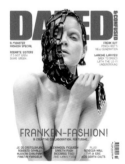

ISSUE 78, VOL. II, OCT 2009
FRANKEN-FASHION
P: DANIEL JACKSON
S: KAREN LANGLEY

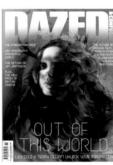

ISSUE 79, VOL. II, NOV 2009
LILY COLE
P: MARTINA HOOGLAND IVANOW
S: KAREN LANGLEY

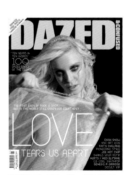

ISSUE 80, VOL. II, DEC 2009
ABBEY LEE
P: DANIEL JACKSON
S: KAREN LANGLEY

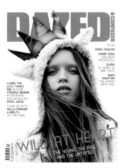

ISSUE 81, VOL. II, JAN 2010
COURTNEY LOVE
P: YELENA YEMCHUK
S: KAREN LANGLEY

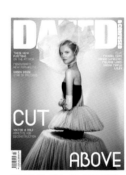

ISSUE 82, VOL. II, FEB 2010
CUT ABOVE
P: JOSH OLINS
S: KATIE SHILLINGFORD

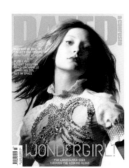

ISSUE 83, VOL. II, MAR 2010
MIA WASIKOWSKA
P: LAURENCE PASSERA
S: KATIE SHILLINGFORD

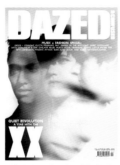

ISSUE 84, VOL. II, APR 2010
THE XX
P: PIERRE DEBUSSCHERE
S: ROBBIE SPENCER

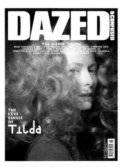

ISSUE 85, VOL. II, MAY 2010
TILDA SWINTON
P: GLEN LUCHFORD
S: KATY ENGLAND

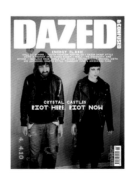

ISSUE 86, VOL. II, JUN 2010
CRYSTAL CASTLES
P: ARI MARCOPOULOS

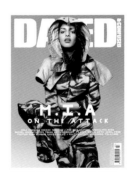

ISSUE 87, VOL. II, JUL 2010
M.I.A.
P: RANKIN
S: KATIE SHILLINGFORD

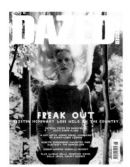

ISSUE 88, VOL. II, AUG 2010
KRISTEN MCMENAMY
P: TIERNEY GEARON
S: KAREN LANGLEY

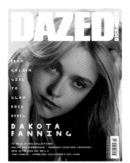

ISSUE 89, VOL. II, SEP 2010
DAKOTA FANNING
P: MARK SEGAL
S: KATIE SHILLINGFORD

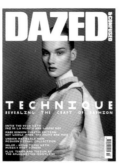

ISSUE 90, VOL. II, OCT 2010
KIRSI PYRHÖNEN
P: SHARIF HAMZA
S: KAREN LANGLEY

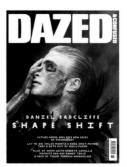

ISSUE 91, VOL. II, NOV 2010
DANIEL RADCLIFFE
P: SERGE LEBLON
S: ROBBIE SPENCER

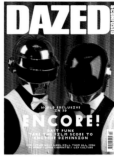

ISSUE 92, VOL. II, DEC 2010
DAFT PUNK
P: SHARIF HAMZA
S: ROBBIE SPENCER

ISSUE 93, VOL. II, JAN 2011
ANNA PAQUIN
P: TERRY RICHARDSON
S: KATIE SHILLINGFORD

ISSUE 94, VOL. II, FEB 2011
ANDREA RISEBOROUGH
P: RANKIN
S: KATIE SHILLINGFORD

ISSUE 95, VOL. II, MAR 2011
ARIZONA MUSE
P: SHARIF HAMZA
S: KAREN LANGLEY

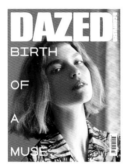

ISSUE 95, VOL. II, MAR 2011
ARIZONA MUSE
P: BENJAMIN ALEXANDER HUSEBY
S: KATIE SHILLINGFORD

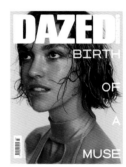

ISSUE 95, VOL. II, MAR 2011
ARIZONA MUSE
P: KACPER KASPRZYK
S: MEL OTTENBERG

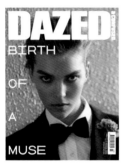

ISSUE 95, VOL. II, MAR 2011
ARIZONA MUSE
P: MARK SEGAL
S: ROBBIE SPENCER

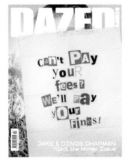

ISSUE 96, VOL. II, APR 2011
CAN'T PAY YOUR FEES?
A: JAKE & DINOS CHAPMAN

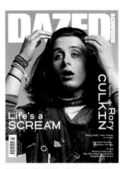

ISSUE 97, VOL. II, MAY 2011
RORY CULKIN
P: HEDI SLIMANE
S: ROBBIE SPENCER

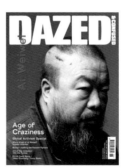

ISSUE 98, VOL. II, JUN 2011
AI WEIWEI
P: GAO YUAN

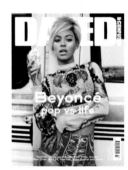

ISSUE 99, VOL. II, JUL 2011
BEYONCÉ
P: SHARIF HAMZA
S: KAREN LANGLEY

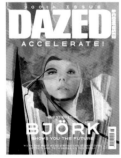

ISSUE 100, VOL. II, AUG 2011
BJÖRK
P: SAM FALLS
S: KATY ENGLAND

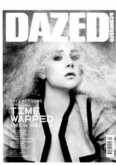

ISSUE 1, VOL. III, SEP 2011
JUNO TEMPLE
P: KACPER KASPRZYK
S: KATIE SHILLINGFORD

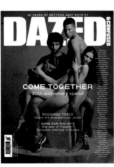

ISSUE 2, VOL. III, OCT 2011
RICCARDO TISCI
P: MATTHEW STONE
S: KATY ENGLAND

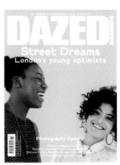

ISSUE 3, VOL. III, NOV 2011
STREET DREAMS
P: BENJAMIN ALEXANDER HUSEBY
S: KATIE SHILLINGFORD

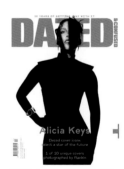

ISSUE 4, VOL. III, DEC 2011
ALICIA KEYS
P: RANKIN
S: YUKI JAMES

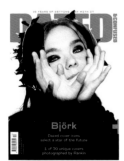

ISSUE 4, VOL. III, DEC 2011
BJÖRK
P: RANKIN
S: ROBBIE SPENCER

ISSUE 4, VOL. III, DEC 2011
BOBBY GILLESPIE
P: RANKIN
S: STEVEN WESTGARTH

ISSUE 4, VOL. III, DEC 2011
CHLOË SEVIGNY
P: RANKIN
S: ROBBIE SPENCER

ISSUE 4, VOL. III, DEC 2011
CILLIAN MURPHY
P: RANKIN
S: TRACEY NICHOLSON

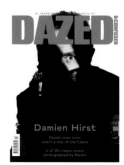

ISSUE 4, VOL. III, DEC 2011
DAMIEN HIRST
P: RANKIN

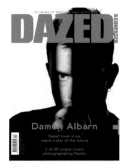

ISSUE 4, VOL. III, DEC 2011
DAMON ALBARN
P: RANKIN
S: STEVEN WESTGARTH

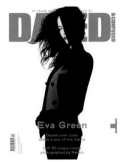

ISSUE 4, VOL. III, DEC 2011
EVA GREEN
P: RANKIN
S: TRACEY NICHOLSON

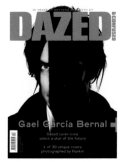

ISSUE 4, VOL. III, DEC 2011
GAEL GARCÍA BERNAL
P: RANKIN
S: CELESTINE COONEY

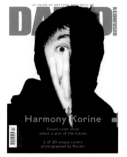

ISSUE 4, VOL. III, DEC 2011
HARMONY KORINE
P: RANKIN
S: SORAYA DAYANI

ISSUE 4, VOL. III, DEC 2011
JARVIS COCKER
P: RANKIN

ISSUE 4, VOL. III, DEC 2011
JULIETTE LEWIS
P: RANKIN
S: LAURA DUNCAN

ISSUE 4, VOL. III, DEC 2011
KATE MOSS
P: RANKIN
S: CATHY EDWARDS

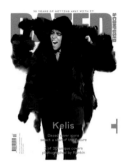

ISSUE 4, VOL. III, DEC 2011
KELIS
P: RANKIN
S: KATIE SHILLINGFORD

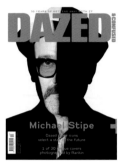

ISSUE 4, VOL. III, DEC 2011
MICHAEL STIPE
P: RANKIN
S: JOANNA SCHLENZKA

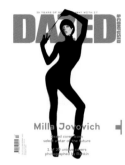

ISSUE 4, VOL. III, DEC 2011
MILLA JOVOVICH
P: RANKIN
S: RYAN HASTINGS

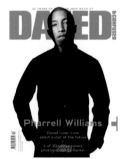

ISSUE 4, VOL. III, DEC 2011
PHARRELL WILLIAMS
P: RANKIN
S: SALLY LYNDLEY

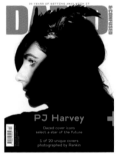

ISSUE 4, VOL. III, DEC 2011
PJ HARVEY
P: RANKIN

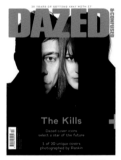

ISSUE 4, VOL. III, DEC 2011
THE KILLS
P: RANKIN
S: TRACEY NICHOLSON

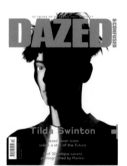

ISSUE 4, VOL. III, DEC 2011
TILDA SWINTON
P: RANKIN
S: KATIE SHILLINGFORD

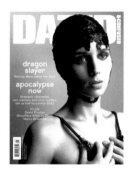

ISSUE 5, VOL. III, JAN 2012
ROONEY MARA
P: GLEN LUCHFORD
S: KAREN LANGLEY

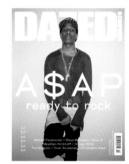

ISSUE 6, VOL. III, FEB 2012
A$AP ROCKY
P: ARI MARCOPOULOS

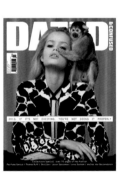

ISSUE 7, VOL. III, MAR 2012
FRIDA AASEN
P: SEAN AND SENG
S: MATTIAS KARLSSON

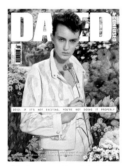

ISSUE 7, VOL. III, MAR 2012
ERONJA ALA
P: ROE ETHRIDGE
S: KATIE SHILLINGFORD

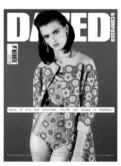

ISSUE 7, VOL. III, MAR 2012
LARA MULLEN
P: BEN TOMS
S: ROBBIE SPENCER

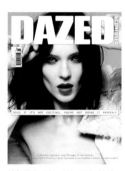

ISSUE 7, VOL. III, MAR 2012
KATI NESCHER
P: DANIEL JACKSON
S: KAREN LANGLEY

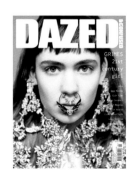

ISSUE 8, VOL. III, APR 2012
GRIMES
P: HEDI SLIMANE
S: ROBBIE SPENCER

ISSUE 9, VOL. III, MAY 2012
GRIMES
P: WALTER PFEIFFER
S: ROBBIE SPENCER

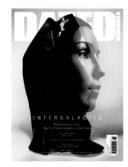

ISSUE 10, VOL. III, JUN 2012
NOOMI RAPACE
P: SØLVE SUNDSBØ
S: KATIE SHILLINGFORD

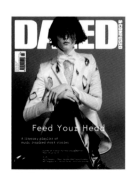

ISSUE 11, VOL. III, JUL 2012
ZEN
P: KACPER KASPRZYK
S: ROBBIE SPENCER

ISSUE 12, VOL. III, AUG 2012
SNOOP DOGG
P: THEO WENNER
S: KAREN LANGLEY

ISSUE 13, VOL. III, SEP 2012
AZEALIA BANKS
P: SHARIF HAMZA
S: KAREN LANGLEY

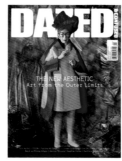

ISSUE 14, VOL. III, OCT 2012
SAM RILEY & JOAN SMALLS
P: SEAN AND SENG
S: KAREN LANGLEY
& ROBBIE SPENCER

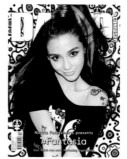

ISSUE 15, VOL. III, NOV 2012
IRIS APFEL
P: JEFF BARK
S: ROBBIE SPENCER

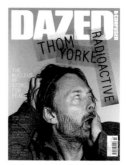

ISSUE 16, VOL. III, DEC 2012
#FANTASIA
P: MATT IRWIN
S: NICOLA FORMICHETTI

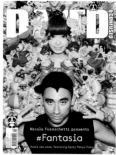

ISSUE 16, VOL. III, DEC 2012
#FANTASIA
P: MATT IRWIN
S: NICOLA FORMICHETTI

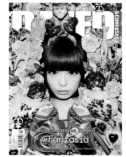

ISSUE 16, VOL. III, DEC 2012
#FANTASIA
P: MATT IRWIN
S: NICOLA FORMICHETTI

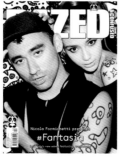

ISSUE 16, VOL. III, DEC 2012
#FANTASIA
P: MATT IRWIN
S: NICOLA FORMICHETTI

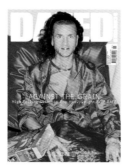

ISSUE 17, VOL. III, JAN 2013
RIFF RAFF
P: NICK HAYMES
S: KAREN LANGLEY

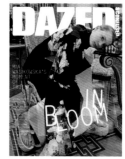

ISSUE 18, VOL. III, FEB 2013
THOM YORKE
P: RICHARD BURBRIDGE
S: ELIZABETH FRASER-BELL

ISSUE 19, VOL. III, MAR 2013
MIA WASIKOWSKA
P: THEO WENNER
S: KAREN LANGLEY

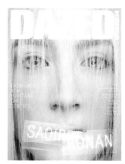

ISSUE 20, VOL. III, APR 2013
SAOIRSE RONAN
P: RANKIN
S: CATHY EDWARDS

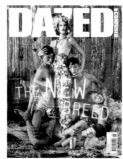

ISSUE 21, VOL. III, MAY 2013
THE NEW BREED
P: JEFF BARK
S: ROBBIE SPENCER

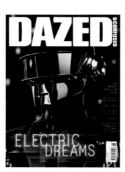

ISSUE 22, VOL. III, JUN 2013
DAFT PUNK
P: HEDI SLIMANE
S: HEDI SLIMANE

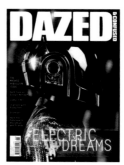

ISSUE 22, VOL. III, JUN 2013
DAFT PUNK
P: HEDI SLIMANE
S: HEDI SLIMANE

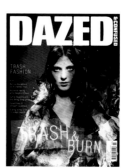

ISSUE 23, VOL. III, JUL 2013
TRASH & BURN
P: PAOLO ROVERSI
S: ROBBIE SPENCER

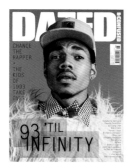

ISSUE 24, VOL. III, AUG 2013
CHANCE THE RAPPER
P: DANIEL JACKSON
S: ALASTAIR MCKIMM

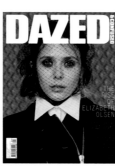

ISSUE 25, VOL. III, SEP 2013
ELIZABETH OLSEN
P: ANGELO PENNETTA
S: ROBBIE SPENCER

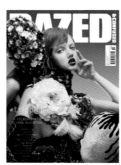

ISSUE 26, VOL. III, OCT 2013
LINDSEY WIXSON
P: PIERRE DEBUSSCHERE
S: ROBBIE SPENCER

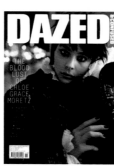

ISSUE 27, VOL. III, NOV 2013
CHLOË GRACE MORETZ
P: GLEN LUCHFORD
S: ROBBIE SPENCER

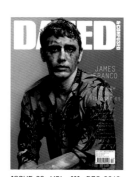

ISSUE 28, VOL. III, DEC 2013
JAMES FRANCO
P: JOSH OLINS
S: ROBBIE SPENCER

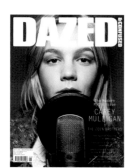

ISSUE 29, VOL. III, JAN 2014
CAREY MULLIGAN
P: RANKIN
S: CATHY EDWARDS

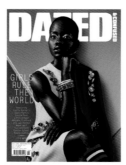

ISSUE 30, VOL. III, FEB 2014
LUPITA NYONG'O
P: SHARIF HAMZA
S: ROBBIE SPENCER

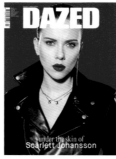

ISSUE 31, VOL. IV, SPRING 2014
SCARLETT JOHANNSON
P: BENJAMIN ALEXANDER HUSEBY
S: JACOB K

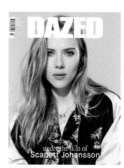

ISSUE 31, VOL. IV, SPRING 2014
SCARLETT JOHANNSON
P: BENJAMIN ALEXANDER HUSEBY
S: JACOB K

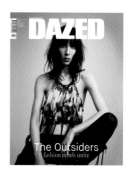

ISSUE 32, VOL. IV, S/S 2014
JAMIE BOCHERT
P: WILLY VANDERPERRE
S: KATY ENGLAND

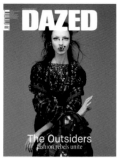

ISSUE 32, VOL. IV, S/S 2014
MARIACARLA BOSCONO
P: WILLY VANDERPERRE
S: PANOS YIAPANIS

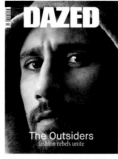

ISSUE 32, VOL. IV, S/S 2014
MATTHIAS SCHOENAERTS
P: WILLY VANDERPERRE

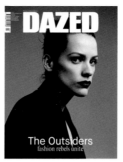

ISSUE 32, VOL. IV, S/S 2014
VEERLE BAETENS
P: WILLY VANDERPERRE
S: ROBBIE SPENCER

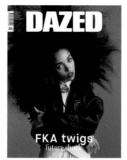

ISSUE 33, VOL. IV, SUMMER 2014
FKA TWIGS
P: INEZ VAN LAMSWEERDE &
 VINOODH MATADIN
S: KAREN CLARKSON

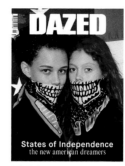

ISSUE 34, VOL. IV, AUTUMN 2014
BINX WALTON & NATALIE WESTLING
P: ROE ETHRIDGE
S: ROBBIE SPENCER

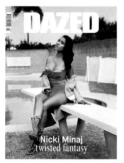

ISSUE 35, VOL. IV, A/W 2014
NICKI MINAJ
P: JEFF BARK
S: ROBBIE SPENCER

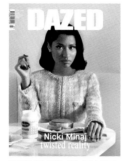

ISSUE 35, VOL. IV, A/W 2014
NICKI MINAJ
P: JEFF BARK
S: ROBBIE SPENCER

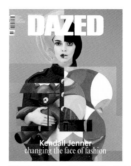

ISSUE 36, VOL. IV, WINTER 2014
KENDALL JENNER
P: BEN TOMS
S: ROBBIE SPENCER

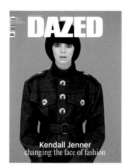

ISSUE 36, VOL. IV, WINTER 2014
KENDALL JENNER
P: BEN TOMS
S: ROBBIE SPENCER

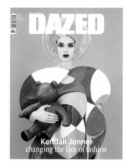

ISSUE 36, VOL. IV, WINTER 2014
KENDALL JENNER
P: BEN TOMS
S: ROBBIE SPENCER

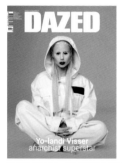

ISSUE 37, VOL. IV, SPRING 2015
YO-LANDI VISSER
P: PIERRE DEBUSSCHERE
S: ROBBIE SPENCER

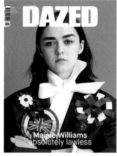

ISSUE 38, VOL. IV, S/S 2015
MAISIE WILLIAMS
P: BEN TOMS
S: ROBBIE SPENCER

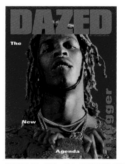

ISSUE 39, VOL. IV, SUMMER 2015
LORDE
P: RYAN MCGINLEY
S: ROBBIE SPENCER

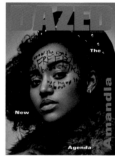

ISSUE 40, VOL. IV, AUTUMN 2015
YOUNG THUG
P: HARLEY WEIR
S: ROBBIE SPENCER

ISSUE 40, VOL. IV, AUTUMN 2015
AMANDLA STENBERG
P: GREGORY HARRIS
S: ROBBIE SPENCER

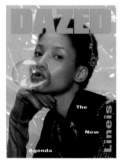

ISSUE 40, VOL. IV, AUTUMN 2015
LINEISY MONTERO
P: ROE ETHRIDGE
S: ROBBIE SPENCER

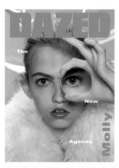

ISSUE 40, VOL. IV, AUTUMN 2015
MOLLY BAIR
P: ROE ETHRIDGE
S: ROBBIE SPENCER

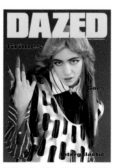

ISSUE 41, VOL. IV, A/W 2015
GRIMES
P: ROE ETHRIDGE
S: ROBBIE SPENCER

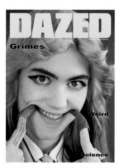

ISSUE 41, VOL. IV, A/W 2015
GRIMES
P: ROE ETHRIDGE
S: ROBBIE SPENCER

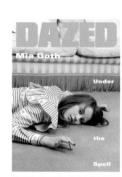

ISSUE 41, VOL. IV, A/W 2015
MIA GOTH
P: BEN TOMS
S: ROBBIE SPENCER

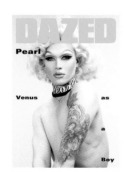

ISSUE 41, VOL. IV, A/W 2015
PEARL
P: WILLY VANDERPERRE
S: ALISTER MACKIE

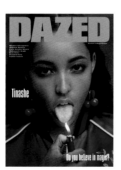

ISSUE 42, VOL. IV, WINTER 2015
TINASHE
P: SEAN AND SENG
S: ROBBIE SPENCER

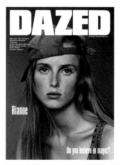

ISSUE 42, VOL. IV, WINTER 2015
RIANNE VAN ROMPAEY
P: COLLIER SCHORR
S: ROBBIE SPENCER

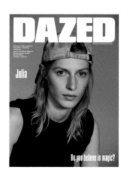

ISSUE 42, VOL. IV, WINTER 2015
JULIA NOBIS
P: COLLIER SCHORR
S: ROBBIE SPENCER

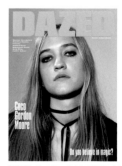

ISSUE 42, VOL. IV, WINTER 2015
COCO GORDON MOORE
P: COLLIER SCHORR
S: ROBBIE SPENCER

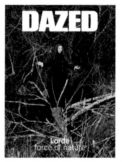

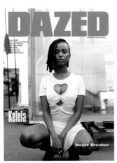

ISSUE 43, VOL. IV, SPRING 2016
KELELA
P: ZOË GHERTNER
S: HALEY WOLLENS

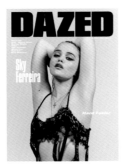

ISSUE 43, VOL. IV, SPRING 2016
SKY FERREIRA
P: COLLIER SCHORR
S: ROBBIE SPENCER

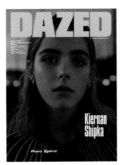

ISSUE 43, VOL. IV, SPRING 2016
KIERNAN SHIPKA
P: BEN TOMS
S: ROBBIE SPENCER

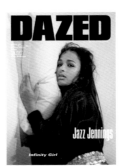

ISSUE 43, VOL. IV, SPRING 2016
JAZZ JENNINGS
P: BRIANNA CAPOZZI
S: EMMA WYMAN

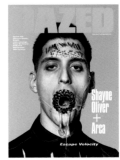

ISSUE 43, VOL. IV, SPRING 2016
SHAYNE OLIVER + ARCA
P: RICHARD BURBRIDGE
S: AKEEM SMITH

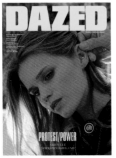

ISSUE 44, VOL. IV, S/S 2016
ABBEY LEE
P: TORBJØRN RØDLAND
S: EMMA WYMAN

ISSUE 44, VOL. IV, S/S 2016
SARFRAJ KRIM
P: HARLEY WEIR
S: TOM GUINNESS

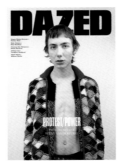

ISSUE 44, VOL. IV, S/S 2016
PAUL HAMELINE
P: WILLY VANDERPERRE
S: OLIVER RIZZO

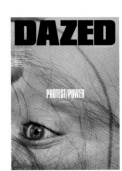

ISSUE 44, VOL. IV, S/S 2016
ANNA EWERS
P: PAOLO ROVERSI
S: ROBBIE SPENCER

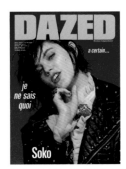

ISSUE 44, VOL. IV, S/S 2016
ANOHNI
P: MEL BLES

ISSUE 45, VOL. IV, SUMMER 2016
YASMIN WIJNALDUM
P: VIVIANE SASSEN
S: ROBBIE SPENCER

ISSUE 45, VOL. IV, SUMMER 2016
ZAYN MALIK
P: COLLIER SCHORR
S: ROBBIE SPENCER

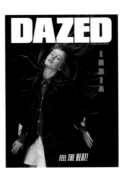

ISSUE 45, VOL. IV, SUMMER 2016
INDIA MENUEZ
P: RYAN MCGINLEY
S: ROBBIE SPENCER

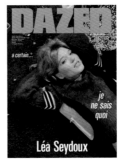

ISSUE 46, VOL. IV, AUTUMN 2016
LÉA SEYDOUX
P: MARK PECKMEZIAN
S: KATIE SHILLINGFORD

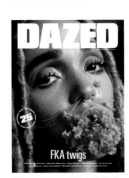

ISSUE 46, VOL. IV, AUTUMN 2016
SOKO
P: ROE ETHRIDGE
S: ROBBIE SPENCER

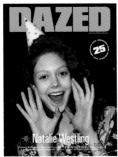

ISSUE 47, VOL. IV, A/W 2016
NATALIE WESTLING
P: WALTER PFEIFFER
S: ROBBIE SPENCER

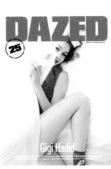

ISSUE 47, VOL. IV, A/W 2016
GIGI HADID
P: RANKIN
S: KATIE GRAND

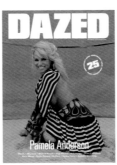

ISSUE 47, VOL. IV, A/W 2016
PAMELA ANDERSON
P: ZOË GHERTNER
S: EMMA WYMAN

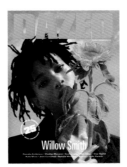

ISSUE 47, VOL. IV, A/W 2016
WILLOW SMITH
P: BEN TOMS
S: ROBBIE SPENCER

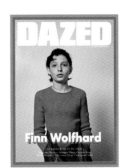

ISSUE 47, VOL. IV, A/W 2016
FKA TWIGS
P: RYAN MCGINLEY
S: KAREN LANGLEY

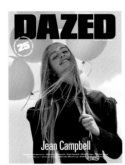

ISSUE 47, VOL. IV, A/W 2016
JEAN CAMPBELL
P: ROE ETHRIDGE
S: ROBBIE SPENCER

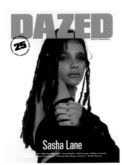

ISSUE 47, VOL. IV, A/W 2016
SASHA LANE
P: SEAN AND SENG
S: ELIZABETH FRASER-BELL

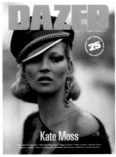

ISSUE 47, VOL. IV, A/W 2016
KATE MOSS
P: ETHAN JAMES GREEN
S: ALISTER MACKIE

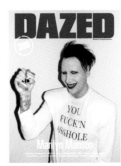

ISSUE 47, VOL. IV, A/W 2016
MARILYN MANSON
P: TERRY RICHARDSON
S: NICOLA FORMICHETTI

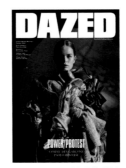

ISSUE 48, VOL. IV, WINTER 2016
FINN WOLFHARD
P: COLLIER SCHORR
S: ROBBIE SPENCER

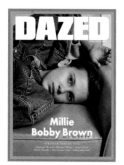

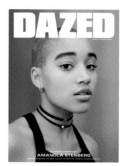

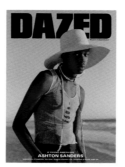

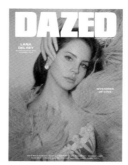

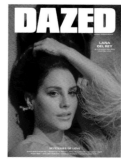

ISSUE 48, VOL. IV, WINTER 2016
MILLIE BOBBY BROWN
P: COLLIER SCHORR
S: ROBBIE SPENCER

ISSUE 49, VOL. IV, SPRING 2017
AMANDLA STENBERG
P: BEN TOMS
S: ROBBIE SPENCER

ISSUE 49, VOL. IV, SPRING 2017
ASHTON SANDERS
P: SEAN AND SENG
S: ROBBIE SPENCER

ISSUE 50, VOL. IV, S/S 2017
LANA DEL REY
P: CHARLOTTE WALES
S: ROBBIE SPENCER

ISSUE 50, VOL. IV, S/S 2017
LANA DEL REY
P: CHARLOTTE WALES
S: ROBBIE SPENCER

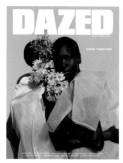

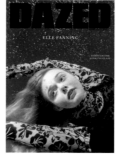

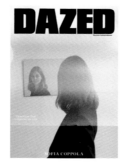

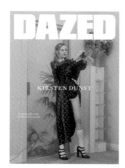

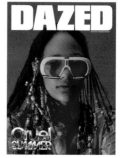

ISSUE 50, VOL. IV, S/S 2017
ALEK WEK
P: VIVIANE SASSEN
S: ROBBIE SPENCER

ISSUE 51, VOL. IV, SUMMER 2017
ELLE FANNING
P: RYAN MCGINLEY
S: ROBBIE SPENCER

ISSUE 51, VOL. IV, SUMMER 2017
SOFIA COPPOLA
P: MARK BORTHWICK

ISSUE 51, VOL. IV, SUMMER 2017
KIRSTEN DUNST
P: CASPER SEJERSEN
S: ROBBIE SPENCER

ISSUE 51, VOL. IV, SUMMER 2017
SELENA FORREST
P: ROE ETHRIDGE
S: ROBBIE SPENCER

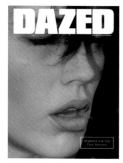

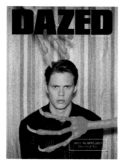

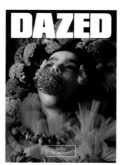

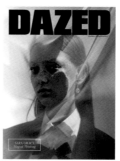

ISSUE 52, VOL. IV, AUTUMN 2017
MARINE VACTH
P: ROBI RODRIGUEZ
S: KATIE SHILLINGFORD

ISSUE 52, VOL. IV, AUTUMN 2017
BILL SKARSGARD
P: WALTER PFEIFFER
S: ROBBIE SPENCER

ISSUE 52, VOL. IV, AUTUMN 2017
BJÖRK
P: JESSE KANDA
S: ROBBIE SPENCER

ISSUE 52, VOL. IV, AUTUMN 2017
SARA GRACE WALLERSTEDT
P: JACK DAVISON
S: ROBBIE SPENCER

ISSUE 53, VOL. IV, A/W 2017
NICKI MINAJ
P: STEVEN KLEIN
S: ROBBIE SPENCER

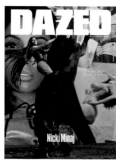

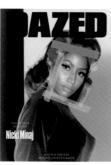

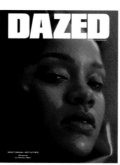

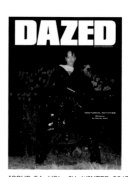

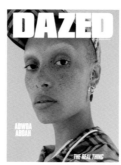

ISSUE 53, VOL. IV, A/W 2017
NICKI MINAJ
P: STEVEN KLEIN
S: ROBBIE SPENCER

ISSUE 53, VOL. IV, A/W 2017
NICKI MINAJ
P: STEVEN KLEIN
S: ROBBIE SPENCER

ISSUE 53, VOL. IV, A/W 2017
ADWOA ABOAH
P: ANGELO PENNETTA
S: ROBBIE SPENCER

ISSUE 54, VOL. IV, WINTER 2017
RIHANNA
P: HARLEY WEIR
S: ROBBIE SPENCER

ISSUE 54, VOL. IV, WINTER 2017
RIHANNA
P: HARLEY WEIR
S: ROBBIE SPENCER

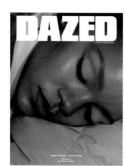

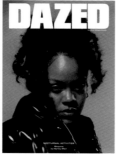

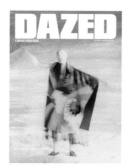

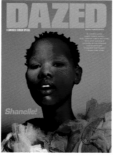

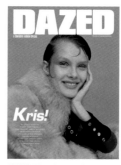

ISSUE 54, VOL. IV, WINTER 2017
RIHANNA
P: HARLEY WEIR
S: ROBBIE SPENCER

ISSUE 54, VOL. IV, WINTER 2017
RIHANNA
P: HARLEY WEIR
S: ROBBIE SPENCER

ISSUE 55, VOL. IV, SPRING 2018
SHANELLE NYASIASE
P: VIVIANE SASSEN
S: ROBBIE SPENCER

ISSUE 55, VOL. IV, SPRING 2018
JONAS GLÖER
P: GARETH MCCONNELL
S: ROBBIE SPENCER

ISSUE 55, VOL. IV, SPRING 2018
KRIS GRIKAITE
P: ANGELO PENNETTA
S: CAMILLE BIDAULT-WADDINGTON

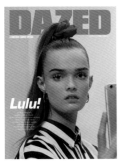

ISSUE 55, VOL. IV, SPRING 2018
LULU TENNEY
P: ROE ETHRIDGE
S: ROBBIE SPENCER

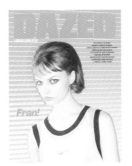

ISSUE 55, VOL. IV, SPRING 2018
FRAN SUMMERS
P: JOHNNY DUFORT
S: EMMA WYMAN

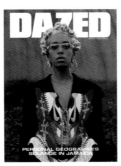

ISSUE 56, VOL. IV, S/S 2018
SOLANGE
P: JACKIE NICKERSON
S: KATIE SHILLINGFORD

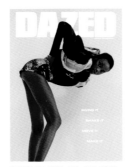

ISSUE 56, VOL. IV, S/S 2018
ANOK YAI
P: BRIANNA CAPOZZI
S: EMMA WYMAN

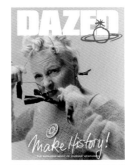

ISSUE 57, VOL. IV, SUMMER 2018
VIVIENNE WESTWOOD
P: HARLEY WEIR
S: ROBBIE SPENCER

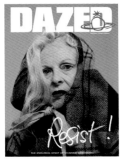

ISSUE 57, VOL. IV, SUMMER 2018
VIVIENNE WESTWOOD
P: HARLEY WEIR
S: ROBBIE SPENCER

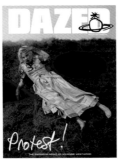

ISSUE 57, VOL. IV, SUMMER 2018
VIVIENNE WESTWOOD
P: HARLEY WEIR
S: ROBBIE SPENCER

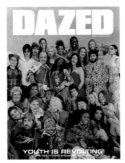

ISSUE 57, VOL. IV, SUMMER 2018
YOUTH IS REVOLTING!
P: HANNA MOON
S: AGATA BELCEN

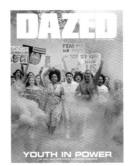

ISSUE 57, VOL. IV, SUMMER 2018
YOUTH IN POWER
P: RYAN MCGINLEY
S: EMMA WYMAN

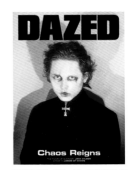

ISSUE 58, VOL. IV, AUTUMN 2018
JACK KILMER
P: CASPER SEJERSEN
S: NELL KALONJI

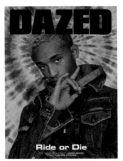

ISSUE 58, VOL. IV, AUTUMN 2018
JADEN SMITH
P: ROE ETHRIDGE
S: ELIZABETH FRASER-BELL

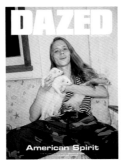

ISSUE 58, VOL. IV, AUTUMN 2018
ISAIAH STONE
P: BEN TOMS
S: DANNY REED

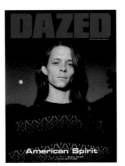

ISSUE 58, VOL. IV, AUTUMN 2018
ISAIAH STONE
P: BEN TOMS
S: DANNY REED

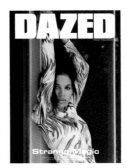

ISSUE 58, VOL. IV, AUTUMN 2018
HELENA HOWARD
P: BRIANNA CAPOZZI
S: EMMA WYMAN

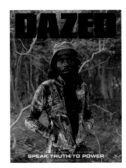

ISSUE 59, VOL. IV, A/W 2018
DEV HYNES
P: WOLFGANG TILLMANS
S: DANNY REED

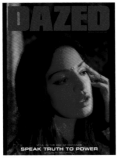

ISSUE 59, VOL. IV, A/W 2018
M.I.A.
P: GARETH MCCONNELL
S: DANNY REED

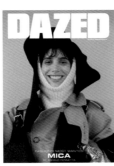

ISSUE 59, VOL. IV, A/W 2018
MICA ARGAÑARAZ
P: ANGELO PENNETTA
S: ROBBIE SPENCER

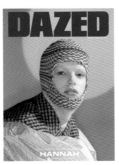

ISSUE 59, VOL. IV, A/W 2018
HANNAH MOTLER
P: JOHNNY DUFORT
S: ROBBIE SPENCER

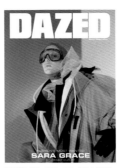

ISSUE 59, VOL. IV, A/W 2018
SARA GRACE WALLERSTEDT
P: JOHNNY DUFORT
S: ROBBIE SPENCER

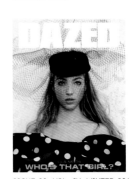

ISSUE 60, VOL. IV, WINTER 2018
LILA MOSS
P: TIM WALKER
S: KATY ENGLAND

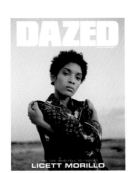

ISSUE 60, VOL. IV, WINTER 2018
LICETT MORILLO
P: BEN TOMS
S: ROBBIE SPENCER

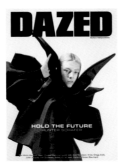

ISSUE 61, VOL. IV, SPRING 2019
HUNTER SCHAFER
P: MARIO SORRENTI
S: ROBBIE SPENCER

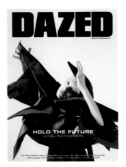

ISSUE 61, VOL. IV, SPRING 2019
ARIEL NICHOLSON
P: MARIO SORRENTI
S: ROBBIE SPENCER

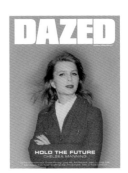

ISSUE 61, VOL. IV, SPRING 2019
KROW
P: SEAN AND SENG
S: ROBBIE SPENCER

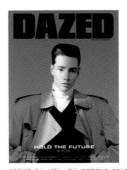

ISSUE 61, VOL. IV, SPRING 2019
CHELSEA MANNING
P: MARK PECKMEZIAN
S: EMMA WYMAN

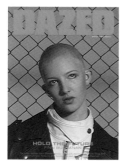

ISSUE 61, VOL. IV, SPRING 2019
FINN BUCHANAN
P: SHARNA OSBORNE
S: HALEY WOLLENS

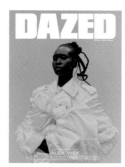

ISSUE 62, VOL. IV, S/S 2019
ALEK WEK
P: TYLER MITCHELL
S: ROBBIE SPENCER

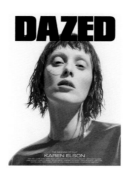

ISSUE 62, VOL. IV, S/S 2019
KAREN ELSON
P: LEA COLOMBO
S: JACOB K

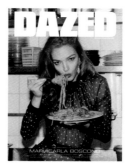

ISSUE 62, VOL. IV, S/S 2019
MARIACARLA BOSCONO
P: CHARLOTTE WALES
S: ELIZABETH FRASER-BELL

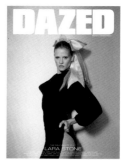

ISSUE 62, VOL. IV, S/S 2019
LARA STONE
P: BRIANNA CAPOZZI
S: EMMA WYMAN

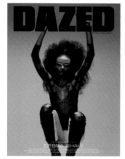

ISSUE 62, VOL. IV, S/S 2019
DEBRA SHAW
P: CAMPBELL ADDY
S: EMMA WYMAN

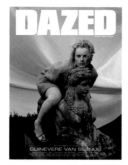

ISSUE 62, VOL. IV, S/S 2019
GUINEVERE VAN SEENUS
P: TOM JOHNSON
S: ELIZABETH FRASER-BELL

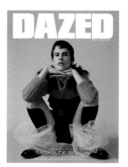

ISSUE 62, VOL. IV, S/S 2019
SASKIA DE BRAUW
P: ANGELO PENNETTA
S: ROBBIE SPENCER

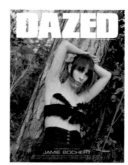

ISSUE 62, VOL. IV, S/S 2019
JAMIE BOCHERT
P: LETTY SCHMITERLOW
S: ELLIE GRACE CUMMING

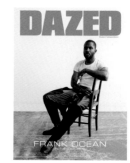

ISSUE 63, VOL. IV, SUMMER 2019
FRANK OCEAN
P: WILLY VANDERPERRE
S: ROBBIE SPENCER

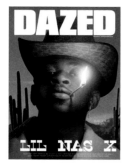

ISSUE 64, VOL. IV, AUTUMN 2019
LIL NAS X
P: CHARLOTTE WALES
S: TOM GUINNESS

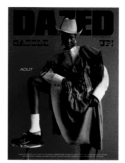

ISSUE 64, VOL. IV, AUTUMN 2019
ADUT AKECH
P: VIVIANE SASSEN
S: ROBBIE SPENCER

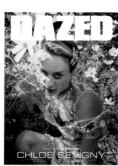

ISSUE 64, VOL. IV, AUTUMN 2019
ADUT AKECH
P: VIVIANE SASSEN
S: ROBBIE SPENCER

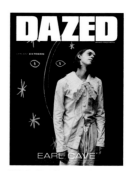

ISSUE 65, VOL. IV, A/W 2019
CHLOË SEVIGNY
P: HARLEY WEIR
S: ROBBIE SPENCER

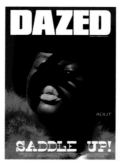

ISSUE 65, VOL. IV, A/W 2019
EARL CAVE
P: JACK DAVISON
S: ROBBIE SPENCER

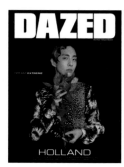

ISSUE 65, VOL. IV, A/W 2019
HOLLAND
P: LESLIE ZHANG
S: ROBBIE SPENCER

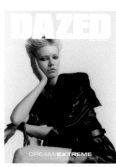

ISSUE 65, VOL. IV, A/W 2019
MAIKE INGA
P: SEAN AND SENG
S: ELIZABETH FRASER-BELL

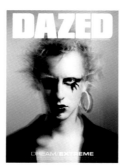

ISSUE 65, VOL. IV, A/W 2019
JULES LEROY
P: PAOLO ROVERSI
S: ROBBIE SPENCER

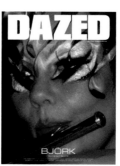

ISSUE 66, VOL. IV, WINTER 2019
BJÖRK
P: HARLEY WEIR
S: ROBBIE SPENCER

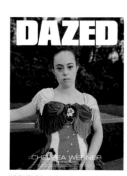

ISSUE 66, VOL. IV, WINTER 2019
CHELSEA WERNER
P: BEN TOMS
S: ROBBIE SPENCER

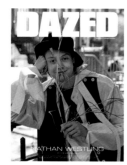

ISSUE 66, VOL. IV, WINTER 2019
NATHAN WESTLING
P: ROE ETHRIDGE
S: ROBBIE SPENCER

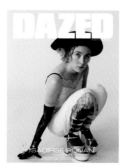

ISSUE 66, VOL. IV, WINTER 2019
SAOIRSE RONAN
P: PAOLO ROVERSI
S: ROBBIE SPENCER

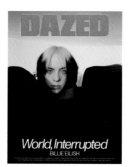

ISSUE 67, VOL. V, SPRING 2020
SELENA GOMEZ
P: BRIANNA CAPOZZI
S: EMMA WYMAN

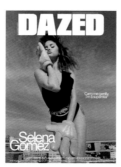

ISSUE 68, VOL. V, S/S 2020
BILLIE EILISH
P: HARMONY KORINE
S: EMMA WYMAN

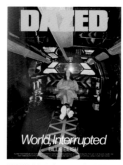

ISSUE 68, VOL. V, S/S 2020
BILLIE EILISH
P: HARMONY KORINE
S: EMMA WYMAN

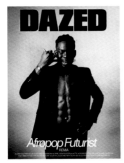

ISSUE 68, VOL. V, S/S 2020
REMA
P: JOSHUA GORDON
S: RAPHAEL HIRSCH

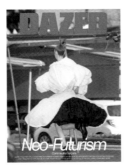

ISSUE 68, VOL. V, S/S 2020
BENTE OORT
P: JOHNNY DUFORT
S: EMMA WYMAN

ISSUE 69, VOL. V, AUTUMN 2020
JANAYA FUTURE KHAN
A: HARSH PATEL

ISSUE 69, VOL. V, AUTUMN 2020
ANONYMOUS CLUB
A: ANONYMOUS CLUB
P: NICK SETHI

ISSUE 69, VOL. V, AUTUMN 2020
ANONYMOUS CLUB
A: JAZZ GRANT

ISSUE 69, VOL. V, AUTUMN 2020
INDIVIDUALLY WE ARE ASLEEP,
AWAKE WE ARE TOGETHER
A: THE WIDE AWAKES AND
HANK WILLIS THOMAS

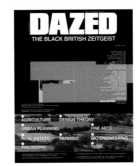

ISSUE 69, VOL. V, AUTUMN 2020
BETWEEN CRITIQUE AND HOPE
A: GRACE WALES BONNER

ISSUE 69, VOL. V, AUTUMN 2020
THE BLACK BRITISH ZEITGEIST
A: SAMUEL ROSS

ISSUE 69, VOL. V, AUTUMN 2020
ACHENRIN MADIT
P: GRACE AHLBOM
S: EMMA WYMAN

ISSUE 70, VOL. V, A/W 2020
LETITIA WRIGHT
P: ARNAUD LAJEUNIE
S: RAPHAEL HIRSCH

ISSUE 70, VOL. V, A/W 2020
PA SALIEU
P: GABRIEL MOSES
S: RAPHAEL HIRSCH

ISSUE 70, VOL. V, A/W 2020
SHYGIRL
P: JORDAN HEMINGWAY
S: NELL KALONJI

ISSUE 70, VOL. V, A/W 2020
KRIS WU
P: YU CONG
S: LUCIA LIU

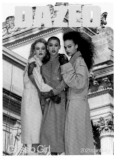

ISSUE 71, VOL. V, SPRING 2021
A: MITRILO

ISSUE 71, VOL. V, SPRING 2021
GOSSIP GIRL
P: ROE ETHRIDGE
S: EMMA WYMAN

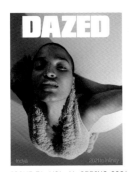

ISSUE 71, VOL. V, SPRING 2021
INDYA MOORE
P: BRIANNA CAPOZZI
S: EMMA WYMAN

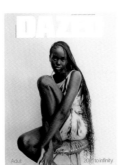

ISSUE 71, VOL. V, SPRING 2021
ADUT AKECH
P: SENTA SIMOND
S: AGATA BELCEN

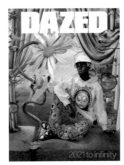

CAMPBELL ADDY
EMMA HOPE ALLWOOD
JEANIE ANNAN-LEWIN
NATALIE APPLETON
NOBUYOSHI ARAKI
ARCA
LIZ JOHNSON ARTUR
BRANDON ATHERLY
ANDREW BAILEY
DAVID BAILEY
JEFF BARK
LAURIE BARTLEY
AGATA BELCEN
NICKI BIDDER
PETER BLAKE
BJÖRK
ROWAN BLANCHARD
MELANIE BLATT
MATTY BOVAN
SELIM BULUT
RICHARD BURBRIDGE
ISABELLA BURLEY
TIM BURROWS
RICHARD BUSH
DOMINIC CADOGAN
ANNA CAFOLLA
BRIANNA CAPOZZI
JON CARAMANICA
JAKE CHAPMAN
DINOS CHAPMAN
DURGA CHEW-BOSE
AARON COBBETT
LIZ COLLINS
JOHN COLVER
ELLIE GRACE CUMMING
LAURA JANE COULSON
CHRIS CUNNINGHAM
RONOJOY DAM
DEAN MAYO DAVIES
EMMA DAVIDSON
JACK DAVISON
CORINNE DAY
JOHNNY DUFORT
CATHY EDWARDS
SASHA EISENMAN
JENNIFER ELSTER
KATY ENGLAND
CHARLIE ENGMAN
ROE ETHRIDGE
SYLVIA FARAGO
JASON FARRER
NICOLA FORMICHETTI
CHARLIE FOX
SUSANNAH FRANKEL
ELISABETH FRASER-BELL
JUSTIN FRENCH
CARMEN FREUDENTHAL
JO-ANN FURNISS
PASCAL GAMBARTE
VAL GARLAND
ZOË GHERTNER
ANDREA GIACOBBE
THOMAS GORTON
JAZZ GRANT
KATIE GRAND
TOM GUINNESS
JEFFERSON HACK
JULIA HACKEL
NINA & CLARE HALLWORTH
SHARIF HAMZA

SIMRAN HANS
GREGORY HARRIS
ALEXEI HAY
CLAIRE MARIE HEALY
SHONA HEATH
JORDAN HEMINGWAY
VALERIA HERKLOTZ
JAMIE HEWLETT
RAPHAEL HIRSCH
DAMIEN HIRST
MARTINA HOOGLAND IVANOW
DEV HYNES
MATT IRWIN
DANIEL JACKSON
HEATHERMARY JACKSON
LEE JENKINS
KIM JONES
NELL KALONJI
AI KAMOSHITA
MAKI KAWAKITA
SANDY KIM
STEVEN KLEIN
HARMONY KORINE
BARBARA KRUGER
KAREN LANGLEY
YOHANA LEBASI
FRANK LEBON
THEO-MASS LEXILEICTOUS
GLEN LUCHFORD
ALISTER MACKIE
BRI MALANDRO
ARI MARCOPOULOS
ROSIE MARKS
AMANDA MARSALIS
GARETH MCCONNELL
SOPHIE MCELLIGOTT
RYAN MCGINLEY
BRYAN MCMAHON
JACK MILLS
TYLER MITCHELL
HANNA MOON
GABRIEL MOSES
JACK MOSS
OWEN MYERS
JACKIE NICKERSON
NICK KNIGHT
TIM NOAKES
LYNETTE NYLANDER
WILSON ORYEMA
SHARNA OSBORNE
RÉMI PARINGAUX
LACEY
LAURENCE PASSERA
HARSH PATEL
ZSOFIA PAULIKOVICS
SARA PAULSEN
MARK PECKMEZIAN
KARENA PERRONET-MILLER
WALTER PFEIFFER
PHIL POYNTER
MARCELE PRICE
BIANCA RAGGI
KATJA RAHLWES
RANKIN
DANNY REED
EMMA REEVES
JAMIE REID
VANESSA REID
TERRY RICHARDSON
MATT ROACH

SIMON ROBINS
MIRANDA ROBSON
TORBJØRN RØDLAND
MISS ROSEN
SAMUEL ROSS
PAOLO ROVERSI
PATRIK SANDBERG
MARK SANDERS
DANIEL SANNWALD
VIVIANE SASSEN
JOANNA SCHLENZKA
NORBERT SCHOERNER
COLLIER SCHORR
SABINA SCHREDER
VENETIA SCOTT
SEAN AND SENG
CASPER SEJERSEN
WILLIAM SELDEN
MARIA SERRA
NICK SETHI
NOAH SHELLEY
KATIE SHILLINGFORD
HEJI SHIN
THORA SIEMSEN
TARYN SIMON
DAVID SIMS
AKEEM SMITH
WILLOW SMITH
PHILIPPA SNOW
MARIO SORRENTI
ROBBIE SPENCER
AMY ROSE SPIEGEL
YVONNE SPORRE
RODERICK STANLEY
TED STANSFIELD
NANCY STEINER
AMANDLA STENBERG
MATTHEW STONE
PAULO SUTCH
AHMAD SWAID
ARCHIE SWINBURN
MARIE TOMANOVA
HANK WILLIS THOMAS
WOLFGANG TILLMANS
BEN TOMS
OLIVIERO TOSCANI
DIANA TOURJÉE
JENNY VAN SOMMERS
WILLY VANDERPERRE
ELLE VERHAGEN
JULIE VERHOEVEN
LORENZO VITTURI
MARIANO VIVANCO
CHARLOTTE WALES
HARLEY WEIR
DANIEL WEISS
THEO WENNER
ADAM ELI WERNER
VIVIENNE WESTWOOD
HALEY WOLLENS
EMMA WYMAN
JUNSUKE YAMASAKI
YELENA YEMCHUK
PHILLIP YOUMANS
GAO YUAN

Cover Image: HARLEY WEIR
Courtesy ART PARTNER

p.084, p.216: RYAN MCGINLEY
p.054, p.164, p.206:
COLLIER SCHORR p.012, p.107,
p.248: ROE ETHRIDGE
Courtesy ARTIST COMMISSIONS

p.010, p.011, p.028, p.029, p.087,
p.198, p.212, p.218: HARLEY WEIR
p.039: TYLER MITCHELL
p.023, p.081, p.255:
TERRY RICHARDSON
p.086: MARIO SORRENTI
p.140, p.145: ZOË GHERTNER
p.258: THEO WENNER
Courtesy ART PARTNER

p.114: JOHNNY DUFORT
p.068, p.102: SEAN AND SENG
p.032: DANIEL SANNWALD
p.102, p.157: SHARNA OSBORNE
p.103: JORDAN HEMINGWAY
Courtesy MA+GROUP

p.044, p.045: RICHARD BURBRIDGE
p.049, p.203: PAOLO ROVERSI
p.016: DANIEL JACKSON
p.116: WALTER PFEIFFER
p.137: WILLY VANDERPERRE
Courtesy ART + COMMERCE

p.048, p.228: HANNA MOON
Courtesy MAP LTD

p.030, p.090, p.091, p.135,
p.150: BRIANNA CAPOZZI
Courtesy REP LTD

p.043: CAMPBELL ADDY
p.067: VENETIA SCOTT
p.123: LIZ COLLINS
p.134: LACEY
Courtesy CLM

p.031, p.106, p.138, p.139, p.141,
p.217: MATT IRWIN
p.078, p.079, p.202: CORINNE DAY
p.224: DAVID SIMS
p.151: MARIANO VIVANCO
Courtesy TRUNK ARCHIVE

p.069: VALERIA HERKLOTZ
p.119: CASPER SEJERSEN
Courtesy ARTISTRY LONDON

p.125: DAMIEN HIRST
© DAMIEN HIRST AND SCIENCE
LTD. All rights reserved,
DACS 2021

p.171: ROSIE MARKS
p.260: FRANK LEBON
Courtesy DOBEDO REPRESENTS INC

p.153: LAURA COULSON
p.234, p.241: MARK PECKMEZIAN
Courtesy WEBBER

p.168: HEJI SHIN
Courtesy CONCRETE REP LTD

p.240: MAKI KAWAKITA
Courtesy ANGLE MANAGEMENT

p.256, p.257: HARMONY KORINE
Courtesy ICONOCLAST IMAGE

p.062, p.063, p.186, p.230, p.232,
p.234: NICK KNIGHT
All Images Courtesy NICK KNIGHT

Every effort has been made to
trace the copyright holders and
obtain permission to reproduce
the material in this book.

First published in the United States of America in 2021
by Rizzoli International Publications, Inc.
300 Park Avenue South
New York, NY 10010
www.rizzoliusa.com

Publisher
CHARLES MIERS

Editorial Coordination
GIULIA DI FILIPPO

Production Manager
COLIN HOUGH TRAPP

Editor
ISABELLA BURLEY

Art Director
JAMIE REID

Project Director,
Rights & Permissions
FELICITY SHAW

Deputy Editors
CLAIRE MARIE HEALY
JACK MILLS

Managing Editor
VALERIA DELLA VALLE

Senior Designer
EVA NAZAROVA

Designer
AIDEN MILLER

Dazed CEO & Co-Founder
JEFFERSON HACK

Typefaces
MONUMENT GROTESK (Dinamo)
UNTITLED SERIF (Klim Type Foundry)

Special Thanks
CAROLINE DAWSON
KEITH GEORGE
BELLE HUTTON
EMMANUEL O'BRIEN
SIMON ROGERS

Printed in Italy

2021 2022 2023 2024 / 10 9 8 7 6 5 4 3 2 1

ISBN-13: 978-0-8478-7073-8
Library of Congress Catalog Control Number: 2021937769

DAZED
&CONFUSED

DAZED and CONF

DAZED

DAZED
&CONFUS

DAZED
&CONFUSED

DAZED
&CONFUSED

and CONFUSED

DAZED

USED

DAZED
&CONFUSED

DAZED
&CONF

DAZED
and CONFUSED

DA

dazed

DAZED
&CONFUSED

DA
&CO

DA
and